John Held, Jr.

John Held, Jr.

ILLUSTRATOR
OF THE JAZZ AGE

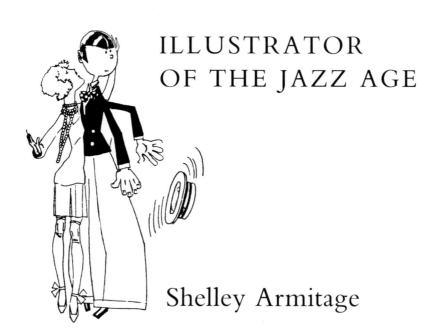

Shelley Armitage

SYRACUSE UNIVERSITY PRESS

FIRST EDITION

92 91 90 89 88 87 6 5 4 3 2 1

The paper used in this publication meets the minimum requirements of American National Standard for Information Sciences—Permanence of Paper for Printed Library Materials, ANSI Z39.48–1984.∞™

Library of Congress Cataloging-in-Publication Data

Armitage, Shelley, 1947–
 John Held, Jr., illustrator of the jazz age.

 Bibliography: p.
 Includes index.
 1. Held, John, 1889–1958. 2. Illustrators—
United States—Biography. I. Title.
NC975.5.H45A87 1987 741.6′092′4[B] 87-7069
ISBN 0-8156-0215-4 (alk. paper)

Manufactured in the United States of America

Contents

Illustrations v

Preface xi

1 The Biography 1

2 The Rise of the New Woman and the Search for Style 61

3 Artistic Exhaustion and Fiction
 The Search for New Meaning 97

4. Watercolors and Bronzes
 The Theme of the Country and the City 127

5 Held's Humor:

 The Artist and the Era 147

 Afterword 183

 Notes 191

 Selected References 199

 Index 211

ILLUSTRATIONS

John Held, Jr. 5

The German Occupation of Manhattan 10

When Preparedness Was New 11

Baseball Game 16

A Few Intimate Sketches at Yellowstone Park 21

The 10 Collegiate Commandments 22–23

The Silent Drama 24

Yo-Ho-Ho and a Deck Full of Rocking Chairs 25

Cape Cod Poster 27

Dude Ranch 30

Teaberry Gum Ad 34

Packard Automobile Ad 35

The Silent Drama 37

They Want to Fix Your Tie 38

His Fingers Met with Disappointment 40

Hold 'Em 42

Gladys Moore 43

Map of Hollywood 44

Mr. and Mrs. John Held, Jr., and Judy 45

John Held, Jr. 46

Gladys Moore and Judy Held 48

Illustration for *Dog Stories* 50

Whisker Inspection at the Century Club 53

Cavanagh's Restaurant Ad 57

The Open Fly 57

Worse Than Doubling in Brass 66

The Modern Martyr 67

Benefit for Sufferers in Europe 67

Prohibition As She Is 68

Do You Like Motoring Sports? 69

The Only Way 77

A Truthful Girl 78

Little Girl—Mother, Dear, Can't I Have a Dress Like That? 78

Here are Eight New Professions 80

Easily Answered 81

Winning the War in the Movies 83

Explain the Black Bottom Dance 85

The Girl Who Went for a Ride in a Balloon 86

Ursula: Is My Nose Shiney, Dearie? 88

Mr. Harkness Talking 88

I've Got to Go Back Now and See a Man about a Buick 90

I Bet You Wish You Were Out in the Parkin' with a Girl 90

Oh! Margy! 92

Oh! Margy! 93

Merely Margy 94

Manhattan Skyline and RCA Building 135

Empire State Building with Clouds 137

Untitled 143

The Rodeo 145

The Ladies of Rum Row 148

One of Held's Belles Travels to the Farm and Knocks It for a Loop 151

I Think That Colts Are Just Too Comical 152

Rosalie Goes Rural 153

Rah-Rah Rosalie 157

A Poor Fish out of Water 158

Why So Pensive, Spike? 158

It's All Right, Santa—You Can Come In 160

Dry Sleuths Are Ready to Admit 160

If Winter Comes 162

A View of the Boat-Races 163

In the Game of Tennis 163

The Girl Who Sat on the Wrong Side of the Field 165

The Dance-Mad Younger Set 165

We Can Be Young Only Once 166

Tonsil Expert 167

Civilization's Progress 169

The Milliner and the City Drummer 170

Curse of the Opera House 172

She Said Now Children Stop Your Cryin' 173

Johnny and Frankie Were Lovers 174

Risking Life and Limb to Secure Oil for Actors' Hair 176

A Swell Map of New York 177

The Great Yachting Map 179

Americana 181

COLOR PLATES
Following page 106

Julian and Julienne

The Skier

Where the Blue Begins

Playing In by Moonlight

The Laughing Stock

The Thinker

Peggy's Progress

Sentimental Sally

All Dated Up

Manhattan Skyline

Cowboy St. Francis and Birds

Cowboy's Grave

Grateful acknowledgment is made to:

Thomas Y. Crowell Company, for permission to reprint illustrations that appeared in *Held's Angels* by John Held, Jr. and Frank B. Gilbreth, Jr. Copyright 1952 by John Held, Jr. and Frank B. Gilbreth, Jr. Reprinted by permission of Thomas Y. Crowell Company, Inc., the publisher.

The New Yorker for drawings copyrighted in 1927, 1954, 1928, and 1956 by The New Yorker Magazine, Inc.

The Illustration House, Inc. and Walt Reed for art work provided for this volume.

Bill Blackbeard and The San Francisco Academy of Comic Art for newspaper cartoons and drawings.

Mr. Henry T. Rockwell, for permission to reproduce illustrations that appeared in *Life* magazine, copyright Old *Life* Magazine, est. F. Berry Rockwell; and for permission to reproduce illustrations that appeared in *Judge* magazine, copyright Old *Life* Magazine, est. F. Berry Rockwell.

Vanguard Press, for permission to reprint drawings that appeared in *Grim Youth* (1930) and *A Bowl of Cherries* (1932).

Judy Held for the reproduction of family photographs.

The Estate of Mrs. John Held, Jr. for selected drawings.

Shelley Armitage received her Ph.D. in American Studies from the University of New Mexico. She has taught in universities in New Mexico, New York, and Ethiopia, and has published a number of journal articles in American cultural studies and literature. She coedited *Reading into Photography*, a collection of critical essays. An associate professor of English, Armitage teaches folklore and American humor at West Texas State University near the family farm at Vega, Texas, where she now lives.

Preface

One cannot pass through the streets of even Albuquerque, New Mexico, it would seem, without encountering some reminder of the lasting popularity of John Held, Jr. Several years ago, after a conversation with a bank teller who turned out to be a Held enthusiast and a collector of his illustrated sheet music, I was jogging down Slate Avenue on a quiet Sunday morning when I heard my name called from the upper story of one of the Victorian homes in the neighborhood. Surprised, I looked up to see the buoyant bank teller, hailing me from his upstairs apartment. I had not yet phoned or stopped by to see the illustrations. He insisted I come up, showed the sheet music to me, gave me a copy, and even wrapped it in plastic for protection so I could carry it, relay style, the remaining miles home. John Held, Jr.'s cartoons, illustrations, advertisements, and decorative work were widely published in the 1920s, and the college students were as zealous in collecting his art as the young bank teller. They pored over the current issues of *Life*, *Judge*, and *College Humor* as if they were fashion plates.

One of these earlier youthful collectors was to become the fourth Mrs. John Held, Jr., Margaret Schuyler Janes met Held at a party in 1936. She was amazed that the tweedy graphic hero of the Jazz Age—the creator of "The Dance Mad Younger Set," Coonskin College Joes, and immortal flappers—was a quiet, even withdrawn, patron of the party who preferred later that evening to walk her home rather than continue the small talk. Indeed, the "roar" of Maggie's 1920s clippings—those jazz babies at football games, the tinkle of beads, the sputtering of the ubiquitous auto, and the clinking of flasks—was a far cry from the personality of the man she later fell in love with. Some fourteen years older than the generation he depicted, Held quietly pursued his dream to be an accomplished serious artist despite his overwhelming success as a popular one. Only ten years before, he made $250,000 a year for a four-panel feature strip for William Randolph Hearst called "Merely Margy," earned hundreds of dollars for single cartoons and covers for *Judge*, *Life*, and other humor magazines, including the block prints for the *New Yorker*, and advertising art for Packard automobiles, Planter's Peanuts, Timken roller bearings, Tintex dyes, and Van

Heusen shirts. In 1927 Vanity Fair named him to their annual "Hall of Fame" along with notables Alfred E. Smith, Grace Coolidge, Harold Ross, and Lawrence of Arabia.

Held socialized with members of the Coffee House Club like Nelson Doubleday, Don Marquis, Rube Goldberg, and Lucius Beebe. He could be seen at Jim Moriarty's speakeasy or at lunch at the Algonquin. In the 1920s he was a colorful member of the Westport, Connecticut, artist community along with Arthur Dove, Vay Wyck Brooks, and Rose O'Neill. Identified with his overwhelmingly popular creation of the flapper, Held illustrated the 1922 collection of F. Scott Fitzgerald stories, *Tales of the Jazz Age*. As the predictable cycle of fashion continued, so did the public's expectations of Held to be associated only with the Jazz Age. The man reported to be the highest-paid popular artist of the 1920s was again asked to recapture short skirts and dropped waists in the 1950s for *Mademoiselle*, *Cosmopolitan*, and other fashion magazines; in 1952, the book, *Held's Angels*, was a retrospective look at college youth. Such popularity, however, had led to a stereotyping of Held's work and personality. This book is an attempt to bring comprehensive critical attention to his thorough genius and variety.

As in the case of the transitional period he captured in his drawings, there was another side of John Held, Jr., "The Other Side of the Twenties," now firmly established by revisionist historians, was Held's own artistic and personal œuvre. The man Maggie met in the 1930s had suffered a severe nervous breakdown from overwork when he turned to fiction writing to compensate for the loss of his art markets. He was separated from his third wife, a beauty queen, had lost his father, and according to some friends, was near suicide. After the stock market crash, having lost his fortune, he was working sporadically, turning to watercolors in which he captured the somber tones of an empty and unpromising Manhattan skyline. Certainly Held's 1920s were "The Roaring Twenties," but his work in the aftermath of that decade illuminates reasons for a nation's restlessness and disappointment. Caught between instant commercial success dictated by the tastes of a mass audience and his own desire both to succeed and to work as a serious artist, Held exemplifies the dilemma of both artist and citizen of the times. His life and career raise important questions about what we now think of as the gaudiest, the saddest, and possibly the most misunderstood period in history.

As a time of unending change, the 1920s was a hollow time between the two world wars, a time of disillusionment over World War I, signaling a loss of idealism and a search for new values. Many Americans centered themselves on material things as a result of a loss of faith. Humankind seemed capable of solving any problem as long as it was mechanical; indeed human beings proved they could reshape their environment through rapidly changing technology. Yet this was most unsettling as well since it brought an awareness that the real problem

might be people themselves. So the surface of things—the materialism of the decade—continued to be appealing, as in the case of mass communications and arts which contained the elements of pure fantasy. During the era of the sports-writer, the press agent, and the newspaper columnist, a large audience continually amused itself by discussing items that floated on the surface. The standards of pure sensation often governed publicity; no wonder that America's heroes were sports figures, movie stars, gangsters—and cartoonists.

As a consumer of the high life of the 1920s, dressed in expensive tweeds and knickers, owner of a penthouse in New York City, a beach house in Florida, and a farm in Connecticut, Held was a member of the very society he caricatured. But in his subtle caricature was the first-hand experience of the artist as keen observer and experimentalist. Even in the popular arena, Held's quest for artistic excellence and originality reflected in his identification of revolutionary forms of fashion in the 1920s. The experimentation with style in his cartoons reveals his direct observation of college youth, particularly women, of his time, how they symbolize modernity, their demise in an insidious process whereby mass tastes are imitative without the corresponding cultural awareness.

Taking the New Woman as a pictorial key for the restless decade, Held turned to new forms, the short story and novel, in an attempt to make a living by seriously confronting the failed promises of the 1920s. Though his fiction fails as well-crafted literature, these often depressing portraits examine the flip side of the so-called revolution in manners and morals. Held's portrayal of women in this literature indicates his understanding of a kind of vamp-as-victim phenomenon. Women's ostensible liberation, as expressed in fashion and behavior, reflected the co-opting of values by the new mass media. Despite the purpose of caricature, Held's cartoons were imitated as models of pseudo-sophistication. As Corey Ford said in *The Time of Laughter*: "Frankly, I had never seen anything remotely resembling that fantastic female until Held's derisive pen portrayed her."

Held mythologized his era as it happened. The autobiographical aspects of his novels, for example *I'm the Happiest Girl in the World* and *The Gods*, suggest he burst the bubble of the airheads in his cartoons—for himself. *I'm the Happiest Girl in the World* deals with his first-hand obervation of the deception of beauty pageants; *The Gods Were Promiscuous* introduces a cartoonist intent on escaping the commercial demands of urban mass communication. During the aftermath of the 1920s, Held continued to reflect a nation's disappointments, bitterness, and nostalgia by turning from fiction to the quietude of his Manhattan city-scapes, the sturdiness of a primarily nineteenth-century style of bronze animal sculpture and the humor of his comic animal watercolors. Because of his struggle with both the superficial and later the "dark side" of the decade, Held's life and career raise important questions about the role of the artist in society. To what extent was Held's life the dilemma of the serious artist corrupted by popu-

larity? How do the popular and fine art traditions intersect in any given period? Does a careful examination of Held's life show the popular depiction of the "Roaring Twenties" to contain its own element of tragedy as well?

The answers to such questions are not simply discovered and analyzed. Held had received little serious attention due to several factors. Much of the primary material—the ads, cartoons, decorative art, book and magazine material, musical comedy sets and costumes, for example—is fugitive. Most of Held's friends and contemporaries are deceased. His fourth wife, Margaret Held, died November 24, 1986. Moreover, scholarly study of Held has been limited by the very breadth of his talents. Few specialists can analyze satisfactorily the meaning of his work either in its cultural or various artistic contexts, which include advertising, graphic design, illustration, poster making, decorative art, cartooning, watercolor, sculpture, and literature. Because most scholars specialize, the temptation has been to dismiss Held as a dilettante, someone who dabbled, albeit interestingly, in many fields. And because there exists no critical apparatus for the interpretation of the popular arts or the cartoons, appreciation of his sophisticated treatment of graphic humor often remains superficial. Throughout his career, Held adopted any style, motif, or gesture, often combining elements for his own amusing ends. Susan E. Meyer, in *America's Great Illustrators*, notes that unlike other illustrators, Held represented a new generation, spirit, and character of the 1920s. He knew no predecessors; his work was idiosyncratic with no stylistic similarity to anyone before. He was an "artistic maverick", a "prototype of an age," expressing a unique comic point of view.

The critic thus begins with the discovery of the delightful personality—the character of this cartoonist/artist so particularly suited to depict the transitional qualities of the 1920s. "Nothing lasts more than five minutes with John," a friend once said. Held was a rapid worker, able to complete twenty drawings a morning before lunch at Delmonico's. But he was a hard worker, too. Maggie kept an army of pencils sharpened and at his elbow as he drew. In the 1920s during his most productive period, he drew into the early morning, sitting on a horse collar to soften the regimen.

His imagination was indefatigable. In addition to the advertising, cartoons, block prints, fiction, watercolors, and bronzes, Held wrote children's stories, comic plays, essays, ran a forge in Weston, Connecticut, designed jewelry and doll furniture. He proved himself several times an apt farmer. He worked as an agent for the Office of Naval Intelligence, making coastal maps and watching for German U-boats in 1917 while attached as the artist to an expedition to Central America for the Museum of Natural History and the Carnegie Foundation to study Mayan ruins. With such versatility, it is not surprising that in the mid-thirties, when his career was at its nadir, he sketched with friend Lee Townsend regularly at the Museum of Modern Art in New York City, then took a habitual swing by the zoo—to see the monkey house, of course.

Two other characteristics distinguish Held and his originality. He was fore-

most a humorist. Gags, like rigging a removable grapeleaf on a model used in a Coffee House skit he composed, were vintage Held. A lover of the one-liner (and master of the pun), Held quipped about his serious fall from a horse in 1925 that sent him to the hospital: "I've always wanted my face lifted but I didn't want a Percheron to do it." Particularly fond of animals and how, when behavior was compared, man often became the laughingstock, he kept Colonel and Mrs. Culpepper in his office when he was artist in residence at the University of Georgia: two chickens. On his Belmar, New Jersey, farm late in life, he named his goats after former wives. Able to laugh at himself as well, upon first meeting Russell Patterson, the cartoonist who supposedly took Held's markets in the 1930s because he could more successfully draw the long skirt, Held walked up and said, "Hi, I'm Russell Patterson." Once Harrie Lindeburg, president of the Coffee House Club, sent Held a telegram, inviting him to a meeting. "If John Held, Jr., tries to disturb the peace by singing," he added, "call the police." Held's humor was gentle, however, "anesthesiac," as art historian Carl Weinhardt has called it. It often was a sympathetic bond through which Held acknowledged the authenticity of child-mind rather than false sophistication. Such an attitude made him both a keen observer and one capable of entering many worlds.

Part of Held's sense of humor led to a humanitarian attitude rather than that of a tease or satirist. When Maggie first met John and he asked her for a date the next Saturday, she said she would be busy giving a baby's party. Surprisingly, he asked if he could help. The party was for Maggie's young married friends with small children. Held brought his friend Lee Townsend along and asked Maggie what she was serving and how he could help. When he found out the treat was ice cream and cake, he told Maggie to order the sponge cake *without* the icing. But when he picked up the cake from Schrafft's, it was covered with a thick layer of gooey icing. Held spent all afternoon with a wet washcloth cleaning off the children's faces, while Lee Townsend won the kids' hearts by cutting out strings of paper dolls.

Held's children—Jack and Jill, Joan, and Judy—were dear to him. The cartoon strip "Oh! Margy!" was titled from Joan's nickname. Held's last official "duty" (and he served as judge for several Miss America beauty pageants in Atlantic City and Galveston) was to serve as judge for a "freckles" contest. Though Held was ill with throat cancer at the time, he served as judge for the little girls.

For this keen observer of life, art was everywhere. Maggie once said Held was interested in everything: "When he looked at a person or situation, his eyes seemed to pierce right through to the core, and with one deeply concentrated glance, he was quickly able to grasp a perfect understanding. If there was any pathos, he felt that first, and deeply, as he was very sympathetic. But he also had an unrivaled sense of humor. After weighing the situation and its sadness, he would look at the funny side, his eyes would twinkle, and his face relax, and I

would be all ready for one of his priceless remarks, which came often, any time of the day or night. When John was depressed, he was very depressed, but it never lasted any amount of time. He analyzed himself thoroughly as he did others. He used to tell me that a sense of humor was the greatest asset in life; anyone who didn't have it naturally, should cultivate it."

Connected to Held's sense of humor was his creative imagination, his ability to see both the actual and the fantastic in things. This is evidenced in all of his work, but especially in his treatment of the West which remained his world of dreams and possibilities. His love of the West—the cowboys, the animals—began when he was a little boy when he drew pictures of animals before he was able to own any. Once when the family bought a new piano, Held took the crate the piano came in and made a bantam house, buying a pair of bantams for his own. When he painted the house where he was born, he placed the piano crate in the yard with the angel Moroni flying over the house with a great light behind him. As Maggie commented, "John was such a devoted, darling, loyal person, so idealistic and at the same time realistic. He wanted everything to be beautiful but could see the bad so clearly. . . . He would tell you that everything was going to pot, then suddenly turn around and describe a beautiful rainbow."

Such an attitude led him not only to return several times to the West, but to prefer to live there. When World War II came, however, he worked for the Signal Corps rather than move back home. Renewed in his trips back to the West, Held maintained old contacts and friendships there. He also painted while on these trips. Watercolors of the Northwest, Utah, Arizona, and Wyoming suggest in their brilliance his ebullient spirit.

The six-acre farm in Belmar, New Jersey, became the next best thing to returning West and satisfied Held in yet another way. Held longed to be self-sufficient and while he never put down his pen, brushes, or putty-knife, he told Maggie he was relieved not to have to draw for a living.

Held had always been fiercely his own man. In the 1930s when he was practically broke, Russell Patterson, who was enjoying the success Held lacked, suggested he could get Held a lucrative job designing store windows for Macy's during Christmas. Held declined, saying he would persist in doing the work he cared about—his sculpture. This independent spirit prevailed at Belmar, where Held worked hard to farm and puttered with his art. At one point he became interested in canning preserves. Brooks Brothers, hearing about his wonderful preserves, offered him a department in their store to sell his wares with an original label. For a week the image of a beautiful brick factory full of preserves in the middle of the cow pasture filled Held's mind, but in the end the bubble burst when he began picturing himself doing nothing but keeping books.

As in every instance in his life, Held was self-taught, learning in his own independent way from life experiences. He greatly valued self-education and was a wordsmith most of his life, outstripping University of Georgia faculty in word games during his tenure there and methodically reading through the dic-

tionary during his life. The books in his library reflect his far-reaching interests: portfolios of Greek vase painting, the complete works of Freud, books on Homer and Whistler, *Death and Taxes* by Dorothy Parker, novels by Stephen Crane and William Faulkner. He insured his library for more than his house.

Held repeatedly acknowledged only two "teachers" during his life: his father and Mahonri M. Young. He did not approve of art schools, believing that anyone who had the aptitude, initiative, and desire to get ahead in a field could learn through observation, contact with their ideals, and constant practice. This philosophy got its start in Held's boyhood when, under the tutelage of a self-made father and the influence of the older Young who had experience and talent, John would watch him draw, paint, and sculpt, asking questions and noting techniques. They both grew to have a strong affinity for the same things: the farm, the soil, animals, the same artistic work, Millet, Daumier, and Winslow Homer. As the two men matured together, they stayed in contact through the years, studying techniques, absorbed in the feeling they had for life. Asked about what he liked in Mahonri's drawings, Held noted the nudes. "They have such flowing lines," he said.

Never liking formal training of any kind, John left elementary school. He was bored and preferred the education of the outside world. He worked on the *Salt Lake City Tribune* where Mahonri already worked. He followed Young to New York City, moved into his studio on 80th and Broadway. His early masks were somewhat in the same vein as the masks Young was making for the Museum of Natural History at that time. Held accompanied Young on trips to Arizona and Indian Country while Young was doing the Indian display for the Museum. While in New York City they ate in Chinatown and spent a lot of time joking together. John cut a block print of a restaurant in Chinatown and called it "Hon Ung." About this time Young was doing a lot of boxing pictures and sketched Held in a boxing pose.

When Young went to Europe, Held went to Central America, but when he returned he went to Mahonri who was living in Leonia, New Jersey, in 1918. Young, on the other hand, visited Held in Weston and made a piece of sculpture with the animals surrounding John, entitled, "John on his own dung heap." In 1922, they accompanied each other on George Putnam's trip West. Young had a home near Held in Connecticut and they kept in contact throughout their lives. They shared the background of a love of the West, art, and a common religion. In Young, Held found the informal teacher who never *made* him learn, but rather encouraged him through model, shared work, and ideas.

Throughout his life, Held remained self-taught, self-made, soaking up whatever traditions interested him. In the 1930s and 40s he continued to frequent the Museum of Modern Art, where he admired the work of Turner and Barry. He once told a friend that the fine arts had influenced his style of caricature. Born with a natural fascination for outline and silhouette, he combined a free-wheeling and uninhibited love of distortion with the fastidiousness and dis-

cipline implicit in his belief that the vase painting of the ancient Greeks was the fountainhead of caricature.

He was able successfully to amalgamate the seemingly disparate art forms with a unique vision of modern life, as in the example of his attitude toward women. He disliked the so-called sophisticated woman he typified as shallow and imitative, rather than knowledgeable, subtle, refined. Maggie noted he said the sophisticated woman in American society was one who frequented the "21 Club" and all the expensive places, to be seen by the right people, dressed in designer clothes, used Madison Avenue phrasing, name-dropping, and put on an artificial pose in general. "John loved to take the starch out of this kind of woman with one carefully worded sentence, or one expertly drawn line." No wonder that Held's expert use of silhouette and line, characteristics of the Greek vase painting he admired, could in a stroke depict and deflate pretentious, superficial qualities.

Ultimately, a thorough study of Held must both encompass and go beyond the engaging personality to a contextual examination of his work. This book attempts to recover Held's œuvre critically from the sometimes simplistic notions of the Jazz Age. Application of critical theory and background in areas of comic art, commercial art, advertising, art history, cultural and literary history, and humor are applied in an interdisciplinary approach. The book begins with an examination of Held's life, attempting to analyze the experiences and attitudes that generated his varied art. The book then proceeds chronologically, by Held's particular areas of focus: Chapter Two explores the development of several cartoon styles, the effect of women's liberation, and modernity. Chapter Three examines Held's literary works as an extension and yet a foil for his comic art. Chapter Four addresses a primary Held theme, the influence of the country and city, introduced in the cartoons, treated in the novels, and the focus of his watercolors and bronzes. Chapter Five studies the connection of cartooning as an art form and Held's humor. The primarily critical rather than biographical focus is an attempt to argue that Held's exceptional artistic abilities when applied largely to the popular arts exemplify a cultural unity in the arts and that particularly his attitude as a humorist conditioned this accomplishment. Allen Gowan remarked that humor primarily is an escape from the pervasive public models of behavior we propose to believe in, allowing us to maintain private realities. In Held's hands, such humor assures that while neither artist nor audience escape their own foibles, we don't make the mistake of taking ourselves too seriously. Certainly Held didn't.

Like the nineteenth-century woman humorist, Marietta Holley, whose character Samantha Allen kept hearing a nagging voice ("Who'll read the book when it's rote"), I have likewise questioned myself. But thanks to several people, like Samantha, I have persisted due to their "cast-iron devotedness." Special thanks to Hamlin Hill, whose reading of "Ruthless Rhymes and Heartless Homes" made me forever a fan of humor—and especially for his patient and

helpful comments on this manuscript in an earlier form. Elizabeth Hadas' supportiveness and expert judgment is deeply appreciated. Everyone should have a mother who can function as a copyeditor; I thank my parents for their untiring encouragement. Also, a special thanks to Bill Hulsey for his enthusiasm for the project and for his invaluable reading of the manuscript in its final forms. And to the memory of Mrs. John Held, Jr. — Maggie — who almost single-handedly for years kept alive the appreciation of her husband's work, this book is affectionately dedicated.

John Held, Jr.

1

The Biography

The boy—perhaps eight years old—slipped into the driver's seat of the wagon, taking up the reins with a confident flair typical of a boy in the West of the 1890s. Behind him, into the wagon bed, stepped his father—bespeckled, resolute, distinguished in mustache and band uniform, but youthfully blond in the full Salt Lake City sun. He held a cornet (a fine silver instrument) with the same poised restraint with which the boy held the horse, and as they eased into the street John Held, Sr., hid himself behind the four billowing muslin sheets moored to poles at each of the wagon's corners. "B. K. Thomas Draper Shop" one sign announced in bold script; the other three sides of the homemade advertisement bore, equally embellished, the names of local establishments. Because of its cargo the wagon seemed to sail over the bumpy streets, music drifting up from behind the screen. First there was "Sweet Alice Ben Bolt," then "Silver Threads among the Gold," but mainly the invisible Raphael played hymns familiar to the predominantly Mormon clientele on the sidewalks this noontime. Heads turned; the boy sat sharply erect; even the horse pricked his ears and pranced a bit to a second verse of "The Old Rugged Cross."

The plan was to drive the wagon through the streets during the noon hour when people would be apt to read the signs. The Held father and son even traveled the unpaved business streets while Mr. Held played his cornet and pulled up in front of each potential client's establishment. The music would attract a crowd who would read the advertising. The citizens in general thought Mr. Held's ideas very original and effective.

As the afternoon wore on, if John Held could not salvage his lip he could at least save his best tune for the biggest crowd and the highest paying customer. The traveling billboard stopped in front of the West Side Saloon, where the elder Held, nursing a swollen lip, and after a few false starts, warbled the opening of a favorite hymn. Immediately his efforts were drowned out by the laughter and hoots of a group of men lounging outside the saloon. Then the door of the saloon flew open, and an even larger and more boisterous crowd poured out. Above all the din was the booming voice of the saloon owner, who cursed and kicked his way to the wagon where he began tearing down the sign. Ripping

through the painted muslin, he discovered John Held, Sr., playing the second chorus of "Nearer My God to Thee." Held broke in the middle of a note, tucked the cornet under his arm, and abandoned the wagon, leaving John Held, Jr., shocked and crying. The horse, more terrified than either father or son, bolted for the livery stable, bouncing the sobbing child all the way home.

John Held, Jr., got his two bits out of the affair—the saloon keeper saw the humor in the event and paid the Helds after suggesting they choose music more appropriate to his place of business—and a good deal more: his childhood was an apprenticeship to an inventive, resourceful, ambitious, energetic, and rather egotistical father—a man who indefatigably sought livelihood through his abilities as an entertainer. Indeed, the entire family flourished because they were able to convert individual talents into one popular art or another.

Grandpa Evans, a wheelwright on the Mormon handcart migration and a carpenter, later helped build the Grand Theater in Salt Lake City, designing and constructing the sets as well. Even Mother Held, reputed to be one of the worst homemakers in town, acted in the local theater. John Held, Jr., would flourish in such a setting, sifting from the theatrical and artistic interests of his family, his training as a craftsman by his father, his enduring love of the West, and his Mormon friendships experiences that would shape his personality and art.

Though John Held, Jr.'s immediate family never formally practiced Mormonism, family history and their daily lives were greatly influenced by it. His maternal grandfather, James Evans, proselytized by a Mormon missionary in England when he was a young man, became a convert and settled in Salt Lake City three years after Brigham Young (1850). In the handcart brigade crossing the plains, he was a great asset because of his training as a carpenter and his abilities as a wheelwright. He married another English emigrant, and the couple had seven children: Emma, Annie, Lizette, Alice, Jessie, Frank, and George. Annie Evans was John Held, Jr.'s mother; she was born to James and Elizabeth Foster Evans in a home within the boundaries of the Twentieth Ward of the Church of Jesus Christ of Latter-day Saints, June 13, 1863.

On the other side of the family, John Held, Sr., was born in Geneva, Switzerland, around 1861. Son of a skilled watchmaker, he was by age nine a fine penman and was discovered by Dr. John R. Park, a Mormon educator, while Park was in Europe looking for child prodigies to bring back to Salt Lake City. He planned to "adopt" such children from converted parents who saw this as an opportunity to get families to Zion, and bring them to the city for training so that they could be teachers for the newly planned University of the Deseret (later to be the University of Utah). Because of his artistic abilities John was chosen to be trained as an art instructor; Dr. Park legally adopted both him and his sister Hortense, and returned with them on July 4, 1870. Though the children first stayed with Miss Kitty Heywood, where John learned English by rigorous exercises at her summer school blackboard, they later lived with Dr. Park and three other adopted children. Temporarily the children took his name; they

called him "father" and were very fond of him. John was to accept Dr. Park's tutelage (which included regular academic studies and studies in nature, music, and art). He worked for his room and board by tending the furnace and then, when he was twenty-one, chose whether to continue university training or pursue his own career. In 1880, when the remainder of John's family came from Switzerland, he left Dr. Park to live with his natural parents. Later he married Annie Evans, whom he met at a church social function. On January 10, 1889, John Held, Jr., was born.

By this time John Held, Sr., began to demonstrate the effects of Mormon belief in the secular arena. The year before Held's birth the elder Held was one of several illustrators for *The Story of the Book of Mormon* (1883). He engraved his own copper plate for the project and devised a special press to print them. This major occupation he continually refined and expanded through his own inventiveness. Running what he called a "stationery" store, he not only provided engraving for the community but invented his own fountain pen and produced a special ink which he found described in a newspaper, then bottled, and put on the market. His greatest joy, however, was "Held's Band," an institution in Salt Lake City for fifty years, begun the year John junior was born. A self-taught cornetist (and painfully so, at least according to family members), John Held, Sr., recruited several untutored volunteers and turned the band into a prominent source of entertainment in town. They appeared at summer concerts, special events, and even church-related socials. A notice exemplifying his contributions in the *Salt Lake City Tribune*, July 25, 1932, reads: "John Held, Sr., Salt Lake City's best known bandmaster for more than 40 years led his fifty piece band in the same concert, Monday at Liberty Park, that was played 45 years ago when he first began to lead in the municipal free concerts. The most popular number was 'Where the Silver Colorado Wends Its Way.'"

Other members of the Held family were equally talented and productive. Along with her husband, Annie Held belonged to a ward dramatic club in the Twentieth Ward, acting in local plays and occasionally in Idaho. A broadside advertisement for the club bills Miss A. Evans (and Hortense Held) in both "Comrades" and "The Rival Brothers" for Friday evening, April 22, 1887. (It also notes that "Held's Brass Band will be in Attendance at Each Performance.") In addition, "Grandpa" Evans built sets and props for the local Grand Theatre which he helped construct. A fine, tall, handsome Englishman, he was very striking with his long white beard, rosy cheeks, and characteristic black Stetson. Active as the stage carpenter until he was eighty-six, he was remembered as a strong person who could carry large sets across the stage with no effort at all. His diligence was such that he could work all day at the theater and well into the night.

For the young Held such family life meant a continual involvement in the arts and their production. Encouraged in his own creative experiments, Held drew his first picture, a horse, in 1892 at age three, appropriately on the flyleaf

of a handsome book in his father's library. Always sketching, he enjoyed other art forms as well. Once when he got lost in the mountains, he was found by his frantic family happily modeling some clay he had discovered. Just the right consistency for his nimble fingers, the clay turned into puppies, ponies, and pigs, each an expression of the natural life Held loved. He had a special affinity for animals always. On one Thanksgiving his pet turkey was killed for table fare; he never ate turkey again. When only eight years old, he did two remarkable watercolors of the Salt Lake Theater productions, these being the earliest extant examples of his work. Later he painted a series of murals for the theater as well as some sets. As boys, he and his friend Hal Burrows loved the theater so much that they often slept there. These two influences continued throughout Held's life, contributing to a creative tension—his love of nature (its promise of peace, escape, autonomy), and the life of the imaginative artist whose livelihood required the urban scene.

Held's early ability was nurtured by another source—his training as a draftsman. Working in his father's engraving shop, he learned the fine art of copper engraving and, perhaps more importantly, block printing. Held drew pictures on the blackboard for his teachers and also (without their approval) on sidewalks and wooden fences near the elementary school. His first payment (nine dollars) came for a blockprint he did at age nine. Other salaried work included engraving friendship hearts for a bracelet fad in 1898 at his father's store at 44 South Main Street. That same year he did advertising work in woodblocks for the Politz Candy Kitchen. Moving to another site at 54 South Main where the Helds lived over the store, John continued to work with his father and his paternal grandfather, the watchmaker. Though he never studied formally, Held later remarked that his father and Mahonri Young were his only art teachers. Held failed to graduate from either Lowell Elementary School or Westside High School, where he and Harold Ross were classmates. Yet public school provided him with more valuable practical art training. He drew cartoons for the school paper, *The Red and the Black*, and while in high school made his first comic block prints. At age fourteen he was sports, political, and "anything else" cartoonist for the *Salt Lake City Tribune* along with fellow reporter Harold Ross, also a chum at the time.

Held and Harold Ross enjoyed an education in some of the shadier aspects of Salt Lake City society. Ross later reminded Held of their excursions into the old redlight district, where one could meet the likes of Ada Wilson, Belle London, or—particularly memorable—Helen Blazes. Ross, in his first trip in an automobile, was sent to interview Helen, ostensibly as a friend of the fallen woman, for the *Salt Lake City Tribune*. Very well-mannered and discreet, dressed in his cadet pants worn at high school during the day, he continued to discuss with Miss Blazes "those fallen women." Finally, she could tolerate the high-level conversation no longer and said, "Jesus Christ, kid, cut out the honey. If I had a railroad tie for every trick I've turned, I could build a railroad from here to San

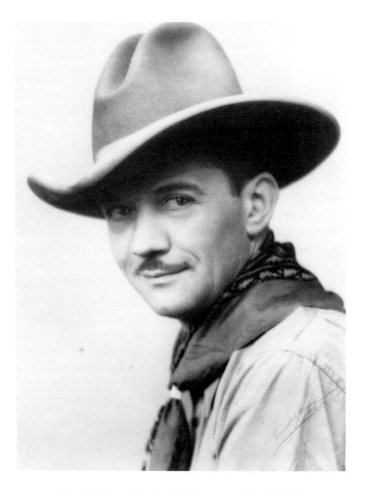

John Held, Jr. (undated). Courtesy of Judy Held

Francisco."As Held's editor on *The Red and the Black*, and later his editor when he created comic block prints for the *New Yorker*, Ross signaled yet another dimension of Held's "practical" experience. If Mormonism and the wide open spaces gave him his impetus and his pictures, the shadier sides of Salt Lake City gave him ample comic fare. The experience introduced him to the realistic if often ironic or humorous world of the newspaper reporter and illustrator. Rather than adopt the vision of the social realists in New York City, Held retained his own perspective of truth in his gentle caricature. Work for the *Tribune* allowed him opportunity to associate with the various levels of that society—experience, if we are to judge from this comment from the introduction to *Frankie and Johnny* (1931), that he held dear: "I led a wild, free existence in an inter-Rocky Mountain settlement with my friends the whores, the pimps, the gamblers, the hopheads, and the lenient police who used to know me, The Mormon Kid."

The epithet is fitting for other reasons. Before he ventured to New York City in 1910, photographs of the young Held show him posing as a soldier of fortune. In one photograph in particular he kneels, holding his prize, a piglet, and wearing workboots with a western hat cocked on his head. Later photographs (some taken on a trip to Arizona with Mahonri Young in 1915 or 1916 and others on a roundup in Wyoming in 1922) show him equally comfortable in western attire. As an early "western" cartoon illustrates, Held saw a similarity in the free-wheeling life of the West and the expansive life of the city. The fact that he could look back on his experiences in Salt Lake City and identify the same types he could find in, say, Bohemian New York, suggests much about this similarity. When prompted to begin a series of reminiscences from his Belmar, New Jersey, farm in the 1950s, he chose to write, not about the pimps, whores, and gamblers, but about elements that equally illuminate what he meant by identifying himself as the "Mormon Kid." In "In My Lovely Deseret," "My Life and Times in Deseret," "Roll Jordan Roll," we have narrative backdrops for the meaning of "Mormon" life; and in "The Sugar Bowl Was Always Empty," "The Indian Wars," "The Day of the Bicycle," and "The Echo Quartette," we read the kid's family experience against this background. What the pimps, whores, et al., represent, then, is another real, yet theatrical, escape—a quasi-urban experience, a special source that adds a new level to the other two.

An awareness of these various Salt Lake City societies was a primary source of Held's humor. Not only did the characters from the more seedy side of life provide models for his Victorian linocuts, later revived for Ross and the *New Yorker*, but they were comic expressions of his larger perception. Each level of society exhibited values conflicting with others. And each projected an ideal exterior for which its real interior served as humorous deflation. For the savvy observer such contradictions were theatrical in nature. Expressed by actors (conforming to roles) who were also real men and women, these contradictions dramatized an essential *alazon-eiron* tension in each relationship. For Held both the family and society in Salt Lake City were the early sources of comedy.

Held's reminiscences reveal his respect for Zion and the territory of Deseret. Memories of stories told by his grandfather and others of the hardships of the handcart migration instilled a sense of history, mission, and the power of a group's mythology and its narrative. Yet an important part of this narrative sense was the stories surrounding his immediate family, second generation Mormons, far enough removed to be primarily social followers. There is indication that the John Held, Sr., family followed some of the strict rules of the church; nevertheless, they are remembered by John Held, Jr., for their comic shortcomings—how they repeatedly fell short of certain ideals.

The courtship of Held's parents is one example. One moonlit night when the schooners were caroming down a snow-covered hill, Annie and John senior's early romance was interrupted when Annie hit a bump, bounced off the sled, crashed into a barn, and tore her pert nose. Not only that, but John senior's

cornet tooting was nothing but a nuisance to the courtship. He persisted in playing at Annie's door until, as the family story goes, she consented to marry him, hoping to end the noise. After the couple's marriage John senior of course continued to play, and when the children were born she had to run a short order house, since the busy family seemed never to be at the table at the same time. John junior liked to quip that his mother permanently ended any longing he might later have for home cooking, since she was forever baking, not really knowing or caring what the result was. Part of the reason was John senior's chronic habit of reading at the table, thus never noticing what food was placed in front of him. John junior claimed that for the fifty years that his mother cooked for his father, he never saw what he was eating. Lost in his dinner table dreams, he once invented an improvement for the self-filling fountain pen while eating smoked shrimp. Another time he composed a patriotic march for his military band. So absent-minded was John senior that—behind the pages of a book—he totally ignored a beautiful pot roast his wife carefully prepared for his birthday. The next meal Mrs. Held concocted a dish of onions, tapioca, and soap, lavishly covered in cheese. Lost in the latest issue of *Scribner's* magazine, John senior dug in, finishing the dish and the article at the same time. He reported that he had read a most interesting article about the unusual food items of the Eskimo, one of which was traded-for soap, which they ate as a delectable dessert.

Along with the strong sense of humor native to Held's family, the elder Held was also a strict teacher, often imposing his energy on his children. If he could not be taught a lesson by his wife, certainly he spent much time teaching his family.

John Held, Jr., remembered and not wistfully, the many miles he bicycled his father's band music for his numerous concerts. Indeed, Held was a taskmaster; not only that, he *dominated* John's life at every turn. Understandably, Held called his father an "exhibitionist." He saw, therefore, and often painfully, the source of caricature in his father. Exaggeration exalted as model—that was the quality of John Held, Jr.'s theatricality. Held always respected Mormonism, always saw the human need for a past articulated through either religious or personal doctrine. Yet he suspected that extreme seriousness in the end debunked the ideals it honored. As his reminiscences indicate, he recognized a saving impudence in youth. Ironically, that impudence early on contributed to his own role modeling after a father who he already believed was extreme.

At the same time that John, Jr., acquired the taste for art and the wit and inventiveness to pursue it, his love for animals and the land deepened. The expansive West of his youth provided more than a picturesque backdrop for an ambitious young man. His childhood experiences playing cowboys and Indians, raising various animal stock, savoring the lore of the Utah countryside resulted in a life-long love of the simplicity and independence this life exemplified— also, the ever-youthful, puckish, child-mind Held possessed. These experiences

fostered a confidence and individuality to match the ambition that would make him a success in the East.

Held's early drive may in some way have reflected his desire to excel, perhaps even outstrip, his father. But his talents and dreams also matched those of an entire generation of gifted artists and writers for whom the East held great promise. His first step to upstage his father was to find a new territory commensurate with his Cinderella dreams and his creative precocity. New York City was the place. In 1908 Held published a cartoon in *Life* magazine in which the characters in a Wild West setting remarked: "Let's go to New York. . . . No, sir, a man's life ain't safe there." The cultural pun is important. One needed plenty of western toughness, resourcefulness, and vigor to make it in the new urban frontier. But, given Held's background and his relationship to his father, it was not a surprising decision for Held or for many such young men of the period. The generation who had followed Greeley's dictum were in fact the fathers of Held's age group, who reversed the direction. With the frontier closed, now settled towns replaced the raw, beckoning land, allowing for only so much personal growth and opportunity. Pioneering now lay to the East, where the rude start made by the artist or writer in his home town could be realized. So, preceded by Mahonri M. Young and Hal Burrows and followed by Harold Ross, Held arrived with other young men from the provinces; Kenneth Burke and Malcolm Cowley from Pennsylvania, Sherwood Anderson and Hart Crane from Ohio, Theodore Dreiser from Indiana, Ernest Hemingway from Illinois, Glenway Wescott from Wisconsin, Sinclair Lewis and F. Scott Fitzgerald from Minnesota, Ezra Pound from Idaho. Though they came to realize individual creativity and personal expression in the larger society, what they gave to New York City added to its own evolution. Writes E. B. White:

> There are roughly three New Yorks. There is, first, the New York of the man or woman who was born here, who takes the city for granted and accepts its size and its turbulence as natural and inevitable. Second, there is the New York of the commuter—the city that is devoured by locusts each day and spat out each night. Third, there is the New York of the person who was born somewhere else and came to New York in quest of something. Of these three trembling cities the greatest is the last—the city of final destination, the city that is a goal. It is this third city that accounts for New York's high-strung disposition, its poetical deportment, its dedication to the arts, and its incomparable achievements. Commuters give the city its tidal restlessness, natives give it solidity and continuity, but the settlers give it its passion.[1]

Appropriately to his pioneering attitude, Held at age 21, with $4 in his pocket, came to the city to make his fortune.

Held initially came alone in 1910, though he had married Myrtle Jennings in 1908 in Salt Lake City. Living will Hal Burrows and Mahonri M. Young in an

apartment on 80th and Broadway, Held intended to find a job before sending for Myrtle. He intended, too, to dedicate himself to the arts. Sculpture, particularly, was his love and ambition. In the tiny apartment, almost in the shadow of nearby Parsons Art School, Held experimented, molding masks. But livelihood soon took precedence, and, because of his ability as an engraver and commercial artist, he was hired at Collier's Street Railway Advertising Company to do streetcar cards and posters. Later he contacted the former head of that advertising department, Eddy Usoskin, who ran a press, the United Lithographic Corporation at 599 11th Avenue at 45th Street. Eddy, who had done showcards and window dressings before, made Held "Designer of Display." He designed Christmas cards, linoleum block prints, and place cards for Brentano's which stuck on the edge of a cocktail glass.

With a steady job, Held sent for Myrtle, who also got a job with Usoskin, writing captions. Formerly the society editor for the *Salt Lake City Tribune*, where Held had met her, Myrtle was clever and resourceful. The couple had a sense of humor in common, and Held later, in his usual glib and evasive way, told a reporter they were fired for talking together so much at the newspaper, so they got married and moved to New York. Myrtle proved an inventive companion and began peddling Held cartoons and illustrations. Held had been working on a cartoon he called "The Worm's Eye View," which depicted the world from that vantage point. Myrtle eventually went to Frank Crowninshield at *Vanity Fair*, taking some sketches Held had done of society women. Because the work was unsigned and because Held was too shy to sell them himself, Myrtle was surprised when the editor asked if she had done the drawings, and responded "yes" rather than give a lengthy explanation. Crowninshield told her to sign one and he would buy it, and from 1912 until 1916 "Myrtle Held" and "Babette" appeared, alongside the script "Held."[2] Myrtle could not draw a line, however, and by 1916 when Crowninshield gave a party to honor the women artists working for him (and he employed a host of them, including Thelma Cudlip, Clara Tice, Ethel Plummer, and Fish) she went to the party with her hand in a bandage, fearing that someone would ask her to draw a picture.

Though Held worked for Usoskin for a year and a half, he was restless and favored freelancing to steady employment. In 1913 he was hired by John Wanamaker Company as an artist in the advertising department, but that lasted only a year. Held preferred to move around, gaining new experience in methods and commercial arts in the city. By this time Held's restlessness also expressed itself in various styles or, rather, in a continual quest for a style. Selling distinctively different cartoons to *Judge*, *Puck*, *Vanity Fair*, and *Life* during this period, he even maintained a separate persona for magazines, signing cartoons for each magazine differently. He was called Jack in those days (one of his signatures for *Life* magazine).

"Restless" is the key word that recurs in remembrances of Held during the early phases of his career. Even his wife Myrtle told Usoskin once that perhaps

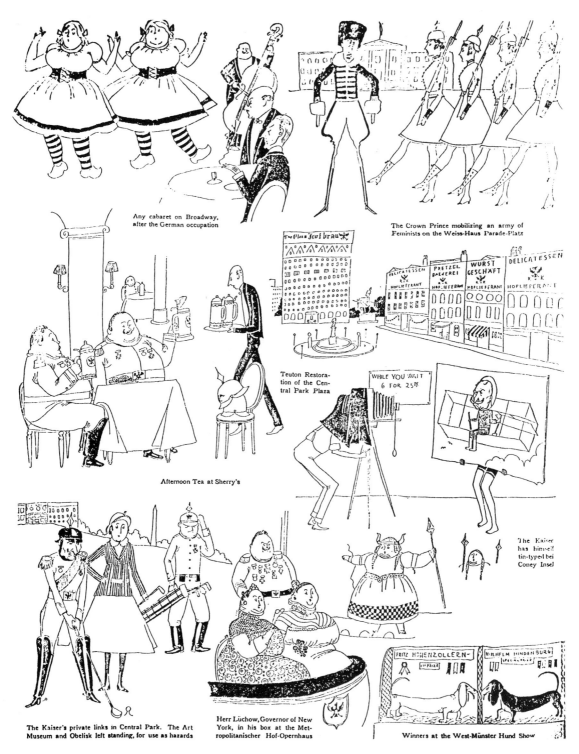

The German Occupation of Manhattan. *Vanity Fair*, May 1916. Courtesy of Illustration House, Inc.

WHEN "PREPAREDNESS" WAS NEW
The science of war-prevention had its beginning a long, long time ago

When "Preparedness" Was New. *Puck*, April 1, 1916.

he needed an additional woman, half-jokingly suggesting *that* might settle him down. But his restiveness derived from a number of factors. For one thing, he had tremendous productive energies. Certainly a personality trait, this characteristic also reflected his father's influence, Held's determination to outdo him, and the effect of Mormonism. Seeing themselves as the "chosen people," the Mormons perhaps best exemplify the phenomenon of the Protestant work ethic. Success marked a man as religiously sanctioned; drive toward that success was a religious duty. Yet, without the burden of intellectual guilt to goad them along, Mormons were equipped with an ebullient spirit. Held's fierce independence, then, was a positive trait matching the expansive and optimistic spirit of New York City in the early 1900s. He found himself a part of the collective expression of this phenomenon. A hybrid strain of new citizens, who bridged the gap between the highbrow or alienated artists and writers and the materialists, was evolving in the city. Neither Babbits nor Bohemians, they formed, generally, a new social stratum. They were metropolitan New Yorkers, though many of them came originally from the Midwest or West. Bright, alert, and enthusiastic, they were urbane and very witty. Above all, they were impudent. Their appearance coincided with the flourishing of a whole range of magazines during the period from 1918 to the depression which expressed the delights and impertinences of their well-traveled and ultrasophisticated audience.

The city that derived its high-strung disposition from this new class in turn became the subject of their passions. This constituted yet another cause for Held's restlessness. The harnessing of this passion was a major obstacle for him. The new stratum of which he found himself a member was dependent on new markets for commercial artists, even though his continuous goal was to become a fine artist. Thinking he could buy time for such training if he became a success commercially, he initially directed his creative energies accordingly. Later he attempted to resolve the tension between private goals and public success by making a fine art out of his illustrations and cartoons. Thus, his frantic search for style and his indomitable energies in the period 1910–25 signified a temporary resolution. Humor, as a personal attitude and a professional calling, became the means for reconciling the extremes of personal and public passions.

Not only that, but humor was also a device for controlling that earlier dynamic we have noted. Itself an amalgam of "stage stuff" and artistry, humor, as expressed in this early period in his cartoons, illustrations, and advertisements, was the device appropriate to Held's personality. It was a vehicle which successfully mediated between the eccentric vision of the highbrows and the absurdities of everyday life and, it was expressive of the extreme and rapid changes in manners and morals of the period. As such, humor was Held's diaphanous membrane between self and society; it was a way of viewing oneself as if a character in a local play. Levels of satire and self-parody often blurred the reality of the 1910s and 1920s. If Held longed for the serious life of an artist, his everyday experiences were that of the practical joke. Indeed, talent was often exercised in the

interest of entertainment. At Usoskin's one office mate could construct materials of papier-mâché to resemble almost anything. The article looked so real that someone would grab scissors only to find them fake, or a paperweight to find it light as a feather. Once a customer who started to leave found his coat had been cut in half, one part apparently on the floor and the other on the table. He flew into a rage only to discover it was all a trick of papier-mâché.

Perhaps the best characterization of the pervasiveness of this humor is Marc Connelly's remembrance of "Cockroach Glades," the apartment at West 37th Street that Held shared with Connelly, Hal Burrows, Paul Perez, Red Smith, and Paul and Stew Palmer. The Glades, named for the habitat of the little bedmates the crew baited with saucers of kerosene, was the front room of a second story in a boardinghouse. The room's two windows kept out neither the bone-chilling cold nor the racket of Sixth Avenue El trains a few yards away. It was lighted by two single gas jets that protruded from the wall between the two windows. Held decorated the non-functioning fireplace with a cardboard mock-up of burning logs; the only heat came from a metal heating device which replaced one of the Wolsback mantels. The crew rotated their schedules to accommodate work and the one double bed and two single cots they had. John and Hal worked in the day, bundled in scarves and sweaters, their drawing boards propped against the kitchen table between them, both engaged in making colored portraits of onions, asparagus, tomatoes, and ears of corn for a seed company's catalog. John assured his permanent alienation from the crew, however, when he brought home a litter of Airedale puppies given to him by a friend from Connecticut, which he intended to sell at a local pet store. The puppies took as their home his dresser drawer. Connelly recalls:

> Besides a community concern with the puppies, a lot of our time went into keeping down the insect population of The Glades. The kerosene augmented by roach powder seemed only to make the little fellows thrive. At first the puppies' whining did not interrupt our sleep as frequently as the bugs, but as they grew older the whines threatened to turn into barks. They learned to crawl out of their container, and we knew it would be only a matter of time before they would join us as bedmates. As our anti-roach campaign was proving hopeless, a council-of-war vote of four to one ended our investment in the Airedales. I forget how much John got for them, but they added a little to the community wealth.[3]

Perhaps it was because of this sense of humor that Held was popular with New York artists. While Connelly reveals him working a bit on sculpture at Cockroach Glades (he won two modest prizes for animals and human figures carved out of Ivory soap), Held walked the city getting ideas—subjects for his cartoons and illustrations. A favorite place was Chinatown, where Held paid weekly visits to the Chinese Delmonico Restaurant on Mott Street. There he

fraternized with his friend Mahonri Young and three other successful artists, Robert Henri, Louis Boucher, and Ernest Haskell. The mediums in which these artists worked fascinated Held. Particularly Haskell was experimental at this time. Known for his pen and ink drawings, he was trying oil, and in the traditional manner he had begun his *pièce de congé*, a great oak tree composed entirely of stippling.

In the spirit of such artists as these, Held channeled his stylistic search variously. At this time he composed a comic, multi-media extravaganza entitled *Deseret* that anticipated later theatrical experiments. A ballet in many scenes, motion pictures, and transparencies, it was reminiscent of John Brougham's comic works and later musical comedies. Held's stage direction provided for a cast of various Paiute Indians, squaws, papooses, mountain men, beaver trappers, and a pioneer wagonful of Latter-day Saints, their leader, the Twelve Apostles and their wives, sons, and daughters, the Forty-Niners, government troops, great hordes of crickets and seagulls. He adds in a note: "In the broad conception of the ballet, there should be no individual pointing up, except in the character of the Leader, and everything that he does should only lead to the unity of the group of Latter Day Saints. The Menaces, such as the Forty-Niners and the Government Troops and the Crickets, should be presented in a manner of fantastic symbolism, as though from a world apart. The treatment of the Latter Day Saints should be one of realism."[4] Obviously written to be read and not performed, the play nevertheless attempts to exist on several levels which, of course, contribute to the comedy. Definitely visual, the play undercuts its own method (and in so doing, suggests the silliness of such productions): "The Indians move off the stage in the darkness, and the scrims are closed. Soon the rising light discloses a footsore band of Pioneers, pushing their way westward with their household goods, some laden, some pushing hand-carts. To get the weary movement across the plains, the pagent moves on the treadmill. The scrim is used to show effects of snow-storms, rain, and adverse elements."[5] And again:

The Harvest is ready, The crops are bountiful. There are prayers of thanks. Then a terror spreads. The stage darkens, and on the scrim is projected a motion picture of the plague of crickets approaching. The motion picture dissolves into the Cricket ballet on the stage. The Saints are gathered in desolation on the cliffs.

Then a scrim is a spot of light, as a distant flying seagull is projected. The screen brightens into a great flock of flying gulls. The picture dissolves in the stage ballet of the Seagulls conquering the Crickets.

The crops are saved by the Gulls. The Saints are again jubilant and thankful. There are Halleluahs and a great celebration that is manifested in an exuberant squaredance by the Saints.

On the scrim is projected a large colored view of the Mormon Temple Square.[6]

Thus, humor was not only a way of Held's conceptualizing himself and his past. It provided an attitude toward form which promoted artistic experimentation as well. He spoofed not only predominant images of the West, but conventions of the theater, ballet, and mixed media. And in his best cartoons, he recognized that through form one best debunks ideas. It was a rare occasion when Held used any of his Mormon material for comedy, yet the nature of the play itself foreshadows his later interest in Broadway comic productions and his insatiable fascination with comic and artistic forms. The play featured a motion picture, a ballet, special effects, and was composed also to be read for comic effect. Held early revealed a basic philosophy of creative composition that would span his career. Styles, forms, and mediums were combined in the interest not of following traditions or schools but of achieving an effect.

During the time he lived at Cockroach Glades (1916 to April 1917), this interest in experimentation resulted in other fine art productions. Having met Lee Townsend in 1915, Held was introduced to his brother, who had a Schnedewind printing press. The three began plotting the printing of a series of linoleum cuts Held wanted to make into a book. The art form was an old, respected, and demanding one; the trio went to the Japan Paper Company to talk with president Hal Marschbanks, and Held chose a rough, heavy, pulpy paper he liked. Later the prints were made at the Townsends', but though individual prints were made and sold, the book never materialized. During the same period (1915–16) Held did a series of covers for *Smart Set*, working in watercolor in an opaque style he would later perfect for *Life*. Both the linoleum block project and his first painted cover designs led to his first art exhibition, titled "A Few Things."

If humor was forever that cocked eye that allowed him to see the world freshly, repeated displacement fueled his palette as well. Throughout his life travel provided new materials, new experiences, new ways of seeing; by the zenith of his career he had visited the West five times, lived in Central America for a year, and vacationed in the Mediterranean. The constant motion of his early life in New York City (he lived at least fifteen places from 1910 to 1942) added to this experience. At one point in 1927 he owned four "homes"—a penthouse in New York City, a winter home in Palm Beach, Florida, an estate in Weston, Connecticut, and a home on the Saugatuck River in Connecticut. This search for place, which would only become a "sense of place" finally in 1942 when he settled at his longest place of residence, the Old Schuyler Farm in New Jersey, was indicative of his restlessness and his quest for appropriate and satisfying work in his early life. In middle life (particularly the period 1929–40) this search manifested itself in new ways of seeing related to not only the pursuit of success but the attempt to escape and, finally, explain and reflect on success. Thus, the contrast of living quarters (a lone apartment in Barbetta's in the middle of the 1930s or the close atmosphere of Cockroach Glades in the late teens) afforded Held personal, and hence, artistic perspectives. Place bore close psychic affilia-

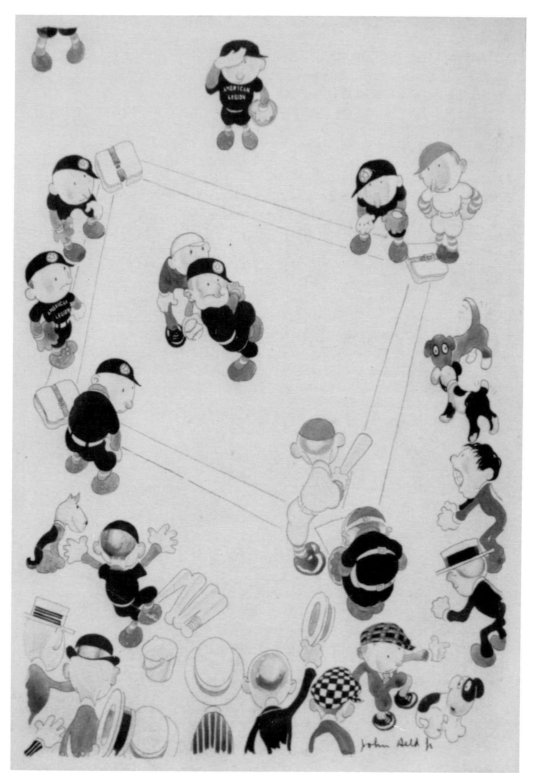

Baseball Game (undated). *American Legion Weekly*. Permission of Illustration House, Inc.

tions with Held's humor as tonal variations come from the narrator's proximity to his audience and subject matter. By the time Held's career was over, he would fit each of the three categories of New Yorkers E. B. White described—the native, the commuter, and the settler—and bear the resulting relationships to his subject and audience.

Held traveled to the Southwest in 1916 and a year later to Central America as artist for the Carnegie Institute. He was inspired by contact with the primitive lives and exotic ruins of both places to a new sense of color and design. Both trips were essentially archaeological. Photographs from each suggest Held saw himself as an adventurer. Wearing boots and western hat, he played the "Mormon Kid" briefly again, seizing the adventure as source for new artistic material. As was common for Held when traveling from New York (whether it was back to Salt Lake City or to California or to North Africa), he recorded scenes along the way, primarily in watercolors. Thus, Mahonri M. Young reports him watercoloring at Walpi in Hopi, Arizona, and Sylvanus G. Morley in his journal of the Carnegie Expedition notes several times Held's documentation in watercolor.[7] Because Held had been specifically hired to document the Central American expedition with maps and paintings and sketches of stellae, codexes, and indexes, he encountered, besides the native color, ancient Mayan styles at the various archaeological sites. Morley often notes Held's expertness at draftsmanship and art. He performed both his assigned cartography and executed required drawings while keeping a personal notebook himself.

In the *Carnegie Institution of Washington Yearbook* recording the expedition, we find this outline of the trip:

> The itinerary of the expedition may be divided into three parts or trips, as follows: 1) A reconnaissance of the Mosquito Coast of Honduras and Nicaragua in September and October 1917. 2) An examination of all archaeological sites in the peninsula of Yucatan known to have hieroglyphic inscriptions, in February, March, and April 1918. 3) A trip to the ruins of Palenque in the state of Chiapas, Mexico, in May 1918. It may also be noted that Mr. Morley was present during the earthquake shocks of December 25, December 29, and January 3, which destroyed Guatemala City, and he assisted in relief work there. . . . Throughout the trip the personnel of the staff continued the same: Mr. Morley as director and Mr. John Held, Jr., as artist.[8]

Through Morley's journal (kept during the duration of the expedition) we learn a bit of the livelier side of the journey. During one of the earthquakes, for instance, Morley writes: "John was taking a bath when the earthquake erupted. I raced to the square to get into the open where I encountered John clad only in a towel and a waterproof wrist watch."[9] Much of Held's personality comes out in this journal, including hints at marital trouble with Myrtle. A letter to Held from friend Gladys Skehan revealed that his wife was bound for Paris on September 16, 1917. Later that week Morley reports:

Started the day with a battle royal with John, the second we've had in six weeks. The last was in Tegucigalpa in August just before we left over nothing. This time that wretched map he made. . . . I said frankly I thought it wasn't a very good job, and that it had been done too hurriedly, three hours for all that work. . . . Of course he was furious. He stalked in, snatched the map from the table and tore it up like a spoiled child. . . . Fortunately, neither of us was the kind who harbors resentment, and before the day was over, we'd quite made up, though I stick to my idea of someone else making the map. (I wonder if this didn't come about due to John's upset over the letter about Myrtle.)[10]

Most times, however, Morley was pleased with Held and delighted in his recording everything from personal peccadillos to their expeditionary work. Held bought panama hats, fought continual battles with sand flies, discovered an unexcavated torso and surrounding ruin, illustrated Morley's lecture at the School of Fine Arts in Merida, and delighted the locals in Merida with caricatures afterward. In July 1917, Morley almost boasted:

A trip was made in Salvador and the central part of Honduras. Mr. Held made color drawings of the painted vases in the Justo Armas collection in San Salvador; and at a Tegucigalpa he painted a magnificent specimen of Maya ceramic art from Copan. At San Pedro Sula a fine example of painted ware in the Waller collection from the Ulua Valley was also drawn in color.[11]

Morley reveals a great deal about Held's methods and utensils as well. He notes, "It's a rare day when he doesn't make three or four watercolors, to say nothing of innumerable pencil drawings."[12] This productivity Morley cites as assuaging the personal stress of the expedition. Held's restlessness still apparent, Morley says "he is happier too for this work and less restless. He is using himself up in this way rather than damning the country, heat, bugs, food, and people. The only danger now is that his paper will give out."[13] Indeed, the hazards make one appreciate the artist's dogged dedication. Morley writes:

Today John made four sketches. Unfortunately, he lost in the sand two of his best brushes, blew right out of his pocket. His paints are even in a more demoralized condition than we are. They have been unable to withstand the vicissitudes of this hostile environment. In Zacapa, his wax frames ran down into a many colored fluid which stained his khaki jacket like Joseph's coat of many colors. The same day heat dried up the glycerine out of the watercolors, while the jogging of the cargo mules ground his pastels to the consistency of dust. Down here the humidity has actually dissolved the watercolors. He tells me almost tearfully that it is the most expensive colors which have the highest coefficient of deliquescence. His sketches of the aftermath of the storm are fine. He seems to have caught the cold menacing gray of the horizon, the restless green of the sea, and the cruel white of the surf.[14]

The results of the expedition have been widely published.[15] Held's greatest contribution was the detail of a panel at Palenque resembling the Beau Relief. According to Morley, Held contributed innumerable maps of rivers, idols, sites, and ruins, along with appropriate drawings. As for Held's career back in the States, Morley noted "John is working hard on new ideas for comic pages of war stuff. He is getting away with it, in a rather whimsical way of his own. He's undoubtedly awfully clever at this sort of thing, and infuses into his 'stuff' a sort of sophisticated humor, which must appeal to the worldly, smart New York palate."[16] Though Morley never mentions his or Held's affiliation with the U.S. Navy on a secret undercover mission to spot and map the movement of German U-Boats while accomplishing their ostensible expeditionary tasks (a report corroborated by several sources[17]), he did recognize what in the long run would be the benefits of the trip for Held. Back in New York in 1918 his magazine work boasted a new style—one inspired by the Mayan sources of color and design in Central America.

When Held returned, he added these new materials to augment an already firm art theory. Interviewed by a reporter for the *New Orleans Times-Picayune* on May 8, 1917, Held claimed "no method, no name, no laws, no philosophy, no purpose, no message, no nothing."[18] But when pursued by the tenacious interviewer Flo Field, he confessed to being a caricaturist primarily and to this definition of the art: "When I draw a caricature it's like writing. I simply pick out the characteristics of a person. I try to make the picture look like them more than they are like themselves." He further commented: "It usually shows something the person does not want shown. The caricaturist, if he does anything, wars upon the individual for the benefit of society."[19] Flo Field was ready for Held; she would not even allow him his usual escape hatch ("High art is my secret vice"). "Is not caricature high art?" she retorted. And then she launched into a series of questions whose obvious answers made Held's primary "art" look very good indeed:

> Do you not put your soul into caricature? Is it not your philosophy? Do you not use it as a weapon of scorn? Have you not endeavored to make it a religion of the American intellect: Is it not your prophecy to the younger generation? Will you not prick the bubble of individualism with it? Do you not use a surgically simple method?[20]

As Morley had revealed of Held's personality, his particularly adventuresome nature led him to discover and observe new people and places with an explorer's eye. His artistic temperament—rising late, railing at flies, despairing over the tropical heat which destroyed the texture of his paints—only reinforces his unique experience of being part of the geography he attended to. While Held would never be identified with the scorn of a Mencken or a conscious effort to make satire an intellectual weapon, his very gentleness, and hence, subtleness as

a caricaturist—its primacy in his early popular art—was in part inspired by the tablaux of the Mayan codices and figures. The style and individuality of Held's cartoons emerged after his Central American tour. His caricatures utilized the memorable forms of the one-dimensional figure, fixing the metaphor of the topical subject exaggerated through line, shape, and color. From this exposure to primitive art, Held discovered the secret of myth-making: creating images as in bas-relief which, through their very power to contain the significant act or gesture, immortalize themselves and take on an iconographic power.

In 1918, Held's most prolific year to date, his drawings became even more popular as he plied his latest experiences in color schemes and black and white tablaux designs. That year Held sold cartoons to every major humor magazine, including *Judge*, *Vanity Fair*, *Puck*, and *Life*. With the postwar boom came a burgeoning magazine market, and Held found fresh subjects to supplant the staid "he-she" fare so typical of *Judge* before the war. Held's new style was manifested in the "one-eyed girl," a coy, roundheaded flapper whose single eye always made her appear as if in profile. From this hallmark he worked into the "roundheaded people," an example of which is the *Vanity Fair* cover of October 1919. The two styles coexisted on into 1923, when Held added another twist to his evolving flapper. The new figure was a Betty Coed type, but she was drawn in more detail, and though she showed vestiges of the round, primitive figure, she was much more realistic. Finally, in a cartoon indicative of the death of this flapper and the full-blown representation of his final stage (and the one he is best known for), Held in "Heavy Date" depicted the fat and aging example of his penultimate flapper in the quaking lap of a college boy (*Life*, April 30, 1925). The same issue introduced the new girl in "Daughters of the American Revolution." Thus was introduced the impudent college flapper who would be the prototype Held woman during the remainder of the decade.

Held continued to freelance throughout this period, and the popularity of his cartoons led to areas of specialization. For *College Humor* he did "The Ten Collegiate Commandments," a recurring double-page spread. For *Life*, the "High Hat" page and the "Silent Drama" heading. *Judge* gave him his own page with this laudatory announcement:

A new portrait of John Held, Jr., famous creator of "Held's Belles," one of America's greatest humorous artists and a brilliant star on *Judge's* staff. Mr. Held was born in Salt Lake City. He is a crack roughrider, a 100 percent sportsman and a two-fisted American in every sense. He does most of his work at his farm in Westport, Connecticut, where he has a kennel of blooded dogs, several blue ribbon saddle-horses, a Chinese cook, a plentiful supply of wild cherry wine of his own brew. . . . As an artist, Mr. Held displayed extraordinary originality in creating a new school, peculiarly his own, which is national in its popularity. His weekly page in *Judge* is one of the most popular features in any American magazine.[21]

A Few Intimate Sketches at Yellowstone Park

by John Held, Jr.

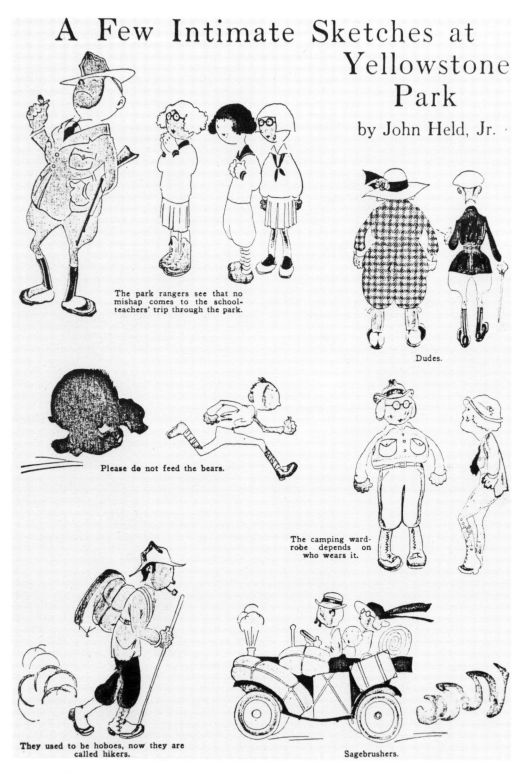

The park rangers see that no mishap comes to the school-teachers' trip through the park.

Dudes.

Please do not feed the bears.

The camping wardrobe depends on who wears it.

They used to be hoboes, now they are called hikers.

Sagebrushers.

A Few Intimate Sketches at Yellowstone Park. *Judge*, ca. 1922. Permission of JB&R, Inc.

The 10 Colleg-

O'LEARY'S

By
John
Held
Jr.

¶ Father rather imagines there's been a misdeal here. Perhaps little wet-behind-the-ears Edmund isn't in his trundle bed after all.

No. 5

Thou shalt not borrow father's car and park outside O'Leary's Bar

¶ Scientists have been working for years on the most effective mixture for internal combustion motors. Edmund has obtained surprising results with equal parts of gin and gas. At this stage in the experiment, the car looks like something that's too late to be classified.

The 10 Collegiate Commandments. *College Humor*, November 1925. Permission of JB&R, Inc.

iate Commandments

¶ If you care to keep your collegiate standing, never stage a groping party until you break fifty-five an hour.

¶ When driving, put lots of stuff on the apple and disregard all silly regulations. Traffic rules are only for old-lady drivers. If stopped by some uniformed Irishman, it is always good form to give him the naive impression that you can't speak Irish.

¶ If a cop grows insistent, raise your eyebrows and say, "Wake me up when the crowd leaves." You needn't worry about Clarabelle, the bottle baby She will go on eating lipsticks in her sleep.

The Silent Drama. *Life*, July 29, 1926. Permission of JB&R, Inc.

Ross, at *The Home Sector*, an armed forces magazine, commissioned a series of covers in 1920. Later the *New Yorker* commissioned him to do the woodblock prints Ross had so loved as a young man in Salt Lake City. Held did a series of comic maps and pseudo–Gay Nineties block prints, beginning in 1925.

Perhaps the most convenient means for the proliferation of Held cartoons was his "Oh! Margy!" series which began in 1924 and ran until 1927 in a number of papers across the country. Detailing the escapades of Held's flapper as established stylistically by 1925, "Oh! Margy!" was popular enough for William Randolph Hearst to syndicate its sequel, "Merely Margy, An Awfully Sweet Girl," and run it in both daily and Sunday supplements in at least seventy newspapers across the country, By 1927, in addition to his income from clamoring editors of *Life*, *Judge*, *College Humor*, and the *New Yorker*, Held was receiving $2,500 a week from Hearst for "Merely Margy."[22] He was reported to be the most prolific and highest paid graphic artist of his day.

Held's success as a cartoonist manifested itself in other forms of the art of illustration as well. From 1922 to 1929, he was named to the Society of American Illustrators as one of the most distinguished. His comic ads led to two notable designs: an advertisement for Edna Ferber's *So Big* and in 1923 the cover for F. Scott Fitzgerald's comic drama *The Vegetable*. The sheiks and shebas that announced the Fitzgerald political satire also contributed to Held's recognition as a sets and costume designer for Florenz Ziegfeld's production of J. P. McEvoy's *The Comic Supplement* in 1925. Though the play opened and closed the same night, reviewers praised Held's costumes. Gilbert Gabriel wrote in the *Telegram and Evening Mail*, Monday, February 2, 1925:

> John Held, Jr., designed the costumes for this late revue, and these . . . remain a tingling memory. For they are full of the essence of that John Heldism which has made the Detroit Athletic Club famous for two-color printing. His alley kids, his bathing girls, his cafeteria counter girls, even his scrub ladies, Mr. Held has turned into the smart glory of his comic weekly flapperations—and

Every sailor must have his own rocking chair, with a hollow arm for his tatting. And a ukulele, magazines and lots of other impedimenta we never had

Yo-Ho-Ho and a Deck Full of Rocking Chairs. *American Legion Weekly*, February 26, 1926. Courtesy of Bill Blackbeard, The San Francisco Academy of Comic Art.

always with the glimpse of pink between Vastus Internus and Gluteus Maximus in which his so seductive pen and brush delight.

Stephen Rathbun, writing for the *New York Sun* on July 21, 1926, continued the compliments in his review of another Held-McEvoy collaboration, *Americana*, a comic revue at the Belmont. He even suggested that Held's background and decorations be extended to the realm of character: "Instead of the out of date Anna Held Girl in the opening number I suggest that she be metamorphosed into a John Held Girl. Too much praise cannot be given Mr. Held's decorations of the production. Everybody who knows the Held style of drawing can imagine what an original background he has given this revue." Held's humor did not stop here, however. He caricatured McEvoy for *Theater Magazine* to accompany the announcement of McEvoy's successful librettos for two of Ziegfeld's *Follies*, and the season's best-seller fiction *Show Girl*.

Held's talents apparently commanded the attention of the purveyors of most of the commercial media of the 1920s. In 1926 he designed for textile creator

Ruzzie Green two patterns for silk prints, "Collegiate," which made the cloth a dance floor for the Charleston, and "100 Percent." The latter title was Held's whimsical own from a suggestion that the design be called "Hats," to which Held responded "100 Percent." Edward Steichen was another asked to contribute a design for that year, and the collection resulted in a show at the Art Center of New York, for which Held designed another print based on the familiar polka dot pattern. A reviewer noted in the *Baltimore Sun*, July 15, 1928:

> The unusual designs for silk print called Americana prints . . . are especially notable as an attempt on the part of well-known designers to interpret the medium of dress patterns as the dynamic force of contemporary American life.
>
> Progressing from the conservative floral and conventional geometric patterns, the designs reach a striking climax in John Held, Jr.'s "Rhapsody," the motive of which is a jazz orchestra, the design being an elaboration of the familiar polka dot.

During the same period Held's poster art and advertisements attracted much attention. One of the freelance poster ads done for MGM in 1928 was for the film *So This is College*. Held also illustrated sheet music to accompany popular films, for example "Hang on to Me," from the Marion Davies film *Marianne*, an MGM film in 1929. Frank R. Arnold, writing on Held's poster work in *Poster*, May 1927, commended Held's talents for more than just the "name" he had. That year Held had created a series of five posters for the New York, New Haven and Hartford Railroad in New England, depicting Cape Cod, Nantucket, Rhode Island, Pine to Palms (New England to Florida), and the Berkshires. His "concentrated essence," as Arnold called it, convincingly distilled the quality and charm of each area in his scratchboard style. One of the results was that in the previous summer the New Haven Railroad for the first time ran through-sleepers daily from New York to Cape Cod and had a great increase in business. Writes Arnold:

> In order to concentrate this one side of Cape Cod in a poster, Mr. Held uses the simple method of showing what he considers the essence of the early colonial. For him it is the New England farmhouse with its hip roof, its huge chimney, and its doorway with a fan light. This he makes the central idea of his poster and puts in the corners two sailing ships, an old-time stagecoach, and a stiffly genteel young man and woman lifted right out of the *New England Primer*. It is all black and white with woodcut crudeness and effectiveness.

Arnold surveyed the other posters, only regretting that Held had not been asked to depict northern New England, including the Vermont Yankee, the White Mountains, and the Penobscot Indian of the Maine coast. The article closes with a recommendation of these posters for the collector and praise for them as high

Cape Cod Poster. *Poster* magazine, 1927.

achievements in advertising art. Not surprisingly, Held also joined the Coffee House of New York during this period, adding his reputation to an all-star list that included Nelson Doubleday, Frank Crowninshield, Rube Goldberg, Don Marquis, Austin Strong, Arnold Genthe, Theodore Steinway, Rockwell Kent, Fontaine Fox, and Geoffrey Parsons. He continued to illustrate the written work of other humorists, including Robert Benchley, Herman Manchewitz, Gelett Burgess, and Stephen Leacock. In 1930 the *Salt Lake Telegram* named him to their list of the twenty greatest living Utahans, listing him before his old friend Mahonri Young, the sculptor. The article in the Sunday morning paper of October 26, 1930, contained a telling remark: "If John Held, Jr., were considered an artist rather than a cartoonist, he would be third" in the Hall of Fame contest.

The schism that surveyors of culture continued to see between the fine and popular arts Held continued to ignore or at least to skirt because of his artistic genius in commercial art. In 1923 he had a very successful one-man show called "A Few Things" at the Brown Robertson Galleries. The show was widely reviewed and consistently praised. But it included comic watercolors, drawings, and woodcut prints. Reviewers agreed that rare indeed was the art exhibit that featured a humorist. But the writers hastened to add that the key to Held's humor was not just attitude but his unfailing eye and genius for color. The *Art News* (February 17, 1923) entitled their review "The Humors of John Held, Jr." The *New York Times* (February 18, 1923) compared the works in their decorativeness to Japanese prints, then noted:

> They are every bit as decorative as any oriental hand could have made them, and the color has a jubilant force that need not be ashamed of a Western origin. And they are funny. . . . You must free yourself from self-esteem and pomposity or John Held never will do for you. He holds the mirror up to nature too skillfully while he pretends that he is merely fooling.

The *New York Evening Post* continued the praise on March 4, 1923:

> His handling of the pure white background is a mastery of technique. No one needs to be told that Mr. Held is a finished draftsman or that his all-pervasive humor never seems to make any difficulty with a serious artistic handling of his medium, whether it is a print or colored drawing. His prints have humor, but they make an equally strong appeal in their tonal contrast and powerful composition.

The *New York American* considered his work a distinct and valuable contribution to contemporary American art. "Mr. Held uses his white paper shrewdly to simulate snowy fields. . . . In his skillful use of watercolor Mr. Held ranks with the best of American painters." Even the woodblock art was lauded as pos-

sessing a crude vigor, as it was carved directly out of the block thus giving "the forthright expression of what is included . . . showing the artist's deep appreciation of this primitive and direct medium." According to *Vanity Fair*, Held possessed the "rare ability to do something amusing, at the same time observing with utmost seriousness the rules of the game."

By the early 1920s Held's abilities as artist and humorist combined to bring him financial success. Critics of the period, some of them members of the college generation Held so cleverly depicted in his later cartoons, noted how the proliferation of fashion, behavior, manners, and morals through the commercial arts was cyclical. The more Held characterized the accouterments of the Jazz Age, the more he was copied, in style and dress, by the public. Held himself even played the part, dressing as a country gentleman at the well-known artist colony in Weston, Connecticut. What this success also brought to Held was a temporary sense of place, among the artists and writers living fashionably in Connecticut.[23]

No doubt part of the reason for Held's amazing productivity during the period was his divorce and remarriage. In 1919 he divorced Myrtle and married "Johnnie" (Ada), who proved to be as ambitious as Held had been restless in his early career. Johnnie was resourceful herself, having served as an ambulance driver during World War I. She also was social and very conscious of Held's early fame and the potentiality for his continued success. After living in several places in Manhattan, the couple maintained their primary residence in the Weston-Westport, Connecticut area, living on three different estates successively larger and more expensive. Their upward mobility was like that of their neighbors, for by the 1920s the area was a well-established art community which attracted the famous and successful of both the fine and commercial artists. With the Lee Townsends there and the Arthur Doves as neighbors, the Helds had managed to move some of their coterie of New York friends to the much more spacious suburbs. With the benefit of the celebrity air of the place, Held could realize his perpetual fantasy. He played the gentleman farmer. And his fancy was popular. Initially, the couple made a hit at their first place on Ladder Hill Road in Weston, the Grindstone Hill house. There, with the aid of Johnnie (a handy "lady" blacksmith), Held ran a forge, producing creative signs and weather vanes and even door and gate hinges made in the shapes of animals. Soon his ironworks began to gain an audience. *Country Life* ran an article about them illustrated with Held signs. Frances Steloff commissioned a sign for her Gotham Book and Art Shop. It is an imitation of an antique alphabet plate with three men sitting in a boat, tending their poles and lines. Beneath them reads the plate motto "Wise Men Fish Here." Even the town of Weston bought a Held sign.

The "Mormon Kid" had resurfaced, if in slightly different company. In 1922 Held accompanied a group of nationally known authors and artists to several western roundups around the country under the sponsorship of Mr. and

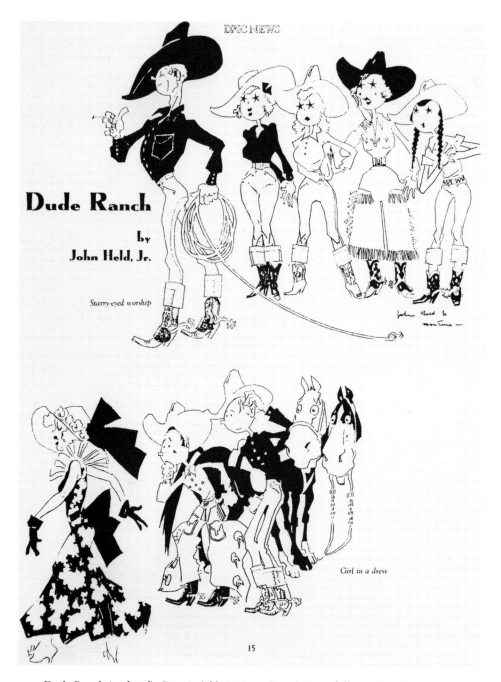

Dude Ranch (undated). *Detroit Athletic News*. Permission of Illustration House, Inc.

Mrs. George Palmer Putnam of G. P. Putnam and Sons, New York publishers. Held must have beamed at the report in the *Portland Oregonian*: "John Held, nationally famous artist and cartoonist of New York, featured in the show today when he made an exhibition ride on Gray Eagle. Held . . . had never ridden bucking horses before, but made a wonderful ride. Those in the stands who knew who he was gave him the biggest hand of the day." Back home, at the 140-acre estate they bought in 1924, Held curried his own horses—a prize stallion, a stable of polo ponies—and the notorious mules Abercrombie and Fitch. Photographs from the period show the Held menage to include ducks, colts, chickens, and rabbits. Held appears in the same photographs as a debonair country gent; fashionable knickers and a tan have replaced his Brooks Brothers suits.

Obviously, Held was far from his native West in his attitude. Reported to have employed twenty people during one period to run the Weston estate, he hardly qualified as a dirt farmer. The gesture toward the idea of the West was there, but it simply added to the degree of success high living in the city had brought him. Here he could try other roles as well. Elected constable in 1922, he ran for Congress from Fairfield County in 1924, nominated by the Democrats of the Fourth District to oppose Schuyler Merritt of Stamford. Held stood on his distinction of never having made an arrest in Weston and quipped: "The campaign will be conducted from the south forty. I haven't got the time to make a lot of speeches and the public hasn't got the time to listen to them. If anyone wants my political views they can get them on my farm in Weston."[24] *Life* magazine on October 9, 1924, had a wonderful time with the campaign, running a page spoof of the cover of the *Congressional Record*—if Held were elected. This copy accompanied the drawing:

> The Democrats in the vicinity of Westport, Connecticut, have nominated John Held, Jr., artist, farmer, and man, as their representative in Congress. (We're not just trying to be funny; they really have.)
>
> Mr. Held, when interviewed by a *Life* reporter, intimated that the nomination had come as a complete surprise to him.
>
> "It all seems like a wonderful dream," said the young genius who designed the Odd Number cover. "I had thought about Congress—yes. I had also thought about the leper colony on Moro Island and the shower baths in Vassar College gymnasium."
>
> When pressed for a description of his platform, the man who painted the famous picture, "Goofy over Horses," replied: "I intend to devote my attention first to the Congressional Record. Here is a magazine that needs new blood! It has struggled along for years (I forget how many) without ever getting a decent display on the newsstands. I'm going to put the Record over with a bang. I'll see that it publishes a gripping new serial by Arthur Somers Roche, some true confessions by internationally known writers and a limerick contest with big cash prizes. Yes, I'll do the covers myself," he added modestly.

"I also promise to make official Washington more collegiate. . . . Just wait till I have Senator Borah wearing a Fair Isle sweater, oxford bags, and a beret!"

From time to time the local artists put on variety shows or plays. Held was always involved as in the case of the minstrel show *Home Brew*. On July 15, 1924, the *Westport Herald* announced:

> Arrangements are about complete for the presentation by John Held, Jr., of his 1924 Follies at the Weston Town Hall, July 26. Not withstanding the fact that the young artist is more than busy—for Held's one of those fellows who works, and then some—he is devoting a lot of time to this affair. Besides other attractions there will be a Chimpanzee act. Mr. Held takes the part of the Chimpanzee, which has a real trainer. The costumes for this act have been made entirely by the artist. Mrs. Helen MacDonald has secured the services of a Russian dancer. Lee Townsend will act some Western "stuff" (rope trick à la well—).

Whether on the political, personal, or social level, Held's attitude was the same. The stage stuff part of Held's boyhood fantasies was played out again. Even the recurring self-parody which characterizes Held's dialogue with interviewers of the time was a pose.

But if a sense of place was derived from playing celebrity farmer/cowboy, then it proved as noxious, in the end, as Held's "home brew." A photograph from late in the 1920s shows what it took for Held to keep up this lifestyle. He pores over a drawing board, hand to his furrowed brow, his bleary eyes almost lost in clouds of cigarette smoke. There was a temporary respite, however. In March, 1925, Held was kicked in the head by a horse. The *Westport Herald* (March 17, 1925) reported:

> John Held, Jr., artist has skull fracture in runaway accident but is expected to recover fully. Held, kicked by the heels of his young horse used for farm work as the animal took fright and bolted on him yesterday, was then pitched into the road. He suffered a depressed fracture of the skull from the horse's kick, and his nose was smashed and his lip badly torn when he was hurled into the road. . . . At the Norwalk hospital Dr. Phillips and Dr. George Fawcett worked over Held in the operating room for over three hours. After the operation, during which surgeons sewed up a severed artery in the brain and relieved the fracture, Held recovered consciousness and joked with his surgeons.

With his typical tack of mythologizing his life, Held claimed the horse knocked some sense into him and was responsible for his success in the late 1920's. What the accident did was send the Helds to Europe for his convalescence. Perhaps Held was prophetic. Travel again seemed to rejuvenate him. Though no new style emerges from the trips to the Mediterranean and North Africa, a burst of

color, done mostly on *Life* covers, was his last major innovation in cartooning. At Christmas in 1930 Held was infuriated by Johnnie's gift—an even larger drawing board for him to do even more drawings on. Later Johnnie gave one of her patented parties—lots of friends and drinks, starting at eleven in the morning. Held was trying to work upstairs in his studio, but the noise was so unbearable that he raced down the stairs yelling: "Get the Hell out and stay out!" Along with such personal pressure, the stock market crash took a major part of his investments in 1929. By March 1931 he was in a sanitarium in Stamford, suffering from nervous exhaustion. That same year he left his second wife, the estate, and his three adopted children. Held realized later that he had been sucked into the pursuit (the maintenance?) of "meretricious beauty": "I had a tiger by the tail and I couldn't let go."[25]

Just how formulaic Held's own life had become is signaled in the repercussions of his horse accident. There was a lot of publicity about Held's near death, and one article in *Harper's* years later misinterpreted Held's own humorous publicity about the head-knocking changing his career. It prompted a quick response from Thomas Gerber, Held's syndicate manager of the time, who wrote the editor of *Harper's* to set the record straight. Gerber recalls that Held requested to see him the morning after the accident because he was concerned about keeping up the weekly "Oh! Margy!" cartoon. Held wanted to work out a plan to continue his work until he could draw again. Gerber, Held, and his wife managed to recover some unfinished sketches from the workroom on Held's farm, giving these to another artist to finish. From files Gerber took many of Held's already published cartoons that could also be reworked. Artist Charles Winner was used for the work, along with some other artists suggested by Hal Burrows. Gerber wrote the "Oh! Margy!" lines himself, then finally employed a young man Held suggested who had written some captions before. They also changed Margy's costumes on old drawings, for example, replacing an umbrella she was carrying with a dog to lead. Thus, the strip continued during Held's recovery.

The relative ease with which "Margy" was produced during this period suggests just how predictable she had become. So deft was Held's penning of this stereotypic figure that he easily made up to $1,000 a day just on flapper drawings sold to other magazines. In addition, the high visibility of his flapper made her popular fare for advertisements. During the period 1918 to 1930 Held illustrated ads for Van Heusen shirts, Timken roller bearings, Planter's peanuts, Tintex dye, and others. The fact that his flapper could change contexts so easily and still carry the same stereotypic appeal provided Held's ultimate monetary success.

But the man who had been the pacesetter for the manners and morals of college youth failed to anticipate the next great change in fashion. By virtue of her very replicability Held's flapper ironically changed her creator into a mere draftsman. Al Hirschfeld put it succinctly: "Short skirts went out, long skirts

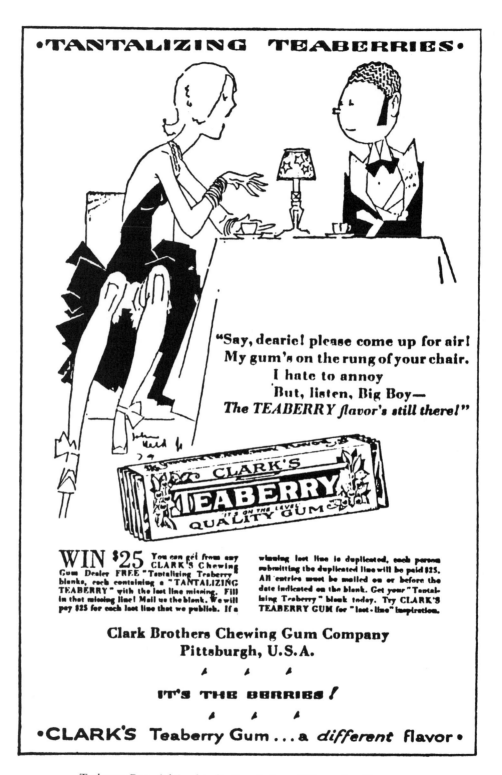

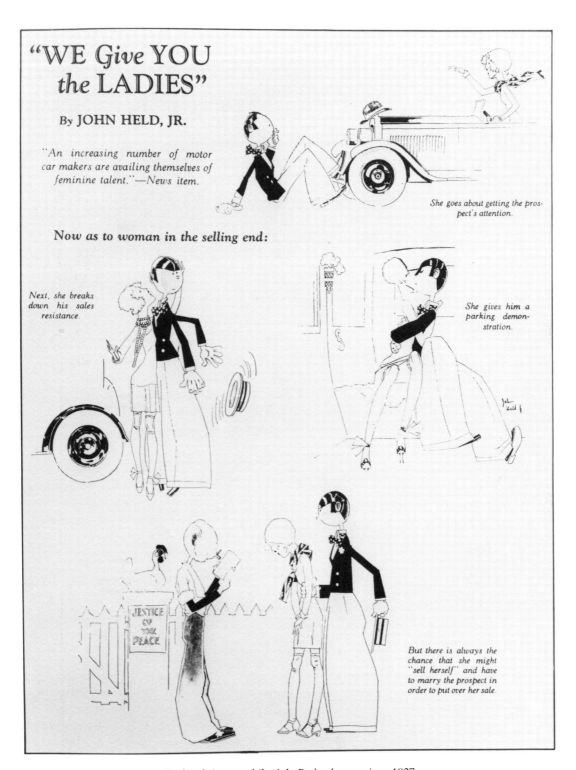

Packard Automobile Ad. *Packard* magazine, 1927.

came in. John couldn't draw long skirts, so Russell Patterson took his work away from him."[26] But fashion reflects shifts in mores, and if Held failed to capture the new fashion of the 1930s, perhaps he dismissed the subtle changes in women as well. His flapper had become the materialistic ideal of the "New Woman." As Mark Sullivan observes, Held failed to note the change in the ideal:

> Supremely the artist of youth in the Jazz Age, in words as well as drawings, was John Held, Jr., whose sardonic sketches of "Flappers," Jelly Beans, and Drug-store Cowboys were a caricature gallery of the youth of that period. Held's drawings became proof of Oscar Wilde's contention that nature imitates art far more than art imitates nature. As the Gibson girl and the Gibson man had been the ideal for youths and maids of the 1890s, so Held's drawings were the archetypes of the late 20s. On every street corner was the Held male, buried in a raccoon coat, with patent leather hair, wrinkled socks, and bell bottom trousers. Frantically bidding for the superior creature's attention as the Held Flapper—stubby feet, incredibly long and brittle legs, brief and skimpy skirt, two accurate circles of rouge just below the cheek bones, and a tight little felt hat like an inverted tumbler. The apotheosis of an attitude heralded its passing.[27]

Held later reflected on this period in his life:

> I was a sick man. I had dozens of carbuncles. I had to sit at my drawing board in a mule collar. Days and nights.
> I guess I've folded more magazines than any man in the country. Whenever a magazine got into trouble, the editor would come to me. He'd say, "I need Held. Held'll pull it out for me." I couldn't pull it out for them. Nobody could. But they came.
> I woke up one morning and read that Ivar Kreuger had just put a bullet in his head. I said to myself, "Oh-oh. There goes my six million dollars." I'm not kidding. I can hardly believe it myself anymore.
> What could I do? I came to New York from Salt Lake City with four dollars in my pocket. I was looking for success. I found it.[28]

By 1931, then, Held was physically, psychologically, and artistically exhausted.

Long before Held's nervous exhaustion, he had reacted to the emotional pressures of his marriage and the lifestyle enjoyed by his wife, Johnnie. In an early comic reaction to the demands he felt, Held designed a sign for the Grindstone Hill farm picturing himself with his nose to the grindstone. Though Held obviously enjoyed and cultivated the role of gentleman farmer adding rare show horses and game to his menagerie, the repetitive work of drawing flappers in order to support this lifestyle threatened his very creativity. Interestingly, the color work he continued to do for Hearst newspapers into the 1930s remained expert, fresh, original, but the black and white Margy panels

THE SILENT DRAMA

The Silent Drama. *Life*, July 7, 1927. Permission of JB&R, Inc.

and single cartoons lost their precision and uncharacteristically sometimes showed little care by the artist. The Helds had adopted three children while in Westport—Jack, Jill, and Joan. The twins, Jack and Jill, had suffered from rickets when the Helds adopted them. Held's love and care obviously went out to the children. Joan, whom he called Margy, was the cartoon strip's namesake. Family albums show father and children playing with the ducks and rabbits on the estate. Yet, in another of his series of losses at the close of the 1920s, Held's marriage crumbled, he lost a small fortune in the stock market crash, and he left the estate and his possessions to his wife and children and returned to Manhattan. The loss of the children was particularly painful. Joan especially begged to go with her father, but he knew he could not properly care for the children in the city, alone. The result of his break with Johnnie was the permanent loss of his children. As they grew up they renounced their father and refused to maintain contact.

What Mark Sullivan identified as the apotheosis of an idea—Held's inability to realize social changes as signified by the change in fashion—more accurately resulted from Held's exhausted creative energies, the pressures to make a living after the stock market crash, and the incessant demands of editors. Hearst continued the Sunday syndicated strips until 1935. As astute a social observer as Held had been could not have ignored the dropping hemlines nor the serious turn of mind of American society after 1929. Beginning in 1929, Held himself turned to serious fiction. From 1930 to 1937 he published four collections of short stories and three novels, all dealing with the vagaries of the material- and youth-oriented 1920s. His public was quite shocked by his first collection of short stories, *Grim Youth*. At first critics were reluctant to accept his attempt to master another medium, even though Held told the *New York Herald Tribune* (December 14, 1930): "Art is art. You can't define it. The underlying theme of drawing, writing, designing, and sculpture are all interlocking." His *Dog Stories*, harmless and almost sentimental interpretation of *his* best friends, had garnered much acclaim. But the critics found this collection to be about "callow

"THEY WANT TO FIX YOUR TIE"

They Want to Fix Your Tie. *Grim Youth*, 1929. Permission of Illustration House, Inc.

youth," "cruel youth," "pretentious youth." As a result, even the illustrations (which accompanied each of his volumes of short stories) critics found more brittle, sardonic, barbed. Held, of course, understood his dilemma well. He later told an interviewer that the secret of his success in the 1920s had been his ability to exaggerate what the youth were doing. But "the cause of his cartoons,

the wild, caroming twenties' kids, came to believe themselves the actual people of the finished cartoons so that cause and effect became hopelessly intermingled and no one knew whether the flaming youth on paper or the flaming youth in life was the real article."[29]

But Held's exploration through four volumes of short stories was more than a predictable rehash of the foibles he spotted in the 1920s. He, too, had perspective and had painfully matured. Critics tried desperately to moor him to some well-known model—Fitzgerald, Lardner, Tarkington—but as we can read in their exasperation, none was quite "grisly" enough. The best they could do was describe the results:

> We have moved a long distance from the starlit expectations of "Seventeen," as recorded by Booth Tarkington. Even the frost-bitten sophistication of F. Scott Fitzgerald's adolescents is quaint and outmoded. In the John Held cosmorama, the beginnings of wisdom appear to coincide with puberty. By the time these strange beings have reached seventeen, their lives have turned to highway dust and cigarette ashes. . . . Ambition is but an urge to "go places"—without arriving, and to "see things"—in the privacy of a parked automobile.[30]

Perhaps Corey Ford had the best handle on what these works meant. After all, he could recognize the reciprocity of kinds of humor:

> His friends have always suspected that Held must know the whole figure of youth in order to be able to caricature its outline so deftly with his pen; but it is a shock and a genuine thrill now to find that pen capable of filling the outlines with words so originally and truly.[31]

Held's attempt to extend his Jazz Age abilities as caricaturist clearly resulted from both a reaction to the 1920s and attempts also to reject it, or at least reevaluate it. The experiences of loss and exhaustion of forms that characterized the end of the decade affected Held in virtually every personal and professional area. He left his demanding wife, his family, farm; lost his fortune along with others in the crash; found commercial sources for income deadening, including the expectation of editors for cartoons and advertising; rejected suggestions from friends in the early 1930s to take up window designing for department stores, a job other displaced artists could turn to. He remarked in an interview with the *New Orleans Times-Picayune* (April 8, 1934) that one gets to be a great artist or writer through "arrested development":

> It's something like a mild form of half-wittedness that makes a man want to earn his living in some such ridiculous way as this, and this. I can prove it. Every child can create, but almost every child grows up and goes into some sensible business like selling bonds.

**HIS FINGERS MET WITH DISAPPOINTMENT AS HE EN-
COUNTERED BLOOMERS AND MANY GARTER BUCKLES**

His Fingers Met with Disappointment. *Bowl of Cherries*, 1932.

Some don't. I think there's a door in the back of everybody's head that lets out the dreams, or the creative instinct, or the mild madness of whatever you want to call it that makes us want to make our livings this way, and not sensibly. For the lucky ones, that door closes at puberty; the unfortunates go on all their lives fighting with publishers or art dealers. They never grow up, and don't say Peter Pan or I'll sock you.

Child-mind, a kind of eternal playfulness that promotes creativity, some would note is always positive. But Held's indefatigable humor manifested itself many times as glancing, self-deprecating commentary. As the *Stamford Advocate* noted in an article in 1925, Held's cartoons were kind; the flapper was pictured as a "stocking-rolling, hootch-drinking, cigarette smoking, extremist, she was a good sport and not a bad girl;" what Held saw in the flappers and jelly beans he no doubt possessed himself, but when the youthful playfulness and innocence revealed darker sides, he noted these as well. The growing pains—the pressures toward maturation—he felt in the 1930s were precipitated by a series of failures that clearly identify him as a part of the times, though he was a generation older than his college models. From 1931 when he published his first novel, *Women Are Necessary*, through his third novel, *I'm the Happiest Girl in the World*, Held continued to dissect "the woman" in American society. Yet the decade began and closed with Held's nostalgic and retreating excursion into childlike fantasy. His *Dog Stories* (1930) and *The Gods Were Promiscuous* (1937), though markedly different in subject and tone, indicate his desire to escape the present through the imagination. These stories concern the loyal companionship of talking dogs and a cartoonist who seeks renewed truth and beauty by escaping the meretricious city for the countryside.

During the first six years of the 1930s, Held seemed to be reevaluating himself and the general plight of the artist. He once defined an artist as a person who had the ability to see objects in their exact relation one to the other and to separate important details from the mass. But he noted that an artist must be able through such ability to recreate the image so others can see through the artist's eyes. The average person looks, but he does not see. Held seemed to be teaching himself to see again, perhaps see anew, as he turned earnestly to fiction writing, sculpture, and serious watercolors.

The period of Held's fiction writing and his thematic attention to women roughly parallels his marriage to his third wife, Gladys Moore. John had met her in 1927 when he served as one of the judges of a beauty contest she had entered. After Johnnie divorced John in Mexico, September 1931, Gladys and John "eloped" on Armistice Day of that year. Gladys, who had been acting in the Ziegfeld Follies since 1927, had married John at a Justice of the Peace in Stamford, Connecticut after they found that New York would not honor the Mexican divorce. The Chicago *Tribune* Service reported on November 12, 1931: "they were married in Stamford, Ct. on Armistice Day, as they had tried to be

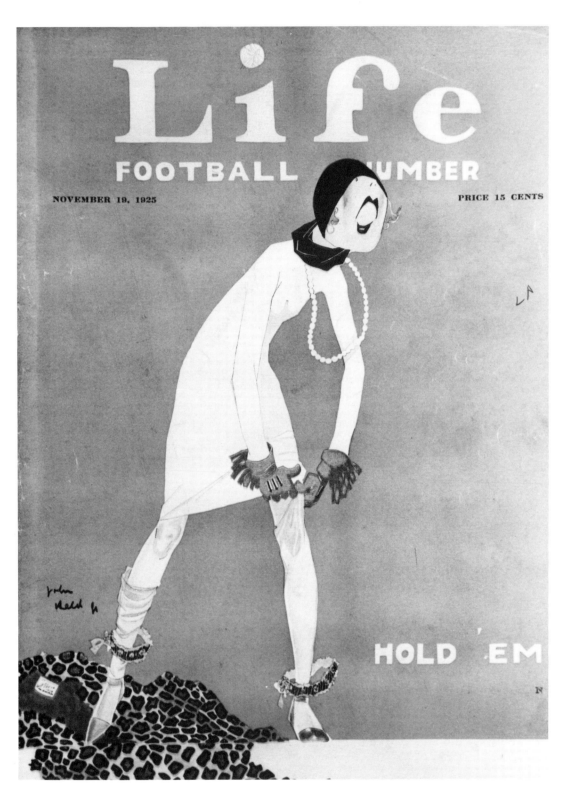

Hold 'Em. *Life*, November 19, 1925. Permission of JB&R, Inc.

Gladys Moore, ca. 1933. Courtesy of Judy Held.

married in New York previously, but they would not recognize a Mexican divorce in New York. This caused a lot of trouble and delay, finally when they did get married there was an Armistice Day parade outside, drums, etc. causing the bridal group great hilarity." Apparently, Held knew both Gladys and her family well by this time. He had taken liberties with her family history in his comic woodblock "Dream Girls of a Dim Decade." The actual subjects for this piece were Gladys' mother and two aunts who were vaudeville performers. One of the aunts billed herself as "the only woman clarinetist in the world" at that

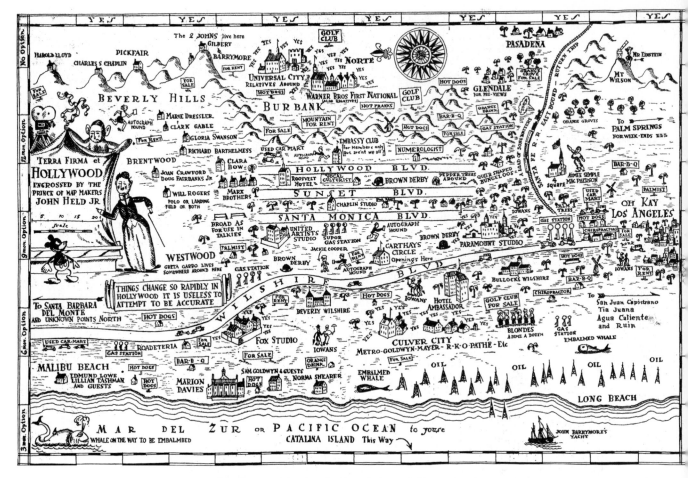

Map of Hollywood (undated). Permission of Illustration House, Inc.

time. The trio teamed up with a quartet, dubbed themselves "The Seven Parisian Violets," and toured as an all-woman orchestral group. Held called them the "Seven Sutherland Sisters" in the woodblock.

By April 1932 John and Gladys made their first trip to the West, where the *Salt Lake City Tribune* reported Held was making his first real visit to his parents since 1912. "The Helds expect to leave late in the week for Hollywood, Cal., where they will visit Charlie Chaplin and other friends in the film colony as well as pay their respects to William Randolph Hearst for whom Mr. Held works." The Helds made friends in the theater as well, including Thelma Ritter and Joe Moran. They moved into the Algonquin Hotel temporarily in 1933 after the birth of their daughter in New Orleans in March 1933. Held contributed the stage sets and the costumes to *Alma Mater* in 1934. By 1935 the couple moved

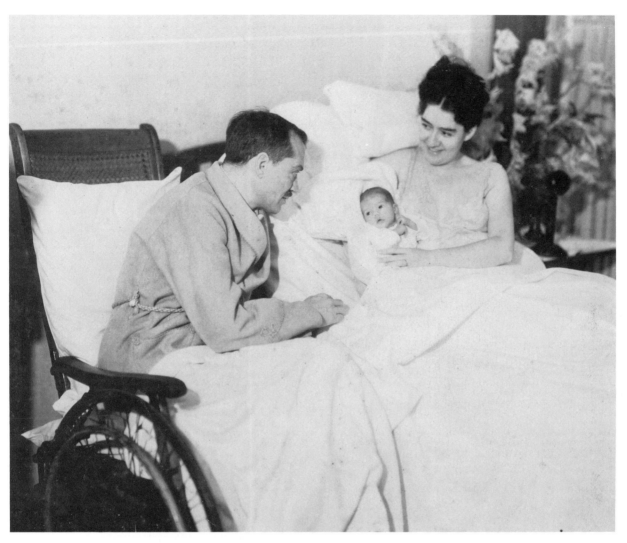

Mr. and Mrs. John Held, Jr., and Judy, March 1933. Courtesy of Judy Held.

into the Barbizon Hotel overlooking Central Park. The decor was thoroughly
modern; Held continued to dress stylishly in loosely woven suits, buckskin
shoes, and a wool shirt. Gladys was playing in the successful Broadway musical
Calling All Stars. Held apparently was back in form in his punchy interviews.
He told a Salt Lake City reporter for the *Tribune* on May 30, 1935, that "one of
the drawbacks of being an artist was that you get too many letters and too many
horsehair belts from penitentiaries." While lecturing on "Art in Advertising" for
the Salt Lake Advertising Club, Held was introduced as an internationally fa-
mous cartoonist, writer, and artist. He demurred, saying, "All I have been try-

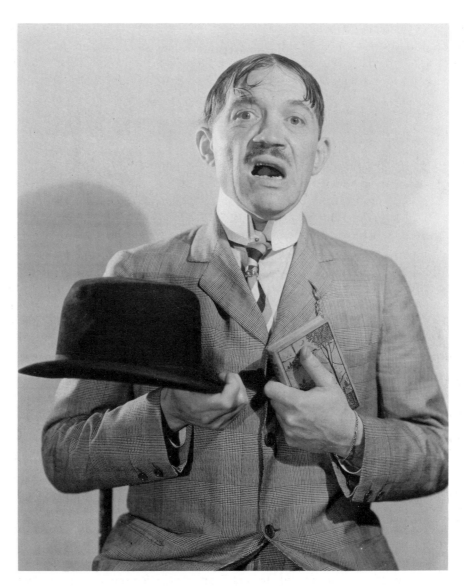

John Held, Jr., 1932. Courtesy of Judy Held.

ing to do is make a living. I've hardly had time to look up from my drawing board." In September of that year the Helds were again in Hollywood; according to the papers, Held was applying for work as a screen writer. In 1935 Held published *I'm the Happiest Girl in the World*, a less than happy account of doings behind-the-scenes at beauty contests.

The couple's honeymoon period appeared to have less than a happy ending as well. Held had quoted from *Alice and Wonderland* in the beginning of *I'm the*

Happiest Girl in the World the queen's remark to Alice that in her country it takes all the running one can do to keep in the same place. The marriage developed into another pressure-cooker where Held again felt the demands of the theater, editors, and advertisers. He seemed to be searching again for new avenues of expression while succumbing to the demands of life in the fast lane. He and Gladys separated and by early 1936 she had returned to New Orleans to stay.

Held began painting his somber Manhattan views in January of 1936, which he continued through May. He moved into Barbetta's Restaurant, a two-room apartment on the top floor, where he also continued to work on sculpture and planned a show at Harry Bland's gallery on East 57th Street. By 1936, Held's morale was at an all-time low. Again he parted with a child, this time Judy Held, his only natural child, four years old at the couple's final separation. Too, the effort to recapture the glamour of the city had failed. His fiction was not really successful; even the Broadway life he and Gladys enjoyed faded with the less than sustained runs of shows they both participated in. During his marital trouble with Gladys earlier, Held began painting from their apartment atop the Barbizon. Blazing with the color schemes so familiar in his humorous flapper covers and typical of his general watercolor palette, these pictures of New York City are hauntingly empty. The city, seen as if in morning or evening light, expresses a birth of knowledge not riotous or exciting as the colors alone would suggest. Rather, the canvases are serious, serene, even cold. They suggest a beauty Held by then was quite familiar with, perhaps a sense of beauty both Gladys and the evaporated twenties left him with. This is an older city, one with which, E. B. White would concur, is of the solid native: the provider of continuity in the life of the city. Held was finally at home, and sadly so.

If there was a piercing lyricism in Held's watercolors toward the end of this decade, there was a strength of classical line in his sculpture. Having worked within this tradition before, Held executed a series of stunning bronzes (mainly of horses) during the 1930s. Significantly, in a period of his greatest personal turbulence he turned primarily to sculpture. After the Bland Gallery's show, reviewers noted the unique combination of classic form with humor that characterized his successful exhibit. "If John Held doesn't watch out, he may turn out to be the Frederic Remington of this era," one writer for the *New York Herald Tribune* commented on March 11, 1939. He continued:

> He announces himself an animalier gifted not only with skill and charm but wit. . . . Remington, who knew other phases of the horse so well could not have caught the loss of blank bewilderment that John Held gives to his "New Foal," nor the slightly aghast expression of the one standing by a clump of cacti and labeled "Desert Blossoms."

Particularly in this, his favorite form, Held revealed his own saving grace. The artist and humorist had come together again in a moment of genius. The reviewers noted his technical brilliance in the medium, but most of all his ability

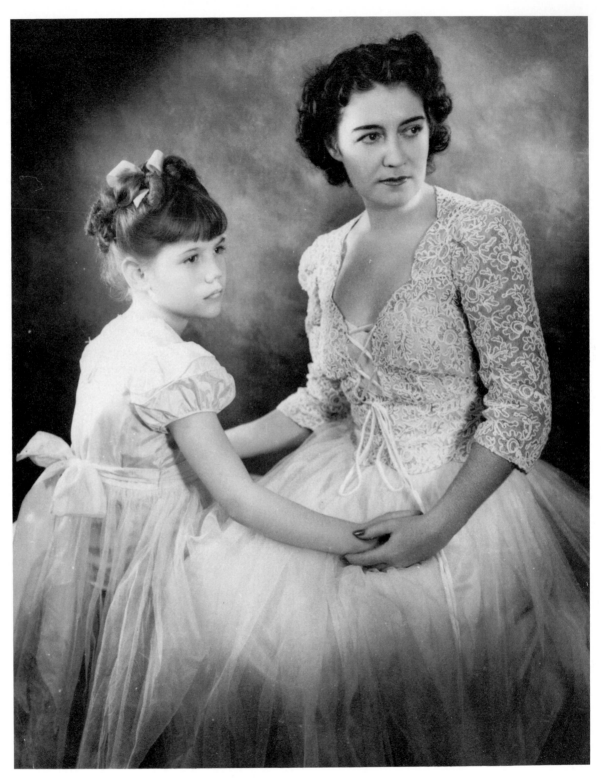

Gladys Moore and Judy Held, 1940. Courtesy of Judy Held.

to see, with comprehension and affection, the drolleries of the animals. As one reviewer noted: "John Held . . . sees that the horse is as open and understandable as a human being—even more so. The horse rarely has guile—and we human beings have far too much." Held's humor as seen in his own appreciation of the innocent comedy associated with animals and their sculpted likeness constituted a personal reserve which contrasted with his more social humor dealing with people during the 1920s. In 1937, when he first met Margaret Schuyler Janes ("Maggie") and was reported by friends to be in deep depression, he thoroughly identified himself with a residual animal pluckiness. Held gave Maggie a copy of *Dog Stories*, drew a dog with a giant tear in his eye on the inside cover, and wrote: "To Janie, from a sad, old Airedale."

Part of the reason for Held's recovered sense of humor was Maggie herself. Each of Held's wives no doubt influenced his lifestyle through their expectations and personalities. His first wife assisted him in the beginning of his commercial career; Johnnie was the quintessential flapper herself, demanding more cartoons, more parties, more money; Gladys, the beauty queen, was connected to the popular arts in other ways, through the theater and through her desire to keep up with the smart set at the Algonquin. Each woman probably affected how Held perceived the New Woman of his cartoons and fiction. Gladys, for example, probably was the model for *I'm the Happiest Girl in the World*, his study of beauty contests. But Maggie brought great admiration, love, and stability at a time Held needed them. His life with her ultimately revolved around a farm, another Held menagerie, and the time to dabble in sculpture, the decorative arts, children's stories, and to reflect on his career.

When Maggie met John she found him rather tall, of medium complexion, with long arms and capable strong hands. He weighed between 175 and 185 pounds. He had wavy hair and in later years wore his hair and mustache closely cropped. His cheeks were pink and his mouth turned up slightly at the corners, giving him a pleasant expression. He wore country clothes most of the time, purchased from Brooks Brothers, Abercrombie and Fitch, or Bean's in Maine. Mixed tweeds were his favorites, worn with a dark blue shirt or a colorful wool plaid, plaid wool socks, and rough buck desert boots. During the 1920s and 1930s he wore an ankle-length raccoon coat from Saks Fifth Avenue. He still prized the coat in the 1950s at the Belmar farm and a friend remarked, "John was one of the last men to go on wearing a raccoon coat."[32] He was also particularly fond of a Norfolk jacket he had purchased at Brooks Brothers in the 1930s. He called it his "Beauty Jacket," since he wore it to judge a Miss America Beauty Contest in Atlantic City.

Held expressed his artistic presence very early in his courtship with Maggie. Often they would dine out at Horn and Hardarts Automat or some evenings at Maggie's apartment. There Held decided he should do something about Maggie's furniture. Though he liked the early American reproductions, he abhorred what he called the "tobacco finish." One night he arrived with a pocket full of

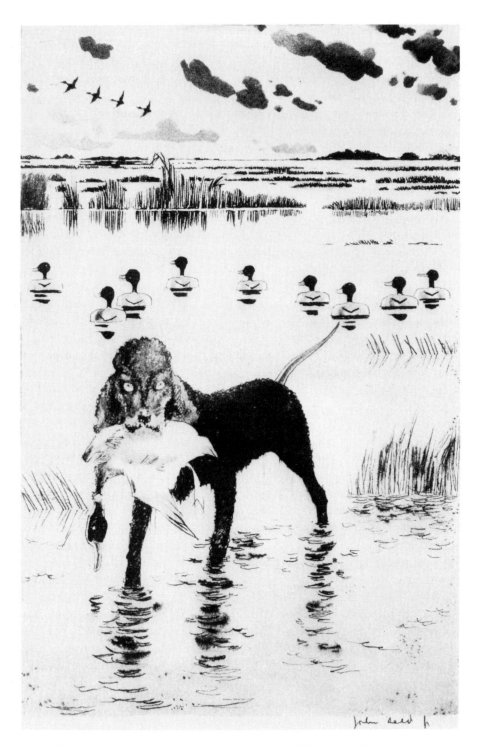

Illustration for *Dog Stories*, 1930. Permission of Illustration House, Inc.

sandpaper and wax and what he termed authentic hardware and began to refinish the furniture. Some of the furniture he simply finished with wax; others he decorated with Pennsylvania Dutch designs à la John Held, Jr. But he didn't stop there. Deciding the walls needed painting, he submitted new colors to the painter so he would make no mistake. Maggie decided to take a short vacation during the process, and she learned through a friend that with each stroke of the brush the painter uttered obscenities about the colors. When she returned, she found out why. At the desk the clerk remarked, "I *hope* you will like your apartment." She walked into a riot of modernist colors, with a purple cow on one wall. Held showed up later with two silver-framed watercolors under each arm. With the paintings up, the furniture in place, all agreed the place was a sensation. In later years, when Maggie watched Held mix his paints combining purples, oranges, hot pinks, turquoise side by side, she continued to be horrified. But Held always entreated her to be patient before she criticized. Sure enough the end result would be a masterpiece of colors which worked harmoniously.

During Held's courtship of Maggie, he became involved again in a number of creative projects, including a variety of shows and other activities with college youth. Once the artist who had set the style and manners of the Jazz Age, then criticized the era largely through his novels of the 1930s, Held had mellowed by the end of that decade, as reflected in his attitude about college youth during a touring radio show.

In 1937, Held and his friend from Westport, Henry Souvaine, sold an idea for a college variety show to the Red Network of NBC radio. Held and Souvaine contacted all the principal colleges of the country and sent down an advance agent weeks before the program to interview students and faculty and to comb the campus for available talent. Excerpts from hit campus plays, school bands, student orchestras, singing troups, campus comics, soloists and instrumentalists were sought. Next, either Souvaine or Held would personally arrive before the broadcast, hear the auditions, and line up the shows. The programs, sponsored by Pontiac, brought a wealth of local color and legend to the microphone, from an actual cattle roundup by the University of Texas to the singing of the earliest Negro spirituals at Vanderbilt to a bagpipe band at Dartmouth. According to Humphrey Doulens, writing in the theater-radio section of the *New York Times*, "Part of the preliminary was that Held carried on investigations into the traditions, the life and culture of the campus." The ultimate question was obvious: have college youth changed? Held adamantly said "yes": "'The campus boys and girls have turned serious. Life to them no longer means a lot of frills, night clubs and necking. They think of life now as a problem of social and economic adjustments. They've discovered that the world's problems are, in fact, their own, and that they cannot find escape from the world in a spirit of abandon.'"[33]

In 1938 Held did the scenery for the Broadway comedy *Hellzapoppin* and sold it to Olson and Johnson, who had a union man paint it on the drops. They

thought up the acts as they rehearsed, while stagehands ate their dinner sandwiches on the side of the stage, making wisecracks, which all became part of the act. They spent most of an evening trying to figure out how they could get a live white horse into an upper box. John and Maggie went to the opening. During intermission a few prizes were given out to the audience: a stepladder, a toilet plunger, etc. Held was given a large cake of ice, which sat in the aisle melting through the rest of the show. There was a small tree in the lobby when the couple came in; when they exited, it had grown into an enormous size. Brooks Atkinson described the fantastic presentation this way:

> *Hellzapoppin*: For the first hilarious half-hour last night it seemed as if this were really true. The Forty-sixth Street Theatre was a madhouse for that length of time. Pandemonium reigned. Pistols were popping all over the place. Bombs were exploding. Lunacy reigned.
>
> Crazy newsreels disclosed Mr. Roosevelt, Hitler, and Mussolini endorsing (sometimes in strange dialect) the Messrs. Olson's and Johnson's new revue. The Seven Dwarfs competed with the new tenants of Krum Elbow for domination of the stage. The boxes bulged with stooges. The aisles were filled with "plants": a woman who kept calling for "Oscar," a ticket scalper who warned that good seats could still be had for "I Married an Angel," and mysterious beings who in a sudden moment of darkness pretended to drop spiders upon the necks of playgoers.[34]

Earlier, in 1933, Held had joined New York's prestigious Century Club, where like shenanigans were informally performed. Held's cronies included Heywood Broun, Howard Dietz, Kenneth Macgowan, Ralph Barton, Frank Crowninshield, George Chappell, Rube Goldberg, Don Marquis, Austin Strong, and Norman Bel Geddes. In 1938 Held exhibited his somber watercolors of Manhattan at Macy's even as he continued to draw advertising posters for MGM (*Schoolhouse on the Lot*, 1938) and color ads for Old Gold cigarettes. The same year as his successful Bland Gallery exhibit of sculpture, he executed murals and a sculpture for the cocktail lounge of a hotel in Atlantic City, Chalfonte-Haddon Hall. In 1940 he was named to artist in residence first at Harvard University and then at University of Georgia under the provisions of the Carnegie Corporation. When Held began his three-month residence in Adams House at Harvard, the Harvard *Crimson* reported (February 1940): "Held is arranging his studio where he will spend the next few months sculpting, painting, and receiving interested student callers." In the same article Held remarked that he had given up his commercial work so he could spend all his time painting and modeling. "I am very serious about my sculpture. . . . I started out to be a serious artist, and now I am going to be one even if I can't eat."

Held's experiences, both at Georgia and Harvard, allowed him to work in a tutorial method with young art majors on each campus as well as pursue his

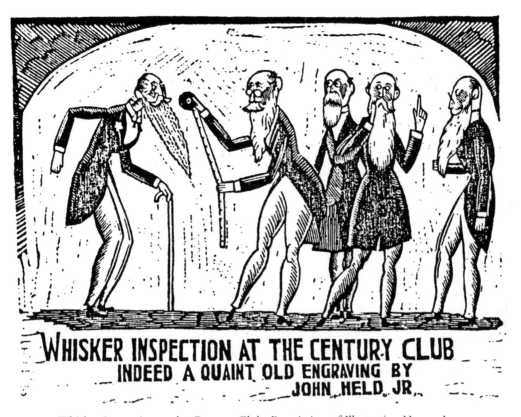

WHISKER INSPECTION AT THE CENTURY CLUB
INDEED A QUAINT OLD ENGRAVING BY
JOHN HELD JR.

Whisker Inspection at the Century Club. Permission of Illustration House, Inc.

long-time serious dedication to sculpture. Working with college youth in a new way no doubt enriched his life as did the contact with faculty members on both campuses. Held was very popular with both, his warmth and humor along with his talent serving each campus effectively. These grant periods also provided a financial respite from the commercial world Held sought finally to escape and a complete turning to a time and a place totally devoted to serious art. Despite the responsibilities of each position, Held characteristically was known for his humor, keeping a rooster and a chicken, Colonel and Mrs. Culpepper, in his office at University of Georgia, ostensibly for modeling purposes.

Around this time as well he made the ritualistic return to the West and his childhood home, which seemed to provide a much-needed reunification with landscape and family. Held and Maggie left June 15, 1941 for Salt Lake City and spent the summer traveling. They visited the Hubbell Trading Post, where Held had been on his Walpi trip in 1916, batched all the way, pinching pennies, cooking and camping out, worrying about their car exploding from the heat, and en-

joying it all like kids. For Held, the trip reunited him with his family and the West of his youth and imagination. Later, when his father died, he and Maggie would return again to bring Held's mother to live with them. Though Gladys had returned to New York City in 1939 in an attempt at reconciliation, that never occurred. Finally John and Maggie were married December 23, 1942. The only slipup was the fact that the certificate that Held had to sign had space for only two recorded divorces. The judge jovially took them into his office for a celebratory drink. He had always wanted to meet John Held, Jr.

Indeed, Held still enjoyed considerable fame. Maggie remembers that people on the street acknowledged him. He was a popular figure in New York City. He kept up friendships with artists Hal Burrow and Lee Townsend, regularly attended the Coffee House Club through these years. He was popular with those who had not personally met him, too. Held received letters from reading classes praising his children's book, *Danny Decoy*, begging for more episodes involving the delightful wooden duck.

In 1942 the couple moved away from their friends. After Held repeatedly tried to enlist in the Army and Air Corps and was turned down for "history of fracture of the skull, absence of bone one and one-half cm. in diameter in left parietal bone, and insufficient natural teeth," the couple joined the Signal Corps. They had rented a new apartment on 31st Street and had just settled in when Held was instructed to report to Camp Evans, in Belmar, New Jersey. The work, as he later described it, was "painting of radar apparatus in operation before the apparatus had been invented so that we could go to Congress and get enough money to invent it."[35] Working under the title of "Educational Visual," Held first took a room in a hotel at North Asbury Park. Finally he found two rooms in a boarding house in the same town. Maggie sublet the apartment and joined him there. Held did not like the living arrangements. For one thing, there was "an all-night abortion factory" in operation next door. Also, the attic apartment was leased to the wife of a young sailor who was out at sea, and she entertained an endless string of beaux. Held called the arrangement a "one woman hors-house," and spent most of every evening yelling for quiet. The last straw came when she left all her dishes to soak in the community bathtub. The one thing Held did to assuage the situation was to write jokes for a local "joke factory" in Bradley Beach. The situation only faintly improved when the couple moved in March 1943 to a bungalow in Shark River Manor back in Belmar. Maggie reports:

> We rented it for $45 a month. It had no interlining, and we could see the outdoors through the walls. There was a porch, living room, dining room, with a wood stove in the center. When we lit the stove there was such a draft, with the holes in the walls, that we couldn't control the fire in the stove. At night it was so cold, we had to sleep with all our clothes on. There were two small bedrooms, with a *window* in between. The owner explained they had put frosted glass in the window so the guests wouldn't look through. There was an opened

back porch, with a wash basin, and an outhouse off the porch. On cold mornings, bathing was a bit chilly.[36]

By late spring the vegetable garden the couple managed to grow prompted them to look for something really to call their own. By August they had found and purchased the Conover Farm—five acres, a brook, and an old colonial style farmhouse in Belmar—just the place for a newlywed couple starting over at this late date.

If Held had finally reconciled himself to the city in his watercolors of the late 1930s, through the five-acre Belmar farm he balanced the sense of East and West that had been a predominant tension throughout his life. We sense none of the role playing exhibited before. Gone are the pipes he smoked at Harvard, the tweed knickers and cocked hat of Westport, the cowboy clothes of his "western hero" days. But he was still a celebrity. Maggie recalls publicity hounds constantly demanding interviews at Belmar. But typical of Held's attitude is John O'Hara's assessment in *Collier's* (May 1948):

> The man I was introduced to at Townsend's exhibition was John Held, Jr. It was a long-delayed pleasure to meet this outstanding artist of an exciting period, now a handsome, rugged gentleman in tweeds and flannel shirt, and sixty-six years old. Naturally you would expect us to talk about the young men and women, the tempora et mores of 1920–29. And if we'd been highbrows that's what we would have talked about. But what we actually did talk about was Guernseys and Jerseys, alfalfa and milk, and the decline of the horse. . . . We talked about the problems of the small dairy, more like a couple of Aggies than two veterans of the speakeasy wars.

His checkered shirts, khaki pants, and cap bear none of the pretentiousness of his earlier costumes, perhaps because they are not costumes. John told Maggie: "Possessions possessed me during a major portion of my life. I never again want to be a slave of possessions.[37] So the couple bought chickens, Muscovy ducks, goats from Mrs. Carl Sandburg to begin their subsistence farming.

Since food was at a premium during the war, the Helds had an excuse to raise their own. They started with a battery of baby chicks, which Held set up on the dining-room table. The chicks outgrew the battery in no time, so Held built a run for them back of the kitchen range where it was warm. In a few weeks they outgrew this too, and were then given a whole room of their own, off the dining room. Held made a wire gate into the room, covered the floor with litter and pans of mash. There was more mash in the air than in the pens. As the chicks grew and tried out their own wings, they explored other parts of the house. When spring came they were finally put outside.

The Helds farmed organically, greatly valuing compost and manure. Maggie remembered their Saturday mornings were spent picking up droppings from barns, chicken coops, or just along the roadside where a riding horse had re-

lieved himself. Held called it "collecting honey." The vegetable garden was a paradise with beefsteak tomatoes so large that none of the retail stores would buy them. The potatoes did particularly well, due to the manure store, and the Helds had to store them in the front parlor. All winter they gave them as door prizes or sneaked them into cars when the owners weren't looking. But when spring came, the potatoes still occupied the parlor. Held put up the house screens and the potatoes sprouted, the vines growing to the screens. By fall the compost pile was expanded and the house cleaned. Held painted and hung out a sign that read "Old Schuyler Farm," joking with an interviewer that he couldn't call it "Old Held Farm." In the same interview he modestly referred to himself as "a dirt farmer" and "just a retired farmer." When asked repeatedly about his flappers, he replied: "I don't think I could draw one even if I wanted to, and I don't."[38] This was not suburbia; this was not the city, nor even the movie-set West. The farm was a peaceful compromise for the man who loved the West of his childhood, yet thrived in the East. Held was finally at home with himself.

The results of the couple's contentment for the next sixteen years did not lead to stagnation, however. Aside from sketching plans for the situating of new pecan trees and such practical chores, Held developed a long abiding interest in the decorative and folk arts. He made miniature dollhouse furniture, fashioned pottery out of native clays, crafted jewelry, and, of course, continued to sculpt. He also did an occasional block print ad for Cavanagh's in New York. With a curious timing that so typifies his versatility, both *Playboy* and *Woman's Day* bought work from him in the mid-1950s. Some of Held's more ribald linocuts (which earlier appeared in the *New Yorker* or privately) introduced the first issues of *Playboy*. Mabel Hill Souvaine, editor at *Woman's Day*, cheerfully purchased Held's illustrated children's stories. "The Tail of Mr. Dooley" is a classic that suggests Held missed the one genre he could have been quite successful in had he had the time for children's stories. His articles for the old *Rural New Yorker* are examples of his fine essay writing as well.

If the farm suggested new avenues of creative expression, none of them conditioned by the pressure of making money, the rural life made Held reflective as well. Held had always resisted the request to write an autobiography. And though he made an aborted attempt, he in effect resisted again. In 1944 he sent some copy to Mabel Hill Souvaine to be passed on to another editor. Mrs. Souvaine replied that the pieces were charming but thin, and pleaded with Held to write a full-scale autobiography attending to his Mormon past, the colorful periods of history his life intersected, and the dramatic contrasts that comprised his life.

But if the autobiography never materialized, Held contributed two other books that provide rich interpretative material. In the late 1940s he did a complete mock-up of an illustrated children's book, *Our Enchanted Farm*. The brilliance of the art work and Held's own cryptic and warm captions again suggest a genre Held excelled in. The book is a story of the Held menagerie. Goats, geese,

A Solemn Ceremony of Utmost Importance
COLORING the MEERSCHAUM PIPE
Engraved by JOHN HELD JR who is ever ready for a fight or a frolic
ON HEARTLESS MEMORY

Elegant dining is still a ceremony of utmost importance at
CAVANAGH'S 72 YEARS at
260 WEST 23RD ST.
in NEW YORK

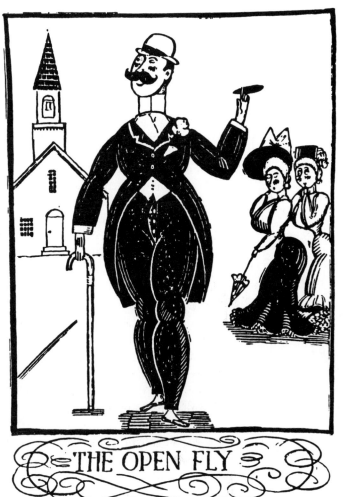

THE OPEN FLY

(*Above*) Cavanagh's Restaurant Ad (undated). Permission of Illustration House, Inc.

(*Right*) The Open Fly. *Playboy* magazine, June 1954. Permission of Illustration House, Inc.

rabbits, turkeys, guineas, and other animals nest and produce their young on the Old Schuyler Farm. The book unfortunately never was published; but it reveals the continuing affection and deep understanding Held had for animals and their importance in his life.

Conversely, the other book was published and sold well. *Held's Angels* (1952), written by Frank Gilbreth and illustrated by Held, describes the misgivings of a middle-aged couple as their son Richard departs to a "good old Midwestern U." College as a rite of passage, and the vicissitudes of youth, suggest the larger Heldian theme. There is an undeniable continuity of the generations,

even if expressed only in life stages which comically intersect adult and young life. Held had lived long enough for the reintroduction of flapper fashions in the mid-1950s. As he was sought out again by interviewers, he remained forever in the public eye as an astute interpreter of youth. He commented in the *Chicago Sunday Tribune* (December 7, 1952):

> My memory of that period is blurred. . . . Some of it is hard to believe, if it were not for the records that I caused to be printed in those years.
>
> One thing is for sure: the youngsters were not juvenile delinquents. Their day was a holdover from past Victorian ideas. They were battling to express themselves, and throw off the fetters of bigotry and arrive at frankness.
>
> The teenagers that I lampooned were at several disadvantages. They had prohibition to contend with, likewise several depressions coupled with the idea that civilization was set on holding them down. It appears today that they won their battle and helped make a better world for their future children. I say this ideologically, not politically.
>
> All this changed the world for me. When I reached the point when I could not bring myself to draw another flapper, I sat back and watched it all change.
>
> So if the rebellion of youth in those dear, dim, horrible days changed things for future youth, they also changed the world for me, if that's important.

The flappers brought Held fame and wealth, but they also enabled him to gain a corresponding wisdom. In the 1920s Irving Babbit identified the vacuousness of youth who had not acquired this wisdom. He noted that any liberation of the spirit without a corresponding mastery of self was pernicious. Though once a wealthy patrician of the largest farm in Weston, Connecticut, Held found contentment on six acres in Belmar. The liberation of his spirit resulted in the shedding of many skins and, ironically, a return to the simple life much like his humble home in Salt Lake City—with plenty of music and books, but not much money. Maggie observed: "I think he learned a lot in his lifetime, what the really important things in life are. Not pretention, false show, unnecessary extravagance, keeping up with the Joneses. . . . John did learn and he learned the hard way, by going into everything first hand, learning about everything that mattered to him. Returning to the simple life he was brought up in, the simple life he believed to be the most worthwhile thing in life resulted in a peaceful life which he could enjoy . . . being satisfied in having tried out all the things he hungered for."[39]

Country Life had published a comic piece entitled "How to Lose Money on a Farm" (December 1929), which was prophetic of the Helds' contentment at Belmar. John wrote: "My first try at farming was on a small scale. I started with about twenty-six acres in the Rocky Mountains of Connecticut. You may wonder how I happened to find the Rockies in the Nutmeg State, but they're there, and I farmed them. My land was described by a neighbor as 'two stone to one

dirt,' and he was, oh, so right." Held continues to detail the attempts to make money which result in debits due to the farmer's ineptitude, or the stock's: "I started in smack from the first to lose money. I did it with chickens. Just a few, and I didn't have much money to lose in those days. The hens were consistent money losers. Those that laid died, and those that didn't die didn't lay. This was a good beginning. I found that I could lose on day-old chickens. They were always a complete loss."

He relates an escapade with the potatoes, noting that he was surprised that they could promise a profit since the crop was all underground. At the end, however, the sixteen bushels of fine, large, certified potatoes that were planted, hoed, and weeded, yielded sixteen bushels of much smaller potatoes. Held concludes: "So all was happiness again. But again profit reared its ugly head. The herd of Shetland pony mares began to have colts, and people wanted to buy them at high prices. This was too much for me, so I moved into New York, where I could pay an exorbitant price for a penthouse. Now I'm happy again. This all goes to show that, no matter how you plan, something will happen so that you can't lose."

Held's life was a cycle of necessary loses, which in the end, garnered a profit. He overcame the loss of a fortune in the stock market crash, his cartooning career, the breakup of three marriages, separation from his children, and the roles of cowboy, critic of college youth, and "official" artist-in-residence; he even gave up overnight the Malichrinos he had smoked most of his life when he discovered he had throat cancer. After surgery and radium treatments, he died on March 2, 1958. Perhaps, as critic George Santayana described the revitalization of American art in the 1920s, Held was a creator of "Penitent Art": art that is revolutionized through caricature and color, generated by direct experience.

2

The Rise of the New Woman and the Search for Style

Writing in 1931 of "My Lost City," F. Scott Fitzgerald remarked that "the flapper, upon whose activities the popularity of my first books was based, had become passé by 1923—anyhow in the East."[1] Though Fitzgerald's observation was part of a focus on larger chronological events, he identified the flapper among the symbols destroyed, or at least made obsolete, by the everchanging city—a condition he called "the betrayal of a persistent idealism."[2] At first Fitzgerald's comment on the flapper seems paradoxical. Not only was this image of woman predominant throughout the 1920s as evidenced in magazines, movies, and advertising, but the flapper signified the fusion of many elements in urban life, an image not merely topical but ideal—the New Woman.[3] Numerous critics of the period note her pervasive influence. Corey Ford, for example, described her 1920s role:

> Fitzgerald christened it the Jazz Age, but John Held, Jr., set its style and manners. His angular and scantily clad flapper was accepted by elders as the prototype of modern youth, the symbol of our moral revolution. . . . Perhaps no comic artist ever had a more immediate impact on a generation. Bearing out Oscar Wilde's contention that nature imitates art, we took his exaggerated cartoon types to heart and patterned ourselves on them. Each new Held drawing was pored over like a Paris fashion plate, girls cropped their hair and rouged their cheeks and shortened their skirts to be in style, galoshes and raccoon coats were indispensable to every male undergraduate wardrobe. So sedulously did we ape his caricatures that they lost their satiric point and came to be a documentary record of our times.[4]

Perhaps what Fitzgerald meant, then, was not that the flapper disappeared after 1923, but that her overwhelming popularity eclipsed not simply her uniqueness but her original symbolic meaning. The effect of this symbol of moral revolution was lost because of the greater passion to be in style. Therefore, like Fitzgerald, Held's purpose was co-opted by the conspicuous consump-

tion and legitimization of his comic art. His symbolic meaning was further destroyed as the concrete referent itself changed. As late as 1929 a subscriber to *College Life* lamented: "As long as John Held, Jr., goes ahead drawing pictures of us, we will keep trying to live up to what we are supposed to be. . . . If tomorrow a sudden reaction were to set in, and the ukase went forth, 'Be yourselves,' there wouldn't be a spark for flaming youth left for miles around."[5] Held's treatment of the flapper—how her development inspired him as a comic observor of social change and an artist—is a key to understanding the less popular and more subtle truths about the Jazz Age. The flapper's popularity and demise as revealed in Held's cartoons also suggest the influences of fashion and art upon each other.

As exemplified in a recent best-selling novel, *A Green Desire* (1981), Held belonged to a generation of emigrants who came to New York City in the 1920s, who were vital, generous, impulsive—a group for whom life, according to novelist Anton Myrer, "was an adventure, a challenge, a very green, fresh thing." For these men and women who came of age just before World War I, it was a wonderful time filled with a sense of infinite possibilities. During this apprenticeship Held acquired all the skills necessary to seize these possibilities. Training as an engraver, advertising artist, cartoonist, and painter assured his success in a city hungry for innovative talent. Even his training as a sculptor and his proficiency at the craft of woodblock printing facilitated the artistic sensibility valuable in the commercial world. His experience as a sports illustrator, too, sharpened his eye for the human form and quickened his pen.

Because of these circumstances Held's artistic style developed in a direction he may have anticipated but did not prefer. Hoping to succeed as a serious artist, primarily as a sculptor, he initially took jobs with department stores and advertising companies in order to buy future time for his serious work. But these jobs led him covertly in another direction. Designing posters for Collier's Street Railway Advertising Company and display cards for Wanamaker's, Held found opportunities and pay plentiful for the illustrator and cartoonist. Because of significant growth in the publishing industry, like other commercial artists Held discovered he could enjoy considerable salary and reputation. He could command a position as important as that of any serious artist and certainly more lucrative.

Of course, by the end of the nineteenth century and during the early decades of the twentieth, periodicals and books provided a major source of public entertainment. The writers and illustrators contributing to these pages assumed unprecedented importance. More than mere picture makers, they played a crucial role in determining the cultural appetites of the day. As Susan Meyer has noted in her study of American illustrators, no American of that period could possibly remain unaffected by the millions of pictures circulated each week.[6]

Preferring to freelance, Held understood the popular and trend-setting appeals of such New York City illustrators in the early 1910s, even as he appre-

ciated the artistic experimentation that distinguished serious art in the city. Though he did not illustrate books until the late 1920s, as an advertising illustrator he practiced valuable design and draftsman techniques that would characterize his later art.

A related market that soon attracted Held was the humor magazine market. To an extent Held was already familiar with this outlet. He had sold a cartoon to *Life* (his first sale) in 1908 and was a fan of T. S. Sullivant, who regularly drew for *Judge*. Early cartoons (1908–12) suggest that he knew the style of George McManus as well. Just as the expectations of advertising managers governed Held's success and therefore his early style, so did the predominant hallmarks of the humor magazine market. By the 1920s magazine humor ranged from ingenious slapstick and mordant satire to juvenile "rah-rah" and impassioned social protest, utilizing both crude amateur efforts and slick professionalism. Though their audiences were not homogeneous in their attitudes, the magazines shared several characteristics and on the whole were concerned not only with the problem of survival in a highly competitive business but with many contradictions and ambivalences about the direction in which society was moving. A brief review of these characteristics explains why Held's early style was both experimental and conformist—an attempt to distinguish himself while pleasing editors and readers.

Since all the humor magazines were oriented toward topical interests and appetites (and we are considering the general characteristics which magazines such as *Puck, Judge,* and *Life* possessed), each sought to keep in close contact with the events of the day and whatever meaning these events afforded. The problem of keeping up lay paradoxically with the alertness of the humorists, who were always watchful for innovations by their competitors and who did not hesitate to imitate practices that seemed successful. The result was a reciprocal influence of magazine on magazine that had as much to do with keeping abreast of other competitors as it did with events and attitudes of society at large. Along with this constant borrowing of ideas and techniques, magazines regularly shuffled or shared staff members.

At the same time each magazine insisted editorially that it had its own point of view distinctly different from its competitors. Inevitably this led to some chameleon-like behavior on the part of writers and cartoonists who moved freely among the magazines. Some of them assumed and discarded different styles and attitudes with unabashed ease. Like the magazines themselves, they often yielded to commercial pressures.

The problem of survival, with its artistic and commercial tensions, was not the only point on which the magazines found common ground. Despite radically different orientations, a basic conservatism about the rapidity and nature of social change ran through most of the magazine humor of the period. *Judge,* for example, afforded new social and intellectual developments sensational coverage but generally tended to ridicule them.

In part, this overall conservatism, this skepticism about newness, was undoubtedly attributable to a belief that the public mind moves slowly in the areas of established practices and institutions. The humorist seemed to assume that the public could enjoy current fads, even become obsessed by them, yet still remain aware of their ephemeral nature. And, of course, some unorthodox activities were mocked as products of absurd mentalities. *Life* might devote an entire issue to nudism, while the *New Yorker* might dismiss the subject with a single satirical cartoon. But the magazines would agree that planned, mixed nudity was to be laughed off. It violated normal behavior patterns.

However, normal (equated with familiar) ideas were being contradicted or challenged in many other areas of American life during the period. One of the most popular considerations was women and sex, the topic that attracted the most attention from humorists, second only to liquor and crime. Page after page of almost every issue of the magazines contained references to, discussion of, and jokes about, sex. For the humorists greater freedom to discuss and depict sex, attributable in part to the diffusion of Freudian psychology, was both exciting and important. "The Puritan conscience was all that was ever wrong with America," wrote a *Life* reviewer. "It divided human activities neatly into good deeds and bad deeds."[7]

But in magazines the wall clearly was breached. The collapse of puritanical ideals opened a vacuum in the interior lives of millions—the secret world of the daydream and the forbidden wish. The humor magazines responded in the 1920s with a flood of sexual fantasy: voyeuristic plumbers surprising ladies in bathtubs, exhibitionistic maidens stripping at every opportunity, college girls and sophisticated matrons tantalizing their beaux with brief costumes and candid speech. The conventions shared by all the magazines conveniently depicted this theme; puns abounded along with the well-worn "he-she" and "frosh-prof" jokes that had appeared as standard fare for years in college magazines and general jokebooks.

Judge, Life, and *College Humor* exploited every opportunity for a glimpse of sex. Among the busiest cartoonists for these three magazines were Russell Patterson and Jefferson Macamer. Their full-page and double-page drawings of girls often had no point whatsoever other than lighthearted display of femininity. The *New Yorker*, appearing halfway through the decade, offered a more polished version of the same theme. Instead of outrageous puns in captions accompanying half-clad girls, New Yorker humorists often substituted a double take, such as a cartoon in which a socialite, wearing the most diaphanous of gowns, sits calmly while her husband snaps at a passing man: "Are you staring at my wife's ankles?"

In much of the sex humor, as in the example of this cartoon, humorists tended to impose a thin veneer over the mass exposure. As in the case of the "spicy satires," magazines which flourished during the 1920s, stories in humor magazines generally led to piously moral conclusions—after a procession of lu-

rid details and provocative illustrations. Sandwiched between a stream of jokes about various states of undress ("Powder my back." "How far down?" "To where my dress begins." "I thought you said your back."), *College Humor* printed sober articles about the virtue of Virtue. *Life* and *Judge* cartoonists ostensibly frowned at immorality when they mocked beach pajamas, scanty bathing suits, and transparent lingerie on washlines, but the cartoonists obviously relished supplying the details; almost always in the corner of the cartoon stood the open-mouthed or grinning male observer. It was clearly a symbolic transference of the reader from his living room right into the pages of the magazine. The magazines gave him the opportunity to deprecate "immorality" by peeking slyly at its manifestations.

Equally ambiguous were the humorists' attitudes about the New Woman herself. As epitomized by Dorothy Parker's sharp-tongued verse, she was far more daring, older in dress, and franker in manner than her magazine predecessor, the Gibson Girl of the 1890s. Socially, she seemed the antithesis of that Edwardian ideal of femininity. And yet the humorists, while they cheerfully kidded both her behavior and her contours, essentially treated the New Woman as the Old Eternal Female: incurably talkative, temperamental, and beyond rational comprehension. Her expanded role in society had not altered her "inherent" nature: "Women can do just about everything that men can do," ran a typical joke, "except listen." Hence, while the new sexual freedom was exploited and enjoyed by the humorists, women, whether described as collegiate "prom trotters" or as "hard-boiled eggs," bore the thrust of the satirical front.

The same pattern prevailed in the humorists' treatment of domestic relationships, where the increased social mobility of women seemed to breed, as it did in other arts of that period, a counterreaction against domination by women. In family squabbles the cartoon wife sounded the loudest, and last, word; in most husband and wife cartoons the caption contained her comment. She proudly represented the forces of illogicality, and proclaimed her incompetence in all normal matters, from driving a car to balancing a checkbook. In one cartoon out of a hundred that might illustrate the point, a burglar enters a house and the wife scares him away by loudly belting her husband with an alarm clock. In a period of rising divorces the humorist placed the primary responsibility for divorce on the wife. She was, in the slang of the period, the old "ball and chain." Moreover, the presumed attitude of the Typical Husband toward the Typical Wife was pictorially symbolized: in *College Humor* cartoons featuring flying rolling pins or *New Yorker* cartoons emphasizing sharp repartee, the woman was consistently drawn larger than the man. Pictorially, she dominated him.

To satisfy these markets, then, Held initially conformed to the themes of formulaic humor (as exhibited by the "he-she" jokes) of the humor magazines. Yet early in his career as a cartoonist, he saw the cartoon as an art form and experimented with and refined it as he would any piece. Beginning with his first cartoons sold to *Vanity Fair* in the early teens, he distinguished himself visually

WORSE THAN DOUBLING IN BRASS

Leader—Otto, you must blay dose liddle notes pecause der piccolo is sick.

Worse Than Doubling in Brass. *Judge*, November 1912. Permission of JB&R, Inc.

by experimenting with a number of styles, all signed differently and appearing in different magazines. The earliest of these *Vanity Fair*-style cartoons, signed "Jack Held," dates from 1906; it is an unpublished cartoon of a cowboy. With the exception of "Lords and Ladies of Fashion" (*Judge*, September 1912), done in a style more in keeping with the early *Vanity Fair* cartoons, Held's earliest signature appeared on boldly drawn and highly detailed western scenes. During the same period he also signed cartoons "Johann Hult," applied always in block style and to cartoons similar to George McManus' "Bringing Up Father." Examples of this style are the 1912 "Music Lover," "An Ingenious Excuse," and "Worse Than Doubling in Brass" (*Judge* Magazine). Like the "Jack Held" cartoons, these are carefully detailed; for example, the fingers and facial expressions are heightened. The most pervasive signature—the one which identified the largest number of cartoons between 1908 and 1916—is a script "Held," most often identifying the *Vanity Fair* cartoons of that period. Six cartoons verify the long life of this style: "Her Solution" (1912); "The Only Way" (1912); "At the Coiffeur's" (1914); "Yearning for Company" (1914); "Feminine Logic" (1916);

THE MODERN MARTYR

BENEFIT FOR SUFFERERS IN EUROPE
Who suffers the more, the sufferers or the audience?

(*Top*) The Modern Martyr, ca. 1908. Permission of Illustration House, Inc.
(*Bottom*) Benefit for Sufferers in Europe. *Judge*, December 14, 1914.

PROHIBITION AS SHE IS

***Puck* Suggests These Sobriety Tests for Georgia Law Makers**

Hereafter if any member of the General Assembly of Georgia becomes intoxicated he will not be allowed to enter the legislative halls. A standing rule was adopted to-day which provides that no member shall be admitted in an intoxicated condition, and the doorkeepers are charged with rigid enforcement of the rule. As Statewide prohibition is the law of Georgia, some members wanted to know how a legislator could get drunk.—*Extract from a telegram from Atlanta.*

Prohibition As She Is. *Puck*, July 31, 1915.

and "Do You Like Motoring Sports?" (1916). Displaying a fluid, urban style, these cartoons resemble most closely Held's contemporary at *Vanity Fair*, "Fish." Distinctly different are the cartoons signed in the block "j held," a group running from 1914 to 1916 in a scratchboard style. Rather primitive looking, these cartoons resemble the earlier woodblock style Held practiced in Salt Lake City (and continued on a private basis, finally publishing a long series in the *New Yorker*). The last of these various signatures is the script "j held," ranging from a rather rigid and predictable pen and ink wash to a sketchy, outline effect, to a bold, high-contrast black and white resembling the style of broadside ballads.

Evidence of the influence of advertising art and humor magazine conventions occurs in Held's earliest cartoons from 1912–16. For example, in the *Judge*

He—Do you like motoring sports? She—Yes, all that I've met.

Do You Like Motoring Sports? *Judge*, January 15, 1916. Permission of JB&R, Inc.

cartoon, "Do You Like Motoring Sports?" (January 15, 1916), Held dramatizes
the standard humorous jibe at women ("Do you like motoring sports?" "Yes, all
that I've met") in a visual comparison of the car and the horses—two status
symbols for "motoring sports" of the rich. Using bold black and white lines re-
inforced in their meaning by equally obvious circles and checks (broken lines),
Held not only parallels the car and horse but uses the clothes of equestrians and
the car's occupants to reinforce this design scheme. There is an immediate as-
sociation between the pretentiousness of the zebra-striped car, the thoroughly
spotted horse (more of a Dalmation than a bona fide thoroughbred), and the
check-clad members of the upper class in the frame. Held's visual statement is
clear because of his use of line and tone for psychological meaning. He chooses

to depict the standard joke about upper class women through design principles. Even the layout, now a common advertising principle, is triangular, leading the viewer's eye from one group to another until he focuses on the speakers in the lower right hand corner. Held knew this is where the advertising signature usually occurs in the ad; he thus capitalized on our natural habit of reading from left to right and down the page. The further use of line in the background (the path, presumably Central Park, is a strong horizontal line behind the characters) is accentuated by Held's understanding of tone: the entire cartoon is a study in high-contrast black and white. The result is that Held fills in the rather accurate realistic shapes of his characters' figures (and of their clothes) with strong design motifs, which, though abstract, carry the visual message and bolster the predictable stock caption.

These various signatures and styles indicate Held's original interest in experimenting with the cartoon form as he established his own artistic persona. As he settled on the script "Held," he communicated through design motifs the expressionistic elements of the New Woman. His illustrative abilities soon dominated the verbal message of the cartoon. Because, in part, Held saw the artwork of his cartoons as the seat of his stylistic innovations, the drawings were not only more creative than their stock captions but began to contradict the humor magazines' conventional depiction of women. Held early recognized urban woman as a dramatic and changing force in society. He looked not to the cartoon models of women and their characteristic behavior, but to the teeming and various life of upper middle class society women in New York City for his inspiration. His earliest flappers are composites of this direct observation. Because for Held these women's expressiveness—their revolution in fashion, figure, and behavior—inspired constant interpretation of form, design, line, texture, and color, the New Woman was not only a source of creativity but the pictorial key to the tremendous changes of the urban world he lived in. The depiction of her revolution in the areas of sex, family, work, and fashion Held's cartoons show as intimately related to a culture's perception of itself.

Held's first stage of stylistic development as inspired by the New Woman occurred from 1912 to 1916, and, because it was based on first-hand observation, confirms what revisionist historians now believe was the rise of the New Woman from the period of 1910 to 1918, a much earlier time than originally thought.[8] To appreciate the consequent documentary aspect of Held's first cartoons and the effects of such verisimilitude on his artistic development, we must closely examine the revolution in manners and morals that Held witnessed. One of the consequences of working and living in the cities, especially as conditions affected women, was that Americans of the period 1900–20 had experienced a vast dissolution of moral authority which formerly had centered in the family and the small community. The traditional straight and narrow could not serve the choices and opportunities of city life. The norms of family, church, and small community, usually reinforcing each other, could only be internalized, so

that the city made for a type of individualization through its distant, casual, specialized, and transient clusters of secondary associations. Thus, the city became a place where the individual came to determine his own behavioral norms.

As a result, the "home is in peril" theme became a fact of sociological literature as early as 1904.[9] One of the most serious signs of the peril was the increasing inability of parents to influence their children in the delicate areas of propriety and morals. The car, already ubiquitous enough to affect dating and premarital patterns, the phone coming to be used for purposes of romantic accommodation, and the variety of partners at the office or the factory, all together assured unparalleled privacy and permissiveness between sexes.[10]

Individualization of members served to disrupt confidence between generations of the family, if not to threaten parents with the role of anachronistic irrelevance. Dorothy Dix observed in 1913 that there had been "so many changes in the conditions of life and point of view in the last twenty years that the parent of today is absolutely unfitted to decide the problems of life for the young man and woman of today. This is particularly the case with women because the whole economic and social position of women has been revolutionized since mother was a girl."[11] Magazine articles lamented the "Passing of the Home Daughter," who now preferred the blessed anonymity of the city to "dying of asphyxiation at home!"[12] The same phenomenon helps to explain the popularity in this period of standardized advisers such as Dorothy Dix, Beatrice Fairfax, and Emily Post, each of whom was besieged with queries on the respective rights of mothers and daughters.

Women's individualization resulted mainly because, whether single or married, gainfully employed or not, she spent more time outside the home. Evidence demonstrates that the so-called job and kitchen revolutions were already in advanced stages by 1910. The great leap forward in women's participation in economic life came between 1900 and 1910; the percentage of women who were employed changed only slightly from 1910 to 1930. A comparison of the percentages of gainfully employed women aged sixteen to forty-four between 1890 and 1930 shows that they comprised 21.7 percent of Americans employed in 1890, 23.5 percent in 1900, 28.1 percent in 1910, 28.3 percent in 1920, and 29.7 percent in 1930. While the growth in occupational activity for women appears to have stagnated from 1910 to 1920, actually a considerable restructuring occurred, with women leaving roles as domestics and assuming positions affording more personal independence as clerks and stenographers.[13]

Married women, especially those in the upper and middle classes, enjoyed commensurate opportunities. Experts in household management advised women to rid themselves of the maid and turn to appliances as the maid of all service. Statistics on money expended on those industries which reduced home labor for the wife suggest that women in middle-class families gained considerable leisure after 1914. This idea is also corroborated from other sources,[14] especially from the tone and content of advertising in popular magazines when they

are compared with advertising at the turn of the century. Generally speaking, women depicted in advertising in or about 1900 are heavier, have gentle, motherly expressions, soft billowy hair, and delicate hands. They are either sitting down or standing motionless; their facial expressions are immobile as are their corseted figures.[15] After 1910 they are depicted as more active figures with more of their activity taking place outside their homes. One woman tells another over the phone: "Yes, drive over right away—I'll be ready. My housework! Oh, that's all done. How do I do it? I just let electricity do my work nowadays."[16] Van Camp's pork and beans promised to save her "100 hours yearly," and Campbell's soups encouraged, "Get some fun out of life," since it was unnecessary to let the "three-meals-a-day problem tie you down to constant drudgery."[17] Wizard polish, minute tapioca, and minute gelatine also offered the same promise. The advertising image of women became more natural, even nonchalant. A lady entertaining a friend remarks: "I don't have to hurry nowadays. I have a Florence Automatic Oil Stove in my kitchen."[18] It became "so very easy" to wax the floors that well-dressed women could manage them.[19] And they enjoyed a round of social activities driving the family car.[20]

The ensuing decade was marked by the development of a revolution in manners and morals; its chief embodiment was the flapper who was urban based and came primarily from the middle and upper classes. Young, assertive, and independent, she experimented with intimate dancing, permissive favors, and casual courtships or affairs. She joined men as comrades, and the differences in behavior of the sexes were narrowed. She became in fact in some degree desexualized. She might ask herself, "Am I not a boy? Yes, I am—Not."[21] Her speech, her interest in thrills and excitement, her dress and hair, her more aggressive sexuality, even perhaps her elaborate beautification, which was a statement of intentions, all point to this. Women, whether single or married, became at once more attractive and freer in their morals and paradoxically less feminine. Indeed, the term sexual revolution as applied to the Progressive era means reversal in the traditional role of women just as it describes a pronounced familiarity of the sexes.

The unmarried woman after 1910 was living in the "Day of the Girl."[22] Dorothy Dix described "the type of girl that the modern young man falls for" in 1915 as a "husky young woman who can play golf all day and dance all night, and drive a motor car, and give first aid to the injured if anybody gets hurt, and who is in no more danger of swooning than he is."[23] Little wonder that she was celebrated in song as "A Dangerous Girl"; the lyrics of one of the popular songs for 1916 read, "You dare me, you scare me, and still I like you more each day. But you're the kind that will charm; and then do harm; you've got a dangerous way."[24] The most popular art print ever issued by *Puck* magazine depicts a made-up young lady puckering her lips and saying, "Take It from Me!"[25] The American girl of 1900 was not described in similar terms.

Girls dispensed with maidenly reserve. By 1910 Margaret Deland, the novelist, could announce a "Change in the Feminine Ideal":

> This person . . . with surprisingly bad manners, has gone to college, and when she graduates she is going to earn her own living . . . she won't go to church; she has views upon marriage and the birth-rate, and she utters them calmly, while her mother blushes with embarrassment; she occupies herself, passionately, with everything except the things that used to occupy the minds of girls.[26]

Meanwhile, as Dorothy Dix notes, it had become "literally true that the average father does not know, by name or sight, the young man who visits his daughter and who takes her out to places of entertainment."[27] Another writer asked: "Where Is Your Daughter This Afternoon?" "Are you sure that she is not being drawn into the whirling vortex of afternoon 'trots'?"[28] Polly, Cliff Sterrett's remarkable comic strip, modern girl from "Polly and Her Pals," washed dishes under the shower and dried them with an electric fan; and while her mother tried hard to domesticate her, Polly wondered, "Gee Whiz! I wish I knew what made my nose shine!"[29]

Since young women were working side by side with men and enjoying entertainment more freely and intimately with them, it was inevitable that they behave like men. Older people sometimes carped that growing familiarity meant that romance was dead or that "nowadays brides hardly blush, much less faint."[30] And Margaret Deland asked, "Has Sweet Sixteen Vanished?"[31] But some observers were encouraged to note that, as girls' ways approximated men's, the sexes were, at least, more comradely. The modern unmarried woman had become a "Diana, Hunting in the Open."[32] Dorothy Dix reported that "nice girls, good girls, girls in good positions in society—frankly take the initiative in furthering an acquaintance with any man who happens to strike their fancy." The new ideal in feminine figure, dress, and hair styles was all semi-masculine. The "1914 girl" with her "slim hips and boy-carriage" was a "slim boy-like creature."[33] The "new figure is Amazonian, rather than Miloan. It is boyish, rather than womanly. It is strong rather than soft."[34] Her dress styles, meanwhile, de-emphasized both hips and bust while they permitted the large waist. The boyish coiffure began in 1912 when young women began to tuck their hair under with a ribbon, and by 1913–14, Newport ladies, actresses like Pauline Frederick, then said to be the prettiest girl in America, and the willowy, popular dancer Irene Castle, were wearing short hair.[35] By 1915 the *Ladies' Home Journal* featured women with short hair on its covers, and even the pure type of woman who advertised Ivory soap appeared to be shorn.

Unmarried flappers were determined pleasure seekers whom novelist Owen Johnson described collectively as "determined to liberate their lives and claim

the same rights of judgment as their brothers."[36] The product of the "feminine revolution startling in the shock of its abruptness," she was living in the city independently of her family. Johnson notes: "She is sure of one life only and that one she passionately desires. She wants to live that life to its fullest. . . . She wants adventure. She wants excitement and mystery. She wants to see, to know, to experience. . . ." She expressed both a "passionate revolt against the commonplace" and a "scorn of conventions."[37] Johnson's heroine in *The Salamander*, Dore Baxter, embodied his views. Her carefree motto is reminiscent of Fitzgerald's flapper of the twenties: "'How do I know what I'll do tomorrow?'"[38] Her nightly prayer, was the modest "O Lord! give me everything I want!"[39] Love was her "supreme law of conduct," and she, like the literary flappers of the 1920s, feared "thirty as a sort of sepulcher, an end of all things!"[40] Johnson believed that all young women in all sections of the country had "a little touch of the Salamander," each alike being impelled by "an impetuous frenzy . . . to sample each new excitement," both the "safe and the dangerous."[41] Young men and women kissed though they did not intend to marry. And kissing was shading into spooning (" 'To Spoon' or 'Not to Spoon' Seems to be the Burning Question with Modern Young America")[42] and even "petting," which was modish among the collegiate set.[43] In fact, excerpts from the diary of a coed written before World War I suggest that experimentation was virtually complete within her peer group. She discussed her "adventures" with other college girls. "We were healthy animals and we were demanding our right to spring's awakening." As for men, she wrote, "I played square with men. I always told them I was not out to pin them down to marriage, but that this intimacy was pleasant and I wanted it as much as they did. We indulged in sex talk, birth control. . . . We thought too much about it."[44]

One of the most interesting developments in changing sexual behavior which characterized these years was the blurring of age lines between young and middle aged women in terms of figure, dress, and cosmetics. A fashion commentator warned matrons, "This is the day of the figure. . . . The face alone, no matter how pretty, counts for nothing unless the body is as straight and yielding as every young girl's."[45] With only slight variations, the optimum style for women's dress between 1908 and 1918 was a modified sheath, straight up and down and clinging.[46] How different from the styles of the high-busted, broad-hipped mother of 1904 for whom Ella Wheeler Wilcox, the journalist and poet, advised the use of veils because the "slightest approach to masculinity in woman's attire is always unlovely and disappointing."[47]

The sloughing off of numerous undergarments and loosening of others underscored women's quickening activity and increasing independence and change in morals. Clinging dresses and their accompanying lack of undergarments eliminated, according to the president of the New York Cotton Exchange, "at least twelve yards of finished goods for each adult female inhabitant."[48] Corset makers were forced to make adjustments too and use more supple materials. Nevertheless, their sales declined.[49]

Too, the American woman of 1910, in contrast with her sister of 1900, avidly cultivated beauty in face and form. In fact, the first American type whose photographs and advertising image we can clearly recognize as belonging to our times flourished between 1910 and 1920. "Nowadays," the speaker of a woman's club declared in 1916, "only the very poor or the extremely careless are old or ugly. You can go to a beauty shop and choose the kind of beauty you will have."[50] Beautification included use of powder, rouge, lipstick, eyelash, and eyebrow stain. Advertising was now manipulating such images for face powder as "Mother tried it and decided to keep it for herself,"[51] or "You can have beautiful Eyebrows and eyelashes. . . . Society women and actresses get them by using Lash-Brow-Inc."[52] Nearly every one of the numerous advertisements for cosmetics promised some variation of "How to Become Beautiful, Fascinating, Attractive."[53]

In her dress as well as her use of cosmetics, the American woman had abandoned passivity. An unprecedented public display of the female figure characterized the period.[54] "Limbs now became legs and more of them showed after 1910, although they were less revealing than the promising hosiery advertisements. Rolled down hose first appeared in 1917."[55] Dresses for opera and restaurant were deeply cut in front and back, and not even the rumor that Mrs. Jacob Astor had suffered a chest cold as a result of wearing deep décolletage deterred their wearers. As for gowns, "Fashion says—Evening gowns must be sleeveless . . . afternoon gowns are made with semi-transparent yokes and sleeveless."[56] Undoubtedly this vogue for transparent blouses and dresses caused the editor of the *Unpopular Review* to declare: "At no time and place under Christianity, except the most corrupt periods in France, certainly never before in America, has woman's form been so freely displayed in society and on the street."[57]

In addition to following the example of young women in dress and beautification, middle-aged women, especially those from the middle and upper classes, were espousing their permissive manners and morals.[58] Smoking and, to a lesser extent, drinking in public were becoming fashionable for married women of the upper class and were making headway at other class levels.[59] As early as 1910 a prominent clubwoman stated: "It has become a well-established habit for women to drink cocktails. It is thought the smart thing to do."[60] Gertrude Atherton described in the novel *Black Oxen* the phenomenon of the middle aged woman who sought to be attractive to younger men, supposedly typifying the 1920s.[61] It was evident in the play *Years of Discretion*. Written by Frederick Hatton and Fanny Locke Hatton, and staged by Belasco, the play was "welcomed cordially both in New York and Chicago" in 1912. It featured a widowed mother forty-eight years of age, who announces, "I intend to look under forty—lots under. I have never attracted men, but I know I can."[62] Again, "I mean to have a wonderful time. To have all sorts and kinds of experience. I intend to love and be loved, to lie and cheat."[63] Dorothy Dix was dismayed over "the interest of women . . . in what we are pleased to term the 'erotic.'" She

continued, "I'll bet there are not ten thousand women in the United States who couldn't get one hundred in an examination of the life and habits of Evelyn Nesbitt and Harry Thaw."[64] Married women among the fashionable set held great parties, at times scandalous ones, which made the 1920s seem staid by comparison.[65] They hired Negro orchestras at Newport and performed and sometimes invented daring dances. They conscientiously practiced birth control, as did women of other classes.[66] And they initiated divorce proceedings, secure in the knowledge that many of their best friends had done the same thing.

Perhaps the best insights on the mores and morals of this group are to be found in the writings of the contemporary realistic novelist Robert Herrick.[67] Herrick derived his heroines from "the higher income groups, the wealthy, upper middle, and professional classes among which he preferred to move."[68] His heroines resemble literary flappers of the 1920s in their repudiation of childbearing. "It takes a year out of a woman's life, of course, no matter how she is situated," they say, or, "Cows do that."[69] Since their lives were seldom more than a meaningless round of social experiences, relieved principally by romantic literature, many of them either contemplated or consented to infidelity. Thus, Margaret Role confesses to her friend Conny Woodyard, "'I'd like to lie out on the beach and forget children and servants and husbands, and stop wondering what life is. Yes, I'd like a vacation—in the Windward Islands, with somebody who understood.' 'To wit, a man!' added Conny. 'Yes, a man! But only for the trip.'"[70] They came finally to live for love in a manner that is startlingly prophetic of some of the famous literary women of the 1920s.[71]

Held's cartoons of this early period reflect the aforementioned characteristics of the revolution in morals and manners. In virtually none of the cartoons is there indication of home life. Women are depicted at elaborate dinner parties, in sporty cars, on street corners, in fashionable sitting rooms, at sporting events, or at work. Many of these women are married, but they appear to enjoy as much freedom from household responsibilities as the single girl, for they so often appear outside the home. When depicted inside, they host parties with servants, or obviously have domestic help that frees them even there from traditional responsibilities. Whether married or single, these women are obviously from the middle or upper class and enjoy considerable social forwardness.

Though clothed in a number of different dresses throughout this period, the figures of these women show marked change. In three cartoons from *Vanity Fair* in 1913, the women are "thicker," more matronly, and exhibit a demeanor appropriate to women who are swathed in yards of material. One cartoon, "The Only Way," depicts a group of suffragettes virtually trapped in their long, elaborately clothed bodies. With fist clenched, a husky woman says: "The only way to gain women's suffrage is by making our appeal through our charm, our grace, and our beauty," to which her equally buxom and big-hipped sisters assent. Longer, sleeker figures and short bobbed hair begin to appear in *Judge* in 1913. And along with these fashion changes a more aggressive, passionate, even

THE ONLY WAY.

Speaker—"The only way we can gain woman's suffrage is by making our appeal through our charm, our grace, and our beauty."

The Only Way. *Judge*, ca. 1912. Permission of JB&R, Inc.

wanton woman emerges. Melvin asks in "A Truthful Girl": "Dear, am I the only one you have sat with in this?" And Melvina answers: "Yes. This is a new hammock" (*Judge*, May 17, 1910). By 1918 these flappers are driving cars and offering servicemen rides.

But this behavior is not merely typical of the young. Middle aged women often cannot be distinguished from younger ones, as in the *Judge* cartoon (February 12, 1916) in which Cuthbert says: "My word, Helen! Look at the peach! Introduce me, will you?" Helen replies: "Silly, that's grandmother." In another cartoon that same year a little girl, wearing a mid-calf full skirt, says to her mother as she observes a woman in a full, but knee-length skirt go by: "Can't I have a dress like that?" The mother, who is wearing the same style as the admired woman, replies: "No, darling, you are too young to wear short skirts" (*Judge*, June 17, 1916). Likewise, fashion, cosmetics, and such constitute these women's most serious conversations. "With the French at war, what will we do for our new fashions," asks one fashionable young woman of another at the corner of Fifth Avenue. "We'll always be sure to be in style if we wear a little less,"

A TRUTHFUL GIRL

Melvin—Dear, am I the only one you have sat with in this hammock?
Melvina—Yes. This is a new hammock.

Little girl—Mother, dear, can't I have a dress like that? *Mother*—No, darling, you are too young
to wear short skirts.

(*Top*) A Truthful Girl. *Judge*, May 17, 1910. Permission of JB&R, Inc.

(*Bottom*) Little Girl—Mother, Dear, Can't I Have a Dress Like That? *Judge*, June 17, 1912. Permission of JB&R, Inc.

suggests the other (*Judge*, July 22, 1913). Or, in "At the Coiffeur's" Francois says to Edith: "Does Madam not think this color of hair becoming to her?" Her reply: "Very; and it goes beautifully with my new hat" (*Judge*, July 18, 1914). Along with these depictions, if fashion and cosmetics blur age lines and comprise conversation, they also contribute to one's success. In "Here Are Eight New Professions for the Ladies" (*Vanity Fair*, December 1916), the politically active woman is spoofed:

> Some of our most unmarried women are taking up prison reform as an indoor sport this season. It necessitates sitting busily on one's desk and telephoning to prison wardens how to run their jobs and arranging who will speak at the next meeting of the Junior Sing-Sing Sewing Circle. Oh, death by capital punishment, where is thy sting! [The single woman sits in man's hat, coat, and mid-calf skirt, atop her desk.]

Or, from the same issue:

> You can't train yourself to be the Hostess at a restaurant *thé dansant*—it's a gift. You must have a sweet and trusting look in your eyes, and you must never, under any circumstances, understand what a man means. We should strive to be kind to all these poor little *thé dansant* Hostesses—for some of them don't even know where their next Rolls-Royce is coming from. Every hotel needs one.

Because fashion was the New Woman's outward signifier of change in manner and morals, Held, after initially creating dress through strong design motifs, began to pay close attention to actual fashion appointments, centering his "realistic" depiction there. The flapper's dress Held saw as her uniform, which identified the role of its wearer. For example, the cartoons during World War I addressed war themes but, more strongly, manner and attitude through the uniform of fashion.

In "Girl out of Uniform" (*Life*, December 1918), Held suggests fashion is a matter of costume or uniform whether it's military or Macy's. The viewer wonders which is the woman out of uniform as they stand side by side, one in evening dress, the other in Army uniform. In another cartoon from *Judge*, October 12, 1918, the flapper says to the Navy man: "Oh, yes! We gave up the houseboat this summer. You know it isn't safe with all those German submarines about." In "The Hero's Return to Utah" a brigade of fashion-wise women escort a returning Navy sergeant down the street (*Judge*, December 21, 1918). Each woman wears a dress as precisely detailed as the man's bemedaled uniform. In "Men in Uniform Welcome If We Go Your Way," Held indicates that hero worship is a matter of external image: "Miss Smythe-Smythe thought she had turned up nothing short of a commander-in-chief, when she offered a lift to a carriage-caller for a Movie Palace" (*Judge*, September 1917). Thus, Held clev-

Behold the Vorticiste—the latest of the lady artists. She has renounced hair dressers, given up stays, and entered a smock for life. She inhabits Washington Square, and lives on Turkish cigarettes and the Freudian theory of dreams. Anyone can be one

If everything else fails, you can always become a Vers Librist. Any girl can be a Gertrude Stein. All the office equipment you need is a dictionary, a pair of shell-rimmed glasses, and an utter disregard for the feelings of your fellow creatures. Close your eyes and open your dictionary, write down a word — any word. Repeat the process until your page is full, and leave the rest to your loving readers

Do you yearn to express yourself, rhythmically? Then, put on your last year's nightgown and an air of aloofness, rush out on the front lawn, and demonstrate to your neighbors that you believe in doing your Christmas shocking early

Here are Eight New Professions For the Ladies

Own up, now; don't you yearn to become a tired business woman?

SKETCHES BY MYRTLE HELD

Why not deal in dogs? It's being done this season. Just try to find a small shop, done up in delicate pinks and blues. Then arrange the dogs of all nations in layers, and await results. If you lack confidence, just turn to the pages of dog advertising in this issue of Vanity Fair. Christmas must be coming, this year, in the dog days

Some of our most unmarried women are taking up Prison Reform as an indoor sport this season. It necessitates sitting busily on one's desk and telephoning to prison wardens how to run their jobs and arranging who will speak at the next meeting of the Junior Sing-Sing Sewing Circle. Oh, death by capital punishment, where is thy sting!

And then, if you have the right figure for it, you can become one of those dowagers of the cabarets, who sing tremblely things about "Sing, sweet bee—ird." Go in for tender things, just to take the diners' minds off their india rubber *filets mignons*. Always work "Darling, I am growing old" into the entrées somewhere, and don't let the cheese escape before you give it "The Rosary"

You can't train yourself to be the Hostess at a restaurant *thé dansant*—it's a gift. You must have a sweet and trusting look in your eyes, and you must never, under any circumstances, understand what a man means. We should strive to be kind to all these poor little *thé dansant* Hostesses— for some of them don't even know where their next Rolls-Royce is coming from. Every hotel needs one

If you think you can train down to the weight, perhaps you can be a vampire. Study the workings of Theda Bara, Nazimova, and other little rays of sunshine. Swathe yourself in one of those perilous bare-back gowns, and wear a single dagger in your hair. Remember that skulls are much worn, and that the whiter the face the better the vamp

Here are Eight New Professions. *Vanity Fair*, December 1916.

EASILY ANSWERED

Sadie—With the French at war, what will we do for our new fashions?

Minnie—We'll always be sure to be in style if we wear just a little less.

Easily Answered. *Judge*, July 22, 1913. Permission of JB&R, Inc.

erly noted the connection between the flapper's attention to dress and the military man's pride in his uniform. If the latter's heroism was instantly communicated by his suit, so the New Woman's characteristics—her supposed

independence, energy, and boldness—were displayed in freer, sometimes waistless dresses, the simple cloche hat, and her practical (and comfortable) shoes.

These uniforms show that modesty, chastity, morality, and traditional concepts of masculinity and femininity were perceived as indivisible, and, in some sense, interchangeable. Therefore, the degree to which the flapper differed from the Gibson Girl (as the earlier ideal type) was most visible in her complete break from almost every major style in the West since the Middle Ages began.[72] If the Gibson Girl was maternal and wifely, the flapper was boyish and single. The Gibson Girl was the embodiment of stability. The flapper's aesthetic ideal was motion, and her characteristics were intensity, energy, volatility. While the Gibson Girl seemed incapable of an immodest thought or deed, the flapper strikes us as brazen and at least capable of sin if not actually guilty of it. She refused to recognize the traditional moral mode of American civilization, while the Gibson Girl had been its guardian. Thus, the flapper wore her hair short in a "Ponjola" bob, a style initiated in this country by the dancer Irene Castle in the mid-1910s but still considered radical at the end of the war. For hundreds of years women's hair—whether worn up or down, natural or wigged, powdered or oiled—had been long. The flapper covered her head and forehead with a cloche-style hat, tweezed her eyebrows, and used a whole range of other cosmetic devices, including trying to make her mouth look small and puckered, "bee-stung" like Clara Bow's. Her dresses were tight, straight, short, and rather plain, with a very low waist, usually about the hips, low necks for evening wear, and short sleeves, or none at all. She wore nude-colored silk or rayon stockings which she often rolled below the knee, or omitted altogether in hot weather, and high-heeled cut-out slippers or pumps. Underneath her outer garments she wore as little as possible. The corset was replaced by a girdle or nothing at all, and a brassiere-like garment was worn to minimize the breasts.

The term "flapper" originated in England as a description of girls of the awkward age, the mid-teens. The awkwardness was meant literally, and a girl who "flapped" had not yet reached mature, dignified womanhood. Originally the flapper "was supposed to need a certain type of clothing—long, straight lines to cover her awkwardness—and the stores advertised these gowns as 'flapper dresses.'"[73]

By the end of the early period of his cartoons dealing with the New Woman (1912–17), Held drew his flapper as the fashionable, and therefore social, counterpoint to her sister the Gibson Girl. In the process he created the flapper uniform, a realistic and detailed external expression of social change. But if Held identified key topics and characters signifying women's liberation, he approbated them not wholly as a documentation. Realism appeared in the interest of communicating an overall attitude.

As in his other artwork Held's cartoons ultimately employ styles to achieve whatever effect he sought. But unlike the Henri group of social realists, who

Drawn by John Held
Our leading vamp has abandoned the leopard
skin for the Stars and Stripes.

Winning the War in the Movies. *Judge*, August 31, 1918. Permission of JB&R, Inc.

like Held emerged from a newspaperman's background, Held avoided the serious social commentary inherent in the realism of that movement. Rather, Held saw comedy in the changing forms of social dress, behavior, and values he witnessed. Shifting his realistic emphasis to fashion, he applied a more symbolic or figurative treatment to the figure and face to accentuate the attitudes he noted. Upon his return from Central America he depicted the flapper as a young woman, middle class, and oftentimes a coed.

This new emphasis on youth Held accomplished in a rounder face and figure and, for the period 1918–20, the one-eyed girl. He probably found inspiration for the one-eyed girl in his sketches of Mayan tableaux and figures. This new

face indicates new perspective. Like the Mayan characters, the vamp in "Winning the War in the Movies" (*Judge*, August 31, 1918) appears not salacious, not coy, but agreeably a combination of both because of this apparent cocked eye. In many of the cartoons Held manages the perspective of profile while suggesting motion and a two-dimensional figure, much in the same manner as Picasso used the overlapped flat planes in his abstract paintings. The *Vanity Fair* cartoons of 1918 illustrate this technique well, as Held's vamps often need but a few shadowy strokes of the pen to suggest their attitudes. Held's flappers of this period lost the earlier hautiness that emerged from their upper class status; in Held's creation of restlessness and motion through the planes of the lines and sometimes the color, they were vibrant in a guileless way. By 1922, then, Held had established his interpretation of the flapper as "modern"; and he emphasized that a revolution in surfaces—as in the case of changes in fashion—was key to her evolution. Moreover, his cartoons were visual demonstrations of the struggle between modernism and traditionalism that was being waged within the American middle class. As in the case of women's radical change in external display —costumes, figure, and behavior—the surfaces of the cartoons create a tension between the implied attitudes and the expressionistic, between the figurative and the real. Held thus manipulated the visual tension of cartoons to express ideas about the larger culture.

In this kind of dynamicism of perceived and recreated tension, Held excels as an artist. By the early 1920s his flapper was an aesthetic ideal as a symbol of cultural change. Finding in her modernity a stimulus for experimenting with spatial and color combinations, Held relied on aspects of constructivism, cubism, futurism, and art deco styles to communicate her essence. Dramatically changing shape from 1918 to 1925, Held's flapper changed from a measure of her newfound sophistication through strict design motifs in the early *Vanity Fair* years to a sleek, slim, identifiable coed in 1923. In 1922 his balloon-headed men and women still appeared, suggesting childlikeness and immaturity, as in "The Dance-Mad Younger Set." But by 1923 his flapper was distinguishable from the men by her longer face and pert nose, as in "An Old Man's Game" and "What Are Little Boys Made Of?" Held's women continued to gain maturity, until by 1925 the flapper had graduated from a little girl image to a plucky, sometimes sophisticated young woman. Her naiveté had been supplanted by a carefree confidence that came from a belief in her savoir faire, even if the humor of the cartoons indicated her misplaced confidence. Not only a college coed, she nevertheless exuded the confidence of youth as she symbolized what was free, spontaneous, and bold about a culture in flux. Color is a key to Held's development of the flapper's symbolism through spatial changes. In the color covers done for *Life* and *Judge* throughout this period, Held boldly juxtaposed often clashing colors, using an opaque, heavy palette to further dramatize the dynamic of spatial tension. These techniques Held most cleverly utilized to balance the figurative and realistic elements of the cartoon, managing to fix the flapper in a historical context yet extrapolate an overarching symbolic essence or attitude.

"EXPLAIN THIS BLACK BOTTOM DANCE."
"YOU DON'T LET YOUR RIGHT HIP KNOW WHAT YOUR LEFT HIP IS DOING."

Explain This Black Bottom Dance (undated). Permission of Illustration House, Inc.

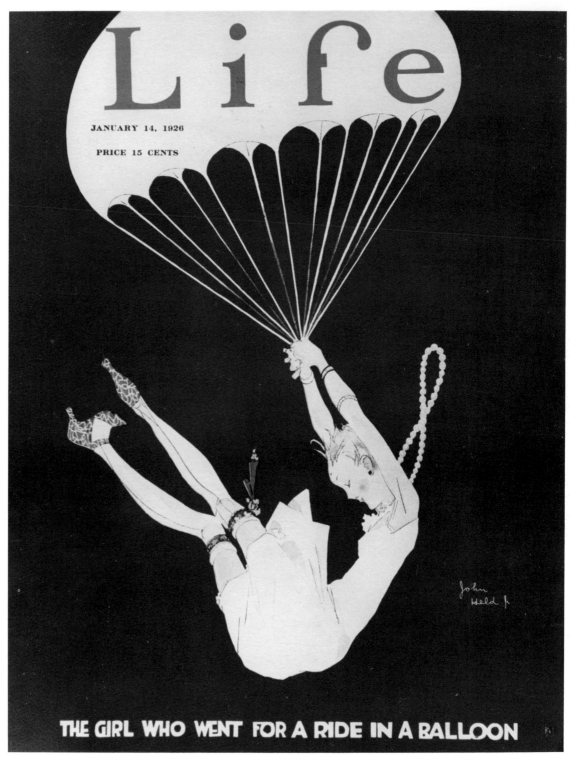

The Girl Who Went for a Ride in a Balloon. *Life*, January 14, 1926. Permission of Illustration House, Inc.

Some examples from the zenith of this achievement—1923–25—will illustrate. Held's ability to suggest accuracy and realism, yet exaggerate or understate part of his portraits, is evident in an old *Life* cartoon: "Ursula: 'Is my nose shiny, dearie?' Lambert: 'No, but your right knee is dusty.'" Typically, Held gives careful detail to the dress of the boy and girl. Lambert's tux is neatly penned, as are the shoes and hosiery of Ursula. Too, anatomically the boy and girl possess correctly articulated and defined hands and trunk. The attitude in which they are sitting is authentically rendered. Particularly, Ursula's elbow is convincingly drawn to the point that it appears a bit heavier than might be expected, no doubt because of its pressure on the sofa. Held plays on the contrast between male and female by figuratively accenting the feet. Always the feet of Joe College (as of Lambert) are ponderous, suggesting his masculinity and perhaps youthful awkwardness. Her flapper's feet are dainty by contrast, suggesting her femininity. The young people's faces are economically drawn—Lambert's a round, full face with a pug nose, and Ursula's a more elliptical face with fine features, the nose daintily upturned. As part of the cartoon's accouterments—and indeed, typically the flapper's and jelly bean's of the period—Lambert's liquor bottle is hinted at in an outline form, as is the smoke Ursula blows from her cigarette and its own trailing vapors.

Part of Held's success with caricature is due to his ability as an artist to distribute visual weight between what appears to be actually realistically drawn in the cartoon and what is suggested as an idea. In the Ursula-Lambert cartoon the visual message of ennui and fecklessness exists without our reading the cutline. Held's genius for using exaggeration and understatement and the ranges between the figurative and the real allow him to root the figures in the real world but extrapolate from them and their setting an overall attitude that assures the comic effect.

Another technique Held masters in these cartoons is selectivity. In the illustration from *Grim Youth*, "Mr. Harkness Talking," Held suggests through contrast of the details of telephone, Harkness's polka-dot tie, a lamp with a number of ties hanging on it, and the mere suggestion (through an economy of line) of facial expression, the table on which he leans, and the trailing smoke of his cigarette, his cavalier spirit. "Mr. Harkness talking" evidently is quite different from Mr. Harkness speaking. Again the comic effect is achieved through the tension between the actual and imaginary or attitudinal planes of the drawing. Held played on the visual assumptions made when images are merely suggested.

Held also applied the techniques of constructivism and futurism in his creation of tension between the concrete and fanciful planes of his pictures. For example, in "The Girl He Left Behind" jagged, colorful edging in the upper left and right corners frames the young couple. This suggests trees, though they flatten the surface of the picture and add a sense of mere fanciful coloring. In "I've got to go back now and see a man about a Buick" (*Grim Youth*), the boy is detailed carefully, particularly his coonskin coat, tie, and herringbone pants. In

Ursula: IS MY NOSE SHINY, DEARIE?
Lambert: NO, BUT YOUR RIGHT KNEE IS DUSTY.

"MR. HARKNESS TALKING"

(*Top*) Ursula: Is My Nose Shiney, Dearie? 1952. *Held's Angels.* Permission of Illustration House, Inc.

(*Bottom*) Mr. Harkness Talking. *Grim Youth*, 1929. Permission of Illustration House, Inc.

contrast, the girl is merely suggested by few figurative lines as she sits on the park bench. Her motion, however, is created through illusion of the dark hair and suggested feelings as she cries. Her whole figure seems to flow or melt with the imagined or suggested tears. Motion is often suggested by Held through interplanar lines, as in the instance of "I bet you wish you were out in the parkin' with a girl, maybe kissin' her." As the couple dance, the girl's movement is communicated through the riot of line that is her swaying skirt. Much in the spirit of Duchamp's Cubistic treatment in "Nude Descending a Staircase," this and other cartoons Held executed in a similar manner create the illusion of motion and passing time. Held cleverly rooted the boy in the scene as a black-clad figure with a bold white stripe down his pant leg. The static line contrasts nicely to the leg of the girl, her swirling hair, and the jagged lines of the dancing dress.

Susan Meyer in her study of American illustrators commends Held for his genius in melding both naturalistic and modernist elements.

> With the crazy disarray of lines zigging and zagging this way and that, Held was conscious of the play of shapes that were adjacent to each other, and he distributed patterns of black and white in unusual relationships. By squinting at the drawings, the viewer can obliterate the pen lines and focus only on the placement of black areas within the page. What becomes evident instantly is Held's ability to abstract shapes and to place them in a daring and unorthodox relation to one another.[74]

As such, his interest in line and color, for example, captures an essence beyond factuality. Roger Fry, commenting upon the characteristic features of modern painting, generalizes what may be applied to Held as well:

> Almost any turn of the kaleidoscope of nature may set up in the artist a detached and esthetic vision, and as he contemplates the particular field of vision, the [esthetically] chaotic and accidental comtemplation of forms and colours begins to crystallize into harmony; and, as this harmony becomes clear to the artist, his actual vision becomes distorted by the emphasis of the rhythm that is set up within him. Certain relations of the line become for him full of meaning; he apprehends them no longer curiously but passionately, and these lines begin to be so stressed and stand out so clearly from the rest that he sees them more distinctly than he did at first. Similarly, colours which in nature have almost always a certain vagueness and elusiveness, become so definite and clear to him, owing to their now so necessary relation to other colours, that, if he chooses to paint his vision, he can state it positively and definitely. In such a creative vision, the objects as such tend to disappear, to lose their separate unities and to take their place as so many bits in the whole mosaic of vision.[75]

Fry recognized the differences between aesthetic values that are intrinsic to things of ordinary experience and the aesthetic value with which the artist is

"I'VE GOT TO GO BACK NOW AND SEE A MAN ABOUT A BUICK"

"I BET YOU WISH YOU WERE OUT IN THE PARKIN' WITH A GIRL, MAYBE KISSIN' HER"

(*Left*) I've Got to Go Back Now and See a Man about a Buick. *Grim Youth*, 1929. Permission of Illustration House, Inc.

(*Right*) I Bet You Wish You Were Out in the Parkin' with a Girl. *Grim Youth*, 1929. Permission of Illustration House, Inc.

concerned. He suggested that the former is directly connected with subject matter. Held himself confirmed this dichotomy in his work when he mused in 1952 that "I had no idea that it would ever be called the 'Flapper Period.'" Part of the appeal of the New Woman, then, was as an inspiration for the experimentation with form, in a purely artistic sense. As Fry suggests, this interest allows not only for the promotion of new ways of seeing but for the private vision of the artist himself. Thus, Held's flapper cartoons also served as his experimental canvas, reflecting individual values while addressing the public social scene and its icons.

Despite the fact that Held's modernist treatment ranged through the commercial and comic arts, he shared with the American modernists of the early 1900s an attempt to capture the predominant unrest that characterized the period. His work is in the spirit of these painters who sought to revitalize pictorial art and with it "the lost soul among nations . . . America." These artists viewed New York as an aesthetic outpost of Paris, where "that new spirit of intellectual adventure might work a permanent transformation on the American provincial cultural scene." Many of these artists, therefore, related this dream and its energy to urban life as in the case of Weber and Stella, who created an urban imagery of hallucinatory character, utilizing the Cubist-Futurist vocabulary of shapes and movement. But as Milton Brown notes, in this early American modernism American painters could not quite separate their art from the world of sight:

> Robert Henri and his associates had captured something of the American Dream in their Realism as the final wave of modernists also approached the formal rigors of modernist style in a mood of almost naive optimism. They would not brook the limits imposed by Cubism, or inflict on themselves the conditions of working "logically within the limitations inherent in an idea." Dada never had a wide following, nor did it leave a lasting imprint on the art of this country as it did in Europe. And Futurism, which canonized the machine, and exalted modern life in a programmatic art, was given a more subjective and unsystematized account in Joseph Stella's painting and verbal utterances. The Americans did not yet take the radical step of entirely disassociating art from the world of sight. A gap persisted between abstraction and the painting that clung to the naturalist vision, and with few exceptions, the gap was not closed by the early American modernists.[76]

Held, too, created a happy mood in his flapper cartoons, closely akin to the urban optimism of his serious associates. However, the purpose of caricature allowed him to combine both naturalistic and modernist elements to artistically reinforce comedy through their disparate qualities.

By 1927, however, Held's cartoons had lost their experimental quality and became formulaic and predictable. The imitative and therefore realistic quality that had come from the referent—the modern woman—lost its appeal as this symbol of cultural change was ubiquitously used by her commercial avatars to sell cars, clothes, and soap. Despite the cyclical nature of fashion, the joke had been told once too often, and hence the modernist aspects of the flapper were seen staid by such cultivated sophistication.

An example of how complete this artistic exhaustion was is the period from 1927 to 1929, during which Held drew very predictable Sunday supplements of his Margy flapper at the same time being used by advertisers. Ironically, the very cartoon style that rose from Held's fine advertising design sense now fitted

Oh! Margy! ca. 1925. Courtesy of Bill Blackbeard, The San Francisco Academy of Comic Art.

comfortably back in that context. The flapper was used to sell everything from Timken bearings to Tintex dyes. The ultimate signal of Held's artistic exhaustion came with the lowering of the skirts. In 1929 Russell Patterson supplanted Held as the primary cover artist for *Life* because of his ability to depict this new, more chic woman. Held's last *Life* cover compares ironically with Patterson's. What would appear to be the "raising" of the flapper to the Ideal Woman really was her reduction. When she ceased being a revolutionary figure, she not only lost her energy for change but lost her symbolic meaning as well. Idealizing begat stasis. Change in contexts made her ridiculous. She became a commercial doll.

Perhaps the last Held comic strips best reveal the devastation and significance of such exhaustion for an artist. Drawing these flappers for "Merely Margy," "Rah-Rah Rosalie," and "Joe College" at a rate of one a week (for a two-year period) Held quickly became as formulaic in his cartoon figures as the copy itself. When Held had his fall from the horse in 1925, it was relatively easy

Oh! Margy!, ca. 1925. Courtesy of Bill Blackbeard, The San Francisco Academy of Comic Art.

to find an artist who merely dubbed in and cut and pasted old Held forms for the continuation of "Merely Margy." Margy, who had been the ultimate example of the revolutionary New Woman in 1925, now was totally predictable. An added umbrella here, a grafted hat there, changed her enough and provided the cosmetics to allow the strip to continue until Held was back on the job. Perhaps most revealing, however, was the discrepancy between the captions and Margy's own actions. Thought and action are fittingly at odds with one another in these cartoons. And if Margy is deceptive to get her men, it is obvious that the frankness emphasized by the rising New Woman has become so fashionable by 1925 that it is yet another lie. The real personality, the woman of the captions, still is dismayed. What these cartoons illustrate is that when Held's image became the ideal it ceased to develop and became static.

When the image of the flapper became formulaic for Held, his work reflected how stereotypic the ideas she represented had become in the culture. In this sense, this aspect of Held's work mirrored the corruption of ideals through commercialism and consumerism. It was the expressionism of the flapper—her

Merely Margy -:- By John Held Jr.

Story By Lloyd Mayer

"ACtually, my dear, I THOUGHT I'd go mad and BITE myself because after I'd COYly arRANGED myself in this beCOMing FAINT on the BEACH, supported by what I FIRMly b'lieved to be BASil's MUSculous ARMS and any MINute expecting him to sucCUMB to my irreSIStible fasiNAtions and start NECKing me, I SUDdenly decided to reVIVE sufficiently to

reWARD the hero with an afFECtionate emBRACE and, my dear, WHAT was my horror seconds later to discover I'd been VAGUEly pressing grateful kisses on BULL's revolting countenance, much to his s'PRISE and deLIGHT and the uncontrollable FUry of ARab and NOIsy and PHWHEN who were FIENDishly elated when they discovered I thought it was BASil

I'd been embracing under the FIRM delusion it was HE who'd REScued me—can you COPE with it, my dear? HONestly, I THOUGHT I'd exPIRE with a few FASHionable OATHS, my dear, because the situation ACtually had me WHIPPED down to a NUB, no less, do you know what I mean? GOSH, I was PRACticably ready

to ROLL over and BUTter myself with disMAY, my dear, but I can't WAIT to tell you about the exCRUciating discoveries I made seconds LAter about this PETrifying performance, my dear, because I know they'll simply SLAY you—I mean I ACtually DO!"

(Copyright, 1929, King Features Syndicate, Inc.)

Merely Margy, 1929. Courtesy of Bill Blackbeard, The San Francisco Academy of Comic Art.

externalization of ideals—that, once co-opted by the media and aped by the public, negated her intellectual effect as a symbol, so that her deeper purpose and meaning was lost. Held found the New Woman creatively inspiring when her portrayal suggested the connection between deeper inner truths (for example, what Freudianism during the times interpreted) and external expression. Once this prescription to internal meaning was usurped by the popularization of her image alone, Held's work too paralleled her ubiquitous treatment. The flapper was dead as both an ideal and a revolutionary form.

Yet, for a time, as the city had inspired the modernist visions of Weber and Stella and thus their experimentation with form, so the flapper—as an aspect of energy and authenticity—inspired Held. Held exemplified the fact that modernism, though it went underground in the 1920s, still was visible as a force in the illustrative or commercial arts. As an artist, Held recognized fashion as a modernist expression which linked highbrow and middlebrow art. By treating the flapper as an art form he also visually acknowledged that fashion provided a means through which the New Woman could alter her "second class" citizenship and close the gap between herself and men. If the flapper as a viable and symbolic form was exhausted in the 1920s, Held turned to fiction during the 1930s in an effort to explore and explain what the surfaces meant.

3

Artistic Exhaustion and Fiction

THE SEARCH FOR NEW MEANING

n his introduction to the *Book League Monthly* edition of John Held, Jr.'s *Grim Youth*,[1] Gamaliel Bradford finds the theme of the title and the short story collection the inevitable schism between age and youth. In an age fearful of youth, Bradford notes:

> When such is the normal attitude of timid age, when can it be expected to find the naked energy, the splendid achieving vigor of youth, to be anything but a trifle grim and terrible? Let age do the best it can, its finest attitude and instinct toward youth is apt to be one of reprehension. That hopeless, fruitless, barren, unprofitable word, "Don't," is forever on its lips. There is always the natural tendency to hold back, to discourage, to repress, to point out the evils and the dangers and the difficulties which long experience has made too painfully manifest.[2]

For Bradford, Held's youth are not inherently "grim"; they appear that way because of the age of the audience. *Grim Youth* is as much about the attitude of age toward youth as about youth itself. As a result, Bradford zealously endorses the collection as "the most promising and effective thing we have had . . . that very best vein of purely American comedy . . . essentially American,"[3] recommending Held's work to a prominent place in American letters.

Yet, something is amiss here. Even if we accept the usual difficulty American writers have had in building lasting reputations on short story writing alone, Bradford must be wrong. Promising? Effective? The sum of Held's literary career—four short story collections *and* four novels—is one short story award (the annual O. Henry collection[4]), publication by a small press (Vanguard[5]), a hatful of reviews (mostly from newspapers across the country—mixed in their criticism[6]), and *no* contemporary criticism. What happened to a man whose work was billed as "essentially American," "the very best vein in American comedy," a man who addressed one of the major themes of American literature—youth—through the vagaries of age?

The answer is crucial. Understanding Held's unpopularity as a writer is as important as his popularity as a graphic artist is to the interpretation of his intent and its intersection with certain cultural characteristics of the 1920s and 1930s. In part, Held's flapper stories must have seemed a literary anachronism to an audience already familiar with "the other side of paradise," not only in Fitzgerald's fiction but in a host of college fiction and movies popular in the 1920s.[7] But, more important, Held's subject and tone were at odds with his audience's attitude. Bradford explains:

> Is not this the deepest of all secrets of life, that we should try at all times and in all ways to put ourselves in other's places? When what we are tempted to call "grim youth" comes close to us, we should set ourselves to appreciate its splendor, burning with that glorious zeal to live. For the gift and the privilege and glory of youth is that it makes living a perpetual adventure. Try everything, explore, reach out, get the taste, the sample, the relish. What matter if you sometimes stumble and falter in the process? There was that splendid Sarah Bernhardt, young till she was eighty, making her motto, "Quand Même," "What Difference Does It Make?" There was Whistler, with his superb phrase, "The career of an artist always begins tomorrow." And surely youth, grim youth, gorgeous youth, glittering youth is the most magnificent of artists.[8]

Despite Bradford's sunny proselytizing, Americans in the 1930s hardly were interested in reliving a historical past they considered extravagent, wasteful, and often morally wrong. This was not rejuvenation, but guilt by association. Because of the great changes in the social temper from 1925 to 1935, America had grown up, painfully; and if its gorgeous and glittering youth were viewed, it was with the detached, analytical eye of the social historian.[9] Contemporary youth were expected to be adult and serious. As for Held and "American comedy," American readers wanted to be entertained. Just as they had rejected the implicit irony of Held's cartoon flappers in the 1920s by their overwhelming approval and imitation of them, in the 1930s they demanded a light tone. The power of such preference is explained by Leo Gurko in *The Angry Decade*:

> What was true of the 1920s was true even more conspicuously of that equally prosperous period two hundred years before, when Jonathan Swift was launching his even more violent satires against the England of the 1720s and the human species in general. Those bitter works, *A Modest Proposal* and *The Drapier's Letters*, were read with amusement, and *Gulliver's Travels* for all its bloodcurdling doctrine, was enshrined, almost at once as a children's classic. Mencken, in the latest of his satires, remained, like Swift, a phenomenon of prosperity. With the depression, he retired to Baltimore, to the relative mildness of his inquiries into the American language, and the writing of his paneled autobiography. A satirical attack on religion in 1932 or 1933 would have been simply

pointless bad taste, for a country hungry and insecure was in no mood for laughter and even less inclined to tolerate an exposure of inadequacies all too painfully evident.[10]

Though Held was no satirist (in the Menckenian vein), he was an ironist. Mencken's timing was not Held's, because Held's personal and professional life and its intersection with the period had more meaning to his art than the mastery of "the art of split-second public timing"[11] Gurko attributes to Mencken. The crash of 1929, a divorce, and a nervous breakdown at the close of the 1920s effected Held's move to the Algonquin Hotel in 1933 *to write*—not draw. The prosperity that had made possible a Mencken made Held ultimately view his commercial success of the 1920s as failed art. He sought an effective mode for his irony, not legitimization by a consumer audience. The result, then, is a group of short stories and novels that is a curious mix of cultural history, artistic experimentation, and autobiography. Darkly humorous and stylistically eclectic, they examine not only the relationship of age and youth but the subtle matrices that connect the artist to his work. Through them Held attempts to *close* the generation gap by depicting the ironic continuity of the personal, cultural, and historical arenas.

Held's predominant interest in the generation gap may be understood by noting its pervasiveness in American society, beginning with the period of Held's own youth, the 1890s. As Robert Sklar notes in *The Plastic Age*, the genteel culture had consolidated its power over alien and dissenting elements in American society before World War I. But this class was losing its appeal to the social group which had historically provided its foundation—the urban, educated middle class.

> Before the war genteel culture had been, if narrow, intelligent and learned within its own bounds. An elite form of sophistication had been one of its prime defenses against cultural intrusions by former newsmen turned literary naturalists or earnest immigrants striving to express themselves. But the rhetoric of war is rarely refined or subtle, and genteel culture far outstripped the usual excesses of war in its frenzy for sentiment and repression.
>
> Ultimately, there was a reaction. The young men who had volunteered for battle in the name of sacrifice, glory, and heroism quickly discovered the horrors of trench and gas warfare, the weariness and cynicism among the Allied troops, the corrupt and undemocratic nature of British and French societies, the civilization that they had been willing to die to defend. At home wartime inflation struck hardest at the urban middle class with salaries and fixed incomes. As their economic position deteriorated, relative to wage-earning groups in American society, the urban middle class discovered their culture changing form around them. The quality of their culture, and the broad acceptance of its values by all American classes before the war, had been their pride. But when the emotions and social turmoil of war had passed they found their cultural leaders had

debased their language and their values, linking them with the most mindless and least sophisticated forms of political opportunism, rural resentment, and religious prejudice. Those who had previously given at least silent acquiescence to genteel hegemony now responded to middle-class leadership with open hostility: the rich were disdainful, and the immigrant groups rejected an imposed and unnatural cultural identity.[12]

Sklar recounts the loss of control by the middle class over those who had previously given them cultural allegiance, a loss of the firm social and economic status that had dominated American life since the eighteenth century. With this loss went the foundation for cultural energy and self-confidence. As early as 1915 Van Wyck Brooks observed in *America's Coming of Age* that there were "two currents of the American mind: idealism, which stems from transcendentalism and Emerson, and 'catch-penny opportunism,' which originated in the practical shifts of Puritan life, becoming a philosophy for Franklin." Maturation (coming of age), as Brooks saw it, ultimately led to disillusionment, not knowledge; in fact, it dismissed the whole realm of ideas. "These are the highbrow and the lowbrow," Brooks said of the ideal and the practical influences, "and the young man is caught between the two; he is indoctrinated in highbrow idealism at college but finds that there is no place where it can be integrated with or applied to the practical world; the ideals therefore end by breeding nothing but cynicism and chagrin; and in becoming permanently catalogued in the mind as impracticable, they lead to a feeling that all ideas are unreal."[13] Ten years later William Carlos Williams would call this condition the "abortion of mind," and attribute it to the very early definition of America as a place abstract and theological. In *The American Grain* Williams claimed the great fault was that of the earliest generation—the Puritans. They did not visualize or realize the continent; rather, they saw it as an extension of the *concept* of place. Therefore, this schism, described by Held as occurring between youth and age, was generational in a much broader sense: it permeated the economic, social, and cultural arenas as well as the personal; and it culminated in a gap between the American and his own past.

Held personally embodies the characteristics of the generation gap—the schism between past and present, ideas and actions. Coming from the West (though not the Midwest), he left Salt Lake City for New York City to make his fortune. His idea was to better his father's accomplishments, a goal which led him to capitalize on the vast opportunities for the commercial artist in New York City in the early teens. Much of his drive for success came from his Mormon background. Though he never formally practiced the religion, he exemplified Mormonism in his dedication, zeal, and indomitable drive to make the most of his talents. Held was a staunch member of the middle class, and he reaped the benefits of consumerism and the Protestant work ethic evident in the burgeoning city at the time. In 1927, when Held was more sorely pressed by this

same success that had made him the ebullient hit of Westport, he discovered other generational schisms in his life—fame expected by a domineering wife, and accomplishments that did not thrive on the status quo. Forced to produce more and more work, Held suffered nervous exhaustion, the end of his second marriage, and estrangement from three adopted children by 1931.

In addition to this pressure, the schism was much deeper. He had always seen himself as an artist; he had battled for the time that would allow him to live as a "fine artist" rather than a commercial one. Too, his commercial art, which Held perfected as if it were a fine art itself, lost both its artistic and social meaning when members of society mimicked its *form* in its own fashions. Thus, Held's position in the alignment of artist to society was doubly ironic. Unlike his intellectual brothers, he could not withdraw or make another life through his forms. Since these depended on the public for their image and success and were imitated by that same audience, they commanded no critical space. Held therefore fought the same battles mirrored in the culture of the times: the schism between fine and popular art; the loss of the past and the search for a viable tradition; and the conflict between the intellectual and the middle class. He faced the same question Edmund Wilson addressed through the life of John Jay Chapman: how to be an artist and retain one's integrity; or even more specifically, how to be a critic in America.[14]

Not surprisingly, then, Held moved from popular artist to the writer of short stories and novels to make his critical points, and to experiment with a new form, beginning with *Grim Youth* in 1929. Each of the ten stories in the collection is varied in setting and character and takes as its basic theme the values of youth. On the whole, the subject of these stories is youth in the 1920s: "Young Prometheus," "Man of the World," "Ordeal," "The Awakening," "An Afternoon," "Until the James Runs Dry," and "Commencement" concern incidents in the life of college youth. Three other stories, "The Ride of the Valkyries," "The Chariot of Cupid," and "Miss Universe" focus on the young. Held's original audience for some of these stories (readers of *Scribner's* magazine, *Harper's Bazaar*, and *College Humor*) indicates his range. "The Chariot of Cupid," for instance, is primarily entertaining, whereas stories such as "Man of the World" and "Commencement" are serious commentaries on the attitudes of youth.

On one level Held recreates topically in these stories the milieu of the college flapper and jelly bean of the 1920s. Settings, though sparsely drawn, include dormitory rooms, fraternity dances, football games, and dinner parties. They are realistic glimpses of the environment of college life. In "Man of the World" Held describes a typical room in the Kappa House:

> The room had been originally decorated in rather good taste, but the boys had made several major improvements. The decorator had never intended that the carefully chosen bridge lamp should be used as a necktie rack. On it hung, perhaps, thirty cravats, only two being fit to be worn. . . . On the gate-legged table

in the center of the room were three pairs of rather soiled tennis shoes that were curled up in front like skis, a few old theater programs, a bowl overflowing with dead cigarette ends and a half-used Eskimo pie, a package of Luckies containing what had been, at one time, four cigarettes, but were now empty tubes of tissue paper. The tobacco had slipped out, long since. But it was a ritual for everyone who entered the room to pick up this package, discover that the cigarettes were useless, and then put the package back on the table. There was also a torn sweatshirt, and atop of everything a saxophone that lacked a reed. (*Grim Youth*, p. 29)

Likewise, cars (in the same story) are "loaded to the gunwales with young couples . . . a pair close in the rumble"; saxophone music is "blue and dirty." Slickers, fur coats, flasks, and skimpy dresses contribute to the personal landscape. Yet, if documentary, these settings subtly suggest what Held really is reporting. In "Ordeal" he describes the football stadium and its occupants:

Groups of solitary males waited at the portals. They were joined from time to time by their female companions, who came up adjusting their hair and hats. They entered the stadium in couples without speaking. Empty ginger-ale bottles were rolled about in the dust by passing feet. Occasionally there was a flat empty that didn't roll. The crisp air seemed to be charged with restrained voltage. The echo of the crowd sifted over the edge of the cement embankment. A band played on the inside, but only the oompah of the basses could be heard. Small whirlpools of dust and bits of paper came to life whenever an opening appeared in the passing crowd. Some timber scaffolding protruded from the cement wall, as the construction of college amphitheaters seems to go on forever. A project of this kind is like contentment; it can never arrive at the perfect state. The passage was narrow between the scaffolding and the wire fence enclosure, and here the progress of the mob was delayed. They filtered through with gay comments and laughter. (*Grim Youth*, p. 55)

Like the line in the earlier example about the "ritual" of examining the cigarette package, the tension between the energies of college life (the perpetual incomplete state of the stadium) and the mood of emptiness and non-communicativeness signals a gap between external and internal reality. Held suggests there is a difference in what we see and what we must know. Words such as "seemed" and "appeared," the description of dust and bits of paper, even the incomplete sound of the band from inside, dramatize the "progress of the mob": "it can never arrive at the perfect state." Even in his use of realistic diction ("baby," "that baby's all wet"), Held details not only the period, but attitudes of the times. The collectivism and conformism of the "mobs" of fashion-conscious youths heighten the loneliness, immaturity, and often vacuousness of individual characters. Setting, then, is psychological. Its overt realism serves to expose its

own pretentiousness, the misconceptions of the characters, and ultimately these shortcomings in the audience itself.

Given this intent, the style of these stories may seem surprising. Some of them are hardly more than vignettes; they are all cryptic and employ no experimental or psychological techniques such as stream of consciousness or interior monolog. The majority of the stories depend on dialog to sustain them; interior thoughts are told mostly through third person limited narration; plots are simple. They are quite traditional—classical, even, in their style. Yet the pervasive understatement of such a simple style is a major device. Rather than draw his figures larger than life, as was Fitzgerald's temptation, Held relates each story in a predictable, straightfoward manner. There is little exposition, and his points are made through his major technique, irony. As action abuts with speech and thought, the reader (and sometimes the main character) apprehends as if through a camera eye. What he had thought to be truth—typical or real—is altered by Held's subtle angle of vision. Held seeks to shock the reader into an understanding by understated dramatic form.

The story "Man of the World" indicates the strong relationship between style and ideas. Spug Harkness, the main character, is introduced: "'Aw nuts!' said Spug Harkness as he turned off the radio. Spug took great delight in being rude to prominent statesmen. He had once played 'I'm Just a Vagabond Love' on the saxophone while President Hoover was delivering an important message to the taxpayers." Spug (read "Smug"?) is characterized as a typical jelly bean; he shares an apartment with three other college students who make a pretense of attending college but whose principal occupations are calling up girls (or waiting to be called), playing poker, and "drawing large black mustachios on the half-tone illustrations of Clara Bow, blocking out a tooth in Buddy Rogers' smile, and adding a goatee on Laura La Plante." Though the tone of the introduction to Spug is "light," we soon find that his preoccupations are more than comic. His leisure as a college man is seductive; though he tells a girlfriend on the phone that he has kept her waiting for hours at the corner drugstore because of a Latin lesson, he has been in fact tapdancing in the hall, roaming from room to room in search of cigarettes, and, most significantly, preening himself in a small shaving mirror. Before he goes to meet Peggy, "he put on his coat. He went over to the small mirror on the window edge and again searched his complexion. He looked at the reflection of his throat for any possible ingrown hairs. He had been shaving for two months, but somehow was never able to find ingrown hairs. He sighed, pushed his hands deep in his trouser pockets, forcing his belt down over his hips. Then he rubbed his chin, turned off the radio, and went out." (*Grim Youth*, p. 31) Spug is seventeen years old, and, Held tells us, "he told everyone he was eighteen, as being young embarrassed him."

Once he places Spug at the drugstore with Peggy, Held continues to pursue the differences between Spug's wish to be grown up and his willingness to rec-

ognize and accept responsibilities. First, he is endlessly critical of the characteristics in Peggy that he exhibits. She answers him "with the unconcern also typical of the feminine, but so false." Held notes:

> Peggy may best be described as exactly like fifty other girls of her age in the town; she dressed like them, she talked like them, she thought like them, and her mannerisms were the same as all the rest. She was one of a family of, oh, say, five or six children. She was employed in some obscure position. Spug had never bothered to find out just what she did. She took her entire salary home every Tuesday, but always had carfare with her. She was a "home girl" as the tabloids say. She had made a deep study of home life, the home life of the popular movie stars. She was consumed with the tender romance of Douglas Fairbanks, Jr., and Joan Crawford, and she thought Lupe Velez and Gary Cooper were sweet. (*Grim Youth*, p. 32)

Held builds on Spug's judgmental and superior attitude by describing the autumn evening as perfect, complete with a big, circular yellow moon—which Spug, despite his romanticizing with the girl, fails even to notice.

Indeed, the couple's interaction signifies anything but the emotions of budding youth. Peggy seeks reassurance from Spug that he, unlike her father, does not believe girls who go out every night are loose. Spug, in turn, launches into a ridiculously naive, and self-possessed, treatise on life—*his* life:

> Life's a funny thing, isn't it? When you think about it. Sometimes I wish I wasn't able to think. Life would be a lot simpler if one couldn't think. I was a lot more contented when I was young. It would be swell not to have any imagination. It would make things a lot easier. Sometimes I get thinking, until I'm nearly nutty, trying to figure out what it's all about. I don't mean the little problems like studying, or eating, or who's going to win the football game. I mean the deeper things. I wonder if we were put on this earth for a purpose or did it all happen by accident. I don't know. But then, we're here; we can't change that, so we've got to make the best of it. Every man has to work out his own destiny, the best way he can. For instance, I had to stop drinking. I found I couldn't stand it. It was getting the best of me. Figured that all myself, so I'm off the stuff. But I guess the man who goes through life with his eyes closed is the happiest. I wish I could do that, but I'm different, because I'm always trying to find out what it's all about. Then again, something happens to make me think what is going to happen is going to happen regardless of anything we try to do about it. That's destiny, I suppose, and all we can do is make the best of it when it happens. (*Grim Youth*, p. 34)

Though supposedly a man of books, Spug's language and philosophy belie how untutored he is. He presumes to cite experience as the greatest teacher. "All the old authors are all wrong, because they wrote about the problems of their time, and they're all wet compared to the problems of to-day, baby." Peggy dutifully

nods, "though she was making no effort to understand." The affair finally is consummated, confirming Spug's faith in experience and Peggy's desires of the evening. The scene is particularly ironic since only moments before Spug has privately criticized Peggy's own lack of sophistication: "He took a package from his pocket, extracted a cigarette and lighted it. He knew if she tried to light it herself that she would blow out the match, because girls always blow through a cigarette when they light it. He handed it to her. She took a deep draft and inhaled the smoke to the bottom of her lungs. As she blew it out, she picked some tobacco from her tongue." (*Grim Youth*, p. 33) The final twist to the story comes when Spug discovers his speech about destiny is tested: Peggy is pregnant. We expect their next meeting, a repeat of the scene in the park, to be his undoing. Experience, philosophy, and fate we expect to be intertwined. But there has been another part to Spug's earlier speech to Peggy that now he acts upon. " No, Baby, it's a big mistake for a man of my background to let his emotions govern him. First thing you know, you don't know where you are. Now take some of the other fellows. They believe anything that's told them. They don't think for themselves, and what will be the result? First thing they know, they're on their own, and it's a question of sink or swim, and they're sunk before they start." Even though we presume his emotions, and Peggy's, have gotten them into this fix, it is certainly not Spug's emotions that will get them out. While Peggy cries, Spug says in a very detached manner:

> All right. I get my money from home in a couple of days, then I'll see you, so don't worry any more. And, listen, Baby, you aren't scaring me. I don't know if you are on the level or not and I haven't any way of finding out, except when you say it. And you know darned well you've got everything on your side. I haven't got a chance. You know the whole world is for you in a case like this. They believe you and I'm stuck. You've got the police on your side. The law will protect you, and it's laying for me. I'll get you the money to get fixed up with. (*Grim Youth*, p. 35)

The final blow of the scene is Spug's excuse to leave. When Peggy calls much distraught, at the fraternity house, he makes the excuse to the brothers that he has to check out a car. "I'll see you in a couple of days when my check comes," he says later to Peggy. "I've got to go back to the house now and see a man about a Buick."

In his next collection, *The Flesh Is Weak* (1931), Held addresses the familiar themes of college youth. "Sax and Sex," "Waltz," "Lochinvar," and "Feet of Clay" typically concern maturation, social conventions, and the relationship of the sexes. However, Held introduces new topics, most significantly an interest in a poorer class of women. "Dumb Bunny" is a story composed largely of the silly and naive dialog of two working class girls at lunch. And "Penitentiary Bait" is about a tenement girl who is abused by a motorman. "Boy in Boy" is essentially a Freudian study of personality, and "The Old Order Changeth" is a

story of the value systems of three generations of women. "Rainbow's Gold" presents the reunion in New York City of two college roommates, one who has made a glamorous life for herself there, the other who stayed in the Midwest to marry a dentist. Thus, it is not only a piece about class and status, but it concerns the theme of rural and city life as well. Perhaps the most surprising story in the collection is "The Pigeon of St. Patrick's." Essentially a fantasy, it is an early one of Held's animal stories, which appear to have serious ideas cast through the tales of the lives of animals told usually from their point of view. If one considers the stories mentioned above as a group, a pattern emerges. In light of the novels that follow—*Crosstown, I'm the Happiest Girl in the World*, and *The Gods Were Promiscuous*—Held is laying out the groundwork in this collection for his interest in lower class women, Freudian psychology, status and role and their relation to place, as well as using folktale, myth, and fantasy to make his points.

At least two of these stories warrant closer examination. "Rainbow's Gold" sets up the expectations of two college chums who plan to get together in New York. Bobby, the resident New Yorker, writes Elizabeth:

Dear Libbs,

I was rather startled, not to say pleased, to get your letter asking me to buy the frock, as per the clipping you enclosed, but, my dear, you failed to give me the size, and as I haven't seen you for ages, I have no way of telling if you are stylist stout, a bony skeleton, or a perfect thirty-six.

I have heard from vague sources about your bearing litters of children. This no doubt has a tendency to change you from the boyish tennis shark of college days into heaven knows what!

Rather than send me your size, why not act on my idea and come to me for a week? I know you must be terribly fed up after these six years, or is it seven, that you have had out on the prairies among the cowboys and Indians. If I remember correctly, you always had an appetite for the nicer things—theaters, people who are doing things, and what have you. Do fix to come, and we will have sprees of shopping and shows and going places, and I want you to meet my new husband. He's not exactly new, I've been married to this one for nearly eight months. That's a record for me. But you may not think so, you who have been married to the same man for six years, or seven as the case may be. But then you married a dentist and I suppose one always goes to the same dentist. (Joke.)

You must come. I won't take "no." Wire me the train that you are on and I will try to meet you. If I miss you, come straight to the house and make yourself at home. I'm dying to see you. It's hard to realize that we haven't seen each other since I was the "missing link" in the Daisy Chain.

So, until I see you,
Yours,
Bobby

Julian and Julienne (undated). Permission of Illustration House, Inc.

The Skier (date unknown). *Vanity Fair*. Permission of Illustration House, Inc.

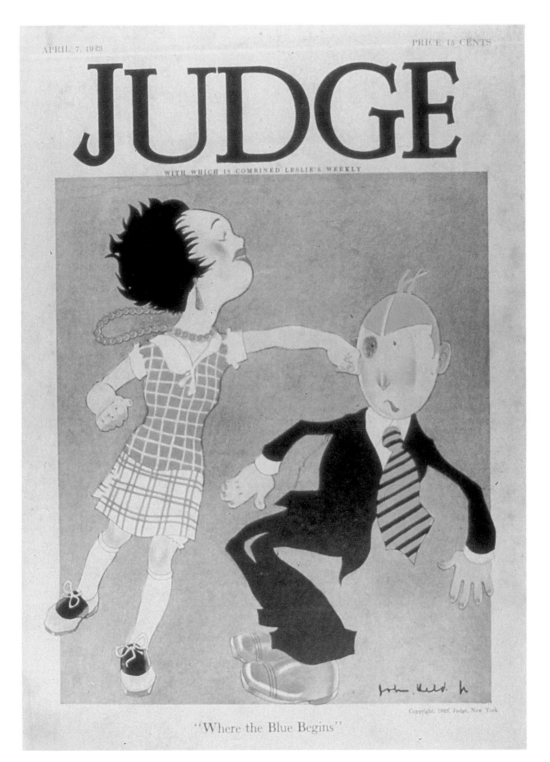

Where the Blue Begins. April 7, 1923. Permission of JB&R, Inc.

Playing in by Moonlight (undated). Permission of Illustration House, Inc.

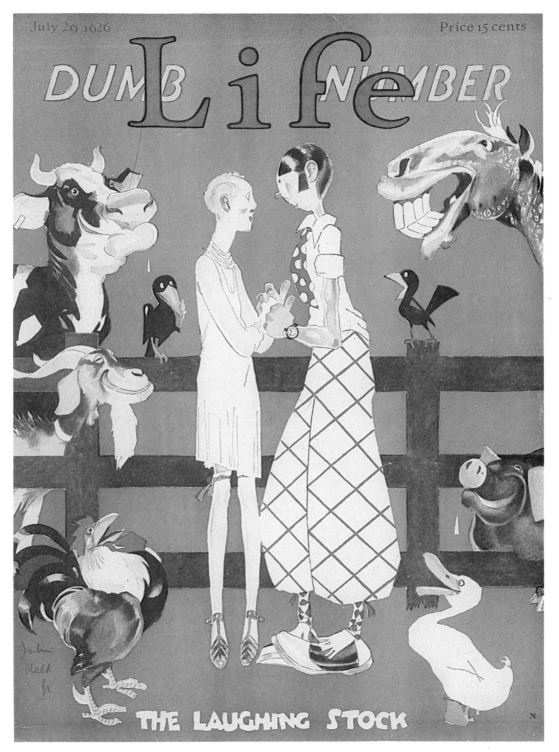

The Laughing Stock. *Life,* July 29, 1926. Courtesy of Bill Blackbeard, The San Francisco Academy of Comic Art.

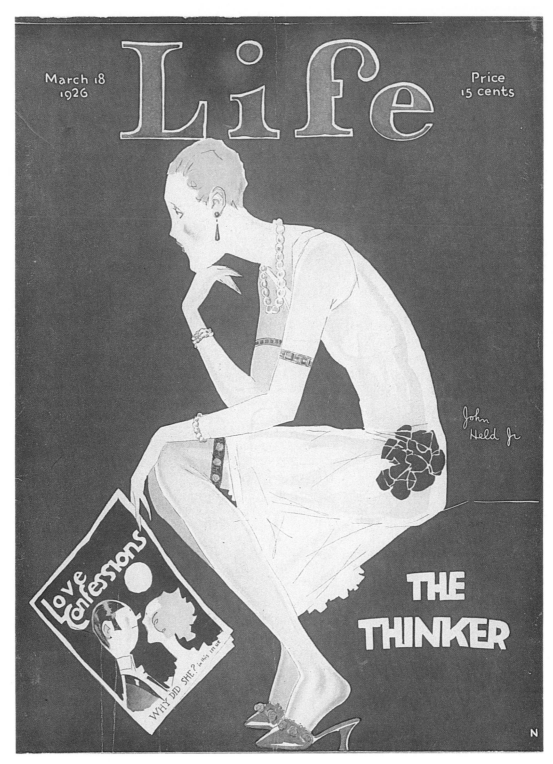

The Thinker. *Life,* March 18, 1926. Courtesy of Bill Blackbeard , The San Francisco Academy of Comic Art.

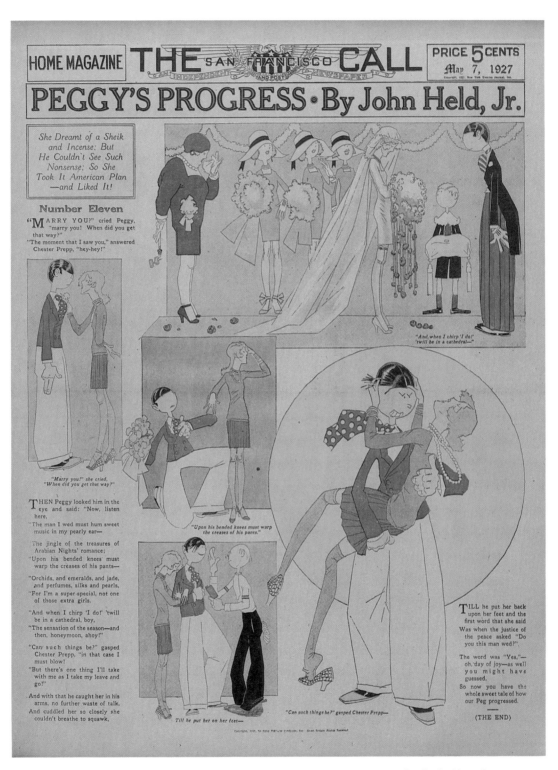

Peggy's Progress. *The San Francisco Call,* May 7, 1927. Courtesy of Bill Blackbeard, The San Francisco Academy of Comic Art.

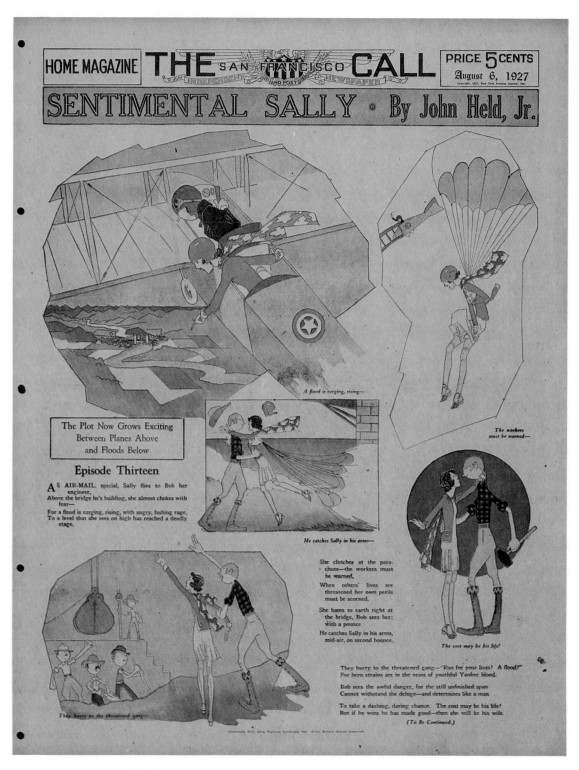

Sentimental Sally. *The San Francisco Call,* August 6, 1927. Courtesy of Bill Black-beard, The San Francisco Academy of Comic Art.

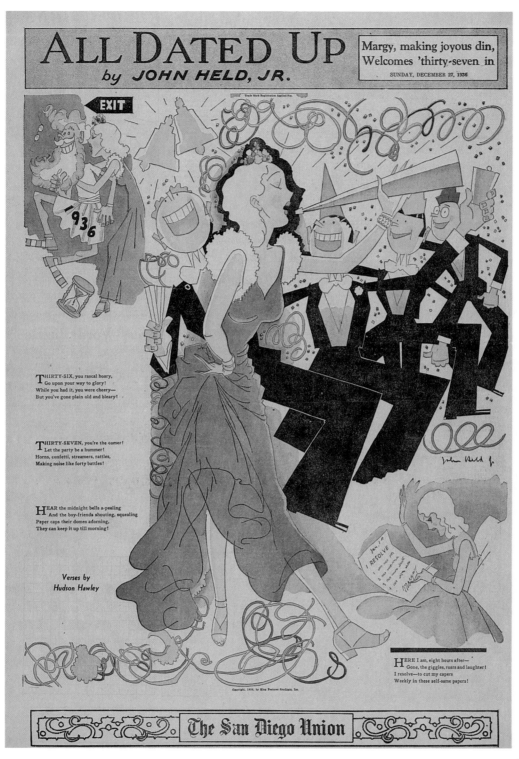

All Dated Up. *The San Diego Union,* December 27, 1936. Courtesy of Bill Black-beard, The San Francisco Academy of Comic Art.

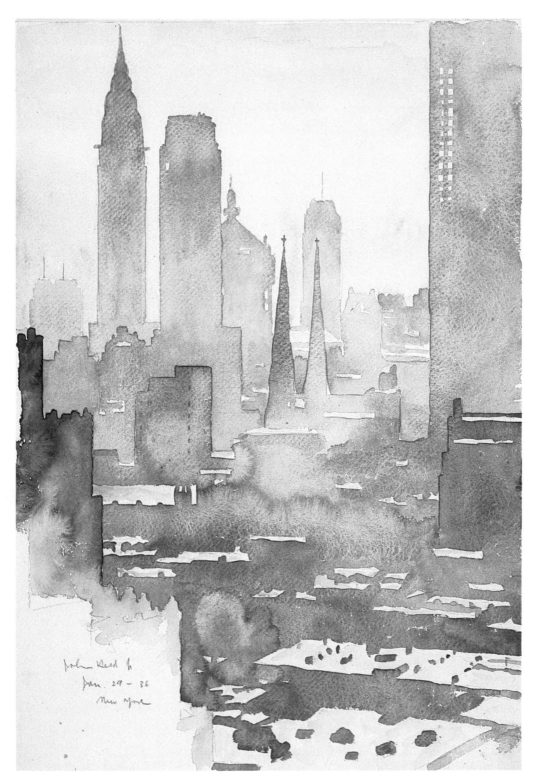

Manhattan Skyline (undated). Courtesy of Illustration House, Inc.

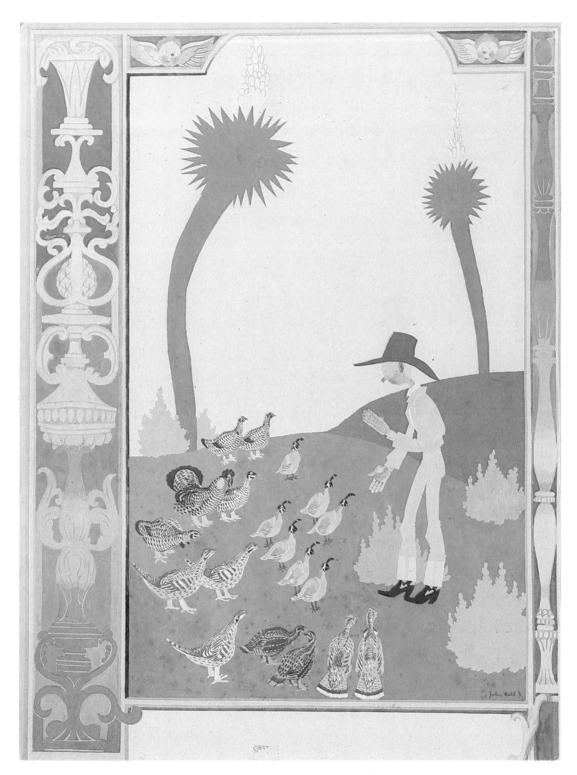

Cowboy St. Francis and Birds (undated). Courtesy of New Britain Museum.

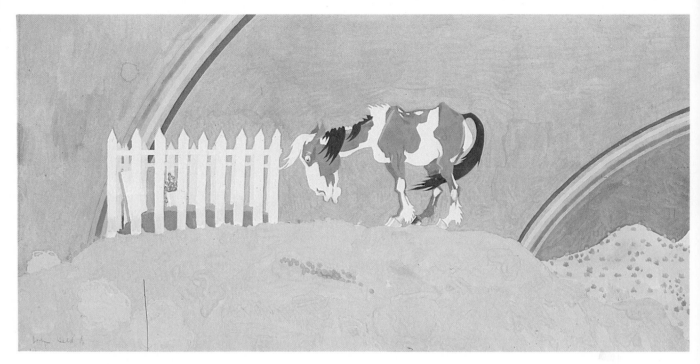

Cowboy's Grave (undated). Illustration House, Inc.

Held juxtaposes this letter, which introduces the story, with the thoughts of Elizabeth. She lives in Erie, Pennsylvania, where to her knowledge there are no cowboys or Indians or prairies. She has not been married six or seven years; it is four. She has not had litters of children; she has had two. Yet Bobby (Roberta) she knows is accurate about a few things. Elizabeth is starved for higher culture, and calculatingly pursues sophistication by serving as a member of several book clubs, patroness of the Puppet Guild, chairman of an art center. She has "gone deeply into shortcuts to psychoanalysis"; stumped in Buffalo for a guaranteed performance of *Porgy* for the city; ordered some pieces of modern furniture by mail; can roll the name "Modigliani" off her tongue, though she is not quite sure what he did. As Held tells us, "She was out of rhythm—not exactly out, but a beat behind." As it might be supposed, Elizabeth would "like to be in the thick of it all." Her husband's nightly habit of listening to "Amos and Andy" is not her cup of tea.

The classic meeting takes place, and Elizabeth is elated. Each of Roberta's three husbands was a man of the arts. They attend *Green Pastures*, go to a speakeasy, lunch at the most fashionable places. Elizabeth thinks: "Now she, Elizabeth, was going to feast at Roberta's groaning board, and how she would overstuff herself with everything that had been starving her aestheticism. People, people who were! To feel the warmth of brilliance! The right musicians, the proper artist, actresses; to be able to talk and have herself understood; sift waters, not the slow moving eddies of the stream where she was always going down for the third time." (*Flesh*, p. 20) Here, as earlier, we have the Held trademark. Roberta gives an elegant party. In attendance are "all the right people": a world-renowned violin virtuoso and his wife; a miniature painter; a Metropolitan soprano; the leading modern sculptor; a painter of the abstract; two or three advertising men who were married to women novelists; authors, poets, architects—even a French caricaturist (born and raised in Cleveland). Elizabeth is a "crow among birds . . . afraid to speak for fear her caw would scare the lovely creatures to flight," so she sits back mute in order to listen to the music of their conversation. But the conversation? Bridges, teeth, dentistry! "Look at this piece of work. I thought I was going to lose every one of mine, until my dentist gave me a treatment. They are all perfectly sound teeth, the hardest that he's ever seen, but I had pyorrhea. My gums started to recede, but look at them now. Isn't that a perfect job? I swear by my man. His bills are exorbitant, but if you want a thing done right, you've got to pay". (*Flesh*, p. 22) As each of these dignified guests checks each other's mouths around the elegant dinner table and begins to shout addresses of their personal best choice of dentists, Roberta flutters around Elizabeth. "How are you getting on? Having a good time, darling?" she asks. "Wonderful," answers Elizabeth.

Though "Rainbow's Gold" is a warmly humorous story about the illusions of sophistication, Held operates with a heavier hand in "Penitentiary Bait." The main character, Kittens, lives with her aunt and uncle in a five-story walk-up.

Her best friend, May, has "left her" to take a job at the Bon Ton Dance Palace, where she met a man the first week, married him the second. Kittens

> wished May was with her. It was much more fun to wear things if your friend was dressed the same. It bolstered the nerve. This later afternoon she was dressed in an elaborate silk waist with a hemstitched neck ruffle, a wide floppy white embroidered hat, shoes with high French heels, and socks rolled down. Her costume was topped off with a pair of long, white sailor pants. The pants were tight across the hips and they fitted her stern snugly. When dressed in this ensemble, she was indeed spankable, and the seat of her trousers had often resounded from the palms of her truck-driving acquaintances and many kidding pats from the neighborhood cop. (*Flesh*, p. 60)

Kittens is described as vulnerable, not only because of her background but because she plays at being a woman. Avoiding her uncle, who casts lecherous eyes at her, and caring for her aunt, who is an alcoholic and must be rescued almost daily, vomiting, on the tenement steps, Kittens dresses up and "kids" with the motormen at the carbarns where she has safely played as a child. It is in this "large, mysterious, attractive interior" in which she "romped and shouted and made up games" as a child that she is accosted by a motorman and raped. Held has set up the scene nicely by developing Kittens's vulnerability and loneliness due to her upbringing, her life in the tenement, and the loss of her friend. Though she can aptly joke ("You're a fresh guy, aren't you?" "And so's your old man," "Yeah, in your own hat"), she pays for her physical repartee and is violated. Yet, this is not the ultimate twist of the story. As the motorman forces her in one of the empty cars she played in childhood, the scene is described:

> She lay there and nursed her smarting cheek. He moved and stood over her threateningly. Her face was wrought with pain, and her eyes filled with tears. She reached her hands up and tugged at the man. He kneeled at her side and took her in his arms. Now her body was meek and submissive. She raised her head and kissed him full on the mouth. Then she lavished kisses on his unshaven face as her breath came faster and faster. (*Flesh*, p. 65)

In the last scene she is at the druggist's asking for a cure for "the worst cold sore" she's ever had. Ending on a naturalistic note, Held has the druggist reply: "No, ma'am. I haven't got a remedy for that kind of cold sore. I would suggest that you visit the clinic for diseases of the blood." The disease, obviously, is congenitally more than physical or even genetic. It is environmental as well.

By 1932 and his *Bowl of Cherries* Held had exhausted his themes as well as his style. Sounding like second-rate Ring Lardner, Held lacks imagination in this volume. Held adds to the usual stories about youth and society three horse stories which only make the book less unified. Only the last three stories in the col-

lection, "History Repeats," "Like Father, Like Daughter," and "Valedictory," convincingly continue his primary and most important theme, the relationship of the generations.

"History Repeats," like "The Old Order Changeth" in the previous volume, examines the mother-daughter relationship. After putting up with her daughter's self-indulgence and thoughtless demands, Jane's mother complains to her own: "I never saw anyone so wild. On the go every minute. She hasn't spent more than four hours in the house this vacation. All she thinks about is parties. Now when I was a girl—" (*Bowl*, p. 70). Grandma interrupts to point out that when her daughter was a little girl she courted in cars, honked their offensive horns, dressed as in the latest fashion, and pursued music just as zealously—even if it was mandolin playing. Grandmother moralizes:

> Then I had difficulty with what was then a modern young woman. You seem to have forgotten how I used to nag about those "sheath skirts" and the "bunny hug" and "spoonings" when you were "that way" about the time you married. You went through all the same things and you didn't come to any bad end. Echo seems to bring back to me something about "living your own life." People always forget the things about their youth that they are quickest to criticize in their own children. I suppose my mother was the same with me. Only in my time it was crinolines, melodeons and buggy rides. Yes, and I had my "own life" that wanted to be lived. (*Bowl*, p. 72)

The fact that Held begins this story with the comment "A simple but complete description of Jane would be to say that she was one of my drawings that had come to life" more fully explains Held's intent. Jane is a flapper who Held indicates is not only normal in her behavior but no worse than her elders.

In "Like Father, Like Daughter" Held pursues this idea, suggesting that youth are a chip off the old block. Little Joe, the daughter, nicknamed because she is the only child, persuades her father, finally, to take her fishing. He has promised for a long time to but dreads taking an incompetent girl along. What he finds out on the fishing trip is not only that she is competent but that she bags the largest fish.

Held's method of criticizing the period of the 1920s, then, was not in keeping with either the most popular Jazz Age novelist, Fitzgerald, or the social critics of the 1920s. These critics added to the juncture between the decades by interpreting the 1920s as a period of national indulgence and extravagance and moral failure, while Fitzgerald elevated history to the level of myth, converting the essential hallmarks of that age into a predominant "attitude." Though the writers of Fitzgerald's time were the first to forgo the philosophical romance (of Melville, Hawthorne, and even James) for more realistic attention to one's own times, they raised the present to epic proportions, romanticizing it to the point

of myth. Neither the social critics nor these writers recognized the continuity between decades; instead, their renderings added to the loss of a nostalgically viewed past. What Held does is not merely to deflate the myth. His staccato dialogue, simple plots, and economically drawn settings and characters are an attempt to reconstruct certain scenes from an era in a manner that does not promote mythologizing. While Fitzgerald's love affair with the period prompted him to bewail its passing and thus depict its archetypally glittering surfaces, Held was interested in its various, and contradictory, interiors. And these interiors, he attempts to show, derive from sources beyond the immediate present. As the stories here suggest, there is an intimate relationship between youth, its brashness and struggle for maturity, its instinctual and cultural meaning, and the commercial ends it unwittingly fulfills through fashion, manners, and morals. For Held, these youth symbolize the very insidious failure of the American dream. In particular, women as commercial objects are ironic. The so-called liberated woman, able to pursue equal opportunities of the predominant culture, is victimized by the very images she adopts to assure her success. Urbanization (and consequent materialism) that make possible her part of the American pie also contain seeds of greater loneliness and agony than before liberation.

In all but his last novel Held continued to explore the role of women in American society. *Women Are Necessary* (1931), as the first of Held's novels, is understandably roughly drawn and imitative. Resembling Crane's *Maggie, A Girl of the Streets* (1893) and Jacob Riis's short stories, the novel focuses on Edna Morgan, an orphan who lives with her Aunt Lizzy, her only living relative. As the novel opens, she is a high school sophomore who is raped by a traveling brush salesman who has given her a ride in his new car. Edna's fortune predictably darkens as she moves from that encounter to an unconcerned boyfriend by whom she gets pregnant. After trying to buy her off with abortion money, he abandons her. Edna wishes to move from Columbus, Ohio, to Cleveland, where she plans to have her baby in a relief hospital for unwed mothers so she can work until time of delivery. Taking her savings from her phone company job in Columbus, she moves to the city, where she has the baby, eventually works and lives with a struggling artist, and goes with him to New York City in an effort to make his fortune. Forced to give up the baby to adoption (something she managed to avoid when the baby, Gloria, was born), she finally is left by the artist (who has never broken out of his regimen as a sign painter) and ends up in jail on a trumped-up charge of vagrancy. Meeting a prostitute there, she learns the tricks of the trade, and once out of jail makes her living that way. The novel ends with Edna committing suicide. She turns on the gas jets in her shabby apartment and dies as she mutters remembrances of her baby and Mack, the artist.

The novel derives its title from the father of Edna's baby, Ronny, who, once he learns of her pregnancy, complains about women trying to "trap" him and

asks the rather rhetorical question of his filling station pal, "Are women necessary?" Far from suggesting that women disturb the otherwise serious and meaningful lives men could lead without them, the novel ironically suggests the opposite: are men necessary, and if so, why (and are they worth it)? The novel is a sympathetic but not sentimental rendering of a poor woman's life in the city, the kind of life resulting from the very limited ways she must get on in the world.

In Held's next novel, *Crosstown* (1933), the plot suggests the novel's thematic kinesiology. Mazie Petropoulos moves—not downtown or uptown but *crosstown*—in order to achieve professional and personal success. The novel is linear, therefore, and told in a simple, straightforward style, with the action of the characters carrying the main themes. Child of an immigrant couple—an Italian mother and Greek father—Mazie is introduced in the beginning of the novel as a poor, working class girl, whose only stability in the home is her private room. There, among posters of her favorite movie stars, she escapes the turmoil of the family (a father who is a drunkard, a distant mother, and brothers who are members of the local gang) in dreams of her boyfriend, a sailor, for whom she is "saving herself." One night she is raped by her drunken father, and she sorrowfully escapes her home, disgraced. She takes up with a friend, a "street bum" quadriplegic, who begs on the streets of New York by day and, with his artificial limbs on, is a dandy by night. He abuses her finally, and she leaves him to take a job at a dance palace. Here she meets a Chinese man who becomes her "sugar daddy." This relationship ends when he has had enough of her, and she takes a job in a chorus line. As a dancer, she meets and is encouraged by several men in the theater. Though she loves none of them, she finally lives with Parker, the public relations man for the theater.

By this time her career is soaring. Each new show brings an increasingly prominent role, until she is the star of the shows Parker reviews. She encourages Parker in his avocation—novel writing—but finally he is so overextended, because of his confidence about the success of his first novel, that they part. By this time Mazie is a success financially, and she offers to help Parker. He cannot accept such aid from a woman, and they part friends. Mazie lives temporarily at the Algonquin, where she meets Michael Houghton, a cartoonist who has long admired her beauty and "nameless" quality. They fall in love and marry, and Mazie discovers he is heir to an enormous fortune. The couple are happy, and the novel ends with Mazie reevaluating her checkerboard life from the vantage point of an elegant penthouse where the couple gives a party; some of the guests are Mazie's old lovers and abusers.

If the plot sounds preposterous and thus adolescent, we must remember that Held's usual eclecticism is operating. Carl Weinhardt has observed that Held never hesitated to unite in his art whatever "schools" he found interesting, yet he never followed the dictates of trends or styles. This proclivity is a reason for the novel's apparent inconsistency. Different sections of *Crosstown* are naturalistic, realistic, romantic, and sentimental. Much like Maggie in Crane's master-

piece, Mazie becomes street-wise as she is shaped by her environment. Yet, if environment acts naturalistically in one sense, in another Held handles it realistically, giving an accurate picture of tenement and Broadway life in the late 1920s. Mazie gets her man in the end (and happiness), so that the story ends on a somewhat unbelievably romantic, even sentimental note. There are several explanations for this—most notably the times. Held may have been pandering to the popular fiction of the day. Though Held's attitudes may appear to conflict, each of them reinforces the predominant tone. Life is ironic, and it can end happily. What readers, characters, even the author, count on finally is paradoxical. Because Held cleverly unites each of these attitudes—the naturalistic, realistic, romantic, and sentimental—through common motifs, imagery, and symbols, this theme is consistently revealed through the irony.

We may examine this cohesiveness in the first two chapters. Held immediately introduces the central conflict: Mazie's desires and her destiny. As she awakes alone in her room, sensing her body, her instinctual self, *her* drive, Mazie's youth is connected with her sexuality. She longs to make love to Pat, her boyfriend, but it is he who has said "no" in the name of societal conventions. Her desire, then, is expressed in her affinity for the *city*. Atop her five-story walk-up she revels in the view of the city, its energy, people, authenticity. She and her "buddy" (so named), a cur dog she gets at a pet shop, frolic among the real plants on the rooftop, and Mazie's youth is so vigorous and uninhibited and unschooled in the expectations and demands society will place on her as a *woman* that she spits playfully at a policeman below. She misses him, of course; but the point is, she has no knowledge of the decorum which will eventually release her sexuality. By the end of the chapter circumstance has rudely conflicted with desire. Her father rapes her while the red artificial lights of Broadway glow into her room. By morning, with her father still asleep in her bed, she is unable to notice the city dawn that has so pleased her before. As she plans her escape from her shame, it is "the end of life's beauty for Mazie"; "she watched the bursting dawn without seeing its beauty."

But if her sexual desires have been ironically satisfied against her will, she does choose to descend into the "man-made canyons" of the city. She resides with Dippy, a cripple whose begging and underworld connections allow him to live a very different life at night; she now takes Buddy to a rooftop landscaped in artificial plants and across from an X-rated publishing house. What was violation in the first chapter becomes consummation in the second. Though she sees herself and Dippy as misfits, she feels sorry for him and is fascinated by his physical condition. When they make love one night "horror adds to the fascination." Through her sexuality she is acquainted with the sordid side of herself and the environment. Once she is educated, she is able to transfer sexual desire to other levels, to sublimate her sexual drive in ambition, will, and creativity.

Though she struggles throughout the remainder of the novel to find an identity suitable to her character and the demands of her environment, each experience adds to her maturation. By the end of the novel desire and destiny are

reconciled. Knowledge tempers desire and youth so that her fate is the cumulative effect of environment, parentage, and actions.

Certain motifs reinforce this idea. Throughout, Mazie, in her disappointment in men, turns her affection and emotional dependence to dogs. Her first, Buddy, is killed by Dippy, to be replaced by a series of animals, less reliable, less friendly, and, in fact, requiring more pampering. If what Mazie needs is a "best friend," she gets it in the Pekingese, the terrier, and even the dachshund, dependent, dumb, and demanding animals that give her nothing in return. Walter, the Chinese, takes the Pekingese when he leaves. The terrier is killed by an automobile because he is not street-wise. At one point, Mazie even adopts a china dog, the most useless and artificial substitute for love and friendship.

Linked to the role she desires of these animals are other "counselors" she meets. Most especially Goosie, a hunchbacked stage manager who is the butt of the boss's jokes, befriends Mazie, and advises her. Goosie is described as a mutt; he even sees himself as the cur of theater life. He is killed one day because of a thoughtless practical joke. Mazie, who takes care of all funeral arrangements, discovers in the experience that the show must go on. Most of the theater people begrudgingly attend the funeral and hurry back to work.

Through this experience, however, Mazie meets Parker, the press agent. He wants to make a human interest story out of Mazie's association with Goosie— primarily to change the truth of the story for advantageous publicity. Mazie refuses, but in her relationship with Parker she learns to appreciate books and knowledge. He educates her; and she provides the sexual inspiration he needs for his writing.

Through Parker Held introduces the theme of the corruptibility of art. Though Parker is bright, he uses his talents to make money. Truth is not the end result of knowledge for Parker; money is. He writes a "Cinderella" novel, as he tells Mazie, which he knows the public can not resist. In Parker's role as advertising man and popular novelist, Held explores the connections between art and artifice. These he connects to the early themes of youth and beauty as Mazie offers Parker the sexual stimulus he needs. But if Parker is corruptible, he still provides essential knowledge and experience for Mazie. For one thing, he tells her that creativity is linked to fear: that it is inferiority that drives people to create.

If Held played with the Cinderella story in *Crosstown*, he alludes to the fairytale he wants to adapt in *I'm the Happiest Girl in the World* (1935). In the epilogue he quotes:

"Well, in *our* country," said Alice, still panting a little, "you'd generally get to somewhere else—if you ran very fast for a long time as we've been doing."

"A slow sort of country!" said the Queen. "Now *here*, you see, it takes all the running *you* can do to keep in the same place. If you want to get somewhere else, you must run at least twice as fast as that!"

Alice through the Looking Glass

I'm the Happiest Girl in the World is another novel of success: that is, the main character, a small town girl from Duchesne, Idaho, makes her way from a part-time job in her aunt's millinery shop to the title of Miss Universe in Galveston, Texas. But, as is the case in *Alice through the Looking Glass*, her achievements require her "to run twice as fast." The overall effect is that of rear projection: the predominant irony in the novel makes her life real in quite the opposite way. And, again, Held suggests that making it to the top of the heap—even as a beauty queen—is lucky but hauntingly empty in the end. The realized dream damns the dreamer, short-circuits the vitality and creativity of the struggle for the goal. The real truth of such a life is the inner knowledge generated by the experience itself. Happiness, then, is the experienced action, not the resulting accomplishment or completed idea.

Much more than *Crosstown, I'm the Happiest Girl in the World* is conditioned by Held's fascination with the applicability of classical symbols. Just as he often defined art in his commercial work as a mysterious interplay of the classical and modern modes, so in this novel he takes a modern theme and depicts it through classical allusions. On one level, the novel is merely topical. Della Crump is a fitting example of the hundreds of girls who competed in local, state, and national beauty pageants beginning in the 1930s and of the small number who got breaks in show business as a result. By the conclusion of the novel Della has entered and won the Miss Duchesne, Miss Pocatello, Miss U.S.A., and Miss Universe contests, reckoning with the problems of sponsors, chaperones, subjective judges, and the unpredictability of such contests. Moreover, her experience provides an insightful commentary on the commercial world's *use* of the hopes and dreams of such women and of female beauty in general.

But Held stylistically takes the novel beyond its historical interest by developing the plot as if it were a mythological story, and using Greek allusions to add an interpretative depth to the story. In effect, the social milieu of the small town and the big city are likened to Athena in her declining days. Art (female beauty) is ostensibly honored for its own sake, but actually is a way of making money for regional advertisers. In a scene from Della's second contest, the announcer purposefully puts the girls through their paces several times, so that they appear frightened and sweating before their consuming audience and their banners are flashed again and again before the public. The appetite for female beauty is not an aesthetic one, and the girls appear as "Christian slaves," "goddesses," on the "sacrificial altar," and even as showgirls later on in a scene of Olympus at the end of the novel. Reinforcing these descriptive suggestions is a predominantly classical plot which, operating out of supreme irony, reaches the climactic moment by unwinding Della's fate. The idea of luck and chance and how they figure in Della's destiny is best explained in the idea of Greek fate.

The climax, then—that of Della being happily reunited with her childhood sweetheart, for whom she has saved herself throughout her rise to stardom—gives full meaning to the novel's title. And Held cleverly satirizes the ridiculous

and impossible nature of the happy ending by making it the result of a contrived plot, stylized, even as the Greeks rigidly fashioned their tragedies, to make the fully ironic point.

What this has to do with youth, then, is a fascinating commentary on the times. Held faithfully details the deception necessary to project the illusion of beauty, and this fleeting appearance is as temporal as youth itself. Held suggests that to idealize this form is only to make it ludicrous—that there is a vast difference between the projected image and the real values. On one level, the novel is a study in the destruction of values by a materialistic society; on another, however, it questions the immutability of youth as a measure of beauty. Because of their rather naive and often selfish ways, youth are easily manipulated and corrupted, and thus the meaning and significance of art is sorely questioned. Moreover, if in Fitzgerald the past cannot be repeated, in Held the present cannot be sustained. Youth is fleeting, intangible, in the end, not a dependable measure of a society's vitality. Knowledge is beauty and comes through experience that is predominantly ironic. Thus, Held is able to contrast the meaning of exterior and interior beauty in this novel. And the discrepancy between the image and the inner essence is a key. At the beginning of the novel Della hearkens to a motto in her mother's kitchen: "Virtue is its Own Reward." At the end, still virtuous (and virgin), Della is nevertheless a hardened veteran whose success is to a great extent a result not of her natural beauty but of her ability to win an audience. Even her role model, confidante, and chaperone, her aunt, who has a continuing affair with a married man, and other liaisons, during the novel, tips the judges to Della by her promotional tactics. It is primarily in the handling of the sexual awakening that Held addresses the full meaning of knowledge. Throughout the novel Della, who is anxious to make love to someone, says no to temptation by offering up reasons recommended by her mother and her aunt. In each instance the reasons are inappropriate or meaningless. Held suggests the essential futility of inflexible values. They are mutable as youth itself.

Held's last novel, *The Gods Were Promiscuous* (1937), treats the same themes of youth, beauty, and the role of the artist common to his previous novels. However, here the combination of these themes appears in another form and is even more autobiographical. Moving beyond the straightforward and wry narration of *Women Are Necessary* and the ironic buttressing of elements of sentimental and naturalistic fiction in the other novels, Held creates a fantastic yarn of a cartoonist who escapes the pressures of job and city life for the ostensible pleasures of the country. Unlike the former novels, centering on the status and personalities of women and their relationship to city life, *Gods* focuses on Jupe Plume, a professional man who is driven from what he has become in the city. Though told in Held's typical straightforward manner (the novel is third person omniscient, conventionally plotted), the reader's confidence first is rattled on page 3 where Jupe addresses his dog Pancho—and he talks back. From this point on the novel operates on the multiple levels of realism and fantasy and

contains elements of the romance, the popular sentimental novel, literary naturalism, and various archetypal themes. Because of the serious tone Held maintains throughout, the reader must enter into Plume's fantastic world, taking his cues for meaning not from the frame of the story but from Jupe's words and actions regarding these various levels of his life. Indeed, the disparate elements of the novel are united in Plume's personality, Held's autobiographical treatment of his own escape from the commercial world of cartooning. Imagination, the cartoonist's professional province, becomes a temporary respite in the search for physical escape which will insure peace of mind. The yarn is framed by a conspicuously absent teller whose elaborations come ironically through the illogical combinations of imaginative elements entered into by Jupe Plume.

Held sets the novel realistically at the beginning. Indeed, the topical base for the novel is post-depression America. Jupe Plume awakes in his third-story studio to the rich aroma of the Italian restaurant that occupies the ground floor. Jupe's friends include his constant companion Pancho, the dog, and a host of ex-vaudeville and off-Broadway people. Conflict develops when Jupe realizes he is attracted to a local stripper. He is further pressured when his editor of the syndicate publishing his cartoons summons him, for

> Jupe Plume was a cartoonist, a cartoonist who, but a few years back, had been a national influence; his drawings had been the vogue and had dominated fashions and customs. His pictures were a mirror of the period. They had been before the eyes of the nation on every billboard and in every publication; his brain children had been reproduced in toys and games. The name, Jupe Plume, had been a symbol, and remained a symbol of the era he depicted. (*Gods,* p. 32)

The editor muses about Jupe's chance for even greater success—with just a little more work and a few new twists, of course: "A little mystery perhaps, those sexy gals of yours all over the place. You know the way you used to draw those gals, a leg, a glimpse of lingerie. Can you see it? Sex—mystery—continuity. Maybe a good bit of kidnapping sequence. It's a knockout." Jupe resists the hype, explaining: "I had indigestion. My hair turned gray. I was trapped. I trapped myself with your bait. I bought a lot of expensive suburban land and built a big house. I bought a winter place in Palm Beach, but did I have any fun? No. I was too busy making more money in order to pay the taxes on my possessions. Never for a second could I do the things I wanted to do." (*Gods,* p. 33) The novel, then, becomes a way of explaining an inverse fable that Held creates. Matching the success stories of the 1920s (and indeed of the earlier Horatio Alger "rags to riches" theme), Held uses that well-known formula inversely to suggest that Jupe's success dooms his personal freedom and identity. Escape to the country is an escape to simpler times where the work ethic is not a dominant value. In the country there are—ostensibly—no demanding editors whose hun-

ger for success compromises their artists' work. Held thus incorporates auto-biographical and historical elements of his era; he explains in his inversions of themes the ironic consequences, personally and socially.

From this point on Held provides sufficient historical references to advance this realistic plot line. The novel, on this level, is closely akin to other depression novels, as Jupe Plume runs from success, society, and the entanglement of a woman into the country, where he is repeatedly mistaken for a bum, one of the innumerable men who traveled the country jobless and rootless in the 1930s. Jupe, who has witnessed the demise of Broadway and the slick commercialism of his own profession, is conned by a highwayman, works for a local farmer, lobbies for a milk strike (then helps break it), and even advises a gas station employee, who dreams of going to the city to become a cartoonist, to stay home.

The first of Held's themes emerges when this historical level of the novel is juxtaposed against classical names and events. Treating Jupe's escape to the country as a return to the pastoral, Held's character tells his dog he is "in search of new fields," the "Elysian Fields." He (Jupiter) has been a god of sorts in the commercial world, but his scepter (plume) had brought fame at the expense of freedom, just as his love of the stripper (Venus) had. Out of the city and in the apparently simpler country, Jupiter assumes new power. Just as the Roman Jupiter was god of the skies and purveyor of oaths, Jupe Plume rides a thunderstorm to save Farmer Jones's valley from the devastation of a milk strike and, with his special powers, gets a new pledge for top production from the milk cows. By-products of Jupiter's might are fortuitous also. In the wake of Jupe's thunderstorm Farmer Jones's daughter Pomona ("dewey but dull") and her suitor are whisked from their tryst in a haystack to the eye of the storm, where their love is consummated. Venus and her father, Vesuvius, get wind of Jupiter's whereabouts and follow him to the country. There Venus, merely a second-rate stripper snubbed by Broadway, blossoms in Jupe's eyes. Her father, in the city a retired professional fire eater and King of Illusions forced to perform on stilts carrying a sandwich board advertising the Blue Lunchroom, regains his old self and entertains at the local country fair. The novel ends with Jupiter marrying Venus in a "Feast of Hymen." The bacchanalian revel is attended by Guernsey "matrons," Madame Blanchette of the Italian restaurant (who caters the affair), and other characters from Jupe's bucolic countryside. Even the cartoon editor sends a note:

Mr. Jupe Plume:
 No doubt it will interest you to know that owing to my inability to sign you on a contract to do a feature cartoon for Fourth Estate Features, the Chief called me on the carpet and gave me merry hell. As I told you, and you already know, he gets what he wants, or else. He was very fair about it. All he asked, in lieu of my failure to sign you, was my resignation. Due to you, my dear fellow, I am no longer with the Fourth Estate Feature Syndicate, and I am just as happy

about it all, because I have found my true forte. I am now employed as customer's man for the Flea Circus, and after managing a comic strip syndicate for years, this present job seems very legitimate.

I am writing you this note to thank you for what you did for me in putting me on the track of happiness. . . .

(*Gods*, p. 245)

Through the classical and realistic levels Held deflates the theme of popular American success stories, for example the rags to riches theme. In its stead Held suggests another: success is personal and resides within the self. For despite the preliminary indication that the bucolic, the pastoral, or the country life is the Elysian Fields Jupe sought, Utopia does not exist in the country or the city. Certainly Jupe and his friends are rejuvenated in the country, but Jupe encounters the same problems there that he did in the city. Pomona, like the young gas attendant, wants to become an artist. Farmer Jones is dissatisfied with milk prices and initiates a milk strike that threatens the health of Americans across the country before it is ended, and strikebreaking federal trucks nearly destroy the bridges and fields of the "happy valley." Jupe learns of the hopeless ambiguity of values wherever human nature operates. At one point on Jupe and Pancho's journey, they fall asleep in a trailer that is parked at a filling station and are whisked away by a newlywed couple who have chosen to sleep in motel rooms during their honeymoon rather than stay in the trailer. Held juxtaposes classical and naturalistic imagery to spoof the pretentiousness of contemporary values. The secret travelers refer to their trip as "a breakfast of the gods" in a "phaeton," while the hopelessly role-laden drivers argue over the husband's marriage to the woman as an excuse to buy the trailer (when, she snips, what she really wanted was a mink coat). Jupe makes it clear that one cannot return to the pastoral life: "Agriculture is a pleasant thing if it weren't for the responsibility."

What Jupe does discover is that his escape from the city is really a search. "I question what happiness is," he remarks. "Perhaps I have left it behind." But Pancho tells him, "You thought you could find Utopia in possession." From the beginning of the novel on, Held establishes another level for interpretation. Like Don Quixote and his sidekick, Jupe and Pancho (Panza?) are characters in a romance, questing for the answers to the ageless questions of man. Leaving his possessions behind, including an enviable career, Jupe, in the manner of the hero of the medieval romance, sallies forth on a rather aimless adventure which turns out to be a journey of self-discovery. Like Cervantes, Held makes knight and squire complement, react to, and even become more like each other as they each represent aspects of philosophical problems. Advising Jupe to avoid sexual involvements with women because of the attendant responsibilities, Pancho says after vanishing for a few days: "A dog's existence approaches the ideal. We are housed and fed by a loving master, and when we stray or lose our homes, we are destroyed in an humane manner. We have but two seasons of passion and

thus are regulated, while you poor mortals know no fetter in sex. I think ours is the better life. We have our hatreds. We can vent our spleen on cats." (*Gods*, p. 25) Jupe is master, but Pancho is the witty guide. "Your conscience leads you in the ways of the world, my genius," the good dog says. "I lead you in the ways of your inner soul." Though Jupe is far from the intellectual Quixote, he is a creative genius who has believed in the dream of fame and economic success, but then in the ideal virtues of the more simple, pastoral life. Pancho's animal nature—his common-sensical earthiness—remind Jupe of his other self. Because of reason, Jupe ran away from his city life and the woman, Venus, but he realizes she represents the inner self he had denied. "Then it's clear to you now that all this escape was but from yourself?" Pancho asks. "I was running away from the part of me that was lacking, and in this Venus I find that part." "Ah, man is composed of all these missing elements that only woman can supply," acknowledges Pancho.

Held treats Jupe's mad adventures in the country as an avenue to discover the meaning of his artistic talent as well. In a comic episode suggesting the knight errant's passage from the city to the country, Jupe and Pancho encounter a talking goat, lounging in a thicket of wild grapes, just after they cross Washington Bridge. He chews their cigarettes, talks about the problems of cellophane and the rewards of marijuana, and as the two adventurers leave they hear a melodious sound, "just the breeze passing through the cockleburrs in his beard." But the unfettered life of the Dionysian goat—and the passionate side of nature it suggests—is later paralleled in Jupe's own description of his creativity as a kind of mad passion. "It is insidious, this want to express one's self in hieroglyphics," Jupe says, "the same as the lotus-eater yearns for company in his escape from reality." Though Jupe has told the goat he needs no narcotic—"I have the ability to conjure up my own dream world"—it is not until the end of the novel that in Venus he finds completeness and no longer needs to escape from reality. Venus has found completeness in Jupe's spontaneousness, as she says, and he tells her, "I sought the Elysian Fields, but it was you I really needed." However, in discovering symbolically his female, Dionysian side to complete his male, rational self, Jupe sees that the imagination need not be governed by commercialism or be an escape. It is, rather, a continuous quest.

As a novel that defends the rights of the imagination, *The Gods Were Promiscuous* suggests the relation between the quixotic spirit and the flight of the artist or the mood of disillusionment in such contemporary novelists as Sinclair Lewis, Ernest Hemingway, or James T. Farrell. Furthermore, the comic treatment of this expatriate theme unites the levels of the novel through startling juxtapositions of the incongruous. In bringing elements of the realistic novel, the romance, and classical mythology together, Held suggests that no one literary or philosophical framework aptly explains the human dilemma and, as W. H. Auden has remarked about a type of comedy: the relations of the individual and society to each other and of both to the true good contain insoluble contradic-

tions which are not so much comic as ironic. Therefore, the quest for Utopia as symbolized in the pastoral life in *Gods* is reminiscent of the highly sophisticated meaning of pastoral advanced by William Empson and employed by other twentieth-century critics. Empson says the pastoral is a device for literary inversion, a means of putting the complex into the simple, and of expressing complex ideas through simple personages. Interestingly, Empson finds this use of the pastoral in the proletarian novel. Held's treatment of the artist's struggle for psychological balance in 1930s America fits this theory.

Most critics of Held's short stories and novels missed his major points. A majority of the reviews reflected the dominant attitude of adults in the early 1930s: a wish to rediscover what was right with America, and an inability to accept any more criticism of it. Much of this attitude was centered on the change in youth. The public wanted to see the young as different from their 1920s counterparts—responsible, hardworking, dedicated. *Grim Youth* prompted the most criticism from this standpoint. Writes one reviewer:

> This reviewer cannot help wondering whether the younger generation is really as dull, stupid, churlish and shallow as Mr. Held makes it out to be.
> These stories, entertaining as they are, certainly belie the common cry that the world is getting better. Indeed, if our college graduates are, in the majority, such morons as slouch about Mr. Held's pages, we would tremble for the future of the republic. . . . But all Mr. Held has done is take the nit-wit as a college type, which he is not.[15]

But if the nitwit were not a college type, some writers worried that the accusation by Held went much deeper. "Are all adolescents so asinine?" asks one reviewer. "If they must all pass through that stage, would it not be kinder to chloroform my two young sons now and put them out of their coming misery?" Though that question is rhetorical, it masks the real issue which is the misery of this generation of fathers in admitting that youth may be, at its heart, and repeatedly (generation after generation) *grim*:

> In this work Held set forth his contempt for the younger generation. He has made his youth so grim that it fails to be youth at all. He has in a manner of speaking lost his balance. His irony has in the transformation from art to literature, taken on a new bitterness. He has issued a pitiless indictment. He has shown modern youth without mercy, without humor, without any of the softening attributes which might alleviate if not excuse the charges against it. It is a stark and disheartening revelation. It left us very unhappy.[16]

Yet another reviewer described Held's view in this manner: "The incongruity of its indolence combined with unrest, its callow assumption of mature ease denied

by fidgets of immature passion . . . on the whole, rather a pathetic world."[17] For these critics, Held's knife cut deep even beyond the contemporary or topical scene. They rebuked him for their own hopes and fears—many of them depended on youth as the future of a new America—for they expected a view solidifying and supportive.

But if there was an excuse for Held's attitude, it could be made on the basis of his being primarily an artist, the "transformation from art to literature" which allowed "a new bitterness." Readers expected what they had perceived in his popular drawings of the 1920s: "One would expect something rollicking, something a bit boisterous, something with delicious abandon which would prompt an involuntary giggle in the reader. Instead 'Grim Youth' is, if anything, a bit doleful and in spots not quite original."[18] The charge of lack of originality was yet another way to try to make sense of Held's stance. If his book could not be successfully compared to his former comic work and form, then perhaps he lined up in some significant way with other American writers. One critic headlined his review, "'Grim Youth' of America Goes Sad and Callow." He wrote:

> Those who felt, ten years ago, that the short-haired heroines and sad young men of F. Scott Fitzgerald's fancy represented the ultimate in disillusioned youth, will get a nasty jolt by reading "Grim Youth."
>
> In ten short stories that are as tersely revealing as his drawings, John Held Jr. shows ten young people of 1930 who not only haven't a moral to their name, but are shockingly lacking in manners and every attribute of civilization as well. These are, indeed, the saddest young men that American writing has yet produced. Vaguely they feel that something is wrong with themselves, but since they are as lacking in intelligence as honor, they do no more about it than utter callow cynicisms regarding life and love.[19]

Also comparing Held a number of times to Ring Lardner, critics tended to see the cynical tone of Held's characters as somehow translating to his own style. In fact, it was through analyzing this style that the criticism became tempered, even favorable at times. "Mr. Held has told his stories with extreme simplicity, in quick, nervous, sensitive, twentieth-century prose."[20] "Mr. Held proves himself as expert in verbal characterization as he is in linear."[21]

This connection to his former art shows at least a deeper understanding of Held's purpose. While many critics reacted to his characterization of youth as pervasive, others recognized the work as retrospective: an attempt to understand what went wrong with youth in the 1920s:

> We have moved a long distance from the starlit aspirations of "Seventeen" as recorded by Booth Tarkington. Even the frostbitten sophistication of F. Scott Fitzgerald's adolescents is quaint and outmoded. In the John Held cosmorama, the beginning of wisdom appears to coincide with puberty. By the time these

strange beings have reached seventeen their lives have turned to highway dust and cigarette ashes. JHJ has set them down without retouching, and the very casualness of his manner contributes in large measure to the forcefulness of the portraits.[22]

Indeed, this casualness—what another writer called the translation of his light brush stroke into glib print—is the key to Held's tone. Embraced as being "authentic" about the period, yet writing "brief and superficial" passages, Held, according to one critic, was accurate: "Youth is superficial and its emotions are brief."[23] The end result for at least one reviewer was to realize the import of Held's legitimized (but intentionally satiric) drawings of the 1920s:

> Now, as though to celebrate the passing of the phase that brought him fame and prosperity, he has expressed in words his true opinion of the very youths and maidens who inspired his popular drawings. In his short stories, collected under the pat title, "Grim youth," he bites the hand that fed him, and bites it with a savage relish. Those who read what he has to say about "Young Prometheus," "A Man of the World," and other awful adolescents will know how much of a bitter truth has lurked behind his laughably grotesque caricatures.[24]

Reviews of his other collections were limited. It is as if the newness had worn off and John Held, Jr., cartoonist now short story writer, was of little interest. Because *The Flesh Is Weak* and *Bowl of Cherries* are basically imitations of *Grim Youth*, they are interesting only in their sometimes varied characters and themes. Still fascinated by the transference of his talents from cartooning to writing, critics continued to observe that his "cynical brevity" came from a distillation of cartooning techniques. Also, writers saw that his "bitterly cynical attitude" was appropriate to his subject. "Held's narrative is terse and effective, his dialogue has some of Hemingway's staccato quality, but the book leaves one with the impression that the author has chosen only those superficial features of contemporary youth which lend themselves most easily to caricature."[25]

Critics, however, failed to recognize Held as a city novelist—that is, they missed the connection between his predominant themes concerning women, beauty, and art, and the urban scene. But his publisher did not. On every book jacket Vanguard published (and they published each of his novels), the blurb was itself the best criticism Held received during his own period. The editor wrote of *Women Are Necessary*:

> *Women Are Necessary* is a novel compounded of the most familiar ingredients— persons we are likely to see any day of our lives—an average girl from a medium-sized American town and the men and women with whom she comes in contact: a brush salesman, the manager of an A. and P. store, a filling station attendant, the cashier in the B. and W. Sandwich and Coffee Shoppe, a sign

painter, an accountant, a sailor on shore leave. Of this commonplace and even drab material Mr. Held has woven an impelling, heart-gripping story that definitely wins for him a place among the foremost writers of contemporary prose. . . . It is an intense and moving drama of American life, the product not of ancient sagas but of a chainstore age.

And, probably more interestingly, the *New York Times* picked up this familiar theme and added to it: "A sort of *Maggie, A Girl of the Streets*, brought up to date and fitted out with the accessories of our golden civilization."[26]

These novels, however, are not problem novels about the city.[27] If there is a didactic aim, it is skillfully buried within the depiction of the city as a physical place, an atmosphere, and as a way of life. Held's intention is not rhetorical, not a call for social action. Unlike Upton Sinclair's *The Jungle*, for example, which proposes a specific remedy for social evils, Held's novels are concerned with a total way of life. They explore the values and manners of the modern city and reveal its total impact upon human character and destiny. Unlike the writer of the problem novel, he interprets the city as a social structure, while the problem novel records, in a more photographic manner, only the symptoms of a particular urban disorder.

In this manner Held may be compared to Crane, Dreiser, Farrell, and Wolfe. While Dreiser thought he could "show up some things" and perhaps help to prevent them, his mature reflection about his work was that it was "picturing or indicating life" with no guarantee of changing it. He understood the purpose of the novel to be the expression of a personal vision of life, and not exhortation. In a preface to a bibliography of his work, Dreiser pointed out that his purpose was that of the creative artist—to recreate his "vision of life": "This is what living in my time has seemed like. . . . You may not like my vision . . . but it is the only one I have seen and felt . . . therefore it is the only one I can give."[28] Later writers, like Farrell, were more aware of the complexity of motives behind the city novelists' act of creation. Farrell saw that his purpose was to communicate a personal discovery about his work and that the primary function of the novel was to provide "aesthetic pleasure." As the writer reveals the confusions and disorder of modern life, Farrell argued, his art becomes an "instrument of social influence."[29] For Wolfe, this social influence suggests social implications symbolically to the reader; the novel is not a direct attack on a social problem.

As Held's novels show, there is a strong relationship between the social sense of the novelist and his aesthetic technique. According to Blanche Gelfant in *The American City Novel*, three forms of the city novel have emerged: the "portrait" study, which reveals the city through a single character, the "synoptic" novel, which, often without a hero, focuses on the city as the protagonist, and the "ecological study" which focuses on a small spatial neighborhood explored in detail. Though Held's novels possess each of these qualities, the most

common is that of the portrait novel. This novel belongs to the literary tradition of the novel of initiation—that is, a novel tracing a young hero's discovery of life and his growth to maturity. In the portrait novel the hero is typically a naive and sensitive newcomer to the city, usually a country youth, as in the fiction of Dreiser, Herrick, and Wolfe.

Structurally, the novel is built upon a series of educating incidents in which the city impresses its meanings, values, and manners upon the hero. As the hero responds to the insistent pressures of city life, his character undergoes a change; he learns what the city is, and this is his achievement of sophistication and maturity. He may adjust himself to an urban way of life and conform to its standards and seek its goals, or after he becomes aware of its social implications, he may repudiate it. The change in character, as a younger person either suffers inner defeat, achieves material success, or arrives at social wisdom, reflects the personal impact of urbanism. Since the portrait study traces a process of social conditioning, the narrative pace may be slow and the effect documentary. Whatever the form and the results of the conditioning, the forces acting upon the hero must be commensurate with the changes in his character. At its best, the form allows for a revelation of a way of life in its greatest personal significance, that is, in its effect upon the human character and destiny. It permits the reader to see and feel the environmental pressures that help mold, if they do not entirely determine, the moral identity of modern city man.

The major themes that come out of this stylistic approach vary according to the novelist. The comprehensive theme of city fiction is personal dissociation: the prototype for the hero is the self-divided man. Dissociation is a pathological symptom which results from, and reflects, a larger social disorder. This dissociated person has not found a way to integrate motive and act and so to organize his life's activities toward a continuous and progressive fulfillment of his desires. Contrasted to inhibition, which implies coercive pressure from an organized society, dissociation arises mainly because of the lack of social unanimity: the community has failed to provide a cohesive tradition that can guide the individual in his choice of goals and moral alternatives. The irony, pathos, and tragedy of city fiction come from this fact of dissociation. From *Sister Carrie* to works such as Nelson Algren's *The Man with the Golden Arm*, city fiction has portrayed man searching for a complete self in an urban world where personal integration or completeness seems to have become impossible. The failure of personal love, too, is both cause and consequence of this inner dissociation. Sherwood Anderson tried to show that an incomplete man cannot love; and a man who cannot objectify himself through relationships of love cannot be sure of his identity. If the failure to conciliate motive, perception, and acts is final, defeat is inevitable.

Yet if Held joins Crane and Dreiser in depicting the city as the arena where women's special dissociation is acted out, he differs from them significantly. With the exception of *Women Are Necessary*, which obviously comes out of the Crane-Riis tradition, the other novels focus on the city as the essential place where women can realize their inner and social potentials. Held recognized the

historical truth that urban culture alone provided the dynamism which allowed women to enter the work force, seek equal opportunity, gain fuller education, and find self-fulfillment. Yet the predominant tone in these novels is not one of ebullience, but rather a pervasive ambiguity. These novels must be seen in sequence, *Women Are Necessary* beginning a series of forays into a dangerous and glittering world that can both reward and defeat. In a sense, Edna, Mazie, Della, and even Venus are parts of the composite modern woman as Held sees her. She fits no rigid category of flapper, or liberated woman, or even impoverished emigrant; rather (if she succeeds, even partially), she survives the dissociating effects of the city and turns them to her advantage. For example, Mazie becomes a Broadway star, meets the man of her dreams, and happily marries; Della comes from the country and finds success in the city as a beauty queen; even Edna finds a degree of independence and meaning in her life as a result of the urban experience. Ultimately, however, Held's view of woman and city is ironic, for he sees them symbolically related. The same conditions that produce Edna's suicide essentially contribute to Mazie's success. Moreover, the values of the city Held finds not only whimsical, amusing, and fleeting, but meretricious as well. What is it *a woman* (during the period of his novels) can expect as success? The ridiculous role of a beauty queen, the empty and pretentious (and vicious) life of a Broadway star, the sexually potent but morally decadent life of a stripper. In the end it is the inner strength and beauty of these women that Held champions— their individuality cast against the way the city will use and conceptualize them.

In this significant way, then, Held creates an image of women in his novels contrasting with that of his period. Critics have agreed that the period is significant because the image of the woman as victim in American literature (in an era darkened by the Gibson Girl's shadow and including Stephen Crane's Maggie, Theodore Dreiser's Jennie Gerhardt, David Graham Phillips's Susan Lenox) was replaced by woman as the first great American grasping BITCH—that is, the flapper, as in Fitzgerald (Daisy), Hemingway (Bret), and Faulkner (Temple Drake), and others. But criticism of Fitzgerald, for instance, leads us to question just how completely the flapper was portrayed. As early as October 1921 John Peale Bishop wrote of Fitzgerald's women, connecting them to his "artistic conscience":

> He has an amazing grasp of the superficialities of the men and women about him, but he has not yet a profound understanding of their motives, either intellectual or passionate. Even with his famous flapper, he has as yet failed to show that hard intelligence, that intricate emotional equipment upon which her charm depends, so that Gloria (of the *Beautiful and the Damned*) remains a little inexplicable, a pretty, vulgar shadow of her prototype.[30]

Similarly, Paul Rosenfeld added four years later, just two months before Gatsby arrived on the scene: "What one does affirm, however, and affirm with a passion, is that the author of *This Side of Paradise* and of the jazzy stories does not

sustainedly perceive his girls and men for what they are, and tends to invest them with precisely the glamour with which they in pathetic assurance rather childishly invest themselves."[31]

As in the case of Fitzgerald, women were also a part of Held's artistic inspiration. But however much Held identified the flapper with urban materialism, he nevertheless treated her with humor and sympathy. His fiction was a reaction to the 1920s—the hollowness of success and the co-opting of changing attitudes through commercialization. But the fiction also reflects Held's ambivalence about the times. Though technically uneven, his fiction indicates that Held was conversant in several literary genres and as apt to combine them for effect or theme as he was in his artwork. This mixture tends to reinforce the ambiguity of the period, too, as grim truths emerge from the supposed carefree attitudes of the era. Held sought to plumb the glittering surfaces of the 1920s, perhaps because the caricatures in his cartoons were neutralized in the imitative period and thus rendered merely glittering surfaces themselves. His other major work of the 1930s—the Manhattan watercolors and the sculpture—are part of these environments, significantly unpeopled backgrounds that figure in his continued examination of the earlier period.

4

Watercolors and Bronzes
THE THEME OF THE COUNTRY AND THE CITY

In his last novel, *The Gods Were Promiscuous* (1937), Held's treatment of the city revives an old theme. Most of the action of the novel takes place in the country, in a modern pastoral setting complete with talking Dionysian goats, milk strikes, and lovely farm girls, and the promise of the good green earth and its residents mirrored against the disappointment and pressure of urban living. Yet, rather than suggest that the city alone is ugly, coercive, impersonal, and deterministic, Held—by introducing myth, social topics, and stereotypes—depicts Jupe Plume's and Pancho's escape to the country as parallel to their victimization in the city. In fact, the ideal of the pastoral turns out to be a ridiculous dream. The country rapidly is experiencing the same problems as the city. Cows go on milk strike, farmers destroy bridges to hamper strikebreaking truckers, farmers' daughters are as easily ravished in haystacks as city girls are in town automobiles, street hawkers are alive and well on country roads, a young man—a gas station attendant—even dreams of becoming a rich and famous cartoonist and going to the city to make his fortune. One wonders: have the evils of the city emerged in the country, corrupting its original pristine condition? Or did the country possess the potentiality for modernization and, hence, corruption, all along?

Held never quite answers these questions, though the novel ambiguously depicts the condition and interrelationship of the country and city. Yet the novel suggests that the city once was seen—even as the raw country was—as new found land, a place for new beginnings, for the successful exercising of those supposedly most American characteristics: independence, self-reliance, and ingenuity. The connection between the country and the city, therefore, is evolutionary in nature. Once exercised on the raw frontier, these characteristics help build civilization and cities. The irony comes, of course, when the city is a place so developed, mechanized, and material that the expression of such qualities of character is impossible. But the hope of regressing to an untainted place for development—by returning to the country—is impossible. Society has prog-

ressed past the pastoral. Immediately any new landscape is transformed into the modern one, with all the problems and characteristics of modern civilization.[1]

This dilemma of the ambiguous relationship of the country and city (both as physical places and as states of mind) was a major theme during the decade in which Held's novel was written. Held's last novel introduces the theme, but the work which most consistently addresses the idea is his serious artwork. His watercolors and bronze sculptures most consistently demonstrate his interest in this theme. Because 1930s America was a period in which artists were struggling to create a regenerative new regionalism, expressive of the significance of the country and the city in American life, Held's perception of this theme in the watercolors and bronzes of this period contribute to the study.

Held's idea of the city and its meaning in American culture during the 1930s is treated in a series of watercolor cityscapes (1934–36), but the beginnings of this depiction began in his landscapes and their evolving subject, style, and theme. Aside from the linocuts which Held executed for various purposes from his youth until the late 1940s, watercolor was his most persistent and natural medium. Its mercurial nature suited his incisive eye and quick and invariably sure hand. From his first depictions of Salt Lake City theater life in the 1900s to the rich and exotic pure landscapes of Central America in the 1910s, to the sensitive paintings of Florida, New York State, Connecticut, Canada, California, and Utah, to the lonely and lovely cityscapes of Manhattan in the 1930s, the ready portability of the medium served him well during the peripatetic years of his creative life. Of all the media Held attempted, watercolor proved the most versatile, able to accommodate his stylistic experimentation, his moods, and the inherent variety of American life he viewed. While to a degree the artforms dictated by his early training (the linocuts), by his capacity for commercial printing (his comic pen and inks—black and white), and by his interest in sculpture were essentially rooted in his expert draftsmanship, watercolor allowed him to study light, and hence color, texture and composition. Held's manipulation of these variables make his canvases fascinating interactions between the world and the world viewed. In each Held painting we are aware of a subtle tension between the subject and the artist's perception—*how* each meets in the membrane of the canvas.

Exemplary watercolors examined chronologically give us an idea of the variety of style and subject, and an idea of Held's knowledge of the work of major artists in the field and the subsequent basis for his thematic use of each. His earliest known work, mixing pencil and watercolor, is of the Salt Lake City theater. Dated in the 1890s when Held was a child, both *Girl Dancing on the Stage* and *Performer with Hoops* are impressionistic: Held seems to have chosen watercolor for its ability to suggest movement, flow, and gaiety in *Girl*; in *Performer* the medium adds the hint of color, and hence, life, to the dominant and more precisely penned stage, performer, and audience. One may even argue that these two styles represent a divergence that would later manifest itself more dramati-

cally: *Girl* is predominantly watercolor, deriving its life and meaning from the medium itself; *Performer* is illustration, a drawing merely colored in. The first creates a dominant mood. The second is illustrational, bordering on realism and suggesting the close relationship between Held's later cartooning and illustration as caricature.

During his tenure in Naval Intelligence and as a cartographer and artist for the Carnegie Institute in Central America (1916–17), Held treated some landscapes in this illustrative mode. His depiction of Palenque, for example, is outstanding for the precise use of the pencil and the vibrancy—one assumes the verisimilitude—of the color. While Held was employed to record the expedition's discoveries, the extant watercolors show how closely he linked illustrations and mood. As Sylvanus Morley noted in his journal of the exhibition, Held was as concerned with how the color was applied—the type of brushstroke—as with the color itself. Most of the paintings from this period are bold and naturalistic because Held replaced the accuracy and the outlining abilities of the pen or pencil with the brush itself. Strokes dominate. Hence, color is often the primary communicator of the scene.

Held continued this experimentation with both the illustrative or realistic mode and the atmospheric in the later watercolors of the 1920s. He achieved a tension between both by using a media and techniques in new and unexpected ways. In *Tapestry Rocks and Pines* and *Marshes* (generally dated in the 1920s) he experimented with watercolor and gouache, adopting the poster paint of his illustrations to a different purpose.

In *Palenque* (May 18, 1918), Held adopts another technique—a pointillism which derives in part from the descriptive quality of the leaves of the trees in the picture. The foreground is washed in various greens, and the trees rise as the only particularized part of the painting. In *Leonia, N.J.* (1918), Held dramatized this same effect, deriving it not so much from the prerequisites of the landscape itself but from a desire to affect the landscape. Each element of the picture is distinguished by a pointillistic style so that the whole effect of the picture is impressionistic. Only the variances of the breadth of the strokes and the flatness of the sky create perspective and depth. The same effect is utilized in *Studio on Hill with Goats* (ca. 1923), so that the overall result is that of a flattened stitchery. The *Palenque* canvas that began with this style because of its appropriateness to scene has now evolved into the depiction of an idea. *Studio on Hill with Goats* looks like a piece of folk art. The style was later refined again in *Lac St. Jean* (September 4, 1931), where Held mixed pointillism with flat, broad strokes to distinguish trees and background from sky and water.

Experimentation with composition as well as texture indicates Held's familiarity with techniques of other well-known watercolorists. In his range of subject and style he demonstrated knowledge of outstanding watercolor painting prior to and during this period. Though he had no formal training, there are definite correspondences between several of his works and those of Winslow Ho-

mer, John Singer Sargent, and Charles Demuth. The early watercolors, *Fallen Tree and Lily Pads*, *Canoeing*, and *Reflections* were painted in August of 1919, when Held was on a trip in the Adirondacks. They may be among his first watercolors of the Northeast. The color and composition of these works recall the later watercolors of Winslow Homer. Held's *Dappled Lake* (July 1931) is reminiscent of some of John Singer Sargent's watercolors at the height of his impressionism. Held uses bold yet transparent strokes in order to utilize the white surfaces of the paper. In his flower watercolors, done toward the end of the 1930s in California, Held recalls the work of Charles Demuth in his composition and daring use of the white paper as part of the image and its background. In the composition of his cityscapes (as we shall see later) Held bears comparison with Georgia O'Keeffe's city paintings. An example is O'Keeffe's *Radiator Building— Night, New York* (1927) with its perspective of a lone building centrally placed, viewed from above and filling up the sheet. Held's perspectives from the Barbizon Hotel are analogous to O'Keeffe's paintings from the Shelton Hotel. As for the context of certain schools of painting, Held was fond of mixing styles or transferring a style deemed appropriate from one medium to another. *Tapestry Rocks and Pines* and *Marshes* demonstrates the characteristics of a distinctive style he developed by mixing watercolor and gouache. The paintings done in this manner, though generally not dated, probably belong to the 1920s. Held was adept at using gouache or poster paint in his illustrations and travel posters, and adapts it to a different purpose here.

By the end of the 1920s Held's landscapes—despite their variousness—exhibited a number of commonalities comprising his watercolor ethic. Primarily, he created an emotional level in the paintings through the manipulation of composition, color, and white paper surfaces. An example is *Water Island*, in which his composition is original almost to the point of audacity. Against a bleak mountain lake and sky a jagged leafless tree thrusts itself like a dagger, looking as if a thousand gales have torn it, stripping it of grace and bloom; its twisted roots grip the rock with the defiant strength of triumph in defeat. Almost equally startling is his untitled sketch in which a densely foliaged promontory casts a profound shadow in the mountain lake beneath it; to the left the white paper surface is left untouched except in the wake of a little sailboat. The transparency of northern waters for pale radiance and shadow is expressed with daring ease.

A key to Held's creation of mood is the management of flat surfaces. In many of the Central American sketches a purple-blue sea meets a wide stretch of beach, above them a cloudless sky. To the right a flight of birds introduces a beautiful soaring line into vast monotony. Another scene (untitled), all in gray-green tones, of flat Long Island country is accented only by a few shacks and telegraph poles; yet such level unbroken dunes establish far reaches of vision unbroken by obstructing forms.

Another method of creating mood is his full use of transparent washes. He gives a rich bloom to dense foliage and shadows; by an inspirational use of white space he keys his work in high silvery tones. His expression has the inevitableness of instinctive talent which arrives at the first stroke like a skilled swordsman's thrust, thus avoiding the muddiness of mulled-over impressions. As Catherine Beach Ely notes in her article on Held's watercolors in *Art in America*:

His color is applied in "transparent blots" just as the masters of aquarelle have always applied it, and each blot is a flower of creative imagination. His sketches are an emotional record, yet free from overemphasis or overelaboration. His composition is not less well balanced because it is unusual. His foliage masses have richness but no redundance. He achieves a purity of light without thinness. He makes shadows atmospheric, neutral tones significant, and gradations convincing. His line is crisp and true. His work rests on the foundations of good draughtsmanship.

He has a preference for lonely scenes with very little that suggests human or animal life; few incidents of any sort are introduced—these few do not detract from the solitary impression. He is inspired rather than repelled by isolation. Even in one of his sketches which is tinged with the gaiety of human life and traffic we feel man invading nature but not making her his own. The pallid lake and sky hold a few vague shadows: stinging bits of color are introduced by the lake craft—russet, intense blue and peagreen. Here and there a tiny boat poises atilt like a vivid butterfly, and the steamer moored to the little wharf is colorful as a bright-plumed bird. The scene has the delicate vitality of creation fresh and unsullied: man's audacity has penetrated but not conquered austere seclusion. In this sketch as in his others the artist has not used nature as a tool to express eccentricity or personal creed, but Nature had gripped him, using him as an outlet for the impetuous surge of her pure essence.[2]

By the time Held executed his New York cityscapes, he was an accomplished watercolorist, critically acclaimed, and master of styles and techniques creating a pervasive mood. Beyond that, his watercolors reflected thematically his peripatetic nature; like so many lovers of landscape, his forms were an attempt to distill the spirit of place—the indwelling essences of varied climates and locations. Each of these places was a frontier—aesthetically and personally. Watercolors were a traveling medium, his means for celebrating and collecting the feeling of place. Held titled the major watercolor show during his lifetime "The Grand Canyon of the City." The title suggests he shared the thematic idea of the city as a frontier with earlier artists who created an "urban sublime" in their cityscapes. Of New York in particular, Joshua Taylor notes in his chapter "Urban Optimism," in *America as Art*: "In its [New York's] image an aesthetic impulse and a social reality came together. The art they represented did not actually grow out of the city . . . but brought the city into a new sphere of mean-

ing."[3] Eventually, in the aesthetic assessment of cities, the city was seen as an expressive form, and such vision would actually have an influence on how cities looked.[4] Taylor suggests a level of synthesis not only of the artist and his subject, but of the work of art and its audience's reaction as well. Likewise, Louis Lozowick, in his essay "The Americanization of Art" (1927), saw a permeable relationship between culture and the city:

> The dominant trend in America of today is towards an industrialization and standardization which requires precise adjustment of structure to function which dictate an economic utilization of processes and material and thereby foster in man a spirit of objectivity excluding all emotional aberration and accustom his vision to shapes and color not paralleled in nature . . . beneath all the apparent chaos and confusion is a trend toward order and organization which find their outward sign and symbol in the rigid geometry of the American city: in the verticals of the smoke stacks, in the parallels of its car tracks, the squares of its streets, the cubes of its factories, the arch of its bridges, the cylinders of its gas tanks.[5]

Lozowick recognized that the functional geometry of the machine fostered, in its reassuring clarity of form, an optimistic faith in a rational future. He more importantly noted the creation of a new reality in the industrial landscape. The "shapes and color not paralleled in nature" became the basis for new thought in which the hierarchy of physical, perceptual, and ideational peaked in the skyline ethic itself.[6]

Wayne Attoe, in his *Skylines: Understanding and Molding Urban Silhouettes*, reaffirms both Taylor's and Lozowick's observations. A member of the School of Architecture and Urban Planning at the University of Wisconsin-Milwaukee, Attoe, in his analysis of skylines as collective symbols, social indexes (utilitarian in nature), skyline aesthetics, skyline rituals, and skylines as icons, confirms the multi-level functions of American skylines. He notes, for example, that as expressive forms skylines inspire the variables of depiction we may note in the works of Stieglitz, Marin, Sheeler, and others. That is,

> lighting and atmospheric conditions can transform the detailed reality of a skyline into sculptural abstraction. When backlighted, or when haze obliterates evidence of window details, structural system, and materials, buildings become shapes that can be enjoyed for their essential, scale-less, formal purity. One reason skylines are popular as subjects for photographers and other artists is that they can so readily be transformed into visually rich abstractions.[7]

Thus, Attoe categorizes "skyline aesthetics" as (a) rhythm; (b) harmonious fit; (c) netting the sky; (d) layering; (g) framing; (h) dramatic approach; (i) sequential revelation; and (j) metaphorical seeing. In any of these treatments the skylines can become "icon":

In view of the value attached to and found in skylines—their role as cultural indexes and collective symbols; their association with social rituals; their occasional unearthly beauty—it is not surprising to find that they sometimes are transformed into icon-like objects, idealized objects which are venerated and which are imbued with the power to intervene in men's lives.[8]

In 1927 Lozowick identified the relationship of the actual skyline—the city itself—and its iconic and therefore aesthetic recreation as a synthesis, a kind of new regionalism for the period:

A composition is most effective when its elements are used in double function: associative, establishing contact with the concrete objects of the real world, and aesthetic, serving to create plastic values. The intrinsic importance of the contemporary theme may thus be immensely enhanced by the formal significance of the treatment. In this manner the flowing rhythms of modern America may be gripped and stayed in its synthesis eloquently rendered in native idiom.[9]

With the depression and the 1930s, however, this new regionalism resulted in an altered view in statements about the city as the previous optimistic and grandiose statements about it changed. Artists such as Hirsch, Stieglitz, and Sheeler commented on the reality of the city, thus denying it sublimity and iconographic power. Sheeler's prosaicness, Charles Demuth's studied irony, and Stieglitz's frontal neutrality were pictorial ways of changing plastic values, thus commenting on changing attitudes about the urban world.

Held proved artistically cognizant of both these traditions. And, as in the case of so much of this work, he noted the irony of the diminished icon—what happens when the sublime ideas of one period are canceled by the next. Because he had personally experienced both the energy and the enervation New York City life could bring, his landscapes of the city's skyline in the late 1930s reveal an attitude about plastic values and the actual city itself. Seeing the city as Grand Canyon is particularly ironic in Held's hands: America's new frontier may be the city, but this urban frontier is empty, haunting, and unregenerative.

Held achieves this synthetic new regionalism in part through the apparent photographic nature of his cityscapes. There is a stunning similarity between Held's *Lavender Cityscape* (1934) and Stieglitz's work of the 1920s. This is particularly evident in the Graham Gallery catalog *The Watercolors of John Held, Jr.*, in which *Lavender Cityscape* is reproduced in black and white. As in Stieglitz's photographs of New York City of this same period, the composition displays a structural ecumenism; no one building is given more visual weight than another. Indeed, the framing has a randomness about it. Held runs the two tallest buildings off the canvas. There is a refractoriness to these buildings so that they appear both real and abstract. But gone is the hazy sublime or romantic aura promoted both by point of view and by atmospheric conditions in the earlier Stieglitz. Held paints from the heights so that, as Attoe says, "one is in charge

of, not a victim of, the city."[10] This controlled perspective generates a quality of unblinking stillness about the painting. There is no wonder here.

But if Held's *Lavender Cityscape* appears simply neutral, maintaining a tension between black and white that suggests both the abstractness of the city as conception and idea, and its mute documentation, then what about Held's use of color? or more generally, of the medium of watercolor itself?

Typically, as critics and watercolorists say of their medium, we expect an element of unpredictability. Monet once claimed that to him painting was like throwing oneself into the water to see if he could swim. This is particularly true of watercolor painting: it presents a challenge which is always assuming different guises because of the nature of the subject and the conditions (watercolor, more than other media, is affected by the environmental conditions, heat, humidity, etc.). Therefore, the painter quickly learns to match his versatility and resourcefulness to the prevailing conditions. Too, requiring such quick decisions, this medium demands that its form be given its appropriate expression at once. Some adjustment is permissible, but essentially watercolor requires careful deliberation, an imaginative projection of what the painting will look like, and rapid, sure execution. One can work only in comparatively short spells of an hour or two because the concentration required is so intense. Yet, because of these demands of the medium, watercolor, more than any other medium, can convey a sense of suspended animation: it can imprison those moments when things are in transition—the sun appearing behind a bank of cloud, a figure stepping out of a shadow, a bird darting out of a thicket. By bringing these elements into focus it seals them for all time by setting them in equipoise with one another, thus defining the constant within the transient. Finally, watercolor possesses a quality of mobility. Unlike the opaque methods of painting where the forms are built up in separate touches, watercolor allows color to be drifted across the surface with changing momentum and density, just as a skillful skater will feel the surface of the ice, sometimes speeding across in great skimming movements, sometime hugging the surface, or contrasting short weaving movements with long glides. In a similar way the skilled watercolorist reacts to and is aware of the surface of the paper, which is never an anonymous, inert place. This change of momentum is, as it were, frozen onto the paper, and, calligraphic in essence, it bears the mark of impulse in perpetuity. At the heart of all this lies the essential simplicity of watercolor: it has the ability to convey information or mood or emotion directly, without the fuss or interpolation of any complex means or medium. And because of this quality, one assumes that its message may be quite unambiguous.

Held worked on his audience's expectation—that watercolor is unambiguous and direct—by emphasizing the photographic qualities of his pictures and rooting them in the concrete world. And by playing this quality off against romantic assumptions about color, he established an ironic tone. Held once commented, in fact, that the city from the heights was romantic:

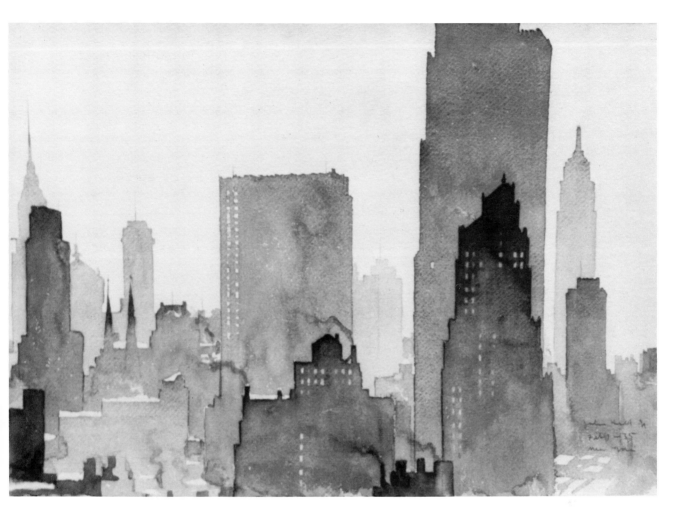

Manhattan Skyline and RCA Building, February 1, 1935. Permission of Illustration House, Inc.

To fly high and look down on the great city with its deep traffic lanes, surging with thousands of motor cars and millions of people and all the tall skyscrapers pointing up at me; to see the smoke make dancing shadows on the roof tops; to watch the light change and make lovely colors in the dim canyons; to see the wide rivers on each side of the city with the queer-shaped boats cutting silver streaks in the water; to fly high and see all this at a glance is romantic, and don't let anyone tell you different.[11]

The speaker, we should add, is a pigeon in a story from *The Flesh Is Weak*, but since Held spent time on the roofs of New York and was for a period fascinated

by the training of homing pigeons and their world, the voice is not surprising. What is important is that the point of view is a glance—a panoramic look—and that is the quality that makes it romantic. When we examine Held's use of color we note that not only are the landscapes precise—and therefore the look specific—but the high pinks, blues, lavenders, greens, and yellows verify that these pictures are studies in light. The titles of the paintings clarify this as well: *Manhattan Sunset* (March 25, 1934); *Red Manhattan* (ca. 1936); *Manhattan Dawn* (March 1936); *Morning* (1936); *Midtown Morning* (March 25, 1936); *Smog* (March 1936); *Golden Empire State Building* (March 1936); *Cityscape with Chrysler Building* (November 17, 1934); *Lavender Cityscape* (November 10, 1934); *Skyscraper in Shadow* (January 25, 1936); *Cityscape in Fog* (March 1936); *The Empire State Building* (1936); and *Blue Landscape* (undated). In each of these, techniques and color serve to suggest ironically that these buildings are primarily surfaces and that aesthetic interest could only be engaged by their shapes and absorption of light. The energy so characteristic of Stella and Weber canvases is gone, canceled out by the motion created, not by machine or building shapes, but by the wash of color upon them. Movement in these canvases is simply diurnal. Otherwise, the city is dead, silent, empty.

Thus, Held fashions his watercolor cityscapes so that they cancel out—or rather show the limitations of—each of these above-mentioned attitudes. Throughout these cityscapes—without exception—his point of view is one from the heights, almost at eye level with the major building in each picture—for example, the Empire State Building. Though we know logically that no building at that time was on eye level, Held creates a perspective of democratic viewing. One is struck by how, simultaneously, he looks down upon the remainder of Manhattan while being on a par with its tallest buildings. Thus, the lyrical, dramatic, and sublime moods created by angular or lower angle perspectives are neutralized by this position. Moreover, such romantic reactions are impossible in such a static, abstract canvas.

But the trick to these watercolors is that the viewer is encouraged to have the typical reaction. Bright and pastel colors, soft washes and hues, promise initially a romantic picture. When one perceives the geometrics of these canvases and the stasis of the abstractions, the temptation is to see them as modern—to embody the energy, agitation, and excitement provided by the picture's abstract qualities. Yet that too is neutralized. And the result is that the order, clarity, and timelessness represented by former painters of the city in this mode are depicted by Held as merely a mirage.

Held's cityscapes suggest that the city is a closed frontier and that in its overweening idealism American life can also possess tragedy. Harold P. Simonson, noting that many Americans have a difficult time admitting that fact about even their own "dark" writers (for example, Melville, Dickinson, Hawthorne), has advanced a theory of American tragedy based on the closing of the western frontier. He says:

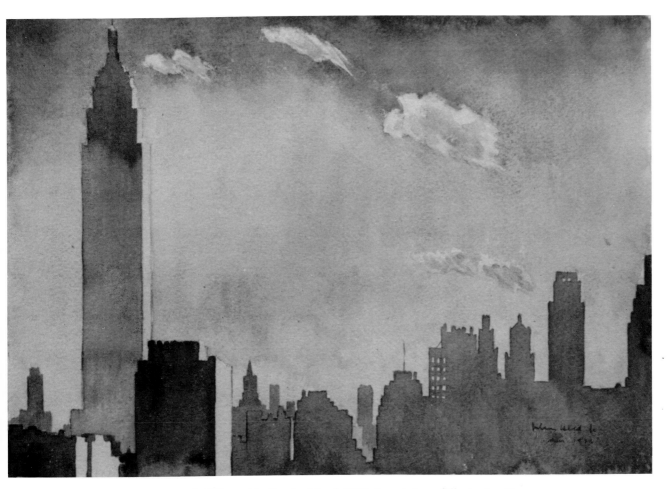

Empire State Building with Clouds, March 1936. Permission of Illustration House, Inc.

Long before Turner made his fateful announcement, James Fenimore Cooper showed that for epical Natty Bumppo the frontier was closed at last, his Edenic sanctuary crudely invaded by the rapacious Ismael Bush. What Hawthorne wrote concerning man's spiritual malignancy struck even deeper levels of tragedy. As for Melville, his universe consisted of walls, his main effort being to strike through them. His greatest stories such as *Moby Dick*, *Pierre*, "Bartleby the Scrivener," and "The Encantadas" take their structure and meaning from this metaphor.[12]

Held lived at the beginning of an era which we now see as "the broad daylight of the post-Freudian and post-Christian world, sinless . . . quite cold, be-

yond comedy, beyond tragedy." Yet, like Fitzgerald, he was still enough a part of the imaginative, hopeful world of the artist to recognize this tragedy and the necessity to keep striking at the wall. Fitzgerald described this action another way. In "My Lost City" he describes the evolution of New York: "There again was my lost city, wrapped cool in its mystery and promise. But that detachment never lasted long—as the toiler must live in the city's belly so I was compelled to live in its disordered mind."[13] The greatest tragedy comes when the writer or artist realizes that the walls, at least upon which one could write, were after all, mirages. Fitzgerald concludes his essay:

> From the ruins, lonely and inexplicable as a sphinx, rose the Empire State Building and, just as it had been a tradition of mine to climb to the Plaza Roof to take leave of the beautiful city, extending as far as my eyes could reach, so now I went to the roof of the last and most magnificent towers. Then I understood—everything was explained: I had discovered the crowning error of the city, its Pandora's box. Full of vaunting Pride the New Yorker had climbed here and seen with dismay what he had never expected, that the city was not the endless succession of canyons that he had supposed but that it had limits—from the tallest structure he saw for the first time that it faded out into the country on all sides, into an expanse of green and blue that alone was limitless. And with the awful realization that New York was a city after all and not a universe, the white shining edifice that he had reared in his imagination came crashing to the ground.
>
> Thus I take leave of my lost city. Seen from the ferry boat in the early morning it no longer whispers of fantastic success and eternal youth. The whoopee mamas who prance before its empty parquets do not suggest to me the ineffable beauty of my dream girls of 1914. . . . All is lost save memory, yet sometimes I imagine myself reading with curious interest. . . . For the moment I can only cry out that I have lost my splendid mirage. Come back, O Glittering and white![14]

Rather than rhapsodize about such a loss, Held apparently never nostalgically reconsidered the city and what it represented to the teeming 1920s. Perhaps it is because he experienced both its glittering promises and its rapacious meretriciousness; certainly his life as a popular artist during that decade is representative of the exceedingly talented who were trapped by their own commercial successes and sometimes denied full recognition as artists. Held's western youth, his coming East to make his fortune, certainly is a kind of expression of the Turner thesis in reverse; yet what he loved most and perhaps valued most, a kind of connection personally and through his art to land, animals, his western past, could not be translated into the Grand Canyon of the city. Even his attempts to maintain farms while working in Manhattan did not really result in a balance between the two worlds or two states of mind. No wonder that Held turned to a very classical, static, and powerful form—sculpture—to express this duality of his need for the stimulation and values represented in both urban

and rural life. It is worth noting that he would continue through various genres to recreate worlds which not only provide commentary on the ideas and struggles of his time but provided him a kind of stability himself—a world of his own to live in.

If Held's inversion of the urban sublime in the 1930s cityscapes depicted the tragic end of the city as new frontier, he, along with several other American artists proclaimed America's usable past in their contemporary treatment of regional subjects and themes.[15] Whereas his watercolors captured the city silenced in its idealistic view, he turned to the strong, seemingly more static form of sculpture to depict positive regional ideals. Lozowick's "native idiom" appeared in a body of New Deal art created during this period, in which artists rediscovered the American rural past, thus restoring concrete values and satisfying the nostalgia of the times. For example, mural art celebrated historic America by centering on certain specific heroic events and peoples. Though this art has been called documentary by some critics, Karal Ann Marling argues it was most notably mythical: it rendered even the most specific subject archetypally.[16] This art thus comprised a search for mythic and symbolic sources of identity in the American tradition. The credo of this group of artists was to discover the forms in which people have experienced the world—the patterns of life and the symbols by which they cope with the world. Though Held was never a New Deal artist in the sense that he worked on such projects or was subsidized by the government, he nevertheless turned to similar regional and mythical themes in his sculpture. Treatment of images of America's past by combining naturalistic and classical styles suggests his desire to concretize certain American qualities that have symbolic referents in other cultures. His animal sculpture, in its mythological and realistic aspects, indicate a celebration of pastoral ideals almost lost in America's romance with the urban world.

Certainly a major prerequisite of such art was that these forms be accessible to the public. One argument about the failure of modernism in America is that its preoccupation with form over content ultimately confused or destroyed meaning. This struggle by a generation of artists educated in the wake of the Armory show is best articulated by Wendell Jones in "Article of Faith" (*Magazine of Art*, 1940). Drawing upon his varied career as a muralist who had plumbed both historical and contemporary themes, Jones cited *style* as the tool both for answering profound social questions and for transcending the merely political. His formula for contemporary epic painting is worth noting because he pinpoints the dynamic, positive aspects of what artists of the 1930s hoped to accomplish through the iconography of myth:

> Mural painting seems to me to give the opportunity to paint symphonically, a range of great scope being possible on one surface. The building itself is the frame and the surface, and only the epic seems worthy of such dimensions. It challenges the broadest spiritual awareness. The building itself is part of the life

of the community. The painting, therefore, must be contemporary and rise out of the spiritual reservoir of that community—a reservoir consisting of nothing more than an unrecorded Indian battle that was fought along the river long ago. Even the statistics of local industry seem to develop into a reservoir from which people get their sense of continuity and self-esteem and faith. It is often evident that the artist has searched the personality of a community and brought forth a costume piece, so difficult is the task of making an epic. Greater still is the task of being contemporary, especially when the din of destruction is destroying the sense of continuity. I believe that mural paintings must explain themselves on such common ground with the onlooker that only a title is necessary, if that, to make it understandable and stimulating to a great range of reflection. Epic *and* contemporary. It is perhaps impossible. The spiritual reservoir of society has countless memories which have given man faith, courage, hope, strength, and a sense of the abiding goodness of life. But what is the contemporary part? It seems to me that for the muralist it is the pageant of social intercourse, not the self-conscious and heroic but the simple functions of man's contact with man in cooperation and trust. These are contemporary epic possibilities. . . .[17]

But as Jones sought a way of reconciling pictorial values and historical truth, the critic Harold Rosenberg identified the artistic dilemma for an artist who chooses to tap his audience's imagination:

In the '30s, American art had become active, having gratefully accepted from politics an assignment in changing the world. Its role was to participate in "the education of the masses." Painting and sculpture were to overcome at last their bohemian isolation and gain an audience of ordinary folk. . . . An enticing outlook—except that practice was to disclose that to educate the masses the educator must himself take on the essential characteristic of the masses, their anonymity.[18]

For the New Deal painter there was danger of assuming stylistic anonymity. He invited a mass audience to read his work in "the language of the streets." While Jones no doubt sought to cope with a different order of truth, there was a chance that because this truth struck at the fundamental roots of the emotional life of a middle class audience he aimed to serve, it might ultimately appear, as one critic assessed it, as a ceaseless recitation of "New Deal fairy tales."

Like Wendell Jones and other New Deal artists and critics, therefore, Held privately sought a medium to explore the mythical level of regional subjects without creating "New Deal fairy tales"—cultural half-truths serving as opiates for a mindless public. Held saw in mythological traditions certain truths about American society generally forgotten. Rather than create a new mythology, however, he plumbed old ones signaling references to America's historic rural past. By primarily depicting work and farm animals (goats, horses, dogs) in a style combining the naturalistic and classical, Held initiated what Wendell Jones

professed in his "Article of Faith": he created pieces both contemporary and epic, capturing the remembered archetypal actions (suggesting the abiding goodness of life) which are daily reenacted. He suggested these animals, familiar to rural and regional life and to the history of America's development, as symbolic of stability and dignity. As an American in the 1930s who had suffered the peak and the crash, Held saw these animals as America's "usable past," suggestive not just of her agrarian roots but of her affinities with Western civilization. Moreover, he distinctively treated the bronze sculpture so that his work suffered none of the "stylistic anonymity" Harold Rosenberg criticized the era's artists for.

Held worked in what critics of his time identified as the animalier tradition.[19] In general, the German school of animaliers broke free from the more naturalistic concepts of the nineteenth-century French school. The ideas expressed by Tuaillion and developed by Gaul culminated in the work of Renée Sintenis, who kept alive the spirit of the animaliers in the years after the first World War when the majority of sculptors everywhere were abandoning impressionism in favor of cubism and surrealism. Renée Sintenis is regarded as the finest animalier sculptor to have appeared in Germany in this century, a worthy successor to Gaul. Her animal figures differ radically from those of Gaul; whereas he preferred his masses compact and static, she was always concerned to depict movement and action. In her earliest work the surfaces of her sculptures were relatively solid, but later she adopted greater freedom in modeling. Her later work is almost impressionist, although carefully controlled in its smallest detail. Although Miss Sintenis has sculpted animals of all kinds, she always had a penchant for young animals—foals, puppies, bear cubs, baby camels, and infant deer, all of which have an innocent leggy quality which provides a refreshing contrast to the work of other animalier sculptors.

Although the years between the world wars provided a lean time for the sculptor of the modern idiom, let alone those who continued to cling to the more traditional modes of expression, it would be wrong to dismiss this period entirely as one in which naturalism and realism did not survive to some extent. The outstanding example of an animalier sculptor whose best work was produced in this period is provided by Herbert Haseltine (1877–1962). In an appreciation of Haseltine's work written in the 1920s, Georges Bénédite of the Académie Française, summed up his accomplishments in this field:

In the course of his close study of these wonderful examples of English breeding, Haseltine has been brought into contact with all those interested in their welfare, from owners to stud-grooms and herdsmen, and has been able to draw upon the knowledge accumulated by them day-to-day to supplement his own power of observation. His chief merit lies in his having realized that the pursuit of the utilitarian ideal of the best furnished the artist with the essentials for his

own pursuit of the beautiful. To give to the line the simplest expression, to re-construct nature's handiwork in accordance with man's directions, to feel in it and to give to it its due proportion, and to endow it with the technical detail which every aspect demands, can alone satisfy the true artist and constitute a true work of art.[20]

The prevailing critical catchphrase for this school of sculpture is "realis-tic" or "naturalistic," by which the reader assumes the animals to be depicted straightforwardly or with predominant attention to their inborn characteristics. However, though Picasso, Braque, and others sculpted animals, their approach was abstract or conceptual. Realistic or naturalistic sculpture was identified with the nineteenth century.

One might note that such sculpture could be of interest to the modern audi-ence only because of the expertness of the sculptor: his technique, his craft. This kind of sculpture, therefore, provides excellent modeling devices; these should reveal the facility of the artist in physiology and kinesiology. Such a critical atti-tude makes the artist respected not for his inventiveness but for his mastery of form.

These characteristics of the animalier school were Held's, along with one other very important one. Certainly sculpture was practice for him. We have only to go to his drawing notebooks to find skeletal sketches of horses' legs, swine backbones, etc. Mastery of body mechanics was a primary challenge. This suggests Held valued a sort of integrity about animal forms; that is, he sought to depict them as they were, to reconstruct their ideal bodies. Photo-graphs and articles about his work at Harvard and the University of Georgia verify his advocacy of such practice to his sculpture students.

Held was always the craftsman first. In all his artwork there is a commit-ment to draftsmanship. Yet one wonders whether the works were built from the inside out or the outside in. Indeed, the *interest* of Held's sculptures comes from the tension between the animal as form—structure—and the attitude this form takes. Held uses the traditional assumptions about the medium figura-tively. That is, he works within the characteristics of the medium (as static, ide-alized) often to suggest the animal's temporal and material quality. In each of the sculptures there is a cultivated harmony between the possibilities of the me-dium, the characteristics of its subject, art traditions, and the imagination of the artist.

One example may be seen by comparing two sculptures of his successful Bland Gallery show, the *Colt of the Pantheon* and *Fly Time.* As the title suggests, one of these sculptures is created in a classical mode. The *Colt* bears a Greek head, bowed in formal regalness, the mane and tail appropriately cropped. The feeling of the whole sculpture is one of mass, even though the subject is a stripling. The form itself is completed in the few marks made to delineate mus-cles in the colt's body. The statue appears idealized, perfect. Yet in one contra-

Untitled (undated). Permission of Illustration House, Inc.

dictory gesture Held has extended—playfully—one hind leg so that the statue in toto is both form yet whimsical. The full effect is one of movement toward maturity. It is as if Held wants us to know that a colt—even a Greek one—is playful and youthful. The violation of conventions also insures a kind of contrariness that challenges the static quality of bronze itself. Likewise the colt in *Fly Time* possesses mane, tail, and overall bodily demeanor of a classical form. Yet the colt bends to shoo away a pesky fly, thereby creating a tension between its appearance—its form—and the animal's behavior.

The degree of realism Held achieves in such a technique is a comment not only on the astuteness of his eye for actual animal behavior, but for the parameters of artistic rendering of behavior itself. Held simply refashions traditional approaches of the past to make fresh observations about an old subject. Therefore, we learn about the possibilities of art and about the characteristics of the animal itself. It is as if the animal returns art to the real world—gives it back to its original point of inspiration.

Another example of this technique is illustrated in *Unicorn Colt*, where a very realistic rendering of the young animal is accented with an embryonic center horn. The dichotomy of classical allusion and naturalistic form gives a his-

torical nature to the colt beyond its own transient form. It also adds a universality to the topical subject. The solidity of form is complemented by the illusory note.

In his purely "realistic" statues, Held also plays on the conventions of his medium, though not in a typical or expected manner. *Clydesdale Stallion* is a massive rendering of the horse which seems to rise out of the block he stands on. The effect of realism (he scratches his nose on his hind leg, wears a bridle, and has a mane properly braided) is neutralized by the attention to form—the Clydesdale's own massiveness echoing the medium he is created out of. Attention to musculature is minimal: the statue articulates the essence of its subject. Yet, again, action, behavior, suggests a greater flexibility—indeed, the marvel of such a powerful beast having the dexterity to scratch his muzzle.

In each of these sculptures Held's method complements the actual behavior of the animal. For instance, in *Unicorn Colt*, the meaning of the small horn is accentuated by the pointed way in which the colt holds his tail. In *Colt of the Pantheon* there is a balance achieved between the subtle curl of his tail and the flick of a foot. In *He Goat* the outstretched neck is reinforced by the stance—particularly the orientation of the hindquarters. The effect of artistic device being balanced with the realistic observation of animal stance or behavior achieves a tension between outer and inner forces of each sculpture. That is, each may be doubly referential (to other art traditions and to animal behavior), as well as suggest the differences between exterior rendering (the sculpting) and inner attitude or reality. There is a marked attention to the schism between what an animal really is and conceptualization.

A writer for the *New York Herald Tribune* on Sunday, March 11, 1939, complimented Held on his ability to capture the individuality of each animal, though he worked in the picturesque animalier tradition:

> They are likable too not only for their truth, but for the singularly engaging style with which they are modeled. Occasionally the form is faintly stylized, as in the attractive "Performing Horse," but, as a rule, there is something personal about the manner in which Mr. Held denotes form, seeing it in a large way, though the dimensions of his sculpture are small, simplifying it and using great reserve in the expression of structural details. He has a suavely direct touch. He has humor, also, as evidenced in several studies of gangling colts, made under his hands very beguiling.

The final assessment of Held's place in American art certainly is enhanced by these watercolors and bronzes executed during his most productive period, the 1930s. While Held's cartoons were studies in expert draftsmanship and showed mastery of numerous styles, the watercolors and bronzes brought to fruition Held's private (personal) and artistic response to the larger environment. The disappointment awash in the studied irony of the Manhattan skyline, the con-

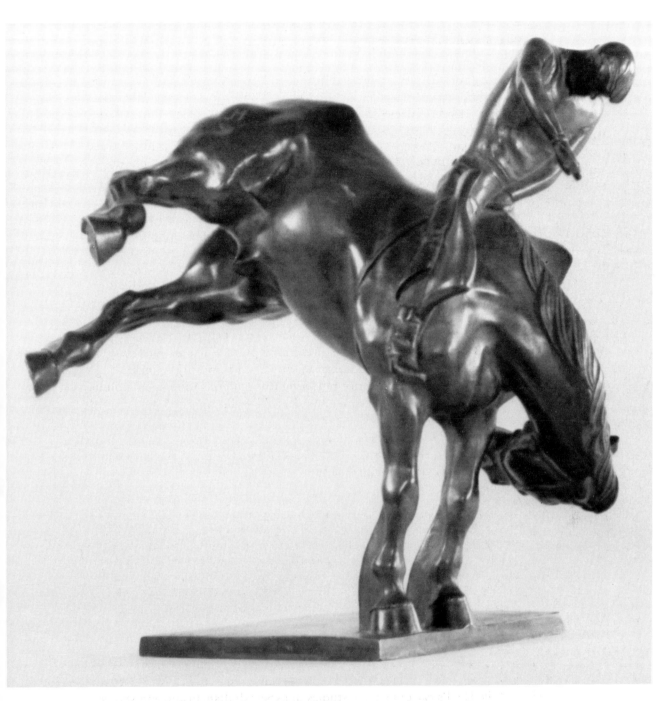

The Rodeo (undated). Permission of Illustration House, Inc.

trolled ebullience of the animal sculptures, testify to the individuality that marked Held's greatness. Certainly these works mirror the struggle of the artist of the time: primarily his shared view of the end of the city as idealistic frontier and the tendency to return to regional images for renewed strength. Yet in his ability to combine schools, traditions, themes, whether current or not, for purposes of his overall effect, Held indicates that new ideals come from the reconstitution of old forms. The aesthetic and personal frontier of place for Held results in an emotional chronicle of the closed frontier of the city—the citizen made outsider, apprehender, again. Fittingly, his bronzes are a treatment not of citizen or place, but of regenerated consciousness whose hallmarks are animal nature as Held perceives it: innocence, puckishness, and enduring strength.

While mythology may be said to represent the ideology of a society, Held's mythical treatment of animals suggests the important aspect of fantasy as well. The sculptures are products of the artist's flight of fancy and keep alive his creative expressiveness. Held demonstrated in his novel *The Gods Were Promiscuous* that one cannot go home again; but in the crisis of creative consciousness—the dichotomy of the closed urban frontier and an unattainable past—one stays alive on the frontiers of the imagination.

5

Held's Humor

THE ARTIST AND THE ERA

As evidenced by his ability to plumb a seemingly endless array of styles and genres for his work, Held exercised an enviable mastery over art traditions and applications. Given his disdain for art schools and his only brief study when a young man with Mahonri Young, Held, like many of his fellow illustrators and artists, was self-made—an accomplished creative genius who took his schooling from the cultural pluralism, too, of his times. He possessed a certain cultural pragmatism—that is, a practicality that allowed him to survive by means of his talents in a society where the marketplace was more partial to the masses than to the elite. His fluency, in several media—watercolor, sculpture, decorative arts, fiction, essays, comic art, etc.—makes his appeal rather universal. He had the distinction of working on several levels; indeed, his work appeals to several audiences. He illustrates the fact that so-called high culture and popular culture are but two aspects of the same thing. His work may be viewed as an example, therefore, of the unity of culture. More than that, his avoidance of emotional commitment to any one medium assured him a kind of psychological and creative freedom.

It is this attitude—one of boundless experimentation and unwillingness to resign himself to any one style or medium—that has confounded critics who wish to compartmentalize or more conveniently type him. One reason for a lack of critical consensus is the overwhelming desire to simply identify Held with certain styles. A number of scholars have tried to place Held in the tradition of art deco, for example. Others, noting his fascination for classical Greco-Roman geometric ornament from childhood along with his discovery of later Mayan geometric ornament, classify him with other modernists in the 1920s and 1930s. Still others understandably have approached Held from the perspective of their own specialties.

Corey Ford gives Held three pages in *The Time of Laughter*;[1] Dale Kramer mentions him in connection with Ross's editorship in *Ross and the New Yorker*;[2] James R. Gaines reprints his "Backscratching at the Algonquin Table" and a

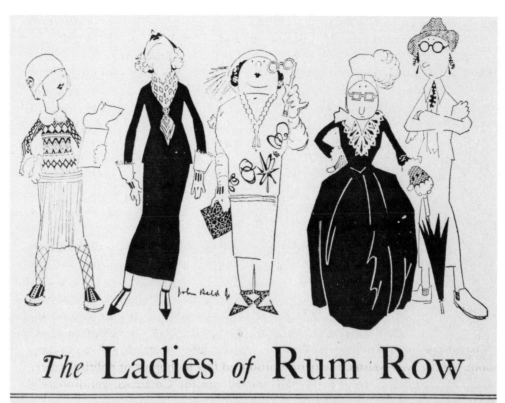

The Ladies of Rum Row. *American Legion Weekly*, May 16, 1924. Courtesy of Bill Blackbeard, The San Francisco Academy of Comic Art.

photograph of Held drawing a "grim youth" in *Wits End: Days and Nights of the Algonquin Round Table*.[3] Art critics are laudatory and more substantial in their analysis: Susan Meyer and Walt Reed name Held as foremost among American illustrators;[4] Richard Merkin, professor of art at the Rhode Island School of Design, emphasizes his uniqueness as a Jazz Age artist;[5] art historian Barlett Hayes praises his excellence as an artist.[6] Archie Green, folklorist and ballad scholar, noting Held's amazing versatility, is fascinated by Held's visual contributions to American music, particularly folk and jazz.[7] Literary critics continue to discuss Held's cultural significance. Perhaps Russell Lynes in "John Held's Mad World" best assesses Held's view of American culture.[8] The most sweeping statement is Corey Ford's, however, who has remarked that while Fitzgerald "christened" the 1920s the Jazz Age, John Held, Jr., set its style and manners.

However, as art historian Carl Weinhardt has noted, Held never preferred one style, but rather "would pull one out and use it, like a magician pulling a scarf from his sleeve."[9] Neither did he conform to traditions or popular styles, necessarily, of his time. As an example, he still used pointillism in the tradition of Seurat, as late as 1931. Therefore, Held may be identified with styles, but utilizing any style was simply a matter of striving for whatever effect he wanted in his work. Examining the overall body of his work, we may note that much of the time this effect comes from his humorous attitude, an attitude of psychological chicanery and irony. In the cartoons, the blockprints, comic maps, watercolors, advertisements, essays and even the bronzes, Held's combinations of styles assure a range of humorous effects. Held's method of accomplishing these effects and the meaning of his humorous approach says much about the artist and his society.

As a humorist, Held addressed the major topics of the 1920s. Together with two other Jazz Age cartoonists, Ralph Barton and Miguel Covarrubias, Held covered the range of pertinent Jazz Age topics: entertainment, the college phenomenon, life in the great metropolis, and the nuances of social circumstances, with an occasional moral or religious accent. Significantly, the political cartoon scene of the 1920s was, for the most part, uninspired. With the exception of the Nastian talents of Rollin Kirby and his anti-Prohibition stand, and cartooning done for the *New Masses*, the period produced few highlights of political satire, and Held himself, except for a half-hearted run for Congress, appropriately spoofed in *Life* magazine, harbored few political inclinations. It is not an exaggeration to say that magazines like the *New Yorker* were above politics; their particular brand of sophistication ruled out any such partisanship.[10]

Held's knowledge of humor is obvious. For one thing, humor was native to him. He once remarked that he could supply the punchline for any joke, suggesting not only his understanding of humor formula but his own inventiveness. He briefly worked in a "joke factory" in New Jersey supplying such punchlines. He was well known for his practical jokes. His generally witty and wise outlook on life exhibited itself even in more formal interviews, in which Held delighted in artfully dodging any question—yet somehow supplying an oblique answer. In addition to his familiarity with the mainstream cartoon themes and styles of his period, he admired graphic humorists who today still are regarded as the experts in their field: T. S. Sullivant, George McManus, Don Marquis, and Herriman. In his early cartoons Held reflects McManus's comedy of manners; Sullivant's droll animals are suggested in Held's farm and country scenes; Marquis's *alazon/eiron* characters, Archie and Mehitabel, though not reflected in any of Held's treatment of animals, exemplify a crackerbox philosophy gone urban which Held employs in his callow-youth cartoons; Herriman's sensibility—his absurdist fantasia—is characteristic of Held's comic watercolors and animals. But Held was no imitator, and his knowledge of what made an audience laugh he adapted imaginatively to the page. Certainly Walter Blair in

his *Native American Humor* and Blair and Hamlin Hill in *America's Humor* have convincingly identified and analyzed the elements and history of American literary humor which illustrate Held's intent.[11]

His comic type, the flapper, as much as a social phenomenon, is a composite of most of the traditions that Blair identifies in *Native American Humor*. In the earliest cartoons she appears in her native scene of the urban, upper class world as a crackerbox type, full of pithy remarks and sage advice characteristic of Down East humor. In the *Vanity Fair* cartoons (1914–17) she is an update of this eastern, frontier type, now on the new frontier of the city yet passing judgment on the same subjects as her 1840s counterpart: fashion, politics, and commonplace issues of family and relationships. Her vernacular speech, however, is the language of the new, burgeoning city. Though she does not speak in dialect, she reveals her unschooled yet wise ways in puns, idioms, metaphors, and similes which derive from fashionable city lingo.

In the next stage of his flapper's evolution, Held characterizes the actions of these young women more than their speech. In fact, in the cartoons from 1917 to 1927 most of the flapper's comedy results from her innocent, awkward, and childlike behavior. In many of these cartoons Held depicts the flapper in terms of Southwest humor: she is rambunctious, and innocently self-involved in her activities. Held's primary metaphor for this adolescent attempting to come of age is that she is coltlike. Her gangling arms and legs and her unfettered attitude he likens to the curious, cute, and confounding colt.

In a period from about 1923 to 1925, Held's *Life* covers depicted this flapper in yet another stage of development. Here she is the fashion plate of her society, and, though still unabashedly independent, is funny for what is said about her. Using mainly the pun as a comic device, Held adopts a more literary humor in these cartoons, depending on the one-liner or one-word cutline to carry the humor. Though far from static, this flapper is tamed somewhat in comparison to her immediate precursor; the New Woman emerges as a master of expensive horses rather than analogous to an innocent and frolicsome colt. A hard-boiled, calculated sophistication replaces innocence. The "Oh! Margy!" flapper is the overbearing, disdainful sophisticate who has lost her wit and wisdom along with her innocence. She is the woman spoofed in *New Yorker* humor of the period and later; she resembles the scornful women of Dorothy Parker or the airheads in later Helen Hokinson cartoons.

If one may reduce Held's comic type to one analysis, it is that these women exemplify what Walter Blair calls one of the major themes of native American humor. "Native American humor has always dealt comically with worries and tribulations—the struggles of a democratic nation to get going, frontier hardships, wartime tragedies, the upheavals accompanying the shift from an agrarian society to an industrial urban society."[12] This is doubly evident when one examines the woodcut style cartoon woman—ostensibly a Victorian type—in Held's *New Yorker* cartoons, who demonstrates the continuity of meaning be-

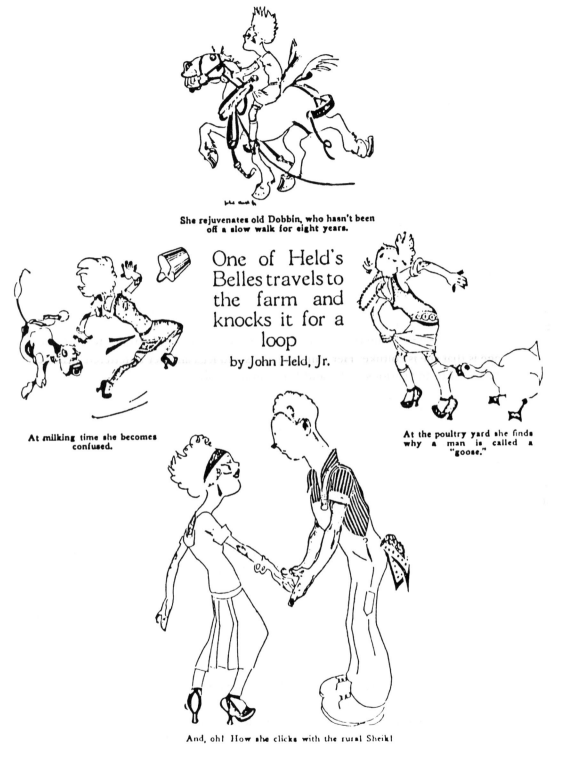

She rejuvenates old Dobbin, who hasn't been off a slow walk for eight years.

One of Held's Belles travels to the farm and knocks it for a loop

by John Held, Jr.

At milking time she becomes confused.

At the poultry yard she finds why a man is called a "goose."

And, oh! How she clicks with the rural Sheik!

One of Held's Belles Travels to the Farm and Knocks It for a Loop. *Judge*, ca. 1922. Permission of JB&R, Inc.

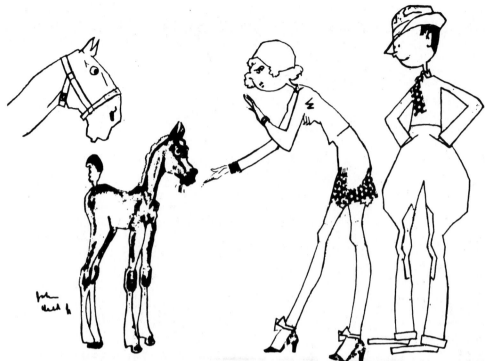

"I think that colts are just too comical—they seem to be all legs."

I Think That Colts Are Just Too Comical. *Life*, ca. 1925. Permission of JB&R, Inc.

tween the era of the Gibson Girl and the flapper. Moreover, the final result of this shift from the agricultural to urban society—Held's "Margy" and her sisters who appear in advertisements at the same time—is the loss of the innocent, primal, non-rational side of humankind. Ironically, this is the side of the psyche women have traditionally represented. When Held's flappers lose their coltlike natures, his portrayal of them reminds us of James Thurber's note on animals and humans:

> For some reason Man has always assumed that he is the highest form of life in the universe. There is, of course, nothing with which to sustain this view. Man is simply the highest form of life on his own planet. His superiority rests on a thin and chancy basis: he has the trick of articulate speech and out of this, slowly and laboriously, he has developed the capacity of abstract reasoning. Abstract reasoning, in itself, has not benefited Man so much as instinct has benefited the lower animals. . . . In giving up instinct and going in for reasoning, Man has aspired higher than the attainment of natural goals; he has developed ideas and no-

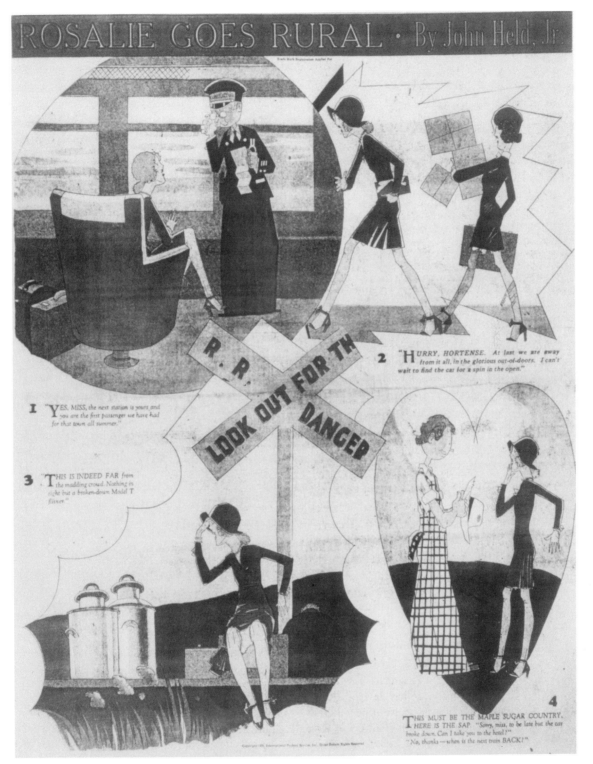

Rosalie Goes Rural. *The San Francisco Call*, July 20, 1929. Courtesy of Bill Black-beard, The San Francisco Academy of Comic Art.

tions; he has monkeyed around with the concepts. The life to which he was naturally adapted was put behind him; in moving into alien and complicated spheres of thought and imagination he has become the least well-adjusted of all the creatures of the earth, and hence the most bewildered. . . . Man . . . is surely farther away from the answer than any other animal this side of the ladybug.[13]

According to Walter Blair, "Thurber's animals seem to have benefited from living by instinct; they are happier, much less frustrated than his humans. When Thurber humanizes his animals, he shows them getting into bad fixes, and the moral is: 'If you live as humans do, it will be the end of you.'"[14]

In his later cartoons Held depicted the flapper as representative of a culture which, for all its expressionism, had lost its authentic feminine side. If, as observed about the popularity of Freudianism during the 1920s, it directed people to an inward explanation for external behavior, the commercialization of such Dionysian characteristics suggested society's less than rudimentary and complete understanding of motivations.

Held's sense of audience told him that making his readers recognize this fact was his greatest challenge. He once defined caricature as the attempt to make society truer than it was. And he utilized elements of American humor in employing this gambit of devices, in the manner in which he translated these elements into graphic depiction. Within the realm of caricature, as we have seen in the case of the flapper, Held relied on varied artistic styles or forms to assure his humorous effect. In addition, he utilized the artistic device of the frame. Through framing techniques Held created comedy in the disjuncture of expected behavioral patterns, consequently dramatizing the difference between the private and public self.

The frame obviously links the artist Held to Held the comic, because it is a tool common to the painter and the cartoonist.[15] Rather than sexually assault their men, Held's women, along with expressing themselves openly—trying honestly to do what they want rather than what is expected of them—show sexual expression to be a natural part of that attitude. Like men, they choose not to worry about propriety. In the natural course of their day (that is, in their sporting or domestic areas) they are full sexual creatures as well. This is their ultimate attempt to bridge the gap between men's and women's worlds. In these cartoons Held uses framed behavior to enlist at once the audience's identification with the commercial realism of its era—only to surprise them. Through his continued ability to surprise lies Held's greatest comic ability and service as a social observer.

When the arrangement of symbols in a message is close enough to the pictures in the heads of the audience, the near coincidence of the pseudo-environments yields credibility. But this is by no means synonymous with objectivity. In fact, credibility depends on a widespread subjective match-up, what seems to be the very opposite of truth independent of the mind. When Held defined cari-

cature as making his Jazz Age characters truer to life than they were, he indicated the connection between his idea of caricature and the lived world: credibility must be established, but objectivity—at least a measure of it—could come through establishing and inverting the time-honored conventions. As Erving Goffman has shown, it links the imagined and the real worlds, serving as a key to human behavior and environments as they are dissected in humor.[16] Examination of Held's use of framing helps clarify his humorous intent—his attitude toward subject and audience and their environment.

Setting down some principles of journalism in 1923, Walter Lippmann wrote that "the real environment is altogether too big, too complex, and too fleeting for direct acquaintance."[17] In 1977 the geographer Yi-Fu Tuan noted, "Nature is too diffuse, its stimuli too powerful and conflicting to be directly accessible to the human mind and sensibility."[18] But, if people cannot know the world directly, they seem willing to put up with a reasonable facsimile. Lippmann called this fabrication a pseudo-environment and noted that people react to this imaginary world, not to the real one. In *The Experience of Landscape* Jay Appleton observes that behavior "is influenced by a person's attitude toward the environment, not as it is but as he thinks it is. In other words, the image of our environment is what counts."[19] Erving Goffman has essentially argued similarly about the relation of behavior to the "real" world. "Commercial realism" is Goffman's term for the pseudo-environment of the cartoon where pieces of human behavior *believed* to be true in the real world are used to establish the verisimilitude of the pseudo-environment. Pseudo-environments, with their consequent influences, do therefore exist; the task is to recognize how their limits are handled, how they are framed.

In the case of the cartoon, the best imagined work is experimental, where the outer world is allowed to seep through the frame into the created and managed pseudo-environment of the story or scene. This relationship between the "out-frame" and the "in-frame" worlds both allows the humor of the cartoon (say, a caricature of some foible or character in society) and prevents the audience from escaping to the pseudo-environment (making it a refuge from reality rather than a treatment of it). Dean W. O'Brien has observed that television news, for example, distorts reality because "it is reduced to the very limited visual vocabulary and professional lingo of small-screen journalism, much as food is moved onto the supermarket shelf, with no grit or other allusion to the outer world of its origins. . . . It doesn't seem to be a symbol-built pseudo-environment like other messages; it seems to be The Environment. It is as if food were a product of supermarkets rather than of soil, seed, weather, decay."[20] When the audience is aware of the framed environment, however, rather than escaping knowledge of too familiar truths, its awareness may be expanded.

While framing is itself selective, as in the case of Held selecting his flappers' dress, behavior, and circumstance, and therefore may bear resemblance to the audience's real environments, another device encourages this awareness. Sub-

framing, or recapitulating the original frame of a story or a scene within the story or scene, dramatizes the difference between in and out, here and there. Held accomplishes this through several techniques; one is by signaling expected behavior patterns of women in the establishment of scene which are then deflated or inverted by the flapper's variant action. It is interesting that, throughout Held's flapper cartoons, the major categories of gender behavior identified by Goffman's research are established by the frame and reversed in the subframe. What Appleton calls "penetrability of margins"—in other words, actual or visual and imaginary access from one zone to another—recapitulates framing, or the experience of consciousness, being on the margin between the inner and outer world and having access to both.

An example from Goffman's categories illustrates how Held plays on the audience's prescribed expectations to create humorous surprise. Goffman documents *functional ranking*, a situation in which a man is likely to perform the executive role with the woman fulfilling a secondary or deferring one. In graphic representations, social weight reaffirming the man's superiority is emphasized through relative size—usually height. The man is nearly always larger or taller. In his flapper cartoons Held violates this convention repeatedly. On the *Life* cover (February 18, 1926) a flapper is taller than the man she dances with, *and* according to the title, she is "teaching old dogs new tricks." In "Adventures of 'The Gang'" (*College Humor*, 1927), a flapper gingerly trims trees, wielding heavy clippers, while an amazed farmer (dumfounded?) gazes from ground level. Even in "Poor Fish out of Water" (*Life*, October 21, 1926), the typical helpless-female-with-broken-down-car routine is altered. The flapper sits very confidently in the car as if telling the puzzled young man, who scratches his head and looks dumbly at the boiling radiator, what to do. Though she sits in the car and he stands in front of the hood, she is on eye-level with him. (Interestingly, in numbers of cartoons where the female is shorter than the male, she often is drawn "upstage" from the man; that is, she is in front of him so that her feet are drawn below his. Therefore, she—if placed on the level plane—is equally tall or taller.) Finally, in "Just a Song at Twilight" the boys in the band have nothing on the girls (*Life*, July 7, 1927). The girls take no instruction and are accorded no lesser positions or assignments. In fact, they play typically "masculine" instruments—the trombone, the drums, and the saxophone.

Goffman continues with a number of other categories which apply equally well to an interpretation of Held's use of the frame for humorous intent. Ritual of subordination consists of a deference expressed in lowering oneself physically in some form or other of prostration. Therefore, women are seen more on beds and floors; they also appear in less elevated physical places: they may often sit while men stand. Correspondingly, men more often appear unashamed, superior, and disdainful.

But Held depicts his women in the opposite fashion. If they sit and the man stands (as in the *Life* cartoon, August 20, 1925), they sit confidently and com-

Rah-Rah Rosalie. *The San Francisco Call*, March 3, 1928. Courtesy of Bill Black-
beard, The San Francisco Academy of Comic Art.

"WHY SO PENSIVE, SPIKE?"
"I WAS THINKING OF A FUNNY COSTUME TO WEAR AT THE MASKED BALL."

(*Left*) A Poor Fish out of Water. *Life*, October 21, 1926. Permission of JB&R, Inc.

(*Right*) Why So Pensive, Spike? *Life*, August 20, 1925. Permission of JB&R, Inc.

mand an additional verbal superiority over the male. "Why so pensive, Spike?" the flapper asks the young man decked in exaggerated knickers, flamboyant sweater, and gargantuan saddle oxfords. "I was thinking of a funny costume to wear at the masked ball." In this instance, the positioning of the flapper's hand —stretched to the top of the chair in which she sits, and extended even further because she holds a cigarette in a long holder—makes her body fill as much space as Spike's. Her long legs dangle from the knees over the chair arm and reach almost to the floor, indicating that were she to stand up, she would be taller. Because she taps the long fingernails of her right hand and extends the left (as described), she dominates pictorially, both in height and breadth. Not only that, but the dark chair itself—her place—balances the frame with her visual weight.

Other physical expressions of the role of subordination are the bashful knee-bend, canting postures, childlike roles, and the smile. The first of these is described as an attitude of unpreparedness, a lack of readiness in a social situation

to fight or flee. The posture presupposes the goodwill of those around the "defenseless" woman; even two women may be seen together without males in the picture, suggesting still that they are lounging unaggressively.

The bashful kneebend is a pervasive stance in all Held women. They are sometimes seen as fashion plates; that is, their posture suggests a modeling pose which best displays their figure and clothes. Yet within this range Held violates these conventions by having the bent knee stop traffic, disturb the harmony of the picture. For instance, in the *Life* cartoon of October 15, 1925, a flapper bends to adjust a garter. The cutline reads: "Bill! She's got *two* sets of garters on!" "Sure, they're all wearing 'em now—one pair to hold up their stockings and the other to hold up traffic." Though the flapper is the slighter of the three prominent figures in the frame (herself and the two men), the organization reinforces her domination over the subjects. Behind her, in the center of the picture, a driver hits a light post, setting it atwirl, and a policeman loses his hat as he blows his whistle. The two men who speak in the frame are at the far right. One leans helplessly on the other, while the other collapses toward him. Their positions are the canting postures in the frame. Moreover, the weight of the frame is balanced by Held's use of dark and light. The girl's garters are black with polka dots. The policeman (at center left) is in solid black, while the twirling post, reinforcing the circular motif, is outlined. The eye finally rests on the man's tie at the far right, unifying the entire frame. It is polka-dot just like the girl's garters. The bent knee not only controls the frame through traditional repose, but it also can suggest action, readiness, and aggressiveness.

Likewise, the canting postures, seen as acceptance of ingratiation, submissiveness, and appeasement, are contrarily expressed by Held to represent arrogance, disdain, or independence. Just as the one-eyed girl was an early version of profiling, Held's later cartoons (1922–24) presented most women in various attitudes of hauteur. Upturned noses, tilted chins, and multi-angle depictions of the face, always turned away from the subject in the cartoon *and* the audience, suggest an air of superiority and even boredom. Sophisticated as these women were, they expressed a general tolerance for the scene at hand. A good example is the famous "Ursula" cartoon from *Life* (October 29, 1925), where both the man in the scene and the woman relax in high-toned fashion in their chairs. Again, the man (depicted in black tux) appears visually to dominate the scene until, upon a closer look, we notice the merely outlined woman to the right commands the most attention by virtue of her exhalation of cigarette smoke (which rises to the top of the cartoon) and the trailing smoke of her lighted cigarette. Pointing to both is her upturned nose, an effective device and symbol of casual disdain.

Finally, Goffman mentions a number of examples of "licensed withdrawal," an attitude particular to women in advertisements which suggests that such averted behavior reinforces the superiority of the male in the picture as the central figure as well as the woman's submissiveness. Head-eye aversion, turning

"It's all right, Santa—you can come in. My parents still believe in you."

(*Left*) It's All Right, Santa—You Can Come In. *Held's Angels*, 1952. Permission of Illustration House, Inc.

(*Below*) Dry Sleuths Are Ready to Admit. *American Legion Weekly*, May 16, 1924. Courtesy of Bill Blackbeard, The San Francisco Academy of Comic Art.

Dry sleuths are ready to admit that women bootleggers present a grave problem to the prohibition forces

one's head away from another, and mental drifting from the scene are examples. Typically, in Held cartoons (particularly during the period 1921–25) licensed withdrawal gives one power over the action and attitudes in the cartoons. When

the flapper engages in each of these activities, she suggests she really does not need the other people in the frame.

Conscious use of color is another of Held's subframing techniques—his way of treating the audience's expectations humorously by constructing a frame within a frame. (We may note that Held accomplished this also with black and white design effects.) A good example of Held's use of color to depict another of Goffman's displays is "Where the Blue Begins," the cover of *Judge* (October 1921). The premises of functional ranking are humorously destroyed in this cartoon. Not only does the girl assault the boy in the picture (she socks him in the eye), but her attitude suggests this is a game in which she is in control—a puckish punch. While the composition, as always in a Held cartoon, assures this inverted behavior, the color in this cartoon further emphasizes it. As the boy's knees give out from under him from her left jab, the flying sprigs of his yellow hair and a matching yellow tie (with black stripes) restate his psychological position. Balancing her aggressive swing, and the opposite swinging orange beads on the other hand, are her black cropped hair and black-topped saddle oxfords. The upturned pink nose, brightly rouged cheeks, and pert red lips offset the boy's paler look of dismay. There is a special dynamic set up in her white and orange checked dress—orderly, yet busy—and his flopping, diagonally striped tie. Though his blue suit is a heavier color than her dress in the frame, the position of her black hair at the top of the picture and the black shoes at the bottom suggest superiority. Yet the one key that deflates the harmful aggression of the scene is her position. She leads with the left hand and left foot—in a mock-serious fighter's stance. She fairly "dances" into the punch. If he is surprised and nearly decked, the execution for her is child's play.

Perhaps the most dramatic of all these subframes in Held's cartoons are the "panty" drawings, depictions of the flapper typically with legs open or in a gamboling attitude that reveals her undergarments. Goffman obliquely mentions in the explanation of one of his categories that women typically appear with closed legs or in conventionally "feminine" seating and standing positions. Held's violation of this traditional display suggests that, given the characteristic handling of sexuality by the humor magazines, such depictions allow for an innocent voyeurism in these cartoons. Flappers who fall skiing, straddle a branch while trimming trees, sit in un-ladylike fashion while playing drums, necking on the stairs, or leaning over a boat bridge to watch the boat races, give a good view of lacy underwear and a hint at what lies beneath. It can even be argued that these are primitive beginnings of the *Playboy* pose: the slightly reclining female whose variously clad body visually supports her enticingly spread legs. But two elements of these displays which displace the original conventional display argue otherwise. Fashion (as Held's major emblem) is connected to the flapper's activity. That is, she is not passively or seductively affording glances above the gluteus maximus. Instead, it is during sport, energetic expression, or mere casualness, that she allows these glimpses. In this way, Held also inverts

Palm Beach suggests a pleasant method of dodging the issue

If Winter Comes

A few remedies for the Coal Shortage

by John Held, Jr.

Love letters revive old flames

In Cuba there is warmth

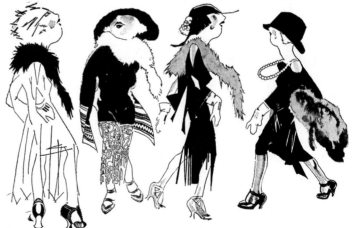

Let the moths shift for themselves. Summer's furs are winter's necessities

(*Left*) If Winter Comes. *Judge*, ca. 1922. Permission of Illustration House, Inc.

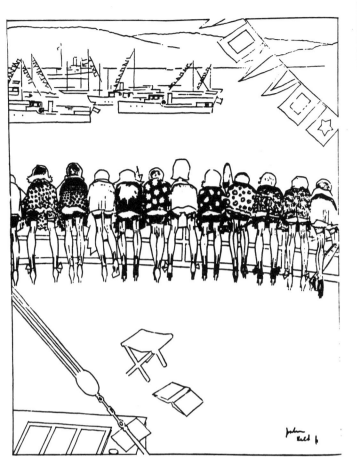

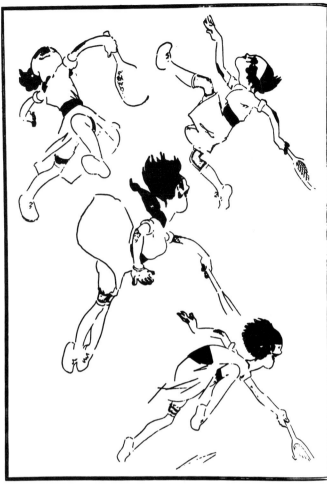

A View of the Boat-Races. *Held's Angels*, 1952. Permission of JB&R, Inc.

In the Game of Tennis. *Held's Angels*, 1952. Permission of Illustration House, Inc.

his contemporaries' standard treatment of the embattled female, or the woman as sexual object—both "frames" of behavior generally perpetuated in cartoons of his period.

Held seems to have seized upon women's sexual liberation as exemplified in the panty cartoons to depict a leveling agent between the sexes. Artistically, this meant establishing a disunity within the frame. This occurs in the disjuncture between frame and subframe (as we have seen in the case of the Goffman categories); it also occurs in Held's combination of traditionally incompatible styles. Colors clash; cubo-constructivist characters exist in naturalistic scenes; forms complement yet rival content. Without the stability of these categories, or sub-

frames, the system of symbols would be incomprehensible chaos to potential readers. Yet synthesis and invention come about not through the stability of categories but through the reconstruction of categories, or reframing. Effectively to render a period (capture the style of it rather than "christen" it, to recall Corey Ford), the writer or artist must convincingly *reinvent* it.

The overall purpose of Held's framing devices, then, is to reinvent the 1920s humorously. We may read what Held believed the period to mean in these cartoons. Archie Green reminds us that the "Jazz Age," or the "Roaring Twenties," is a term which implies a given musical form but essentially has come to mark a time period, 1918–29. Fixed in the imagination by fiction, sports, drama, film, and graphic art, the decade is best recalled by a set of non-musical names— F. Scott Fitzgerald, Clara Bow, Rudolph Valentino, Al Capone, Babe Ruth, Lucky Lindy, Will Rogers—all representative of some highly visible aspect of American life. Like them, John Held popularized a set of stock figures—his shebas and sheiks—which described the Jazz Age as a state of mind. Examining the illustrations from *Held's Angels* (1952), Green observes that in Held's art one finds no Negro musicians in any of the low-life settings where jazz was born. Instead, his musicians are all white, young, collegiate, and often engaged in activity to which music seem auxiliary. Citing "The Dance-Mad Younger Set" as the quintessential Jazz Age drawing, Green concludes:

> Within it no one dances to music, and a four-man (sax, ukulele, drums, piano) band, relegated to the room's margins, is curiously passive. If this is a milestone of the Roaring Twenties, it suggests that the "roar" is non-musical, and that collegiate combos played more pallid side-line music than hot jazz. Central to Held's drawing, however, is a gaudy notion of sin, of unashamed necking on the stairway. In a metaphoric sense, the term "Jazz Age" as applied to Held's art slips away from rhythmic or improvised musical expression to hedonistic conduct, to the breaking of puritanical code, to the public display of sensuality. Thus, John Held has translated pulsating sound into visual art because his cool pen helped extend the word "jazz" to cover a turbulent decade in national life.[21]

Moreover, Held's fascination with American youth went a long way in identifying them as a distinct social class as opposed to an age group, something that had not happened until the 1920s. (They were still referred to as schoolboys and schoolgirls and were not yet isolated as thoroughly exploitable market for manufacturers and publishers as they were after World War I.) Yet the "younger generation," which usually encompassed the ages of about sixteen to thirty, had been discovered. Says Mark Sullivan in *Our Times*: "After the war an emphasis was placed on the young simply because they were young that had probably never been equaled in the history of the world."[22] This new class, urged into adulthood faster than any before, displayed more sophisticated attitudes toward sex, amusement, and manners than their elders of the decade before. Attitudi-

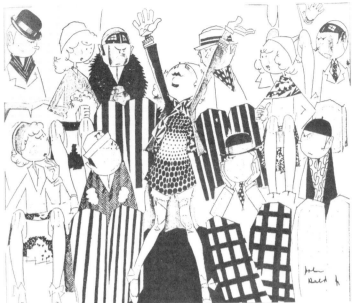

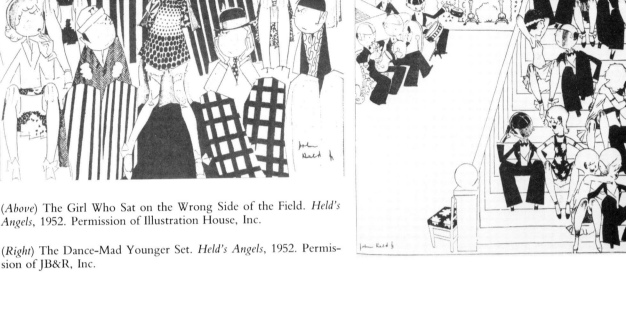

(*Above*) The Girl Who Sat on the Wrong Side of the Field. *Held's Angels*, 1952. Permission of Illustration House, Inc.

(*Right*) The Dance-Mad Younger Set. *Held's Angels*, 1952. Permission of JB&R, Inc.

nally, this sophistication often took the character of a kind of heartlessness—a studied carelessness about the feelings of others.

Held documented the ability of fashion and behavior to blur age barriers, and so we have no distinction between the looks of a seventeen-year-old and a college graduate. Furthermore, Held was aware of America's infatuation with youth, so much so that adults mimed the attitudes and appearances of the younger generation. Mark Sullivan observes that this was a period in which youth was the model, age the imitator. "On the dance floor, in the beauty parlor, on the golf course, in clothes, manners, and many points of view, elders strove earnestly to look and act like their children, in many cases, their grandchildren."[23] Held himself, some fourteen years older than the age group he depicted, was fascinated by the jazz babies and jelly beans:

Held enormously enjoyed the mannerless manners of the 'twenties though that is not to say that he approved of them. If he had not enjoyed them he could not have endowed them with such plausible life, nor could he have dissected their

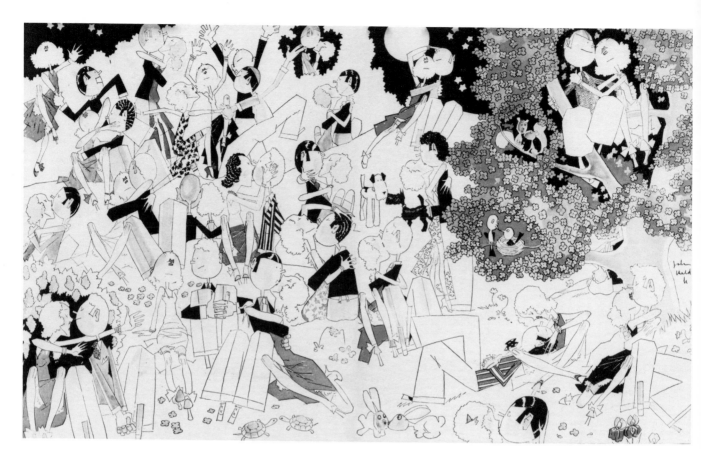

We Can Be Young Only Once (undated). *Cosmopolitan* magazine. Permission of Illustration House, Inc.

foibles in such a manner that he became a hero to those whom he most ridiculed. There is nothing bitter about his satire; but there is nothing sentimental about it either. His scalpel scarcely ever cut to the bone; as it is, very frequently his comment is submerged under a gag, as it was in his famous cover the old *Life* ran of a young woman doing the Charleston with an old chap twice her age. The caption is "Teaching Old Dogs New Tricks."[24]

Held's stylistic and humorous treatment of the Roaring Twenties identified its real essence: more interested in manners (and their meaning) than in morals, Held recognized the revolt in the 1920s as social and antisocial too. It was against the idealism of the save-the-world-for-democracy spirit of World War I. It rallied around the debunker, the sophisticates, the live-it-up-but-talk-it-down smart set. It was primarily a revolt of manners and only secondarily a revolt of

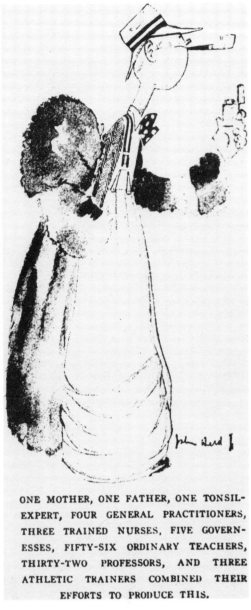

ONE MOTHER, ONE FATHER, ONE TONSIL-
EXPERT, FOUR GENERAL PRACTITIONERS,
THREE TRAINED NURSES, FIVE GOVERN-
ESSES, FIFTY-SIX ORDINARY TEACHERS,
THIRTY-TWO PROFESSORS, AND THREE
ATHLETIC TRAINERS COMBINED THEIR
EFFORTS TO PRODUCE THIS.

Tonsil Expert. *Held's Angels*, 1952. Permission of Illustration House, Inc.

morals—as Russell Lynes notes, a revolt of externals rather than of principles. A famous Held cartoon depicts a young man in a raccoon coat, his hat pushed back on his head, a vacuous look on his bland face from which protrudes a pipe. It reads: "One mother, one father, one tonsil expert, four general practitioners, three trained nurses, five governesses, fifty-six ordinary teachers, thirty-two

professors, and three athletic trainers combined their efforts to produce this." If Held best depicted the Jazz Age as a state of mind, this cartoon illustrates the gap between real sophistication or moral change, and external flirtation with its idea. As his comment on this aspect of the 1920s, Held reinvented the era through another set of cartoons, his Victorian block prints done for the *New Yorker* beginning in 1925. These cartoons established a new context—the earlier generation, what Held called the "dear, dead days"—for Held's ideas on the 1920s. They are some of the most inventive of his frames since they appear to depict a different era but relate metaphorically to the then present period.

Archie Green was first to use the term "Gilded Age" to describe Held's block prints. This is a significant term because of the hallmarks of the period. Mark Twain's first novel, *The Gilded Age* (1873), portrayed a bloated and vulgar life in Washington after the Civil War. Twain lampooned opulent tycoons and free-spending politicians alike; his title entered common speech to describe the last three decades of the nineteenth century. If we date the Gilded Age as 1876–1900, we may say it opened with the Philadelphia Centennial Exposition's emphasis on technological progress. Also, these years included two separate periods, the Mauve Decade and the Gay Nineties. We know that life was frequently oppressive for blacks and immigrants new to urban industrial life, yet for many Americans this quarter-century was abundant and expansive. New national magazines as diverse as *Popular Science* (1892), *Scribner's* (1887), and *Vogue* (1892) in colorful pictures and prose proclaimed that convenience and elegance were at hand. By electric wire President Cleveland, at the White House in 1893, turned on all the lights at the Chicago-Columbia Exposition—some to light halls of glistening machinery, some to light Little Egypt's belly-dancing tent.

From his vantage point some twenty-five years later, Held handily spoofs the era and its suggested better days both in the individual *New Yorker* linocuts and in the collected pieces in *The Wages of Sin and Other Victorian Joys and Sorrows* (Washburn, 1931). Billing his depictions as "The Dear, Dead Days," he makes his intent obvious: the nostalgia felt by many in turmoil during the 1920s was ridiculous. Not only were the dear, dead days not better, they either directly contained the same conflicts and problems as the 1920s, or they marked the beginning of these problems. A majority of these linocuts first appeared in the *New Yorker* (a few others in *Vanity Fair, Collier's, Life,* and *Country Life*), so that by examining their thematic groupings in *The Wages of Sin* we may appreciate Held's purpose more. In the first section, "The Wages of Sin," Held explores the fallen woman: the rewards of extramarital sex, drinking, and smoking. These violations of implied moral commandments appear to be lessons. "The Fallen Man": "The Fallen Man Again Can Soar/But Woman Falls to Rise No More." Or "The Road to Ruin," which depicts a woman tiptoeing to the "family entrance" of a bar where a seated policeman is drinking. Or "The Milliner and the City Drummer," where the drummer ("out for no good") winks salaciously at the young sweet thing.

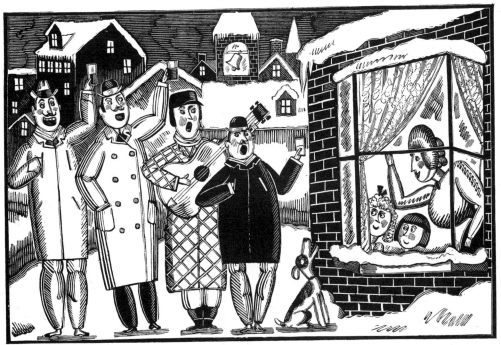

A Happy New Year The Days Beyond Recall

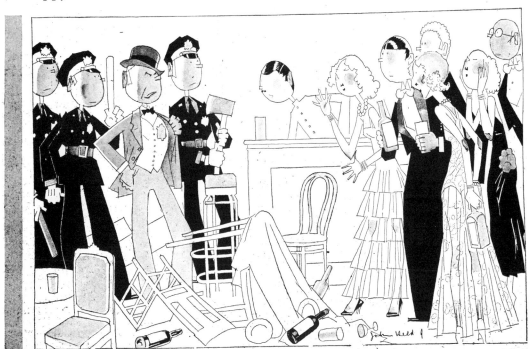

The Happy New Year Today and The Party Raided

Civilization's Progress. *Liberty* magazine, January 2, 1932. Permission of Illustration House, Inc.

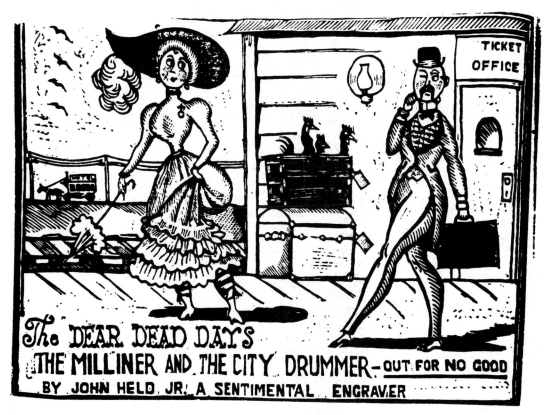

The Milliner and the City Drummer (undated). Permission of Illustration House, Inc.

Other themes of other sections point up apparent morals. In "Americana De Luxe," "Klassy Kut Kollege Klothes" are boxy, blooming, and ridiculous; in "The Birth of American Art Appreciation" we see the wall of a livery barn lined with pictures of Dan Patch and other famous (and not so famous) horses; likewise, "The Fountainhead of American Art" is the landscape on the office safe which, on one side, reads "Hay, Grain, and Seed"; "A Solemn Ceremony of Utmost Importance" is the "Coloring of the Meerschaum Pipe"; "The Background of America's Aesthetic Taste" is none other than "Mission Furniture" (graced by an overstuffed pillow that says "In the background of America's Aesthetic Taste"). A large, double-page spread shows a young boy, suspenders down, headed for the outhouse with the dime novel "Diamond Dick." If this section parodies aesthetic America in the Gilded Age, then "The Price of Too Great Painstaking" continues the theme, including "Soldering the Bustle," "Strategic Ruffles," and "Lacing the Corset." "The Open Packet" is best, a

companion piece to "The Open Fly" in the next section, "Big Moments in the Faint Rosy Past." These big moments include "Horsewhipping the Masher," "Dancing the Turkey Trot," "A Big Moment in the Love Life of an Elevator Starter," "The First Flush" (the modern toilet), and others. Other sections, "The Way of the Transgressor," "When the Theatre Was Fraught with Romance," "Many Morals for Young and Old," "Start the Piano—Here Comes a Sailor," "Yesterday and Today," "Songs without Music," and "Just an Old Fashioned Romance" explore the social issues of sin, morals, romance, mores of young and old, bar scenes, and even older ballad themes of love, deception, revenge, and unrequited lovers.

Thus, the block prints destroy the validity of the past by taking its rosily viewed situations and values to ironic task. Held implies nostalgia is false; there was no rosy past; what by some is considered a superior time with no tensions and problems was wrought with the same dilemmas of the 1920s. Moreover, these are universal themes. Held's inclusion of ballad and folksong situations and lyrics suggests that he recognizes these issues as existing beyond the Gilded Age or the 1920s. They are age-old themes.

Much of Held's knowledge of these universal themes and his method of illustrating them came from his understanding of a source of native American humor, the ballad and the folksong. He collaborated with Frank Shay for three song collections published by the Macaulay Company: *My Pious Friends and Drunken Companions* (1927), *More Pious Friends and Drunken Companions* (1928), and *Drawn from the Wood* (1929), all illustrated in the Gilded Age style. As we have already noted, Held was familiar with the linocut from a young age in Salt Lake City, and he first applied it as an illustrator to the *Navy Song Book* in 1918. His association with Shay is important because Shay, a Greenwich Village bookseller and Cape Cod resident, was one of the informal band of scholars, writers, concert performers, and record company scouts who popularized the folksong in the 1920s. Hence, Shay shared many roles with Robert Winslow Gordon, James Weldon Johnson, Carl Sandburg, John Lomax, and Ralph Peer. In his three anthologies Shay freely mixed traditional ballads, sentimental ditties, and hoary chestnuts, at times offering valuable folksong variants from his own wanderings (the Canadian Rockies, a Standard Oil tanker, and army camps in France). For these three books Held primarily brought together earlier block prints from the *New Yorker*. (Later he provided the same comment for James Geller's *Grandfather's Follies*, 1934, an easygoing comment on nineteenth-century melodrama.) Shay, much to the dismay of some ballad scholars, cheerfully jumbled together folk and Tin Pan Alley material in the books. Held similarly was free with his labels, indiscriminately using phrases such as "American Folk Song," "Old Song," "Old Ballad," and "A Song from the Dear, Dim Past."

But what Shay accomplished with such randomness was to broaden the popularization of the American folksong. He anticipated the folklore purists' criticism when he wrote in the preface to *My Pious Friends*: "The Folklorist will

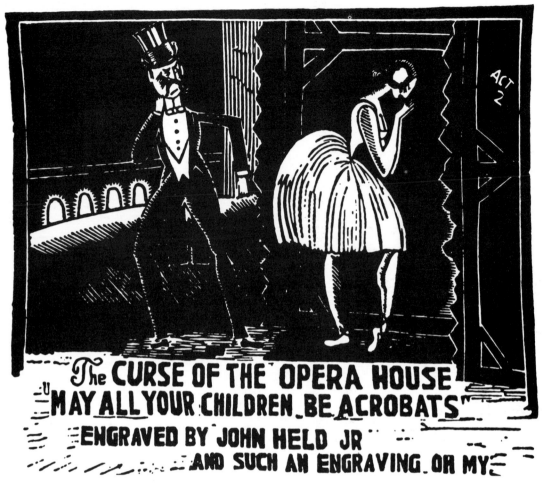

Curse of the Opera House. *My Pious Friends and Drunken Companions*, 1927. Permission of Illustration House, Inc.

dismiss them with the phrase profane and vulgar. To him they are but the product of low resorts, gutter songs, the communal musical expression of an artistically destitute society."[25] Of course, Shay believed just the opposite, and so did Held as exemplified in his wide knowledge and appreciation of this American artform. In one of his picture books, *The Saga of Frankie and Johnny*, he indicates the importance of the ballad as personalizing cultural experience:

When a youth I learned the song of "Frankie and Johnny" from a colored piano player, who was called "Professor" in a parlor house.

The parlor house was owned and run by a lady who was called Madam Helen Blazes. You may conclude that mine was a misspent youth, but the

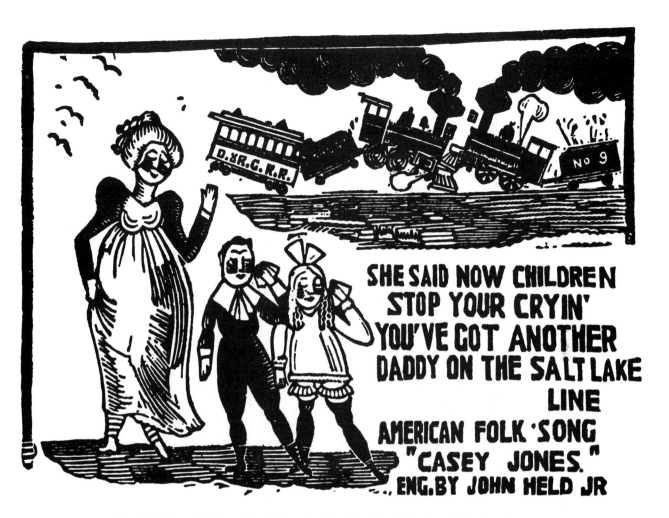

SHE SAID NOW CHILDREN STOP YOUR CRYIN' YOU'VE GOT ANOTHER DADDY ON THE SALT LAKE LINE AMERICAN FOLK·SONG "CASEY JONES." ENG.BY JOHN HELD JR

She Said Now Children Stop Your Cryin'. *My Pious Friends and Drunken Companions*, 1927. Permission of Illustration House, Inc.

knowing of these ladies and the houses that they ran has enabled me to fashion this book of woodcuts from fond memories.

The history and origin of this song has been studied by better minds than mine. Versions in the hundreds have been turned up, but basically the saga is the same. Verisons have been evolved to fit the locality, but the story of the eternal triangle remains identical. Details are rearranged to fit geographic conditions. In the illustrated edition, I have taken only the rudimentary verses. I have tried to keep off local tangents. To many this song will undoubtedly seem incomplete, as verses differ in different parts of the land. . . .

The engraving of these blocks has taken many hours and a strong right arm, but in doing them I have lived again a wild free existence in an Inter-Rocky Mountain settlement with my friends, the whores, the pimps, the gam-

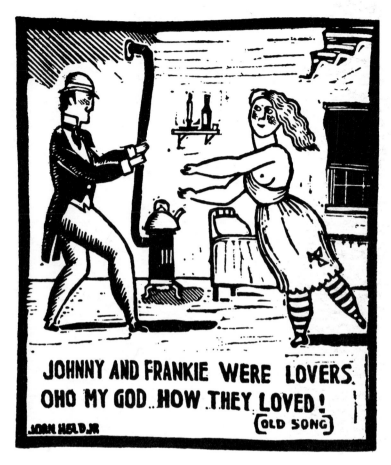

Johnny and Frankie Were Lovers. *My Pious Friends and Drunken Companions*, 1927.
Permission of Illustration House, Inc.

blers, the hop-heads and the lenient police, who used to know "The Mormon
Kid."[26]

Despite the somewhat tongue-in-cheek account, Held indicates his firsthand
experience with native American humorous materials. He takes a rather unique
place, too, as a chronicler of a whole sequence of visual art inspired by an Amer-
ican folksong. As Archie Green has noted, very few American folksongs have
inspired whole cycles of visual art. Beginning about 1927, Thomas Hart Benton
made a few oil paintings and lithographs based on special traditional ballads and
fiddle tunes. In 1930 Miguel Covarrubias illustrated "Frankie and Johnny" in the
form of a printed play by John Huston. Between 1944 and 1954 Palmer Hayden
placed the John Henry narrative in twelve paintings. Working in the genre of
ephemeral broadside art, Held's Gilded Age art tapped the sources of early Eng-

lish chapbooks, broadside ballads, sensational almanac illustrations, and lurid theater posters.[27]

Such clever combinations of sources and conventions of American humor allowed Held better to affect *New Yorker* humor. By commenting on the aspects of life in the 1920s through the metaphor of the Gilded Age, he not only cancels the nostalgic safety of the past, but questions the contemporary era. Moreover, because caricature of an era already an exaggeration of itself became impossible through flapper drawings, Held's Victorian women become caricatures of their flat-chested, long-legged progeny. They are a visual way Held could overstate the absurdity of the 1920s. He poked fun at the ignored cultural continuum that existed between the dear, dead days and the jazzy present. Just as he dissolved the apparent tragedy of wickedness and evil of the Gilded Age into bathos, so he questioned the radicalness of the Jazz Age.

At first glance we may assume Harold Ross enlisted Held's block-print work in 1925 for the *New Yorker* exclusively for the purpose of freshness. The flapper was worn out as an image readily identified with a half-dozen other magazines. The melodramatic block prints were distinctive and therefore effective in the context of other *New Yorker* cartoons. Yet Ross's decision was more than commercial; he recognized in the Held block prints a strain of humor that would come to be characterized as *New Yorker* humor—a sophisticated, detached attitude that exhibited none of the moralizing or sentimentality of the traditional parodist, satirist, or humorist. Observes art critic Joshua Taylor of the period: "In art, the cult of the city was often closely allied with tendencies that sought to avoid all sentimentality and spontaneous personal expressiveness in favor of a disciplined order and a detachment that sometimes was manifested in a studied irony."[28] Taylor goes on to note in *America as Art* that this sophistication was directly wedded to urbanity and could exist nowhere else but in the metropolis:

> This self-conscious detachment and wit, the reluctance to admit any whole-bodied commitment, the wariness of enthusiasm, were . . . a part of the new cult of the city. . . . To assume the nature of the city, not to wonder at it, was the first law of sophistication. The kind of humor and polished writing established in 1925 by the *New Yorker*, which was called "the semi-official organ of sophistication" by Gilbert Seldes in 1932, represent well the careful skepticism with regard to content and the serious devotion to a sense of style that would not likely come outside an urban environment. What the magazine stood for seems clearly to have been appreciated because it was much in demand by would-be sophisticates throughout the country, certainly more for its "tone" than for its information about New York.[29]

Most critics of Held have failed to see him as a *voice of sophistication* during the period, primarily because they expect of humorists a basically superior stance to their subjects. But in his use of framing techniques and his combina-

THE WHALE HUNTERS

RISKING LIFE AND LIMB TO SECURE OIL FOR ACTORS HAIR
AN ENGRAVING WITH A MESSAGE BY JOHN HELD JR

Risking Life and Limb to Secure Oil for Actors' Hair. *My Pious Friends and Drunken Companions*, 1927. Permission of Illustration House, Inc.

tion of various styles, as in the case of the Victorian linocuts, he affected a cool pen. Maintaining a detached and warmly ironic relationship to his pictures, he accomplished the goals of caricature without the acidic or satiric and thus superior tone of, say, Daumier, Hogarth, or Posada. One of the hallmarks of *New Yorker* humor was its turning inward, its emphasis precisely on non-moralizing, its emphasis on absurdity, including the humorist himself. In short, *New Yorker* humor was a change from older, traditional forms. It was ahistorical and amoral—truly an expression of a modernist culture.

For Benchley, Thurber, and the host of *New Yorker* humorists, the world was absurd, centerless except for the befuddled narrator who exercised narrative control over his mad world by identifying himself as its creator. Like these sufferers from dementia praecox, Held confessed himself the architect of this

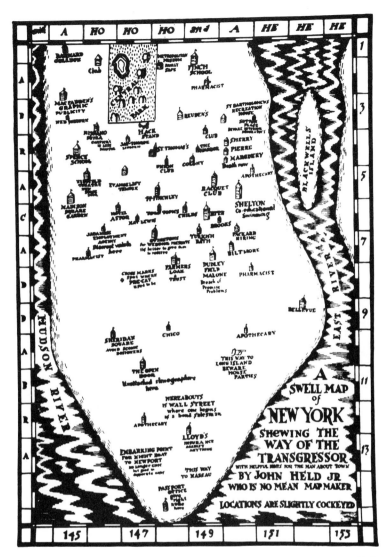

A Swell Map of New York. *The New Yorker*, © 1927, 1954. Permission of *The New Yorker* Magazine, Inc.

world, if not its victim.[30] "John Held, Jr., Cartographer," appeared on a series of comic maps done for the *New Yorker* during the 1920s, and in various forms alerted the reader to the whimsy and unreliability of this mapmaker. In the *New Yorker* and *Country Life* and later partially collected in *The Wages of Sin*, the mapped worlds are a kind of Yoknaptawpha County where, like William Faulkner, Held is sole proprietor and operator. In the lower right-hand corner of the bottom of each of these maps, Held identifies himself as chief cartographer: "After All, No One Makes Maps Quite As Well As John Held Jr. try as they may"; "John Held Jr. Cartographer Deluxe;" "Another One of Those Silly Maps by

John Held Jr. who thinks of the darndest things"; "A Map by John Held Jr. who wishes He Had Never Started the Idea"; "Map Engrossed by John Held Jr. as Only He Can Engross"; "John Held Jr. Who is No Mean Mapmaker." The pun of the last sobriquet is significant. The mapmaker comes to us highly touted (by himself!) and ironically so, for, while these maps often directly describe real places, the places are crazy as much because of the way our mapmaker "sees" them as because of now they really are. In "A Swell Map of New York Shewing the Way of the Transgressor with Helpful Hints for the Man About Town," Held confesses at the bottom of the map that "Locations Are Slightly Cock-eyed." Each of these maps is done in the old woodcut style suggesting venerable old maps, and they are funny because of the same conventions Held used in his Gilded Age woodcuts. There is the implied truth of an earlier era because of the design, the identification of an "unreliable" narrator who obviously revels in cockeyed depictions, the suggested affinity to the actual present—real locations, such as the Ziegfeld Theater in New York—asides to the audience, or paren-thetical remarks which further deflate the scene ("Saratoga Springs A Map by John Held Jr. . . . One of the Charms of a Map Like This Is That Nothing Is Any Where Near Correct"). The Gilded Age woodcuts read like samplers with homilies. The maps read similarly: they contain a title, a scale (usually inset and bordering the map), the map itself, a compass, inset and scrolled subtitles, and various credits to the tongue-in-cheek cartographer. The overall result is the to-tal destruction of "truth." While the map appears real, it obliterates the reliabil-ity of the pathfinder, the map and its accruements, and the territory itself. The reader is totally lost in the hilarity of such a labyrinth; nevertheless, this world is very real.

As in the Gilded Age woodcuts, Held again offers no alternative set of val-ues or worlds to the one he destroys. Unlike the true caricaturist, who tradition-ally distorted characteristics of a time and people to suggest a better alternative, Held offers no such recommendation in his maps. One lives within these absurd borders.

If one cannot critically recommend a better world or take this one seriously to assault its problems, Held shows that the same worldview that allows for cockeyed mapmaking can invent new worlds of fantasy. Carrying his cockeyed-ness one step further, Held drew a whole series of maps that are flights of fancy. Like Walter Mitty, Held's escape from absurdity is to revel in another level of it. "A Sportsman's Map of Florida," "A Dog's Idea of the Ideal Country Estate (An Imaginative Map by John Held Jr.)," and several others offer dreamed of Uto-pias to visit. If the reader seeking direction from maps of Saratoga, New York, Broadway, Americana, and Great Neck is lost in a miasma of contradictions, the imaginative reader of the maps finds a haven for his bruised psyche. But, of course, these maps only suggest that Held's imaginative world is madder. The only perfection exists on the flat and deceptive planes of the created page.

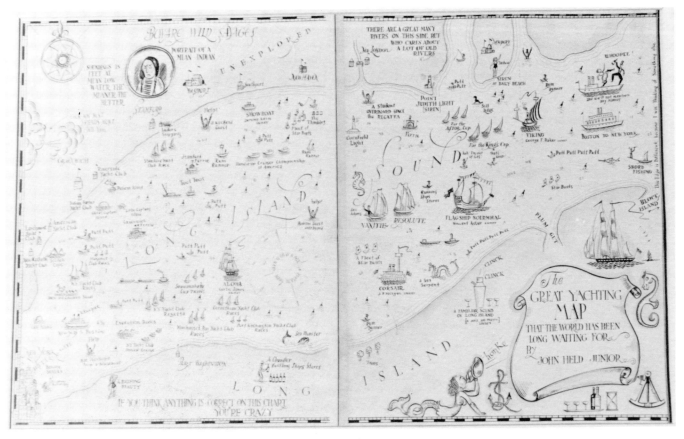

The Great Yachting Map (undated). Permission of Illustration House, Inc.

Beyond these mapped territories Held created yet another world inhabited by barnyard creatures, mythical beings, and an occasional shocked human. Much of Held's animal humor borders on a dream or fantasy world where time zones are warped and the inhabitants of the peaceable kingdom are harmoniously at home with a timeless array of brethren. In *Pan and the Sheep*, a watercolor painted in the 1930s, the goat-footed fellow lectures a spellbound flock on a western mesa. In *Afternoon Fantasy* a hunting dog points to a playful Pan in the bush as the surprised hunter looks on. *Cowboy Centaurs* depicts four creatures who are half-man—cowboy—and half-horse as they pass before a spectacular mountain. A horned toad crouches nearby. *Angel over Saint Patrick* shows a surprised flock of pigeons recognizing an angel—equally surprised—in their midst. In *Navajo Pan* the mythical creature, complete with headband, pipes to a lusty array of goats he is shepherding. These watercolors, most of them painted

in the mid to late 1930s, demonstrate the same sentiment Held expressed in 1926 on a *Life* cover entitled "The Laughing Stock." Here a group of farm animals guffaw over the syrupy looks of a flapper and jelly bean as they plaintively hold hands. In these fantasy worlds, the animals are wise, witty, and content.

Held always depicted himself comically as a cowboy and many times as a cowboy centaur, part man and part of the beasts he was so fond of. When Maggie first met him they exchanged gifts that Christmas, Maggie giving him a pair of ski boots he's seen in a store window and liked. He sent her a thank-you card, painting himself as a cowboy centaur wearing the ski boots on his two front feet. For an elderly woman who used to knit his argyle socks, Held sent a thank-you note with the cowboy centaur wearing the socks, one pair on the front feet and one on the back feet. His love of mythology dated from his youth when he was fond of *Bulfinch's Age of Fable* in his father's library. Throughout his career, he painted Pan, Bacchus, unicorns, the Valkyries and others, usually debunking human traits by emphasizing their split qualities as little gods yet animals. This combining of the classical and contemporary as in the case of the cowboy centaur is typical Held humor, for as he once remarked, "Humor is nothing more than the upsetting of false dignity."

Therefore, in reinventing the world—reframing it—Held emphasized that the manner of access through the frame is what matters. In essentially rendering a process—the historic and attitudinal period of the 1920s—Held attempted to create a metaphorical sense of place. Margaret Halsey pointed out in *With Malice toward Some* that one frequently opens a door in some English home only to find a brick wall. Winston Churchill may have been thinking along those same lines when he said of Lloyd George, a native of the Celtic fringe, "He's had that deep original instinct which peers through the surface of words and things—the vision which sees dimly but surely the other side of the brick wall."[31] The wall is visible only if it is seen through or past. A symbolic wall is penetrable only if it is seen. Held used artistic devices for humorous effect; he reinvented the 1920s by standardizing not style, but effect. As such his pictures are not mirrors or windows for viewing this culture, but the shrewd depiction of surfaces. By focusing the audience on these surfaces—the very externals of the culture in which he lived—Held enabled us to see beyond this brick wall. And the rare element that produced his peculiar and special genius was that he was an artist *and*, as *Vanity Fair* noted in naming him to their 1927 Hall of Fame, a "born comedian." By exercising both, he set not the style and manners of a period but its tone.

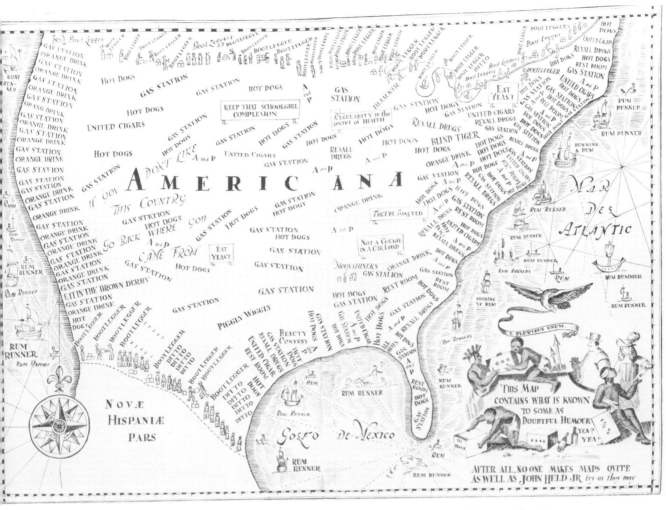

Americana. *The New Yorker*, © 1928, 1956. Permission of *The New Yorker* Magazine, Inc.

Afterword

One of the most sensitive and attentive critics of Held's work, Carl Weinhardt, Jr., once made this comparison of Fitzgerald and Held: "Unfortunately, Held's posthumous critical reputation has been until now more or less equal to what Scott Fitzgerald's would have been had Fitzgerald been judged solely on the basis of his best and brilliant and very superficial short stories. . . . By his prime Held had had no real crack-up, and was for the most part a remarkably happy man. The content of his work is therefore more generally surficial, though at its best it has no less integrity and skill than his literary counterpart."[1] Though true to a point, Weinhardt's comment reveals more about the immaturity of any critical apparatus for interpreting the popular or comic arts than it does for Held's canon itself. The lack of serious study of comic art, and indeed, humor in general, almost always results in an evaluation of its forms as surficial, and therefore, inconsequential. Due to its realistic, yet exaggerated, qualities, the cartoon or caricature often constitutes varying definitions of reality. In the case of a gifted artist such as Held, the essence of style lies in the tension between his artistic aims and the actual foibles of the period he drew—between his art and his era.

Historically, the success of cartoon art depended on its grounding in realism with a corresponding graphic emphasis—a style that created a new world out of the tension between the "artistic" and the "factual." Whether chiefly political, social, or personal, comic art often created a new reality through which the audience could spy certain old truths, varying in its manipulation of known facts or behavior due to the artist's documentary, expressionistic, or futuristic style. Therefore, when the critic examines the documentation of an historic period in the cartoon, he confronts not an actual world, but a fiction. Admitting to this concept frees interpretation since the cartoon is, as Northrop Frye says of poetry, "a mirror to the world, but not the world itself."[2] The cartoon thus is a world we build up and enter into at the same time. As a form it is rooted in identifiable experience; it does replicate. But the way in which the cartoonist renders reality creates an inherent paradox. Because this process involves certain artistic conventions, when the cartoonist attempts to render, he in fact makes.

In Held's hands, the role of the maker communicating the reciprocity between actual and fictional worlds establishes him as a mediator, a narrator mediating between the image and the imaged, executing certain elements of the cartoon which deliver his idea on the subject. Because the cartoon is above all graphic, its visual language often operates through a system of nondiscursive symbols, requiring the maker to create contexts as a clue to interpretation. Each cartoon may create its own context or may derive meaning from the reference to other contexts—other specific cartoons, conventions, or generic affiliations. In this way, ideas come from playing on what is considered by the audience to be true. Held's ability to recreate the era of the 1920s thus hinged not only on the documentary qualities of his comic art, but on the symbolic and referential aspects as well. Moreover, he exploited the paradoxical role of the "maker" by emphasizing his own astigmatisms, therefore suggesting any truth is by nature warped and distorted—and hence, inherently humorous. As Minor White has suggested, to get from the tangible to the intangible in any medium, which mature artists claim as their task, a paradox is often helpful. Held distorts to document and documents to distort. The cartoon is at once a mirage and a metaphor. If he is surficial, as Weinhardt suggests, this attitude is in itself a tool. So vital was Held's imagination as an artist, he sought to free himself from the tyranny of surfaces and forms by creating a paradox out of the well-known surficial qualities of the 1920s. By incorporating a plethora of artistic ornaments and styles into his depiction of a distinct time period, he creates paradox by what George Kubler has called "a disjunction between form and meaning," which occurs when the artist tries to make meaning by remaking forms:

> Renascent forms are repetitions of a past tradition made to assure its perpetuation. The disjunctive forms, on the contrary, infuse old forms with new meanings, and clothe old meanings with new forms. Artist and artisans of all times face this choice about the forms of the past; either the past is viable, deserving to be continued, or it is irrelevant, and discarded for a time. Most commonly the choice imposes a separation or disjunction between form and meaning.[3]

Thus, Held's best cartoon art is ideographic; its meaning resides both in the documentary aspect and in what, as maker, Held suggests about this world. By riffling through an almost bottomless hamper of earlier artistic forms to characterize his contemporary world, Held utilizes these disjunctive forms symbolically—as a device at once concrete and abstract. That he does not discard the forms of the past suggests his comprehensive view as an artist. In these seemingly illogical juxtapositions lie disjunction, the visual paradoxes that constitute his humor.

In this aspect of irony or "doubleness," as Malcolm Cowley called it in describing F. Scott Fitzgerald, Held and Fitzgerald may be most suitably com-

pared. The exuberant and distinguished journalist, Jack Shuttleworth, wrote a memorable account of meeting the two in 1925:

> He was tall, dark, and tweedy, and I found him sitting with F. Scott Fitzgerald in a midtown restaurant called "Bearnaise," a basement lounge filled with over-stuffed chairs, marble-topped cocktail tables, potted palms, and artificial leaves. It was in the fall of 1925. I remember it especially well because we had so much to talk about. There was Harold Ross' new magazine, and what effect it would have on *Life*—then and until 1936 a lively humorous weekly—and on my magazine, *Judge*; we figured the *New Yorker* would last another four months. There was the boom in Florida; the Scopes trial; Chaplin in the *Gold Rush*; Gershwin's "Rhapsody in Blue"; Red Grange turning pro; and Scotty's new novel, *The Great Gatsby*. I didn't know it then, but I was smack in the middle of the Jazz Age with its two creators—Fitzgerald and Held. Fitzgerald wrote it, Held drew it—drew its flat-chested flappers with their shingled hair, flapping galoshes, and high-riding skirts; drew their saxophone-playing boyfriends in coonskin coats, pocket-flasks bulging from bell-bottom trousers. In marvelous pen-and-ink sketches, Held caught them making whoopee.[4]

This encounter was to be the two men's first and last. They were not friends or even professional associates though Held did illustrate a book cover for Fitzgerald's *The Vegetable*. But of special significance is that their consequent attitudes as artists and their careers were markedly similar. Fitzgerald, as Cowley's "Double Man," had that special gift for recording the changes in an era so that his work communicates a sense of living in history. He valued the momentary color of an event and believed that through writing one could give value to the moment, suspending it volubly in time, even giving it a timeless quality. But he was also able to approach these moments ironically both as observer and partici-pant, one who was simultaneously enchanted and repelled by the conflicting manners and aspirations of his characters. Furthermore, like a Turgenev, he used his doubleness to reflect on a society in transition and on the problem of a society with false standards where the individual must find a way to make his place in it.

Held, too, possessed this redeeming quality of doubleness, and it is this abil-ity which makes his work endure. As topical as humor is said to be, one would expect that Held's humorous drawings would have only nostalgic appeal as arti-facts of a bygone time in American history. No doubt his cartoon art will persist as curiosities, but more because of his ability to address universal foibles of man-kind so that the era, though central to the meaning of the cartoons, functions as a backdrop as well. Unlike the sharp satirists before him—Swift, say, or Daumier—Held's implicit irony comes from his warmth, the fact that he was attracted to the period and its shortcomings. As the most popular graphic artist of the 1920s, he was part of the parade; he was a participant in the fast and furi-

ous lifestyle he depicted. And as the case of Fitzgerald, Held also withdrew from the fray in the 1930s, almost losing his gift of irony in a bitterness in the fiction and a "smiling through the tears" nostalgia demonstrated in interviews during this time. In his serious art, he either retreated into the substantial world of animal sculpture, to the earlier formal style of the *animalier* tradition, or the purgative and somber canvases of his Manhattan watercolors. His comic watercolors, populated by a ribald or at least gregarious lot of comic animals, provided a fantastic escape similar to that of Jupe Plume's, the cartoonist who bolts the pressures of the city for the fantasy world of the country. Jupe Plume faces the question asked by both Fitzgerald and Held of how the individual may rise in a corrupted society. His initial escape into fantasy is directly related to Held's own retreat from the limelight and commercialism in the 1930s. Yet Plume discovers he cannot live in a fantasy world. His marriage to the city girlfriend at the close of the novel suggests Held's own admission of his inability to escape through imagination.

Part of Held's doubleness, too, was his buttressing of an essentially western, Mormon background and his incredible eastern career and commercial success. Significantly, most of his life he was pulled by these two forces—the need for peace and contentment signified by farm life and the pursuit of artistic success. Implicit in Held's Mormon upbringing was another set of contraries. His success as a cartoonist was one which grew out of his belief in hard work and the Mormon ethic of perfectibility. In his early New York City days this unyielding drive for perfection led him to create expertly and quickly. Said to have worked like a human production line, Held practiced a work ethic that exactly fit the commercial demands of the 1920s. He manufactured the little flappers in every comic pose, with every accoutrement imaginable.

But in the end, Held's quick mind and artful variousness—really, his comic and playful self—was co-opted by these same commercial demands. The demands of editors and the insatiable public "purchased" his sense of humor so that when the stock market crashed and the skirts dropped, it was not the fact that he couldn't draw the flapper in the long skirt that cost him his success. Rather, his comic attitude toward such creatures was exhausted. The creatures themselves had been transformed by society into something else. Held's Mormon background which taught hard work and a faith in working toward perfection thus came into direct conflict with the consumer culture of the 1920s. In Held's craftsmanship, there was no formula for perfection.

But, as with Fitzgerald, if the angst Held suffered from the creative dissipation of his flappers led to a temporary loss of his gift of standing outside himself—his doubleness—the dark side of the 1920s carried a corresponding wisdom as well. In the drama of conflicting manners and aspirations, Held was both the audience and a leading character. Held took hold of his own characters through their dreams, and like them, he took hold of himself by poking gentle fun at such dreamers. Fitzgerald had the capacity to live the great moments and

live them again when he created their drama; but seeing himself as part of the picture, he was also able to coldly stand apart and pass judgment on himself. Held recognized this premise of the divided self—this gift for irony—in the microcosm of the cartoon which itself is a transitional world frozen in ironic word and gesture. As with all gifted artists, Held's pictures are sharp and immediate in their perceptions and bring the audience face to face with the artist's double world. Uniquely in Held's work, the gentle, if double-edged, humor is that of a western boy who would be a successful serious artist—smiling at his dreams and the world he created from them. For one thing, Held had the brilliance to combine the tablaux effect of one-dimensional art, for example Mayan relief or Grecian vase painting, with the abstract quality of line and color of modern art. In uniting these styles in the service of caricature, Held gave the cartoon a memorable quality, a mythic quality which registers in the public mind as one of those powerful images that survives as folklore of its time. Through his clever manipulation of planes of reference, he captured what the most astute progenitors of folk tale, folk art do: the highly memorable rituals of people that rise to peaks in the form of tableaux scenes in the hands of the artist. The effect of stylizing these actions is to give each its own peculiar aesthetic value. Everything superfluous is suppressed, leaving only the essential as salient and striking. As in the case of the folktale, for example, Held created sculptured situations based on fantasy and reality. Such tableaux scenes frequently convey not a sense of the ephemeral but rather a certain quality of persistence through time, as in the case of Perseus holding the head of Medusa. These lingering actions—which also play a large role in sculpture—possess the singular power of being able to etch themselves in one's memory. Thus Held's immortalization of the flappers, Joe College, and the Jazz Age, like the folk tale, progressed as through a series of bas reliefs, the cartoon's composition like that of sculpture. When Held applied the perspective of painting, it was to heighten the iconographic power of the cartoon. He is memorable today certainly because he captured the ritualistic behavior of the 1920s, but also because his work depicts universal actions that we respond to collectively. And because he recreated these actions through the brilliant unification of the popular and high arts, the attitudes they suggest outlive their original contexts.

As Thomas Inge has demonstrated in an article on Faulkner and the funnies, no less an admirer and imitator than William Faulkner emulated Held's blockprint and more fluid cartoon styles, finding in this visual form, with its ability to capture the energy of dance and music and its satiric and detached point of view, a lingering influence on his own fiction. Indeed, Held's imitators were many, but in the case of Faulkner, one can see the recognition of Held's archetypal power. In his unpublished short story, "Frankie and Johnny," for example, Inge notes that Faulkner has "recast and revised the American folk ballad in the form of a series of bold vignettes and rough prints much in the style of Held's unrefined woodcuts."[5] Moreover, Faulkner explored the psychological depths of

such images in the story line, using bittersweet comic detail, stereotypes of characters, setting all in the naturalistic context of a *Maggie* by Stephen Crane or Theodore Dreiser's *Sister Carrie*. It is significant that Held, too, remained interested in the art of melodrama and the power of juxtaposing the effects of such comic art models against a naturalistic setting, such as he attempts in some of his novels in the 1930s. Held did own a copy of *Sanctuary*, Faulkner's novel published in 1931. There is a possibility he was influenced by Faulkner himself and that ironically the two men demonstrate a kind of reciprocal awareness of the comic strip character, in the case of *Sanctuary* the stylized caricature-like Popeye, and the irony of his melodramatic actions against a naturalistic background. Both artists, Held and Faulkner, acknowledged the currency of such popular, yet pervasive, characters and actions, and their evocative connection to the serious purpose of the novel. At one point, in Faulkner's *Pylon*, he describes the forlorn main characters of the novel as forming "a tableau reminiscent . . . of the cartoon pictures of city anarchists."[6] While Held's novels have an autobiographical slant, and hence a modicum of the melodrama may have come from his disappointment in the 1930s, he recognized, like Faulkner, that from a pervasively ironic view can come a laughter that defies the meaninglessness life may appear to have.

Lucky for us that Held's talents exploded in the realm of popular comic art for his ability argues for a continuity of meaning between the so-called "low" or popular arts and high art. Held once remarked upon seeing a brilliant sunset, "I can paint a better sky than that," and rushed inside to his paints. Held believed that the artist was both seer and craftsman. Throughout the interviews with Held, it is clear he saw artistic talent (often associated with a kind of "craziness"—a vision contrary to that of mainstream society) as a gift: one that compels the recipient to create. Yet, he also believed art to be a product of hard work and conscientious craftsmanship. Held typifies the artist as a transitional cultural figure. If we follow Allen Gowan's argument in *Learning to See,* he posits that until the late 19th century, the artist was a person whose training as a craftsperson enabled him to execute a "substitute imagery"—artwork that symbolized significant meanings in the culture. This ability was a byproduct of his talent to "see," to recognize what this substitute imagery should be. However, later, Gowan asserts, when the artist became a professional, even a celebrity, the fine arts became divorced from their original cultural functions, the first of these, to create a substitute imagery. That is, art became an end in itself. In Held's hands, art remains tied to the culture as experience primarily objectified through humor.

Held wrote no great novels as Fitzgerald did. Perhaps his most successful art still is on the level of Fitzgerald's more popular short stories. Yet, as well as Fitzgerald, he had a great understanding of human nature and tremendous gift for immortalizing that lasting gesture in his art. Examined as a whole his work gives us an informal history of two decades of American life—the 1920s and its

aftermath. More importantly perhaps, his work is an intimate journal of an artist whose story, observed in his own eyes, and judged by his own consciousness, is more impressive than any critic could make. We like him now because he touches that deep understanding and the doubleness in us all.

Notes

1—The Biography

1. E. B. White, *Essays of E. B. White* (New York: Harper and Row, 1977), p. 121.

2. See index to *Vanity Fair* magazine, 1912–16, for entries under the names "Babette," "Myrtle Held," and "Held."

3. "The Doings at Cockroach Glades," in *The Most of John Held, Jr.* (Brattleboro, Vermont: The Stephen Greene Press, 1972), p. 9.

4. John Held, Jr., Papers, Archives of American Art, Washington, D.C.

5. Ibid.

6. Ibid.

7. Sponsored by the Smithsonian Institution and the Carnegie Institute, Young and Held recorded specific sites for the sponsoring agencies. See also Sylvanus G. Morley, "Journal," in *The American Archives of Archaeology*, the Carnegie Institute, Washington, D.C.

8. *Carnegie Institute of Washington Yearbook*, vol. 17 (1917/1918), p. 269.

9. Morley, "Journal," p. 36.

10. Ibid., p. 38.

11. Ibid., p. 42.

12. Ibid., p. 22.

13. Ibid., p. 32.

14. Ibid., p. 41.

15. See "The Strange Story," *Natural History*, December 1939, pp. 289–94, for an example.

16. Morley, "Journal," p. 51.

17. Interview, Mrs. John Held, Jr., 23 May 1981, Clinton, Conn.

18. Flo Field, "The Discovery and Pursuit of a Celebrity," *The Times-Picayune*, 6 May 1917, p. 42.

19. Ibid., p. 11.

20. Ibid.

21. *Judge*, 24 September 1921, p. 14.

22. "Oh! Margy!" ran as a half-page cartoon in various dailies in the period 1924–26. "Merely Margy, An Awfully Sweet Girl" ran in dailies and later in Sunday supplements from 1927 to 1929. In addition, Held created "Joe Prep," "Rah-Rah Rosalie," "Sentimental Sally," and "Peggy's Progress" in other color Sunday supplements for William Randolph Hearst.

23. Various newspaper articles report the "quality" of life Held and his artist friends enjoyed in the Westport-Weston area. For example, the *Westport Herald*, 19 Sept. 1924, reported:

> "Polo and other spectacular activities were formerly the privilege of only millionaires—now creative people, artists, writers, sculptors (Laura Fraser esp.). Among those who will be on hand, Oscar Howard cartoonist of "Metropolitan Movies," Clark and Nancy Ray, illustrators, Wm. Meade Prince highest paid advertising illustrator in America, Henry Raleigh and John Held Jr. who needs no introduction to anybody, and H. T. Webster the cartoonist."

Among the people who lived in Westport in the 1920s were Clive Weed, James and Laura Fraser, Hal Mowatt, Maud Tousey, Fangel, Ralph and Becky Boyer, Oscar and Lila Howard, Arthur and Sylvia

Fuller, Hubert Mathien, Lee Townsend, Harry Davie, Gene McNerney, Charles LaSalle, "Red" Huerlin, Ray Straug, Harry Hult, Tony and Sophie Balcom, William Meade Prince, Clint Shepherd, Carl Mueller, Rose O'Neill, Howard and Ellen Heath, Arthur Elder, Everett Shinn, Henry and Kay Luhrs, Harold Von Schmidt, James Daugherty, Sam Brown, Robert and Marie Lawson, Aliee, Harvey Ramsey, Perry and Dorothy Barlow, Garret Thew, George Clisbee, Kerr Eby, John Curry, and Leslie Benton. Westport as an art community was well established by this time. Even the Fitzgeralds rented a house in 1920.

24. Interview, Mrs. John Held, Jr., 21 May 1981, Clinton, Conn.

25. Quoted in the Stamford *Courier*, 15 January 1945.

26. Al Hirschfield quoted in "John Held, Jr.: The Making of an Era," by Tom Johnson, Minnesota *Daily*, Friday, 8 October 1982, p. 8.

27. *Our Times* (New York: Charles Scribner's Sons, 1936), vol. 2, p. 472.

28. Stamford *Courier*, 15 January 1945.

29. George Britt, "Modern Youth on the Griddle," The New York *World*, 17 April 1930.

30. Lisle Bell, "Books," *The Nation*, 27 April 1930.

31. Corey Ford, quoted on back of dust jacket in John Held, Jr., *Grim Youth* (New York: Vanguard, 1930).

32. Interview, Mrs. John Held, Jr., 21 May 1981.

33. John Held, Jr., Papers, Archives of American Art.

34. Brooks Atkinson, "'Hellzapoppin!'" New York *Herald Tribune*, 23 September 1938.

35. Interview, Mrs. John Held, Jr., 21 May 1981, Clinton, Conn.

36. Ibid.

37. Ibid.

38. Ibid.

39. Ibid.

2—The Rise of the New Woman and the Search for Style

1. F. Scott Fitzgerald, "My Lost City," *The Crack-Up* (New York: Scribner's, 1931), p. 25.

2. Fitzgerald, p. 27.

3. I am using this term to designate women seeking liberation during the period 1910–29, who sought opportunity and equality in the areas of home and professional life, and who categorically represent a departure in "manners and morals" from the Victorian women of the preceding period.

4. Corey Ford, *The Time for Laughter* (Boston: Little, Brown, 1967), p. 12.

5. *College Humor*, September 1929, p. 39.

6. Susan Meyer, *America's Great Illustrators* (New York: Abrams, 1978), p. 92.

7. G. K. Chesterton, "Morals Today," *Life*, October 1921, p. 32.

8. Revisionism, in the form of a developmental interpretation of the relationship between the Progressive era and the twenties, has been gaining strong support in recent years. De-emphasizing the disruptive impact of World War I, Henry F. May asked whether the 1920s could be understood fully "without giving more attention to the old regime," in "Shifting Perspectives on the 1920s," *Mississippi Valley Historical Review* 43 (December 1956): 405–27; see also Henry F. May, "The Rebellion of the Intellectuals, 1912–1917," *American Quarterly* 8, no. 2 (1956): 145, wherein May describes 1912–17 as a "prerevolutionary or early revolutionary period." May declared that "immediately prewar America must be newly explored," especially "its inarticulate assumptions—assumptions in such areas as morality, politics, class and race relations, popular art and literature, and family life." May pursued his inquiry in *The End of American Innocence* (New York: Knopf, 1959) and showed that for the purpose of intellectual history, at least, the twenties were not as significant as the preceding decade. Political historians have been reassessing the relationship of the Progressive era to the twenties as well. Arthur Link has demonstrated that progressivism survived World War I ("What Happened to the Progressive Movement in the 1920s?" *American Historical Review* 44 [1959]: 433–51), and J. Joseph Huthmacher has established continuity between progressivism and the New Deal in the immigrants' steadfast devotion to the ameliorative powers of the government in "Urban Liberalism and the Age of Reform," *Mississippi Valley Historical Review* 49 (1962): 231–41. Together with May's analysis, their writings suggest that the 1920s are much more the result of earlier intrinsic social changes than either the sudden, supposedly traumatic experiences of the

war or unique developments in the twenties. Since this assertion is certain to encounter the formidable claims that the 1920s, at least in manners and morals, amounted to a revolution, its viability is tested when examining the period of American women's "emancipation" in manners and morals before World War I and the consequent reflection of this emancipation in Held's cartoons.

9. George Elliott Howard, "Social Control and the Functions of the Family," Howard J. Rogers, ed., *International Congress of Arts and Sciences: St. Louis, 1904,* 8 vols. (New York: University Alliance, 1907–8), 7: 702.

10. Dorothy Dix, *Boston American,* 9 September 1912.

11. Ibid., 15 October 1913.

12. Marian Harlan, "The Passing of the Home Daughter," *Independent,* 13 July 1911, p. 90.

13. Sophonsiba P. Breckenridge, *Women in the Twentieth Century: A Study of Their Political, Social and Economic Activities* (New York: McGraw-Hill, 1933), p. 112. Overall percentages of women gainfully employed rose from 19 percent of the total work force in 1890 to 20.6 percent in 1900, 24.3 percent in 1910, 24 percent in 1920, and 25.3 percent in 1930.

14. Martha Bensley Bruere and Robert W. Bruere, *Increasing Home Efficiency* (New York: Macmillan, 1914), pp. 236–41.

15. See William H. Lough, *High-Level Consumption: Its Behavior; Its Consequences* (New York: McGraw-Hill, 1935), pp. 236, 241. Also James Dewhurst, *America's Needs and Resources: A New Survey* (New York: Twentieth Century Fund, 1955), pp. 702, 704, 180.

16. For example, see *Cosmopolitan,* May–October 1903; *Ladies' Home Journal,* December 1903–May 1904.

17. *Collier's,* 27 November 1915, p. 4. See also *Ladies' Home Journal,* May 1917, which shows a woman entertaining stylish women friends, pp. 34, 89, 92, driving the car or on an automobile trip, pp. 36–37, 74, economizing on time spent in housework, p. 42, the object of "outdoor girl" ads, p. 78, beautifying at a social affair or appearing very chic, pp. 102, 106. Perhaps the best illustration for woman's activity in advertisements was employed in *Ladies' Home Journal* by Williams talc powder. It read, "After the game, the ride, the swim, the brisk walk, or a day at the sea-shore, turn for comfort to Williams Talc Powder," *Ladies' Home Journal,* July 1917, p. 74.

18. *Cosmopolitan,* June 1915, advertising section, p. 50.

19. *Collier's,* 25 September 1915, p. 22.

20. *Collier's,* 27 November 1915, p. 25.

21. Neil Brinkley, a nationally syndicated cartoonist and commentator on women's activities asked this question of one of his young women (*Boston American,* 14 July 1913).

22. Neil Brinkley coined the phrase (*Boston American,* 14 November 1916).

23. Dix, *Boston American,* 4 May 1915. See also *Ladies' Home Journal,* July 1915, which depicts a young woman driving a speedboat while her boyfriend sits next to her.

24. *Boston American,* 1 October 1916.

25. *Collier's,* 4 March 1916, p. 38.

26. Margaret Deland, *The Change in the Feminine Ideal* (New York: Vantage, 1910), p. 291.

27. *Boston American,* 6 May 1910.

28. Ethel Watts Mumford, "Where Is Your Daughter This Afternoon?" *Harper's Weekly,* 17 January 1914, p. 28.

29. *Boston American,* 5 September 1916.

30. Alice Duer Miller, "The New Dances of the Younger Generation," *Harper's Bazaar,* May 1912, p. 250.

31. Deland, p. 293.

32. *Boston American,* 24 March 1916. In a letter to the editor of the *New York Times,* one critic of the "women of New York" complained that they seemed to be part of a "new race" or super sex. He waxed poetic: "Sweet seventeen is rouge-pot made. And nobles to her tasks blasé. . . . Where are the girls of yesterday?" *New York Times,* 20 July 1914. According to Helen Rowland, the woman was no "longer Man's plaything, but his playmate" ("The Emancipation of the Rib," *Delineator,* March 1911, p. 233).

33. *Boston American,* 7 April 1910.

34. *Boston American,* 10 May 1910.

35. On Newport and Boston society women, see *Boston American,* 6 July, p. 27, 10 August, p. 24, 1913. Pauline Frederick's picture may be found in *Boston American,* 2 August 1913. For Irene Castle, see Mr. and Mrs. Vernon Castle, *Modern Dancing* (New York: Harper, 1914), pp. 98, 105.

36. Owen Johnson, *The Salamander* (Indianapolis: Bobbs-Merrill, 1914), foreword, n.p.

37. Ibid., p. 9.

38. Ibid., p. 129.

39. Ibid., p. 66.

40. Ibid., p. 61.

41. Ibid., foreword, n.p.

42. "The kiss of friendship" had become a major issue of her mail by 1913. See, for example, *Current Opinion*, 5 July 1913. Girls shocked her with inquiries as to whether it was permissible to "soul kiss" on the first date. An engaged girl asked whether it would be all right to kiss men other than her fiancé (*Current Opinion*, 2 May 1916).

43. *Current Opinion*, 8 February 1917, p. 96.

44. *Boston American*, 15 June 1911, p. 18.

45. "Today in the world of fashion, all women are young, and they grow more so all the time" (Docuilet, "When the World Looks Young," *Delineator*, August 1913, p. 20). Advertisements used flattery or played up the value of youth for women and warned that they might age unless certain products were used. See *Cosmopolitan*, November 1915, p. 112; *Cosmopolitan*, July 1915, p. 81; *Ladies' Home Journal*, 1916, p. 65; *Cosmopolitan*, October 1915, p. 57.

46. Eleanor Chambers, "Facts and Figures," *Delineator*, April 1914, p. 38.

47. *Boston American*, 20 March 1910; *Delineator*, October 1916, p. 66.

48. *New York Tribune*, 4 April 1912.

49. Percival White, "Figuring Us Out, *North American Review* 27 (1929): 69.

50. *Boston American*, 10 September 1916.

51. *Delineator*, July 1914, p. 55.

52. *Boston American*, 3 September 1916.

53. *Cosmopolitan*, July 1915, p. 92.

54. *Our Times* (New York: Scribner's, 1936), vol. 2, p. 472.

55. *Ladies' Home Journal*, October 1917, p. 98.

56. *Boston American*, 8 June 1907. "The conventions of evening dress have changed radically in the last four or five years. Not so very long ago a high-necked gown was considered *au fait* for all evening functions except formal dinners and the opera. Nowadays, well-dressed women wear décolleté dresses even for home dinners, and semi-décolleté gowns for restaurants and theaters" (*Delineator*, January 1910, p. 98).

57. "The Cult of St. Vitus," *Unpopular Review* 3 (1915): 94.

58. *Boston American*, 6 July 1912. Dix noted "flirtations" of middle aged women were "aping the airs and graces of the debutante" and "trying to act kittenish" with men.

59. Quoted in *New York Herald Tribune*, Sunday, 14 December 1930.

60. *Boston American*, 7 March 1910.

61. William E. Leuchtenburg, *Perils of Prosperity* (Chicago: University of Chicago Press, 1958), pp. 174–75.

62. "'Years of Discretion': A Play of Cupid at Fifty," *Current Opinion*, February 1915, p. 116.

63. *Current Opinion*, p. 117.

64. *Boston American*, 10 April 1908. Evelyn Nesbitt, the wife of Harry Thaw, was romantically involved with architect Stanford White, whom Thaw shot to death.

65. *Boston American*, 25 August and 1 September, 1912.

66. Lewis I. Dublin, "Birth Control," *Social Hygiene* 6 (1920): 6.

67. Alfred Kazin, "Three Pioneer Realists," *Saturday Review of Literature*, 8 July 1939, p. 15. Herrick's biographer, Blake Nevius, declares, "It can be argued that Herrick is the most comprehensive and reliable social historian in American fiction to appear in the interregnum between Howells and the writers of the Twenties."

68. Nevius, *Robert Herrick* (Berkeley: University of California Press, 1962), p. 177.

69. Ibid., pp. 91, 392.

70. Ibid., pp. 263, 250–51, 320–24.

71. Herrick describes the temperament of the modern woman as one of "mistress rather than wife."

72. Elizabeth Sage, *A Study of Costume* (New York: Scribner's, 1926), p. 216.

73. Kenneth A. Vellis, "Prosperity's Child: Some Thoughts on the Flapper," *American Quarterly* 16, no. 2 (1974): 44.

74. Meyer, p. 95.

75. Quoted in John Dewey, *Art as Experience* (New York: Minton, Balch, 1934), p. 88.

76. Milton W. Brown, et al., *The History of American Art* (New York: Abrams, 1979), p. 492.

3—Artistic Exhaustion and Fiction

1. Gamaliel Bradford introduction, John Held, Jr., *Grim Youth* (New York: Vanguard, 1930), p. iii.

2. Ibid.

3. Ibid., p. iv.

4. Awarded in 1932.

5. Vanguard Press was founded to publish books to appeal to the social needs of the middle and lower class. The books therefore had appropriate "social" themes.

6. Held's works attracted considerable attention—over 350 reviews in the nine years that marked his first and last publications.

7. See Malcolm Bradbury and Howard Temperly, eds., *Introduction to American Studies* (London: Longman, 1981), for reports of the popularity of flapper fiction and movies as a phenomenon of the 1920s.

8. Bradford, p. iv.

9. See Frederick Lewis Allen, *Only Yesterday: An Informal History of the 1920's* (New York: Blue Ribbon Books, 1931), for an example.

10. Leo Gurko, *The Angry Decade* (New York: Harper and Row, 1947), p. 54.

11. Gurko, p. 55.

12. Robert Sklar, *The Plastic Age, 1917–1930* (New York: George Braziller, 1970), p. 12.

13. Van Wyck Brooks, *America's Coming of Age* (New York: B. W. Huebsch, 1915), p. 52.

14. See Edmund Wilson, "John Jay Chapman," *New Republic*, 26 November 1931, p. 32.

15. (Camden, N.J.) *Courier*, 10 April 1930.

16. Toledo (Ohio) *Times*, 25 May 1930.

17. *Atlanta Constitution*, 7 June 1930.

18. *Denver News*, 31 May 1930.

19. *San Francisco Chronicle*, 7 June 1930.

20. *New York World*, 30 August 1930.

21. *Macon* (Georgia) *Telegraph*, 1 June 1930.

22. Lisle Bell, *Books*, 27 April 1930.

23. *San Francisco Chronicle*, 18 April 1930.

24. *Scribner's*, June 1930.

25. "The Flesh Is Weak," *The New Republic*, 23 December 1931, p. 83.

26. *New York Times*, 7 January 1932.

27. Blanche Gelfant, *The American City Novel* (Norman: University of Oklahoma Press, 1954).

28. Theodore Dreiser, preface to Edward McDonald, *A Bibliography of the Writings of Theodore Dreiser* (Philadelphia: Centaur Book Shop, 1928), p. 12.

29. James T. Farrell, *A Note on Literary Criticism* (New York: Vanguard, 1936), p. 11.

30. Quoted in Frederick J. Hoffman, *The Twenties: American Writing in the Post-War Decade* (New York: Viking, 1955), p. 95.

31. Ibid., p. 102.

4—Watercolors and Bronzes

1. See Lucy Hazard, *The Frontier in American Literature* (New York: Crowell, 1927); Arthur Schlesinger, *The Rise of the City: 1878–1898* (New York: Macmillan, 1933); and R. W. B. Lewis, *The American Adam* (Chicago: University of Chicago Press, 1955), for treatment of this idea.

2. Catherine Beach Ely. "John Held, Jr.," *Art in America*, vol. 10 (February 1922), pp. 86, 90. Other reviewers of Held's watercolors were laudatory as well. A typical response from the *New York American*, 25 May 1923, reads: "In this skillful use of watercolor Mr. Held ranks with the best of American painters." Though Held publicly exhibited little of his watercolor work during his lifetime, every published

review named him a major talent. The best compendium of his work may be seen in the collection of Graham Gallery catalogs (New York) of his shows done during his life and posthumously.

3. Joshua C. Taylor, *America as Art* (New York: Harper & Row, 1976), p. 190.

4. See also Sidney Allan Sadakichi Hartmann, "The 'Flat-Iron' Building: An Esthetical Dissertation," *Camera Work* 2 (October 1903): 34–40; Martin Friedman, *Charles Sheeler* (New York: Watson-Guptill, 1975); Irma B. Jaffe, *Joseph Stella* (Cambridge, Mass.: Harvard University Press, 1970); Lewis Mumford, "The Metropolitan Milieu," in *America and Alfred Stieglitz: A Collective Portrait*, ed. Waldo Frank et al. (New York: Literary Guild, 1934); Sheldon Riech, *John Marin: A Stylistic Analysis and Catalogue Raisonné* (Tucson: University of Arizona Press, 1970).

5. Quoted in Taylor, *America as Art*, p. 195.

6. The best short source analyzing the optimisitc treatment of the city as frontier of new landscape is Dominic Ricciotti, "Symbols and Monuments: Images of the Skyscraper in American Art," *Landscape* 26 (1982): 18–27.

7. Wayne Attoe, *Skylines: Understanding and Molding Urban Silhouettes* (New York: Wiley, 1981), p. 10.

8. Ibid., p. 12. For other studies of the cultural meaning of skylines, see also Wayne Attoe, *Architecture and Critical Imagination* (Chichester, England: Wiley, 1978); V. Cornish, *Scenery and the Sense of Sight* (Cambridge University Press, 1935); C. Jencks, *Skyscrapers-Skyprickers-Skycities* (New York: Rizzoli, 1980); Peter F. Smith, *The Syntax of Cities* (London: Hutchinson, 1977); Winston Wiseman, "A New View of Skyscraper History," *The Rise of American Architecture*, ed. Edgar Kaufmann, Jr. (New York: Abrams, 1970); and Diane Agrest, "Architectural Anagrams: The Symbolic Performance of Skyscrapers," *Oppositions* (winter 1977).

9. Quoted in Taylor, *America as Art*, p. 196.

10. Attoe, *Skylines*, p. 55.

11. John Held, Jr., "The Pigeon of St. Patrick's," *The Flesh is Weak* (New York: Vanguard, 1931), p. 92.

12. Harold P. Simonson, *The Closed Frontier: Studies in American Literary Tragedy* (New York: Holt, Rinehart, & Winston, 1970), p. 32.

13. F. Scott Fitzgerald, "My Lost City," *The Crack-Up* (New York: Scribners, 1931), p. 13.

14. Ibid., p. 14.

15. Holger Cahill in Holger Cahill and Alfred H. Bass, Jr., eds., *Art in America in Modern Times* (New York: Reynal & Hitchcock, 1934), p. 98.

16. Karal Ann Marling, "A Note on New Deal Iconography," *Prospects* 4 (1979): 421–44.

17. Wendell Jones, "Article of Faith," *Magazine of Art* 33 (1940): 554.

18. Harold Rosenberg, *The Anxious Object* (New York: Collier Books, 1973), p. 39.

19. Howard Devree in the *American Magazine of Art*, April 1939, p. 232, recognized Held's place in the animalier tradition: "Here are puckish colts and staid performing circus horses, baby unicorns and rodeo groups, in which Held has taken a line between Herbert Haseltine and Renée Sintenis. His beasties are humorous without loss of dignity to the pieces; spirited without exaggeration or grotesqueness; live and full of direct appeal." See James McKay, *A Collector's Guide to Animal Sculptors of the 19th and 20th Centuries* (New York: Dutton, 1973).

20. Georges Bénédite, quoted in McKay, *A Collector's Guide,* p. 94.

5—Held's Humor

1. Corey Ford, *The Time of Laughter* (Boston: Little, Brown, 1967).

2. Dale Kramer, *Ross and the New Yorker* (Garden City, N.Y.: Doubleday, 1951).

3. James R. Gaines, *Wits End: Days and Nights of the Algonquin Round Table* (New York: Harcourt, Brace, Jovanovich, 1977).

4. Susan Meyer, *America's Great Illustrators* (New York: Abrams, 1978); Walt Reed, *The Illustrator in America* (New York: Reinhold, 1967).

5. Richard Merkin, "The Jazz Age as Seen through the Eyes of Ralph Barton, Miguel Covarrubias, and John Held, Jr." (Providence: Rhode Island School of Design, 1968).

6. Bartlett Hayes, "Optical Illusions," *The Art of John Held, Jr.* (Washington, D.C.: Smithsonian Institution, 1969).

7. Archie Green, "John Held, Jr.: Jazz and Gilded Age," *JEMR Quarterly* 14 (1978), p. 24.

8. Russell Lynes, "John Held's Mad World," *Harper's*, November 1967.

9. Carl J. Weinhardt, Introduction, *The Most of John Held, Jr.* (Brattleboro, Vermont: Stephen Greene Press, 1972), p. 16.

10. Examination of a number of other sources reveals that Held's themes were mainstream. See William Murrell, *A History of American Graphic Humor* (New York: Whitney Museum of American Art, 1933, 1938), 2 vols., who was the first authority to document the history of the development of pictorial satire and cartooning in America; Coulton Waugh's *The Comics* (New York: Macmillan, 1947); and Stephen Becker's *Comic Art in America* (Berkeley: University of California Press, 1981).

11. See Walter Blair, *Native American Humor* (Scranton, Pa.: Chandler, 1937); and Walter Blair and Hamlin Hill, *America's Humor* (New York: Oxford University Press, 1981).

12. Blair, *Native American Humor*, p. 181.

13. Ibid.

14. Ibid.

15. It is interesting to note how many art critics reviewed Held's work by commenting on the successful combination of his wit and artwork. Example:

> Few of us need an introduction to these delightful, whimsical pictures, for Mr. Held's work is widely known. But one of the unexpected things of the exhibition is the revelation of his color, which in reproduction has usually become black and white, but color is here, and so alluring in its perfect coordination with the design of the drawing that one forgets to find out what the picture is all about in delight at the harmony of the ensemble.
>
> His handling of the pure white background is a mastery of technique. No one needs to be told that Mr. Held is a finished draftsman or that his all pervasive humor never seems to make any difficulty with a serious, artistic handling of his medium, whether it is a print or colored drawing. His prints have delicious humor, but they make equally strong appeal in their tonal contrasts and powerful composition. (*New York Evening Post*, 4 March 1923)

16. The nearest existing analysis of the cartoon as commercial "art" is in Erving Goffman, "Gender Advertisements," *Studies in the Anthropology of Visual Communication* 3, no. 2 (1976): 97.

17. Walter Lippmann, *Public Opinion* (New York: Macmillan, 1961), p. 92.

18. Yi-Fu Tuan, *Space and Place: The Perspective of Experience* (Minneapolis: University of Minnesota Press, 1977), p. 131.

19. Jay Appleton, *The Experience of Landscape* (London: Wiley, 1975), p. 84.

20. Dean W. O'Brien, "Television and Place," *Landscape* 11 (1981): 32.

21. Green, p. 23.

22. Mark Sullivan, *Our Times*, vol. 2 (New York: Scribner's, 1926–35), p. 1001.

23. Ibid., p. 1002.

24. Lynes, "John Held's Mad World," p. 24.

25. Frank Shay, preface, *My Pious Friends and Drunken Companions* (New York: 1927), n.p.

26. John Held, Jr., *The Saga of Frankie and Johnny* (New York: Washburn, 1931), n.p.

27. See David Kunzle, *The Early Comic Strip* (Berkeley: University of California Press, 1973), which reaches to the year 1825 before the comic strip as we know it began. Kunzle traces the full development of narrative art in the European broadsheet, which he sees as an antecedent to the comic strip as he defines it.

28. Joshua Taylor, *America as Art* (New York: Harper & Row, 1976), p. 196.

29. Ibid., p. 197.

30. Blair and Hill, *America's Humor*, p. 436, cite these important characteristics of absurdist or dementia praecox humor: "[T]he world itself had become so chaotic and unreasonable that instead of feeling comfortably superior, a large segment of readers could identify with these comic types. Their problems, their futile attempts to solve them, and their defense mechanisms for surviving among them seemed all too universal. . . . Except for the most disguised sort, both Benchley and Perelman stop short of satire. Both point out the frailty of contemporary human beings confronting the technological world. Both see something ridiculous in man's fate. But the tidal waves of banter, frivolity, and whimsy prevent most readers from coming away from their *New Yorker*–style material clutching any message."

31. Quoted in O'Brien, "Television and Place," p. 34.

Afterword

1. Carl Weinhardt, "The Rise of the Mormon Kid," *The Most of John Held, Jr.* (Brattleboro: The Stephen Greene Press, 1972), p.13.

2. Northrop Frye, *Anatomy of Criticism* (Princeton: Princeton University Press, 1957), p. 73.

3. George Kubler, *The Shape of Time, Remarks on the History of Things* (New Haven: Yale University Press, 1962), p. 98.

4. Jack Shuttleworth, "John Held, Jr. and his world," *American Heritage*, vol. 16 (August 1985), p. 29.

5. M. Thomas Inge, "Faulkner Reads the Funny Papers," in *Faulkner and Humor*, edited by Doreen Fowler and Ann J. Abadie (Jackson: University Press of Mississippi, 1986), p. 156.

6. William Faulkner, *Pylon* (New York: Harrison Smith and Robert Haas, 1935), p. 81.

Selected References

PRIMARY SOURCES

Short story collections

John Held, Jr.'s Dog Stories. New York: Vanguard Press, 1930.
Grim Youth. New York: Vanguard Press, 1930.
The Flesh Is Weak. New York: Vanguard Press, 1931.
A Bowl of Cherries. New York: Vanguard Press, 1932.

Novels

Women Are Necessary. New York: Vanguard Press, 1931.
Crosstown. New York: Vanguard Press, 1933.
I'm the Happiest Girl in the World. New York: Vanguard Press, 1935.
The Gods Were Promiscuous. New York: Vanguard Press, 1937.

Children's stories

Danny Decoy. New York: A. S. Barnes & Co., 1942.
"The Tail of Mr. Dooley." *Woman's Day*, October 1949.
"Butch and Mr. Dooley." *Woman's Day*, February 1952.
"Corkie." *Woman's Day*, May 1953.
"Mr. Dooley Goes West." *Woman's Day*, October 1954.

Books illustrated

Eaton, Walter Pritchard. *Nantucket.* New York: Rand, McNally & Co., 1925.
————. *Rhode Island Shores.* New York: Rand, McNally & Co., 1925.
————. *Cape Cod.* New Haven: Press of W. H. Lee, Co., 1927.
Shay, Frank. *My Pious Friends and Drunken Companions.* New York: Macmillan Co., 1927.
————. *More Pious Friends and Drunken Companions.* New York: Macaulay Co., 1928.
————. *Drawn from the Wood.* New York: Macaulay Co., 1929.
Levy, Newman. *Saturday to Monday.* New York: Alfred A. Knopf, 1930.
Hunt, Ridgely, and George S. Chappell. *The Saloon in the Home.* New York: Coward-McCann, 1930.
Harriman, Lee. *The Dublin Letters.* New York: Washburn, 1931.
Geller, James Jacob. *Grandfather's Follies.* New York: 1934.

Hopton, Ralph, and Anne Balliol. *Pink Pants*. New York: Vanguard Press, 1935.
Gilbreth, Frank B. *Held's Angels*. New York: Thomas Y. Crowell Co., 1952.

Illustrated books by Held

Frankie and Johnny. New York: W. V. McKee, 1930.
Outlines of Sport. New York: E. P. Dutton Co., 1930.
The Wages of Sin and Other Victorian Joys and Sorrows. New York: Washburn, 1931.
The Works of John Held, Jr. New York: Washburn, 1931.

Exhibitions

ONE-MAN EXHIBITIONS

1923 New York City: "A Few Things"
1924 Westchester Biltmore Country Club (golf pictures)
1930 Dutton's, New York City (dog drawings)
1938 Macy's Gallery, New York City: "The Grand Canyon of New York" (watercolors)
1955 The Little Gallery, Princeton, N.J. (sculpture)
1969 Graham Gallery, New York City. "The Art of John Held, Jr."
1969 Smithsonian Institution, Washington, D.C.: "The Art of John Held, Jr."
1971 Graham Gallery, New York City: "Golf Show"
1975 Navy Memorial Museum: "John Held II.—Works"
1981 Graham Gallery, New York City: "The Watercolors of John Held, Jr."
1986 Smithsonian Institution Traveling Exhibit Service, Washington, D.C. "John Held's America—Flappers, The Jazz Age, and Beyond"

GROUP EXHIBITIONS

1920 The Art Alliance, New York City: "An Exhibition of Lithographs, Etchings, Engravings and the Like"
1922 Brown-Robertson Galleries, New York City: "Annual Exhibition of Painter-Engravers of America"
1939 Bland Gallery, New York City: "Sculptures"
1941 George Jensen, Inc.: "Exhibition of Small Sculpture"
1968 Museum, Rhode Island School of Design: "Jazz Age as Seen through the Eyes of Ralph Barton, Miguel Covarrubias, and John Held, Jr."

Selected Works in Various Media

1909 *Unian*, University of Utah Alumnae Association (illustration)
1917 "The Men Who Roasted the Plays: New York Critics as Seen by John Held, Jr." *The Theatre*, March 1917 (illustrations)
 "Hand Proofed Woodcuts from Linoleum Blocks." *New York Tribune*, March 1917 (linocuts)
 "Vera Cruz," "Lillie Elena," "Hog Island," "Yucatan" (watercolors)
1919 *Navy Song Book*, Navy Department Commission (illustrations)
 "Adirondacks" (watercolor)
 Illustrated books, *Ships*, unpublished (woodblock prints)
1920 St. Augustine, Florida; Federal Point, Florida (watercolors)
1921 Hippopotamus in gray clay, copyright 9 March 1921 (sculpture)

1922 Grindstone Hill Farm (watercolor)

F. Scott Fitzgerald's *Tales of the Jazz Age, Life,* 7 September 1922

1923 Golf series (watercolors)

Cover, Coffee House Club Bulletin (illustration)

1924 Gelett Burgess, "The Human Body: Its Care and Prevention." *Harper's,* April 1924 (illustrations)

F. Scott Fitzgerald's *The Vegetable* (dust jacket illustration)

Life, 1 May 1924 (advertisement for Ipana toothpaste)

Life, 10 July 1924 (advertisement for Clicquot Club ginger ale)

"Weston Follies," *Westport Herald,* 26 July 1924 (poster)

Westport Herald, 3 October 1924 (street signs for the town of Weston)

Gotham Book Mart, "Wise Men Fish Here" (sign)

Life, 31 January 1924 (advertisement for Planters peanuts)

1925 "Things from Grindstone Hill Forge," Fairfield, Conn. (brochure)

1926 "Comic Valentines," *Collier's,* 13 February 1926 (illustrations)

Life, 23 May 1926 (advertisement for Tintex dye)

Americana, a play (set design)

MGM films, *The Twenties, Tin Hats, The Boyfriend, Money Talks* (poster advertisements)

Wildroot New Crude Oil shampoo, *Collier's,* 23 October 1926 (advertisement)

1927 Robert Benchley, "The Children's Day," *Life,* January 1927 (illustration)

Calendar, Metropolitan Museum of Art (textile designs)

"The Breadth of the Avenue," *Amos Parrish Magazine,* April 1927 (illustrations)

The Poor Nut, a film. *Photoplay* magazine (advertisement)

Life, 6 October 1927 (advertisement for Timken bearings)

Cover, Yale-Princeton football program, 12 November 1927 (woodblock print)

1928 Emily Post, "Etiquette," *Harper's Bazaar,* June 1928 (illustration)

1929 *The Packard Magazine,* fall 1929 (illustrations)

1932 *Illustrated Detective Magazine,* June 1932 (Tintex dye advertisement)

America as Americans See It. New York: Harcourt, Brace, & Co., 1932 (illustration)

Utah scenes (watercolors)

1933 New Orleans scenes (watercolors)

New York cityscapes (watercolors)

1934 *Miss Page Glory,* a film (poster)

1935 Flowers in California (watercolors)

Peychaud's Cocktails (illustrated brochure)

"Off to the Blinds," *Hunting and Fishing,* September 1935 (illustration)

Connecticut Tercentenial, 1935 (brochure)

The Barbizon-Plaza Hotel (advertisements)

The New Haven Railroad (poster)

1937 Cover, *Ohio Stater,* 1937 (illustration)

1938 Dutton's, New York City (illustrations)

Announcement for Father and Son Dinner, Century Club, New York City (illustrations)

Brochure, Schenley's (illustrations)

Hellzapoppin', play (set designs)

1944 "Five Hundred Years of English Prose," *Woman's Day,* December 1944 (illustrations)

Cavanaugh's, New York City (advertisement)

1946 "Mud Pies for Grownups," *Woman's Day,* March 1946 (illustrations)

"Whittler's Hobby," *Woman's Day,* June 1946 (illustrations)

1947 "Famous Villains of the Theatre," *Woman's Day*, March 1947 (illustrations)

 Labels, Old Schuyler Farm products (illustrations)

1948 William Hodapp, *The Pleasures of the Jazz Age*. New York: Farrar & Straus, 1948 (dust jacket)

 Cover, *Cinema Guild* for Greenwich, Stamford, Darien, and New Canaan, Conn. (illustration)

1950 "Mencken and the Twenties." *Harper's*, July 1950 (illustrations)

 Menu, reunion of former executives, Standard Oil Co., 9 October 1950 (illustrations)

 "Happy Motoring." Massachusetts Transportation Co., 1950 (illustrations)

1951 "Fitzgerald: The Double Man," *Saturday Review of Literature*, 24 February 1951 (illustrations)

1954 "The Saga of Frankie and Johnnie." *Playboy*, February 1954 (blockprint cartoon)

 "The Open Fly," *Playboy*, June 1954 (blockprint cartoon)

1955 "The Strategic Ruffles," "The Hobble Skirt," "The Open Placket." *Playboy*, August 1955 (blockprint cartoons)

1957 "The Goofy Girls." *Playboy*, August 1957 (blockprint)

 Postcard, Cavanaugh's, New York City (advertisement)

 "Today with Women," *Chicago Daily Tribune*, 23 November 1957 (illustrations)

SECONDARY SOURCES

Reviews of Books

GRIM YOUTH

Advertiser (Huntington, W.Va.), 25 May 1930.

Advertiser (Huntington, W.Va.), 1 June 1930.

Atlanta Constitution, 7 June 1930.

Bell, Lisle. "Books," *Nation*, 27 April 1930.

Britt, George. "Modern Youth on Griddle." *New York World*, 17 April 1930.

Charleston Gazette, 27 April 1930.

Citizen (Columbus, Ohio), 18 April 1930.

Courier (Camden, N.J.), 10 April 1930.

Repository (Canton, Ohio), 4 May 1930.

Republican (Phoenix, Ariz.), 4 May 1930.

Republican (Waterbury, Conn.), 8 June 1930.

Salt Lake City Tribune, 2 March 1930.

New Republic, 28 May 1930, p. 53.

New York Evening Post, 17 April 1930.

New York Times Book Review, 11 May 1930.

New York World, 17 April 1930, p. 16.

New York World, 30 August 1930.

News (Denver, Colo.), 31 May 1930.

News (San Francisco), 28 May 1930.

News-Sentinel (Ft. Wayne, Ind.), 19 April 1930.

News-Times (South Bend, Ind.), 18 May 1930.

Oklahoma (Oklahoma City, Okla.), 20 July 1930.

San Francisco Chronicle, 7 June 1930.

Scribner's, June 1930.

Telegraph (Macon, Ga.), 1 June 1930.

Times-Union (Jacksonville, Fla.), 27 April 1930.

Times (Akron, Ohio), 6 July 1930.
Times (Erie, Pa.), 30 November 1929.
Times (Toledo, Ohio), 25 May 1930.
Times (Trenton, N.J.), 18 May 1930.
World (Tulsa, Okla.), 6 April 1930.
World (Tulsa, Okla.), 11 May 1930.

DOG STORIES

News (Portland, Me.), 20 December 1930.
Observer (Raleigh, N.C.), 23 November 1930.
Public Ledger (Philadelphia), 6 December 1930.
Record (Philadelphia), 1 November 1930.
Times (Davenport, Ind.), 30 November 1929.

DANNY DECOY

Atlanta Constitution, 11 October 1942.
Current (Hartford, Conn.), 13 December 1942.
Journal (Atlanta, Ga.), 20 September 1942.
Enquirer (Cincinnati, Ohio), 3 October 1942.
News (Buffalo), 19 December 1942.
Telegram (Worcester, Mass.), 4 October 1942.
Times (Madison, Wis.), 20 September 1942.

WOMEN ARE NECESSARY

Argus (Rock Island, Ill.), 18 July 1931.
Bisbee Arizona Review, 28 June 1931.
Courier-Express (Buffalo), 8 February 1931.
Evening Sun (Baltimore), 1 June 1931.
Greensboro News (N.C.), 5 March 1931.
Times (Toledo, Ohio), 5 April 1931.

CROSSTOWN

Press (Akron, Ohio), 19 November 1933.
Times (Los Angeles), 26 November 1933.

I'M THE HAPPIEST GIRL IN THE WORLD

Argonaut (San Francisco), 4 January 1935.
Sun (San Diego), 12 January 1935.
Trancript (Boston, Mass.), 9 February 1935.
Chicago Tribune, 5 January 1935.
Union (Sacramento), 17 February 1935.

THE GODS WERE PROMISCUOUS

"John Held's Fable," *New York Times Book Review*, 5 December 1937.
Ledger (Columbus, Ga.), 20 December 1937.
News (Charlotte, N.C.), 23 January 1938.
New York Herald Tribune Books, 12 December 1939.
New York World Telegram, 15 January 1937.
San Francisco Chronicle, 10 December 1937.
Times (Palo Alto), 8 December 1937.
Times (Los Angeles), 19 June 1938.

DRAWN FROM THE WOOD

Times (Buffalo), 29 December 1929.
News (Newark, N.J.), 10 May 1930.

THE SALOON IN THE HOME

Evening News (Buffalo), 20 September 1930.

SATURDAY TO MONDAY

Cleveland News, 12 April 1930.
Union (Sacramento), 21 May 1930.

THE WORKS OF JOHN HELD, JR.

Cleveland Plain Dealer, 6 December 1931.
Columbus Dispatch, 13 December 1931.
Mail (Charleton, W. Va.), 27 December 1931.
News (Mansfield, Ohio), 14 December 1931.
Record (Philadelphia), 6 December 1931.
Sacramento Bee, 26 December 1932.
Times-Advertiser (Trenton, N.J.), 20 December 1931.

HELD'S ANGELS

Asbury Park Evening Press (N.J.), 17 October 1952.
Miami Daily News, 17 October 1952.

Reviews of Exhibits

"A Few Things." *New York American*, 4 March 1923.
"A Few Things." *New York Evening Post*, 10 March 1923.
"A Few Things." *New York Herald*, 19 February 1923.
"A Few Things." *New York World*, 18 February 1923.
"Bronzes." *Country Life*, January 1931.
Deveree, H. *Magazine of Art*, April 1939, pp. 232–33.
Ely, C. B. "John Held, Jr." *Art in America*, February 1922, pp. 86–92.
"Exhibition of Watercolor Drawings." *Art News*, 17 February 1923, p. 2.
"Former Utahn Seen at Macy's Gallery." *Deseret News*, 26 April 1938.
"Fly Time." *Art Digest*, 15 March 1939, p. 58.
"Illustrator Enters New Field." *Deseret News*, 5 March 1939.
"Interesting Modern Experiments in an Old Method." *Vanity Fair*, October 1923.
"John Held's Drawings." *New York Times*, 18 February 1923.
"Litle Gems of Christmas Thought." *Century*, December 1923, pp. 291–95.
"News of the Art World." *New York World*, 12 May 1921.
New York Post, 8 November 1930 (dog illustrations, Dutton's)
New York Times, 27 July 1924 (golf pictures at the Westchester Biltmore Country Club)
"Prints by John Held." *American Artist*, 28 November 1964, p. 6.
"Razor-Back Hog Becomes Art." *Atlantic Journal*, 7 May 1941.
"Statuette of Clydesdale Stallion." *Country Life*, August 1933, p. 44.
"Woodblock Prints Are Feature of Held Exhibit." *New Hampshire Herald*, 18 February 1923.
"Works by John Held, Jr." *New York Evening Post*, 17 February 1923.

Anon. "John Held, Jr. Creator of an Era." *Playboy* 13 (January 1966), pp. 91–97, 247.

"'Americana' at the Belmont." *New York Sun*, 27 July 1926.

"Applies for Job in Hollywood." *Salt Lake City Tribune*, 5 September 1935.

"Appointment as Carnegie Artist-in-Residence at Athens, Ga." *Parnassus*, October 1940, p. 12.

"Appointment with O'Hara." *Collier's*, 1 April 1955.

Arnold, F. R. "John Held, Jr.'s Poster Work." *Poster*, May 1927, pp. 9, 20.

"Artist Terms Glamour Girl Synthetic Symbol of Age." *Boston Daily Globe*, 6 February 1940.

Atkinson, Brooks. "*Hellzapoppin!*" *New York Herald Tribune*, 23 September 1938.

Bolton, T. "American Book Illustrators: Checklist." *Publishers' Weekly*, 3 July 1937, p. 30.

Bradford, Gamaliel. Introduction. *Grim Youth*. New York: Vanguard Press, 1930.

"But He Is Hankering to Sculpt." *New Orleans Times-Picayune*, 8 April 1934.

"Cartoonist Ill from Overwork." *Stamford Advocate*, 27 May 1931.

Doulens, Humphrey. "Historian of 'Flapper Age' Finds American Youth Sober in 1937." *New York World*, 31 May 1937.

"Elegantly Modest." *New York Herald Tribune*, 18 February 1940.

"Famous American Artist Comes Here during Fall." Athens (Ga.) *Banner-Herald*, 30 September 1940.

"Famous Artist Received as High as $5,000 for Single Drawing; Started Printing Car Cards." *Deseret News*, 12 January 1935.

Field, Flo. "The Discovery and Pursuit of a Celebrity." *New Orleans Times-Picayune*, 6 May 1917, pp. 17–18.

"'Flapper Girl' Famous Cartoon Character Is 'Jilted' by Author for Career in Sculpture." Athens (Ga.) *Banner-Herald*, 6 October 1940.

"Flapper Girl's Daddy at Athens." *Athens Journal*, 29 September 1940.

"Flapper of the 20s Reforms; Now She Goes to College." *Boston Sunday Advertiser*, 11 February 1940.

Ford, Corey. *The Time for Laughter*. Boston: Little, Brown & Co., 1967, pp. 4–6.

Gabriel, Gilbert W. "The Comic Supplement: An Irregular Glimpse of the Rich Young Revue which Foreswore New York." *New York Telegram*, 2 February 1925.

Gaines, James R. *Wits End: Days and Nights of the Algonquin Round Table*. New York: Harcourt, Brace, Jovanovich, 1977, pp. 234, 89.

"Glamour Girl Symbol of Age, Says John Held, Jr., at Harvard." *Boston Herald*, 6 February 1940.

"Glamour and John Held, Jr." *Glamour*, August 1949.

Green, Archie. "Jazz Age and Gilded Age." *J E M F Quarterly* 14 (1978): 23–37.

"Has Grown Up Announces John." *Bridgeport Sunday Post*, 2 May 1937.

Hayes, Bartlett. "Optical Allusions." *The Art of John Held, Jr.* Washington: Smithsonian Institution, 1969, pp. 12–16.

"Headliners of the 20s." *Life*, January 1950, p. 28.

"Heads South." *Art Digest* 15 (1 October 1940): 28.

"Held Accepts Post as Resident Artist." *The Red and the Black*, 4 October 1940.

"Held, Jr., 'On Tap' at Harvard: First 'Artist in Residence.'" *Boston Evening Transcript*, 6 February 1940.

"He Ran for Congress." *Norwalk Telegram*, 1 October 1926.

"John Held, Creator of Flapper Girl, Finds Happiness on Glendola Farm." *Asbury Park Evening Press*, 22 February 1944.

"John Held, Jr., at State U." *La Grange Daily News*, 4 October 1940.

"John Held, Jr." *Vanity Fair*, February 1930.

"John Held, Jr., Famous Cartoonist, to have Residence and Studio in Adams." *Harvard Crimson*, 11 February 1940.

"John Held, Jr., Will Be Resident Artist at Georgia U. 1940." *Shenandoah Daily News*, 20 September 1940.

"John Held to Brush Up at Harvard." *New York Post*, 6 February 1940.

Johnson, Tom. "John Held, Jr.: The Making of an Era." *Minnesota Daily*, 8 October 1982, pp. 8, 9.

Kramer, Dale. *Ross and the New Yorker*. New York: Doubleday Co., 1951, p. 104.

Lynes, Russell. "John Held's Mad World." *Harper's*, November 1967, pp. 23–26.

Merkin, Richard. "John Held, Jr." *The Art of John Held, Jr.* Washington: Smithsonian Institution, 1969, pp. 5–7.

———. "The Jazz Age As Seen through the Eyes of Ralph Barton, Miguel Covarrubias, and John Held, Jr." Providence: Rhode Island School of Design, 1968.

[Artist in residence at Harvard] *New York Herald Tribune*, 12 March 1939.

[Artist in residence at Harvard] *New York Sun*, 11 March 1939.

[Artist in residence at Harvard] *New York Times*, 11 March 1939.

"Packard's Artist, John Held, Jr." *The Packard Cormorant*, spring 1980.

"Portrait of 1927." *Mademoiselle*, January 1927, p. 61.

Reed, Walt. *The Illustrator in America*. New York: Reinhold Publishing Co., 1967, p. 92.

Russell, Francis. "Sheiks, Shebas, Dance No More." *Horizon*, July 1963, pp. 118–19.

[Pontiac radio show] *Salt Lake City Tribune*, 2 May 1937.

"Says Glamour Girl Doomed." *Boston Post*, 6 February 1940.

"Silk Prints at Museum." *Baltimore Sun*, 15 July 1928.

"Stephen Greene Brings Back the Flapper." *Publishers' Weekly*, 10 July 1972, p. 33.

Tarrant, John, and Dorothy. "John Held, Jr., Inventor of the Jazz Age." *Smithsonian*, vol. 17, no. 6 (September 1986), pp. 94–104.

"The Authors of the New Musical Review Take a Bow." *Life*, 9 February 1925, p. 4.

"The Jazz Age Cartoonist Teachers Art." *Atlanta Constitution*, 13 October 1940.

The Most of John Held, Jr. Brattleboro, Vt.: Stephen Greene Press, 1972.

"The Sheik Curtain by John Held, Jr., from 'Americana' at the Belmont Theatre." *New York Evening World*, 5 September 1926.

[Grindstone farm signs] *Westport Herald*, 24 May 1924.

[Grindstone farm signs] *Westport Herald*, 3 June 1924.

[Grindstone farm signs] *Westport Herald*, 6 July 1924.

[Signs for town of Weston] *Westport Herald*, 3 October 1924.

"World's Titles Won at Round-Up." *The Sunday Oregonian*, 24 September 1922.

"Writers and Artists Flocking to Colonies along the Seaside." *Asbury Park Evening Press*, 3 July 1952.

"Young Warburg's Ballet Loudly Hailed at Hartford." *New York World-Telegram*, 11 December 1934.

Other Background Sources

Agrest, Diane. "Architectural Anagrams: The Symbolic Performance of Skyscrapers." Frederick Lewis Allen, *Oppositions* 2 (1977): 32–41.

Allen, Frederick Lewis. *Only Yesterday: An Informal History of the 1920s*. New York: Blue Ribbon Books, 1931.

Appleton, Jay. *The Experience of Landscape*. London: John Wiley & Sons, 1975.

Attoe, Wayne. *Architecture and Critical Imagination*. London: John Wiley & Sons, 1978.

———. *Skylines: Understanding and Molding Urban Silhouettes*. New York: John Wiley & Sons, 1981.

Becker, Stephen. *Comic Art in America*. Berkeley: University of California Press, 1981.

Blair, Walter. *Native American Humor*. Scranton, Pa.: Chandler Publishing Co., 1937.

Blair, Walter, and Hamlin Hill. *America's Humor*. New York: Oxford University Press, 1981.

Boorstin, Daniel J. *The Americans: The Democratic Experience*. New York: Random House, 1973.

Bradbury, Malcolm, and Howard Temperley, eds. *Introduction to American Studies*. London: Longman, 1981.

Breckenridge, Sophonsiba, P. *Women in the Twentieth Century: A Study of Their Political, Social and Economic Activities*. New York: McGraw-Hill, 1933.

Brinkley, Neil. "The New Woman." *Boston American*, 14 November 1916, p. 14.

———. "Woman's Place." *Boston American*, 14 July 1913, p. 18.

———. "Women and Fashion." *Boston American*, 25 August 1912, p. 19.

Brooks, Van Wyck. *America's Coming of Age*. New York: Octagon Books, 1957.

Brown, Milton W., et al. *The History of American Art*. New York: Harry N. Abrams, 1979.

Broyard, Anatole. "Reading and Writing." *New York Times Book Review*, 8 November 1981, p. 51.

Bruere, Martha Bensley, and Robert W. Bruere. *Increasing Home Efficiency*. New York: McGraw-Hill, 1914.

Cahill, Holger, and Alfred H. Barr, Jr., eds. *Art in America in Modern Times*. New York: Reynal and Hitchcock, 1934.

Castle, Vernon. *Modern Dancing*. New York: Macmillan Co., 1914.

Chambers, Eleanor. "Facts and Figures." *Delineator*, April 1914, p. 38.

Chesterton, G. K. "Morals Today." *Life*, October 1921, p. 32.

[Advertising section] *Cosmopolitan*, May–October 1903.

[Advertisement] *Cosmopolitan*, June 1915, p. 50.

[Advertisement] *Cosmopolitan*, July 1915, p. 81.

[Advertisement] *Cosmopolitan*, October 1915.

[Advertisement] *Cosmopolitan*, November 1915.

[Advertisement] *Collier's*, 25 September 1915, p. 22.

[Advertisement] *Collier's*, 27 November 1915, pp. 4, 25.

[Advertisement] *Collier's*, 4 March 1916, p. 38.

Cornish, V. *Scenery and the Sense of Sight*. Cambridge: Cambridge University Press, 1935.

"Curent Dances." *Boston American*, 11 November 1912, p. 32.

[Advertisement] *Delineator*, July 1914, p. 55.

Dewey, John. *Art as Experience*. New York: Minton, Balch & Co., 1934.

Dewhurst, James. *Needs and Resources: A New Survey*. New York: The Twentieth Century Fund, 1955.

Dix, Dorothy. "A Modern Diana." *Boston American*, 7 April 1910, p. 61.

———. [Column] *Boston American*, 21 August 1912, p. 14.

———. [Column] *Boston American*, 9 September 1912, p. 20.

———. [Column] *Boston American*, 21 August 1913, p. 21.

———. [Column] *Boston American*, 10 December 1916, p. 13.

———. "To Smoke or Not to Smoke." *Boston American*, 12 April 1916.

———. "Women." *Boston American*, 6 May 1910.

———. "Women and Work." *Boston American*, 7 April 1910.

Docuilet, M. "When the World Looks Young." *Delineator*, August 1913, p. 20.

Dreiser, Theodore. Preface to Edward McDonald, *A Bibliography of the Writings of Theodore Dreiser*. Philadelphia: Centaur Book Shop, 1928.

Dublin, Lewis I. "Birth Control." *Social Hygiene* 6 (1920): 6.

Facts and Figures of the Automobile Industry. Toronto: Canadian Automobile Chamber of Commerce, 1929.

Fairfax, Beatrice. "Letters." *Current Opinion* 5 July 1913, p. 9.

———. "Letters." *Current Opinion*, 2 May 1916, p. 15.

———. "New Reflection on the Dancing Mania." *Current Opinion*, 8 October 1913, p. 262.

Farrell, James T. *A Note on Literary Criticism*. New York: Vanguard Press, 1936.

Fitzgerald, F. Scott. "My Lost City." *The Crack-Up*. New York: Charles Scribner's Sons, 1931.

———. "Echoes of the Jazz Age." *Scribner's*, 90 (1931): 460.

Flugel, John C. *The Psychology of Clothes*. New York: International Universities Press, 1966.

Friedman, Martin. *Charles Sheeler*. New York: Watson-Guptill Publications, 1975.

Gelfant, Blanche. *The American City Novel*. Norman: University of Oklahoma Press, 1954.

Goffman, Erving. "Gender Advertisements." *Studies in the Anthropology of Visual Communication* 3, no. 2 (1976): 97–123.

Gurko, Leo. *The Angry Decade*. New York: Harper & Row, 1947.

Harlan, Marian. "The Passing of the Home Daughter." *Independent*, 13 July 1911, p. 90.

Hartmann, Sidney Allan Sadakichi. "The 'Flat-Iron' Building: An Esthetical Dissertation." *Camera Work*, October 1903, pp. 36–40.

Hazard, Lucy. *The Frontier in American Literature*. New York: Thomas Y. Crowell Co., 1927.

Hoffman, Frederick J. *The Twenties: American Writing in the Post-War Decade*. New York: Viking Press, 1955.

Howard, George Elliott. "Social Control and the Functions of the Family," in Howard J. Rogers, ed., *Congress of Arts & Sciences: St. Louis*. 8 vols. New York: University Alliance, 1907–8.

Huthmacher, Joseph J. "Urban Liberalism and the Age of Reform," *Mississippi Historical Review* 49 (1962): 231–41.

Jaffe, Irma B. *Joseph Stella*. Cambridge: Harvard University Press, 1970.

Jencks, C. *Skyscrapers-Skyprickers-Skycities*. New York: Rizzoli International Publication, 1980.

Johnson, Owen. *The Salamander*. Indianapolis: Bobbs-Merrill Co., 1914.

Jones, Wendell. "Article of Faith." *Magazine of Art* 33 (1940): 554.

Jordy, William H., and Ralph Coe, eds. *American Architecture and Other Writings*. Cambridge: Harvard University Press, 1961.

Kaufman, Emma B. "The Education of a Debutante." *Cosmopolitan*, September 1903, pp. 499–508.

Kazin, Alfred. "Three Pioneer Realists." *Saturday Review of Literature*, 8 July 1939, p. 15.

Kunzle, David. *The Early Comic Strip*. Berkeley: University of California Press, 1973.

[Advertisement] *Ladies' Home Journal*, May 1917, pp. 34, 36, 37, 74, 78, 89, 92, 102, 106.

[Advertisement] *Ladies' Home Journal*, July 1917, p. 74.

[Advertisement] *Ladies' Home Journal*, October 1917, p. 98.

Lang, Kurt, and Gladys. "Fashion: Identification and Differentiation in the Mass Society." In May Ellen Roach and Joanne Bobolz Eicher, eds., *Dress, Adornment, and the Social Order*. New York: Wiley, 1965.

Leuchtenburg, William E. *Perils of Prosperity*. Chicago: University of Chicago Press, 1958.

Lewis, R. W. B. *The American Adam*. Chicago: University of Chicago Press, 1955.

Link, Arthur. "What Happened to the Progressive Movement in the 1920s?" *American Historical Review* 44 (1959): 433–511.

Lippmann, Walter. *Public Opinion*. New York: Macmillan Co., 1961, p. 92.

Lough, William H. *High-Level Consumption: Its Behavior; Its Consequences*. New York: McGraw-Hill Book Co., 1935.

Marling, Karal Ann. "A Note on New Deal Iconography." *Prospects* 4 (1979): 421–44.

May, Henry F. "Shifting Perspectives on the 1920s." *Mississippi Valley Historical Review* 43 (1956): 405–27.

————. *The End of American Innocence*. New York: Alfred A. Knopf, 1959.

————. "The Rebellion of the Intellectuals, 1912–1917." *American Quarterly* 8 (1956): 145.

McKay, James. *A Collector's Guide to Animal Sculptors of the 19th and 20th Centuries*. New York: E. P. Dutton & Co., 1973.

Miller, Alice Duer. "The New Dances of the Younger Generation." *Harper's Bazaar*, May 1912, p. 250.

"Mrs. Atherton Tells of Her 'Perch of the Devil.'" *Current Opinion*, November 1914, p. 349.

Mumford, Ethel Watts. "Where Is Your Daughter This Afternoon?" *Harper's Weekly*, 17 January 1914, p. 28.

Murrell, William. *A History of American Graphic Humor*. 2 vols. New York: Whitney Museum of American Art, 1933, 1938.

Nearing, Scott, and Nellie. *Woman and Social Progress*. New York: Macmillan Co., 1914.

Nevius, Blake. *Robert Herrick: The Development of a Novelist*. Berkeley: University of California Press, 1962.

"New York Cotton Exchange." *New York Tribune*, 4 April 1912.

[Editorial] *New York Times*, 6 July 1914.

[Letter] *New York Times*, 20 July 1914.

Norman, Dorothy. *Alfred Steiglitz: An American Seer*. New York: Random House, 1973.

O'Brien, Dean. "Television and Place." *Landscape* 11 (1981): 32.

Plum, Dorothy A. *The Great Accomplishment: A Chronicle of Vassar College*. Poughkeepsie, N.Y.: Vassar College Press, 1961.

Reich, Sheldon. *John Marin: A Stylistic Analysis and Catalogue Raisonné*. Tucson: University of Arizona Press, 1970.

Ricciotti, Domini. "Symbols and Monuments: Images of the Skyscraper in American Art." *Landscape* 26 (1982): 18–27.

Rosenberg, Harold. *The Anxious Object*. New York: Collier Books, 1973.

Sage, Elizabeth. *A Study of Costume*. New York: Charles Scribner's Sons, 1926.

Schlesinger, Arthur. *The Rise of the City, 1878–98*. New York: Macmillan Co., 1933.

Simonson, Harold P. *The Closed Frontier: Studies in American Literary Tragedy*. New York: Holt, Rinehart, & Winston, 1970.

Sklar, Robert. *The Plastic Age, 1917–1930*. New York: George Braziller, 1970.

Smith, Peter F. *The Syntax of Cities*. London: Hutchinson & Co., 1977.

Sterrett, Cliff. "Polly and Her Pals." *Boston American*, 5 September 1916, p. 20.

Taylor, Joshua C. *America as Art*. New York: Harper & Row, 1976.

"The Cult of St. Vitus." *Unpopular Review* 3 (1915): 94.

Thomas, William I. *The Unadjusted Girls with Cases and Standpoint for Behavior Analysis*. Boston: Little, Brown, 1923.

Tuan, Yi-Fu. *Space and Place: The Perspectives of Experience*. Minneapolis: University of Minnesota Press, 1977.

Tunnard, Christopher, and Henry Hope Reed. *American Skyline: The Growth and Form of Our Cities and Towns*. Boston: Houghton Mifflin, 1953.

U.S. Department of Commerce, Bureau of the Census; Historical Statistics of the United States, Colonial Times to 1957. Washington, D.C.: G.P.O., 1960.

Vellis, Kenneth A. "Prosperity's Child: Some Thoughts on the Flapper." *American Quarterly* 16, no. 2 (1974): 44.

Waugh, Colton. *The Comics*. New York: Macmillan Co., 1947.

Weisman, Winston. "A New View of Skyscraper History." *The Rise of an American Architecture*, Edgar Kaufman, Jr., ed. New York: Praeger Publishers, 1970.

White, Percival. "Figuring Us Out." *North American Review* 227 (1929): 69.

Wilcox, Ella Winston. "Fashion." *Boston American*, 15 June 1911, p. 32.

Willcox, Louise Collier. "Our Supervised Morals." *North American Review* 118 (1913): 708.

Wilson, Edmund. "John Jay Chapman." *New Republic*, 26 November 1931, p. 32.

Young, Agnes Brooks. *Recurring Cycles of Fashion, 1760–1937*. New York: Harper & Row, 1937.

Interviews

Author with Mrs. John Held, Jr., May 21, 1981–May 30, 1981
 May 22, 1981
 May 23, 1981
 May 24, 1981
 May 25, 1981
 May 26, 1981
 May 27, 1981
 May 28, 1981
 May 29, 1981
 May 30, 1981
Author with Carl Weinhardt, Jr., November 24, 1982

Letters

Margaret Held to author, February 25, 1981
 March 18, 1981
 April 27, 1981
 May 29, 1981
 July 19, 1981
 August 1, 1981
 August 11, 1981
 August 17, 1981
 August 24, 1981
 August 29, 1981
 September 6, 1981
 September 18, 1981

Papers

John Held, Jr., Papers, Archives of American Art, Washington, D.C.

Index

Note: n refers to footnote

Adirondack Mountains, 130
"Adventures of 'The Gang,'" 156
Advertising art, xi, 9, 39, 52, 56, 68, 70; flappers, 33, 61, 91–92, 152; humor, 12, 149; image of women, 61, 71–72, 73, 75, 159; posters, 26, 28
"An Afternoon," 101
Afternoon Fantasy, 179
Age and youth, 97, 99, 100
Algonquin Hotel, xii, 44, 49, 99
Algren, Nelson, 124
Alice through the Looking Glass (Carroll), 46–47, 113, 114
Alma Mater, 44
America as Art (Taylor), 131–32, 175
Americana (play), 25
"*Americana*" (map): illustration, 181
"Americana De Luxe," 170
The American City Novel (Gelfant), 123
The American Grain (Williams), 100
"The Americanization of Art" (Lozowick), 132
American Legion Weekly: illustrations, 16, 25, 148, 160
America's Coming of Age (Brooks), 100
America's Great Illustrators (Meyer), xiv
America's Humor (Blair), 150, 197n30
Anderson, Sherwood, 8, 124
Angel over Saint Patrick, 179
The Angry Decade (Gurko), 98–99
Animalier tradition, 141–45, 186, 196n19
Animals, xv, 4, 7, 53, 56–57, 138, 149; *Crosstown*, 113; *Dog Stories*, 37, 41, 49; fiction, 106; humor, 179–80; illustration, 50; sculpture, xiii, 139–45, 186; Thurber's, 152, 154. *See also* Horses
Appleton, Jay (quoted), 155, 156

Arnold, Frank M. (quoted), 26
Art Center of New York, 26
Art Deco, 84, 147
"Article of Faith" (Jones), 139
Art in America, 131
Artists, 41, 187, 188; commercial, 138; fiction, 115–20; New Deal, 140–41, 145; 1920s, xii; role of in society, xiii, 101
Atherton, Gertrude, 75
Atkinson, Brooks (quoted), 52
"At the Coiffeur's," 66, 79
Attoe, Wayne (quoted), 132–34
Auden, W. H., 119–20
"The Awakening," 101

Babbit, Irving, 58
Babette, 9, 191n2
"The Background of America's Aesthetic Taste," 170
"Backscratching at the Algonquin Table," 147–48
Ballads, 171–74, 187
Barbetta's Restaurant, 47
Barbizon Hotel, 45, 47, 130
Barton, Ralph, 52, 149
"Baseball Game": illustration, 16
Beautiful and the Damned (Fitzgerald), 125
Beauty pageants, xv, 46, 49. *See also I'm the Happiest Girl in the World*
Beebe, Lucius, xii
Bel Geddes, Norman, 52
Belmar, N.J., xv, xvi, 6, 54–55, 58
Benchley, Robert, 28, 176, 197n30
Benedite, Georges (quoted), 141–42

"Benefit for Sufferers in Europe": illustration, 67

Benton, Thomas Hart, 174

"A Big Moment in the Love Life of an Elevator Starter," 171

"Big Moments in the Faint Rosy Past," 171

"The Birth of American Art Appreciation," 170

Bishop, John Peale (quoted), 125

Black Oxen (Atherton), 75

Blair, Walter (quoted), 149–50, 154, 197n30

Bland, Harry, 47

Bland Gallery, 47, 52, 142

Blazes, Helen, 4, 172

Block prints, xvii, 4, 9, 15, 28, 62, 128, 149, 187; Gilded Age, 171, 173–75, 178; *New Yorker*, xi, 5, 24, 68, 150, 171; Victorian, 6, 56, 168, 176; *The Wages of Sin and Other Victorian Joys and Sorrows*, 168, 170–71. *See also* specific titles

Blue Landscape, 136

Book covers, 24, 185

Boucher, Louis, 14

Bow, Clara, 82, 164

Bowl of Cherries, 108–9, 122; illustration, 40

"Boy in Boy," 105

Bradbury, Malcolm (quoted), 195n7

Bradford, Gamaliel (quoted), 97, 98

Braque, Georges, 142

Brentano's, 9

"Bringing up Father" (McManus), 66

Brinkley, Neil, 193n21, 193n22

Bronze sculptures, 127–45, 149; animals, xiii, 47; illustrations, 143, 145

Brooks, Van Wyck, xii; quoted, 100

Broun, Heywood, 52

Brown, Milton (quoted), 91

Brown Robertson Galleries, 28

Burgess, Gelett, 28

Burke, Kenneth, 8

Burrows, Hal, 4, 8, 13, 33, 54

Canoeing, 130

"Cape Cod," 26; illustration, 27

Caricature, xiii, 19–20, 91, 126, 129, 176; comic maps, 178; defined, 154–55; influence of fine arts, xvii–xviii; influence of 1920s, 39; style, 87, 187; women, 175; youth, 122

Carnegie Corporation, 52

Carnegie Foundation: Central America expedition, xiv, 17–20

Carnegie Institute, 17, 129

Cartography. *See* Maps

Cartoons, xi, xiv, 9, 20, 24, 39, 63, 84, 91, 168, 183–87, 197n16; caricature, 126; color, 33; fashion, 76–77, 79; flappers, 62, 82, 87, 90, 98, 150, 154, 156; framing technique, 155; humor, 12, 15, 41; morals, 76; political, 149; style, xiii, 65–66, 68–70, 89, 144, 149; women, 156, 158–63. *See also* specific titles

Castle, Irene, 73, 82, 193n35

Cavanagh's Restaurant: advertising, 56; illustration, 57

Central America, xiv, xvii, 15, 17–20; landscapes, 128–29, 130

Century Club, 52

Chalfonte-Haddon Hall Hotel, 52

Chaplin, Charlie, 44

Chappell, George, 52

"The Chariot of Cupid," 101

Chicago-Columbia Exposition, 168

Children: changes in 1920s, 71; Held's, xv, 33, 37, 44, 47, 59, 101

Children's stories, 49, 56–57

Chinese Delmonico Restaurant, 13

City fiction, 122–25

City life. *See* Urban life

Cityscape in Fog, 136

Cityscapes, xiii, 128, 130–33, 136

Cityscape with Chrysler Building, 136

"Civilization's Progress": illustration, 169

Clothes. *See* Fashion

Clydesdale Stallion, 144

Cockroach Glades, 13, 15

Coffee House Club, xii, xv, 28, 54

College Humor, 20, 24, 64, 65, 101, 156; illustration, 22–23

College life: in fiction, 101–5

"Collegiate," 26

Collier's, 168

Collier's Street Railway Advertising Company, 9, 62

Color, 20, 51, 84, 89, 187; cartoons, 33, 36, 161, 163, 197n15; humor, 28; watercolors, 47, 128, 129, 130, 134–36

"Coloring of the Meershaum Pipe," 170

Colt of the Pantheon, 142–44

Comic art, 183–84, 188

Comic strips, 197n27

The Comic Supplement (McEvoy), 24

"Commencement," 101

Commercial art, 95, 100–101, 114, 128, 197n16; relationship to fine art, 28, 62, 101

Commercial realism, 155

Congressional Record, 31

Connelly, Marc (quoted), 13

Conover Farm, 55

Constructivism, 84, 87

Cooper, James Fenimore, 137

Cosmopolitan, xii; illustration, 166

Costume designs, 24, 44

Country life, 140–41; *The Gods Were Promiscuous*, 115–19, 127; versus urban life, 106, 138, 150, 152
Country Life, 29, 58, 168, 177
Covarrubias, Miguel, 149, 174
Covers. *See* Book covers, Magazine covers
Cowboy Centaurs, 179
"The Cowboy Grave": illustration, following page 106
"Cowboy St. Francis and Birds": illustration, following page 106
Cowley, Malcolm, 8; quoted, 184, 185
Crane, Hart, 8
Crane, Stephen, xvii, 110, 111–12, 123, 124, 125, 188
Criticism of 1920s, 109–10
Critics, 147–48, 175–76, 183; art, 148–49, 197n15; literary, 37–39, 120–23, 125, 148. *See also* specific names
Crosstown, 106, 111–13
Crowninshield, Frank, 9, 28, 52
Crump, Della, 114–15, 125
Cubism, 84, 89, 91, 141
"The Curse of the Opera House": illustration, 172

Dada, 91
"The Dance-Mad Younger Set," 84, 164; illustration, 165
"Dancing the Turkey Trot," 171
Danny Decoy, 54
Dappled Lake, 130
"Daughters of the American Revolution," 20
Daumier, Honoré, 176, 185
Davies, Marion, 26
"The Day of the Bicycle," 6
Death and Taxes (Parker), xvii
Decorative arts, 49, 56
Deland, Margaret (quoted), 73
Demuth, Charles, 130, 133
Deseret, 6
Deseret (play), 14
Detroit Athletic News: illustration, 30
Devree, Howard (quoted), 196n19
Dickinson, Charles, 136
Dietz, Howard, 52
Dix, Dorothy (quoted), 71, 72, 75–76, 194n58
Docuilet, M. (quoted), 194n45
"A Dog's Idea of the Ideal Country Estate," 178
Dog Stories, 37, 41, 49; illustration, 50
Doubleday, Nelson, xii, 28
Doulens, Humphrey (quoted), 51
Dove, Arthur, xii, 29

"Do You Like Motoring Sports?" 68, 69; illustration, 69
Draftsmanship, 4, 63, 128, 131, 142, 144
Drawn from the Wood (Shay), 171
"Dream Girls of a Dim Decade," 43
Dreiser, Theodore, 8, 123, 124, 125, 188
"Dry Sleuths Are Ready to Admit": illustration, 160
Duchamp, Marcel, 89
"Dude Ranch": illustration, 30
"Dumb Bunny," 105

The Early Comic Strip (Kunzle), 197n27
"Easily Answered": illustration, 81
"The Echo Quartette," 6
Education: Held's, xvi–xvii, 4
Ely, Catherine Beach (quoted), 131
"The Emancipation of the Rib" (Rowland), 193n32
The Empire State Building, 136
Empson, William, 120
The End of American Innocence (May), 192n8
Evans, Annie. *See* Held, Mrs. John, Sr. (Annie Evans)
The Experience of Landscape (Appleton), 155
"Explain This Black Bottom Dance": illustration, 85

Fairfax, Beatrice, 71
"The Fallen Man," 168
"The Fallen Man Again Can Soar/But Woman Falls to Rise No More," 168
Fallen Tree and Lily Pads, 130
Family: changes in 1920s, 70–71; Held's, 1–4, 6–7, 54, 192n8
Fantasy, xiii, 106, 145; animals, 179–80; comic maps, 178; *The Gods Were Promiscuous*, 115–20, 186; sculpture, 187
Farming, xiv, xvi, 36, 55–56, 138, 186
Farrell, James T., 119, 123
Fashion, xii, xiii, 83, 91, 110, 159, 194n45, 194n56; changes, 33, 36–37, 70, 73–77, 79; commercial art, 29, 95; flappers, 58, 79, 81–82, 83, 161, 186; Held's, 29, 49, 55; influence of World War I, 77, 81–82; influence on art, 62, 95; youth, 165
Father, xvii, 1–4, 6–8, 54, 100
Faulkner, William, xvii, 125, 177, 187–88
"Feet of Clay," 105
"Feminine Logic," 66
Ferber, Edna, 24

"A Few Intimate Sketches at Yellowstone Park":
 illustration, 21
"A Few Things," 15, 28
Fiction, xii, xiii, 37, 41, 47, 95, 97–126, 186;
 characters, 110; critics, 37–39, 120–23, 125,
 147-48; dialog, 103, 110, 122; plots, 103, 110,
 114–15, 117; reviews, 97, 120–23, 195n6;
 women, 105–15, 124–26. *See also* specific
 titles
Field, Flo, 19
"The First Flush," 171
"Fish," 68
Fitzgerald, F. Scott, 8, 39, 103, 115, 183–86, 188;
 flappers, 61, 74, 125; "My Lost City," 138;
 1920s, 109, 148, 164; *Tales of the Jazz Age*, xi;
 The Vegetable, 24; women, 126; youth, 121
Flappers, xii, 24, 33, 36, 58, 61, 90, 93, 95, 180,
 187; advertising art, 33, 61, 91–92, 152; be-
 havior, 41, 72, 73–74, 77, 82, 150; caricature,
 175; changes in image, 20, 84, 91, 150, 152,
 154; fashion, 58, 79, 81–82, 83, 161, 186; fic-
 tion, 98, 101, 109, 125–26; framing tech-
 nique, 155–56, 158–64; origin, 82; speech,
 150. *See also* Women
The Flesh Is Weak, 105–8, 122, 135
Fly Time, 142–43
Folk art, 56, 187
Folksongs, 171–74
Ford, Corey (quoted), xiii, 39, 61, 147, 148, 164
Forge, 29
"The Fountainhead of American Art," 170
Fox, Fontaine, 28
Framing technique, 154–56, 158–64, 175–76,
 180
Frankie and Johnny (book), 5
"Frankie and Johnny" (song), 172–74
"Frankie and Johnny" (Faulkner), 187
Frederick, Pauline, 73, 193n35
Freudian psychology, 64, 95, 105, 106, 154
Freud, Sigmund, xvii
Frye, Northrop (quoted), 183
Fry, Roger (quoted), 89
Functional ranking, 156, 161
Furniture: dollhouse, 56; refinishing, 49, 51
Futurism, 84, 87, 91

Gabriel, Gilbert (quoted), 24
Gaines, James R. (quoted), 147–48
Gaul, Gilbert, 141
Gelfant, Blanche (quoted), 123
Geller, James, 171
"Gender Advertisements" (Goffman), 197n16

Genthe, Arnold, 28
Gerber, Thomas, 33
Gibson Girl, 36, 65, 82, 125, 152
Gilbreth, Frank, 57
Gilded Age, 168, 170–78
The Gilded Age (Twain), 168
Girl Dancing on the Stage, 128–29
"The Girl He Left Behind," 87
"Girl out of Uniform," 79
"The Girl Who Sat on the Wrong Side of the
 Field": illustration, 165
"The Girl Who Went for a Ride in a Balloon": il-
 lustration, 86
The Gods Were Promiscuous, xiii, 41, 106, 115–20,
 127, 145
Goffman, Erving (quoted), 155, 156, 159, 161,
 197n16
Goldberg, Rube, xii, 28, 52
Golden Empire State Building, 136
Gordon, Robert Winslow, 171
Gotham Book and Art Shop, 29
Gouache, 129, 130
Gowan, Allen (quoted), xviii, 188
Graham Gallery, 133
"The Grand Canyon of the City," 131
Grandfather's Follies (Geller), 171
"The Great Yachting Map": illustration, 179
Greek vase painting, xvii–xviii, 187
Green, Archie (quoted), 148, 164, 168, 174
Green, Ruzzie, 26
A Green Desire (Myrer), 62
Grim Youth, 37, 87, 97, 101–5; illustrations, 38,
 88, 90; reviews, 120–22
Grindstone Hill, 29, 36
Gurko, Leo (quoted), 98–99

Halsey, Margaret, 180
"Hang On to Me," 26
Harkness, Spug, 103–5
Harper's Bazaar, 101
Harvard University, 52
Haseltine, Herbert, 141–42, 196n19
Haskell, Ernest, 14
Hatton, Fanny Locke, 75
Hatton, Frederick, 75
Hawthorne, Nathaniel, 136–37
Hayden, Palmer, 174
Hayes, Barlett (quoted), 148
"Hay, Grain, and Seed," 170
Hearst, William Randolph, xi, 24, 37, 44
"Heavy Date," 20
He Goat, 144

Held, Jack, xv, 37
Held, Jill, xv, 37
Held, Joan, xv, 37
Held, John, Jr.: photographs, 5, 45, 46
Held, Mrs. John, Jr. (Ada). *See* Held, Mrs. John, Jr. (Johnnie)
Held, Mrs. John, Jr. (Gladys Moore), 41, 43–47, 49, 54; photographs, 43, 45, 48
Held, Mrs. John, Jr. (Johnnie), 29, 33, 36, 49
Held, Mrs. John, Jr. (Maggie). *See* Held, Mrs. John, Jr. (Margaret)
Held, Mrs. John, Jr. (Margaret), xi, xiv, xv, 49, 51, 53, 180; Belmar, N.J., 55; marriage, 54; quoted, xv–xvi, xviii, 58
Held, Mrs. John, Jr. (Myrtle), 8–9, 17, 29, 49, 191n2; signature illustration, 80
Held, Mrs. John, Sr. (Annie Evans), 2–3
Held, Judy, xv, 44, 47; photographs, 45, 48
Held's Angels (Gilbreth), xii, 57–58, 164; illustrations, 88, 160, 163, 165, 167
Hellzapoppin, 51–52
Hemingway, Ernest, 8, 119, 122, 125
Henri, Robert, 14, 82–83, 91
"Here are Eight New Professions for the Ladies," 79; illustration, 80
"The Hero's Return to Utah," 79
Herrick, Robert, 124, 194n67; quoted, 76
Herriman, George, 149
"Her Solution," 66
"High Hat," 20
Hill, Hamlin (quoted), 150, 197n30
Hirsch, Joseph, 133
Hirschfeld, Al (quoted), 33, 36
"His Fingers Met with Disappointment": illustration, 40
"History Repeats," 109
Hogarth, William, 176
Hokinson, Helen, 150
"Hold 'Em": illustration, 42
Hollywood, Calif., 44, 46
Home Brew, 32
Homer, Winslow, xvii, 129–30
The Home Sector, 24
"Hon Ung," xvii
Horses, 31, 36, 49, 69; accident, 32–33; bronze sculptures, 47; stories, 108. *See also* Animals
"Horsewhipping the Masher," 171
Houghton, Michael, 111
"How to Lose Money on a Farm," 58
Hubbell Trading Post, 53
Hult, Johann, 66; signature illustration, 66
Humor, xviii, 197n30; crime, 64; Held's, xv, 6, 12–13, 15, 28, 41, 83, 147–80, 187–88, 197n15; Held's sculpture, 47, 49; liquor, 64; magazines, xi, 20, 63–65, 68, 70; native American, 150; *New Yorker*, 150, 175, 176; sex, 64–65
Huston, John, 174
Huthmacher, J. Joseph (quoted), 192n8

"I Bet You Wish You Were Out in the Parkin' with a Girl": illustration, 90
"If Winter Comes": illustration, 162
Illustrators, 62–63
Impressionism, 141
I'm the Happiest Girl in the World, xiii, 41, 46–47, 49, 106, 113–15
"The Indian Wars," 6
"An Ingenious Excuse," 66
Inge, Thomas (quoted), 187
"In My Lovely Deseret," 6
"In the Game of Tennis": illustration, 163
Introduction to American Studies (Bradbury), 195n7
Ironworks, 29
"I Think That Colts Are Just Too Comical": illustration, 152
"It's All Right, Santa—You Can Come In": illustration, 160
"I've Got to Go Back Now and See a Man about a Buick," 87, 89; illustration, 90

Janes, Margaret Schuyler. *See* Held, Mrs. John, Jr. (Margaret)
Japan Paper Company, 15
Jazz Age: defined, 164
Jennings, Myrtle. *See* Held, Mrs. John, Jr. (Myrtle)
Jewelry, 56
"Joe College," 72
"Joe Prep," 191n22
"John Held's Mad World" (Lynes), 148
"Johnny and Frankie Were Lovers": illustration, 174
Johnson, James Weldon, 171
Johnson, Owen (quoted), 74
John Wanamaker Company, 9, 62
Jones, Wendell (quoted), 139–40
Journalism, 155
Judge, xi, 63; cartoons, 9, 20, 24, 66, 68–69, 77, 79, 84; covers, 84, 161; fashion, 76; illustrations, 21, 66, 67, 69, 77, 78, 81, 83, 151, 162, following page 106; morals, 64–65
"Julian and Julienne": illustration, following page 106
The Jungle (Sinclair), 123

"Just an Old Fashioned Romance," 171
"Just a Song at Twilight," 156

Kent, Rockwell, 28
Kirby, Rollin, 149
"Klassy Kut Kollege Klothes," 170
Kramer, Dale (quoted), 147
Kubler, George (quoted), 184
Kunzle, David (quoted), 197n27

"Lacing the Corset," 170
Lac St. Jean, 129
Ladies' Home Journal, 73
"The Ladies of Rum Row": illustration, 148
Landscapes, 128, 130, 131
Lardner, Ring, 39, 108, 121
"The Laughing Stock," 180; illustration, following page 106
Lavender Cityscape, 133, 134
Lavender Landscape, 136
Leacock, Stephen, 28
Learning to See (Gowan), 188
Leonia, N.J., xvii, 129
Lewis, Sinclair, 8, 119
Liberty: illustration, 169
Library, xvii
Life, xi, 24, 63; block prints, 168; cartoons, 8, 9, 20, 79, 87, 156, 159; covers, 15, 33, 84, 92, 150, 156, 166, 180; Held's political campaign, 31, 149; illustrations, 24, 37, 42, 86, 152, 158, following page 106; morals, 64–65
"Like Father, Like Daughter," 109
Lindeburg, Harrie, xv
Link, Arthur (quoted), 192n8
Linocuts. *See* Block prints
Linoleum block prints. *See* Block prints
Linoleum cuts. *See* Block prints
Lippmann, Walter (quoted), 155
"Lochinvar," 105
Lomax, John, 171
London, Belle, 4
"Lords and Ladies of Fashion," 66
Lozowick, Louis (quoted), 132, 133, 139
Lynes, Russell (quoted), 148, 167

Macamer, Jefferson, 64
McEvoy, J. P., 24, 25
Macgowan, Kenneth, 52

McManus, George, 63, 66, 149
Macy's, 52
Mademoiselle, xii
Magazine covers, xi, 15, 24, 33, 84, 92, 150, 156, 161, 166, 179–80. *See also* titles of specific magazines
Maggie, a Girl of the Streets (Crane), 110, 111–12, 123, 125, 188
Manchewitz, Herman, 28
Manhattan Dawn, 136
Manhattan Sunset, 136
"Man of the World," 101–5, 122
The Man with the Golden Arm (Algren), 124
"Many Morals for Young and Old," 171
"Map of Hollywood": illustration, 44
Maps: comic, 24, 149, 177–78; Navy, xiv, 129. *See also* specific titles
"Margy, Making Joyous Din, Welcomes 'Thirty Seven In'": illustration, following page 106
Marianne, 26
Marin, John, 132
Marling, Karal Ann (quoted), 139
Marquis, Don, xii, 28, 52, 149
Marriages, xii, 49, 59, 99, 101; Gladys, 41, 43, 47; Johnnie, 29, 33, 36–37; Margaret, 54; Myrtle, 8, 17, 29
Marschbanks, Hal, 15
Marshes, 129, 130
Masks, xvii, 9
Mayan ruins, xiv, 17, 19–20; influence, 83–84, 147, 187
May, Henry F. (quoted), 192n8
Melville, Herman, 136–37
Mencken, H. L., 98–99
"Men in Uniform Welcome If We Go Your Way," 79
"Merely Margy, an Awfully Sweet Girl," xi, 24, 92–93, 191n22; illustration, 94
Merkin, Richard (quoted), 148
Meyer, Susan E. (quoted), xiv, 62, 89, 148
MGM, 26, 52
Midtown Morning, 136
Military uniforms, 79, 81–82
"The Milliner and the City Drummer," 168; illustration, 170
"Mission Furniture," 170
"Miss Universe," 101
"Mr. Harkness Talking," 87; illustration, 88
Modernism, 89, 91, 95, 139, 147
"The Modern Martyr": illustration, 67
Monet, Claude, 134
Moore, Gladys. *See* Held, Mrs. John, Jr. (Gladys Moore)
Morals, 192n8; changes in 1920s, 70–76, 79, 109–10, 166–67; commercial art, 29; flap-

pers, 82; humor magazines, 64–65; *The Wages of Sin and Other Victorian Joys and Sorrows*, 168, 170–71; women, 72–76, 79, 168; youth, 33

Moran, Joe, 44

More Pious Friends and Drunken Companions (Shay), 171

Morgan, Edna, 110–11, 125

Morley, Sylvanus G., 17–19, 129

Mormonism, 1–7, 12, 15, 100, 186

Morning, 136

Murals, 139; Held's, 4, 52

Museum of Modern Art, xiv, xvii

Museum of Natural History, xiv

"Music Lover," 66

"My Life and Times in Deseret," 6

"My Lost City" (Fitzgerald), 138

My Pious Friends and Drunken Companions (Shay), 171–72; illustrations, 172–74, 176

Myer, Anton (quoted), 62

Mythology, xiii, 140, 179–80, 187; animals, 145; fiction, 106, 114; *The Gods Were Promiscuous*, 117–20, 127; 1920s, 110; sculpture, 139

Native American Humor (Blair), 149–50

Navajo Pan, 179

Naval Intelligence. *See* United States Navy

Navy Song Book, 171

NBC Radio, 51

Nervous breakdown, 33, 99, 101

Nesbitt, Evelyn, 76, 194n64

Nevius, Blake (quoted), 194n67

New Deal art, 139–40

New Masses, 149

New Orleans, La., 44

New York City, 12, 17, 100; artists' view, 91; cityscapes, 133; emigrants, 8, 62; Held's residences, xvii, 15, 54

New Yorker, 24, 64, 65, 149; block prints, xi, 5, 24, 68, 150, 171; comic maps, 177–78; humor, 150, 175, 176; illustrations, 177, 179, 181; urban environment, 175; Victorian block prints, 6, 56, 168, 175

New York, New Haven and Hartford Railroad, 26

Novels, xiii, 37, 41, 101, 188; city, 122–25. *See also* Fiction, specific titles

"Nude Descending a Staircase" (Duchamp), 89

O'Brien, Dean W. (quoted), 155

Office of Naval Intelligence. *See* United States Navy

O'Hara, John (quoted), 55

"Oh! Margy!" xv, 24, 33, 36, 91, 150, 152, 191n22; illustrations, 92, 93

O'Keeffe, Georgia, 130

Old Gold cigarettes, 52

"An Old Man's Game," 84

"The Old Order Changeth," 105–6

Old Schuyler Farm, 15, 56–57

"One-eyed girl," 20, 83–84, 159

"100 percent," 26

O'Neill, Rose, xii

"One of Held's Belles Travels to the Farm and Knocks It for a Loop": illustration, 151

"The Only Way," 66, 76; illustration, 77

"The Open Fly," 171; illustration, 57

"The Open Packet," 170

"Ordeal," 101, 102

Our Enchanted Farm, 56–57

Our Times (Sullivan), 164

Packard automobiles: advertising, xi; illustration, 35

Palenque, 129

Palm Beach, Fla., 15

Palmer, Paul, 13

Palmer, Stew, 13

Pan and the Sheep, 179

Parents: changes in 1920s, 71; Held's, 6–7

Parker, Dorothy, xvii, 65, 150

Parsons, Geoffrey, 28

Patterson, Russell, xv, xvi, 36, 64, 92

Peer, Ralph, 171

"Peggy's Progress," 191n22; illustration, following page 106

"Penitentiary Bait," 105, 107–8

Perelman, S. J., 197n30

Perez, Paul, 13

Performer in the Hoops, 128–29

Performing Horse, 144

Petropoulos, Mazie, 111–13, 125

Philadelphia Centennial Exposition, 168

Phillips, David Graham, 125

Picasso, Pablo, 84, 142

"The Pigeon of St. Patrick's," 106

Pigeons, 135–36

Planter's Peanuts, xi, 33

The Plastic Age (Sklar), 99–100

Playboy, 56, 161; illustration, 57

"Playing In by Moonlight": illustration, following page 106

Plume, Jupe, 115–19, 127, 186

Pointillism, 129, 149

Political cartoons, 149

Politics, 31–32, 149, 192n8
"Polly and Her Pals" (Sterrett), 73
"Poor Fish out of Water," 156; illustration, 158
Popular Science, 168
Posada, José Guadalupe, 176
Post, Emily, 71
Poster: illustration, 27
Posters, 9, 26, 52, 62, 130
Pottery, 56
Pound, Ezra, 8
Preserves, xvi
"The Price of Too Great Painstaking," 170
"Prohibition As She Is": illustration, 68
Puck, 9, 20, 63, 72; illustrations, 11, 68
Putnam, George, xvii, 31
Pylon (Faulkner), 188

Radiator Building—Night, New York (O'Keeffe), 130
Radio show, 51
"Rah-Rah Rosalie," 92, 191n22; illustration, 157
"Rainbow's Gold," 106–7
Rathbun, Stephen (quoted), 25
"The Rebellion of the Intellectuals, 1912–1917" (May), 192n8
The Red and the Black, 4–5
Red Manhattan, 136
Reed, Walter (quoted), 148
Reflections, 130
Remington, Frederic, 47
Revisionism, 192n8
"Rhapsody," 26
Ricciotti, Dominic (quoted), 196n6
"The Ride of the Valkyries," 101
Riis, Jacob, 110, 124
"Risking Life and Limb to Secure Oil for Actors' Hair": illustration, 176
Ritter, Thelma, 44
"The Road to Ruin," 168
"Roll Jordan Roll," 6
"Rosalie Goes Rural": illustration, 153
Rosenburg, Harold (quoted), 140, 141
Rosenfeld, Paul (quoted), 125–26
Ross and the New Yorker (Kramer), 147
Ross, Harold, xii, 4–5, 8, 24, 175
Rowland, Helen (quoted), 193n32
Rural life. *See* Country life
Rural New Yorker, 56

The Saga of Frankie and Johnny, 172–73
The Salamander (Johnson), 74

Salt Lake Advertising Club, 45
Salt Lake City Tribune, xvii, 4, 5, 9
Salt Lake City, Utah, 1–2, 53; society, 4–6; theater, 128
Sanctuary (Faulkner), 188
Sandburg, Carl, 171
Sandburg, Mrs. Carl, 55
San Diego Union: illustration, following page 106
The San Francisco Call: illustrations, 153, 157, following page 106
Santayana, George, 59
Sargent, John Singer, 130
Satire, 98–99, 114–15, 149, 166, 185, 197n30
"Sax and Sex," 105
Schoolhouse on the Lot, 52
Scribner's, 101, 168
Sculpture, xvi, 41, 47, 49, 52–53, 56, 126, 128, 187; animal, xiii, 139–45, 186; soap, 13. *See also* Bronze sculptures
"Sentimental Sally," 191n22; illustration, following page 106
Set designs. *See* Theater: sets
Seurat, Georges, 149
"Seven Sutherland Sisters," 44
Sexuality, 64–65, 70, 72, 74, 154, 168; cartoons, 161, 163; *Crosstown*, 112–13; humor magazines, 161; *I'm the Happiest Girl in the World*, 115; youth, 164–65
Shay, Frank, 171–72
Sheeler, Charles, 132, 133
Sheet music, xi, 26
"She Said Now Children Stop Your Cryin'": illustration, 173
"Shifting Perspectives on the 1920's" (May), 192n8
Short stories, xiii, 37, 39, 101. *See also* Fiction, specific titles
Show Girl, 25
Shuttleworth, Jack (quoted), 185
Signal Corps. *See* United States Army Signal Corps
Signatures, 9, 66, 68
"Silent Drama," 20; illustrations, 24, 37
Silk prints, 26
Simonson, Harold P. (quoted), 136–37
Sinclair, Upton, 123
Sintenis, Renee, 141, 196n19
Sister Carrie (Dreiser), 124, 188
Skehan, Gladys, 17
"The Skier": illustration, following page 106
Sklar, Robert (quoted), 99–100
Skylines, 132–33, 196n8
Skylines: Understanding and Molding Urban Silhouettes (Attoe), 132
Skyscraper in Shadow, 136

Smart Set, 15
Smith, Red, 13
Smog, 136
So Big (Ferber), 24
Social changes, 37, 62, 63, 83, 98, 192n8
Social class, 99–100, 192n8; fiction, 105–6; youth, 164
Society, 12; New York City, 70; Salt Lake City, 4–6
Society of American Illustrators, 24
"Soldering the Bustle," 170
"A Solemn Ceremony of Utmost Importance," 170
"Songs without Music," 171
So This is College, 26
Souvaine, Henry, 51
Souvaine, Mabel Hill, 56
Spatial tension, 84, 87
"A Sportsman's Map of Florida," 178
"Start the Piano—Here Comes a Sailor," 171
Steichen, Edward, 26
Steinway, Theodore, 28
Stella, Joseph, 91, 95, 136
Steloff, Frances, 29
Sterrett, Cliff, 73
Stieglitz, Alfred, 132, 133
Stock market crash, xii, 33, 37, 59, 99, 186
"Strategic Ruffles," 170
Strong, Austin, 28, 52
Studio on Hill with Goats, 129
Style, 184; artistic, 62, 63, 65–66, 149, 154; cartoons, 70, 82; Gilded Age, 171, 176; influence of women, 70; literary, 103, 121; sculpture, 140–41; watercolors, 128
"The Sugar Bowl Was Always Empty," 6
Sullivan, Mark (quoted), 36, 37, 164, 166
Sullivant, T. S., 63, 149
Surrealism, 141
"A Swell Map of New York," 178; illustration, 177
Swift, Jonathan, 98, 185
"Symbols and Monuments: Images of the Skyscraper in American Art" (Ricciotti), 196n6

"The Tail of Mr. Dooley," 56
Tales of the Jazz Age (Fitzgerald), xii
Tapestry Rocks and Pines, 129, 130
Tarkington, Booth, 39, 121
Taylor, Joshua (quoted), 131–32, 175
Teaberry Gum; illustration, 34
"Teaching Old Dogs New Tricks," 156, 166
Temperly, Howard (quoted), 195n7
"The Ten Collegiate Commandments," 20; illustration, 22–23

Textiles, 25–26
Thaw, Harry, 76, 194n64
Theater, 4, 14, 15, 24; Salt Lake City, 128; sets, 4, 24, 44, 51
Theater Magazine, 25
"They Want to Fix Your Tie": illustration, 38
"The Thinker" (Held): illustration, following page 106
This Side of Paradise (Fitzgerald), 125–26
Thurber, James, 176; quoted, 152, 154
The Time of Laughter (Ford), xiii, 147
Timken roller bearings, xi, 33, 92
Tintex dyes, xi, 33, 92
"Tonsil Expert," 167–68; illustration, 167
Townsend, Lee, xiv, xv, 15, 29, 54, 192n23
Travel, 15, 17–20, 32, 53–54
"A Truthful Girl," 77; illustration, 78
Tuaillion, Louis, 141
Tuan, Yi-Fu (quoted), 155
Twain, Mark, 168

Unicorn Colt, 143–44
United Lithographic Corporation, 9
United States Army Signal Corps, xvi, 54
United States Navy, xiv, 19, 129
University of Georgia, xv, xvi, 52, 53
Unpopular Review, 75
"Until the James Runs Dry," 101
"Urban Liberalism and the Age of Reform" (Huthmacher), 192n8
Urban life, 138, 145, 175; art, 131–33, 196n6; *Crosstown*, 112; flappers, 150; *The Gods Were Promiscuous*, 115–19, 127, 186; morals, 70–71; novels, 122–26; versus country life, 6, 8, 106, 138, 150, 152; women, 70, 110, 124–26
"Ursula," 87, 159; illustration, 88
Usoskin, Eddy, 9, 13

"Valedictory," 109
Vanguard Press, 97, 122, 195n5
Van Heusen shirts, xi, 33
Vanity Fair, xii, 9, 180; block prints, 168; cartoons, 20, 65–66, 68, 76, 79, 84, 150; illustrations, 10, 80, following page 106
The Vegetable (Fitzgerald), 24, 185
Victorian block prints, 6, 56, 168, 176
"A View of the Boat-Races": illustration, 163
Vogue, 168

The Wages of Sin and Other Victorian Joys and Sorrows, 168, 170–71, 177
"Waltz," 105
Watercolors, xii, 4, 41, 127–45, 149; animal, xiii, 179–80; cityscapes, 128, 130, 136; comic, 28, 149, 186; illustrations, 135, 137, following page 106; photographic qualities, 134; reviews, 195n2; Salt Lake City theater, 128–29; travel, 17–18; The West, xvi
The Watercolors of John Held, Jr., 133
Water Island, 130
"The Way of the Transgressor," 171
Weber, Max, 91, 95, 136
"We Can Be Young Only Once": illustration, 166
Weinhardt, Carl (quoted), xv, 111, 149, 183, 184
Wescott, Glenway, 8
The West, xvi, xvii, 2, 6, 7, 15, 31, 53
Weston, Conn., xiv, xvii, 15, 29, 31, 191n23
Westport, Conn., xii, 29, 101, 191n23
"What Are Little Boys Made Of?" 84
"What Happened to the Progressive Movement in the 1920's?" (Link), 192n8
"When 'Preparedness' Was New": illustration, 11
"When the Theatre Was Fraught with Romance," 171
"When the World Looks Young" (Docuilet), 194n45
"Where the Blue Begins," 161; illustration, following page 106
"Whisker Inspection at the Century Club": illustration, 53
Whistler, James, xvii
White, E. B. (quoted), 8, 17
White, Minor (quoted), 184
White, Stanford, 194n64
"Why So Pensive, Spike?": illustration, 158
Wilcox, Ella Wheeler (quoted), 74
Williams, William Carlos (quoted), 100
Wilson, Ada, 4
Wilson, Edmund, 101
Winner, Charles, 33
"Winning the War in the Movies," 84; illustration, 83
With Malice toward Some (Halsey), 180
Wits End: Days and Nights of the Algonquin Round Table (Gaines), 147–48

Wolfe, Thomas, 123, 124
Woman's Day, 56
Women, xiii, xviii, 20, 41, 49, 61–95, 192n3, 193n8; changes, 36, 193n32; cosmetics, 75, 77, 79, 82; employment, 71, 193n13; fashion, 70, 73, 74, 77, 79, 81–82, 84, 194n45; hair styles, 73, 82; image in advertising, 71–72, 73, 75, 159, 193n17, 194n45; image in cartoons, 156, 158–63; image in fiction, xiii, 105–15, 122, 124–26; image in humor magazines, 65, 70, 150, 175; morals, 72–76, 79, 168; sexuality, 64–65, 70, 72, 74, 154, 168; urban culture, 70, 110, 124–26
Women Are Necessary, 41, 110–11, 115, 122–23, 124
Woodblock prints. *See* Block prints
Woodcuts. *See* Block prints
World War I, xii, 62, 99, 141, 166, 192n8; influence on fashion, 79, 81–82; youth, 164
World War II, xvi
"The Worm's Eye View," 9
"Worse Than Doubling in Brass," 66; illustration, 66

"Yearning for Company," 66
Years of Discretion (Hatton), 75
"Yesterday and Today," 171
"Yo-Ho-Ho and a Deck Full of Rocking Chairs": illustration, 25
Young, Mahonri M., xvii, 4, 6, 8, 14, 17, 28, 147
"Young Prometheus," 101, 122
Youth, xiii, 33, 58, 83, 84, 110, 164–68; *Bowl of Cherries,* 108–9; changes in 1930s, 120–21; *Crosstown,* 112; *Dog Stories,* 37–39; *The Flesh Is Weak,* 105–8; *The Gods Were Promiscuous,* 115; *Grim Youth,* 101–2, 120–22; *Held's Angels,* xii, 57–58; *I'm the Happiest Girl in the World,* 115; radio show, 51; relationship to age, 97, 99, 100

Ziegfeld, Florenz, 24
Ziegfeld's *Follies,* 25

JOHN HELD, JR.

was composed in 10½ on 13 Bembo on a Mergenthaler Linotron 202
by Eastern Graphics;
with chapter titles set in Metropolis Bold
and chapter numerals and initial capitals set in Design Demi
by Rochester Mono/Headliners;
four-color insert printed by sheet-fed offset on 70-pound, acid-free Warren Patina
by Frank A. West Company, Inc.;
text printed by sheet-fed offset on 70-pound, acid-free Warren Patina,
Smyth sewn and bound over binder's boards in Joanna Arrestox B
by Maple-Vail Book Manufacturing Group, Inc.;
with dust jackets printed in four colors
by Frank A. West Company, Inc.;
designed by Will Underwood;
and published by

SYRACUSE UNIVERSITY PRESS
SYRACUSE, NEW YORK 13244-5160